SAMUEL PALMER

his life and art

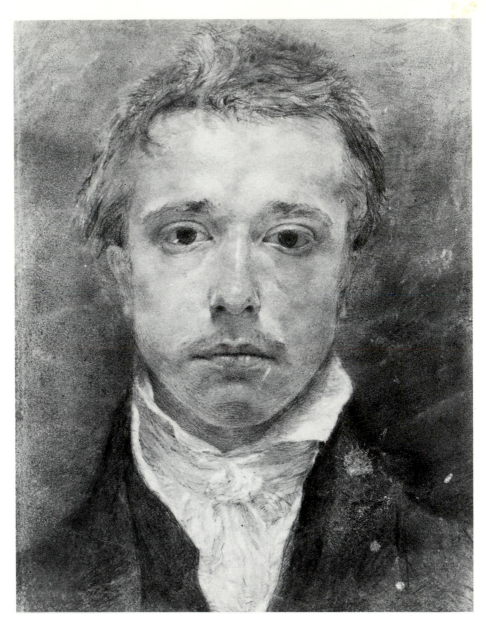

Self-portrait, *circa* 1826. Black chalk heightened with white on paper; 291 × 229 mm (Ashmolean Museum, Oxford)

SAMUEL PALMER

his life and art

ನ್ನು

RAYMOND LISTER

Emeritus Fellow
Wolfson College, Cambridge

The right of the
University of Cambridge
to print and sell
all manner of books
was granted by
Henry VIII in 1534.
The University has printed
and published continuously
since 1584.

CAMBRIDGE UNIVERSITY PRESS

Cambridge
New York New Rochelle Melbourne Sydney

Published by the Press Syndicate of the University of Cambridge
The Pitt Building, Trumpington Street, Cambridge CB2 1RP
32 East 57th Street, New York NY 10022, USA
10 Stamford Road, Oakleigh, Melbourne 3166, Australia

First published 1987

Printed in Great Britain by The Bath Press, Avon

British Library cataloguing in publication data

Lister, Raymond
Samuel Palmer: his life and art.
1. Palmer, Samuel, *1805–1881*
I. Title II. Palmer, Samuel, *1805–1881*
759.2 ND497.P3

Library of Congress cataloguing in publication data

Lister, Raymond.
Samuel Palmer: his life and art.
Bibliography.
1. Palmer, Samuel, 1805–1881. 2. Painting, British.
3. Painting, Modern–19th century– Great Britain.
4. Painters–Great Britain–Biography. I. Title.
ND497.P3L573 1987 760′.092′4 [B] 87–9335

ISBN 0 521 32850 0

For Angel and David Gould
Arcades ambo

So double was his paines, so double be his prayse.
<div align="right">Edmund Spenser, *The Faerie Queene*, II.ii.25</div>

Contents

Illustrations

Preface

It is twelve years since my *Samuel Palmer: A Biography* was published and I have now had the opportunity – one that comes rarely to an author – to expand and rewrite it. Inevitably, during the last decade, I have modified a few of my assessments of Palmer's character, in the light of material which has provided many fresh nuances and many changes of emphasis in the narrative of the artist's life and in consideration of his work.

Further, I have taken the opportunity to present his work in much greater detail than was possible in the earlier book (a purely biographical study little concerned with Palmer's art); hence the considerable increase – nearly four times as many – in the number of illustrations. I have endeavoured to put into context not only Palmer's early visionary work, but also his later work, which is of greater importance than has sometimes been alleged by those who have taken little trouble to understand it. Palmer's visionary period lasted only for a few years, the greater part of his work being of a different kind, yet taking its place in an interrelated continuity of development.

This approach should enable the reader both to place Palmer's work firmly into the matrix of his life, and to understand the quality and motivation of the artist's mind, a mind that by some paradoxical process was more often than not able to distance itself from the turmoil of a frustrating and often tragic life – no less tragic because many of its troubles were self-inflicted.

Wolfson College, Cambridge R.L.
1987

Acknowledgments

For making available original material, I am grateful to Mrs Nina Griggs; Miss Joan Linnell Ivimy; the late Mrs Cecil Keith; the late Sir Geoffrey Keynes; the Linnell Trust; Mr Paul Mellon; the Pierpont Morgan Library, New York; the late Mr Anthony Richmond; Mr John E. A. Samuels. Information and assistance was kindly supplied by the Ashmolean Museum; Mr A. K. Astbury; Dr Edward V. Bevan; the Bodleian Library; the British Museum; Fondation Custodia (coll. F. Lugt), Institut Néerlandais, Paris; Dr Myles Gleeson-White; Mr David Gould; the Henry E. Huntington Library and Art Gallery, San Marino, California; Miss Joan Linnell Ivimy; Maidstone Public Record Office, Kent County Council; the Pierpont Morgan Library, New York; Mr John E. A. Samuels; the Victoria and Albert Museum; the late Mr C. Franklin White; Yale University Library, New Haven, Connecticut.

I am grateful to my cousin Verna Cole for secretarial help, and to Ruth Smith for her constructive and sympathetic editorial work. As always, my wife, Pamela, has given me encouragement and practical help throughout.

Family Tree

William Wake

William Wake, Clerk,
of Wareham, Dorset

William Wake
of Shapwick, Dorset,
d. 1705, aet. 77

Edward Wake
of Charlton,
d. 1680

Charles Wake

William Wake,
Archbishop of
Canterbury,
b. 1657, d 1737

Edward Wake

William Wake,
Rector of Walgrave,
Northants.

A Daughter = *Samuel Palmer*,
Rector of Wylve, Wilts.

Edward Palmer,
Rector of Ringmer,
Sussex

Nathaniel Palmer *Catherine Palmer* *Thomas Palmer*

Edward Palmer *Christopher Palmer* = *Sarah Moxon* *Catherine Palmer*

Edward Palmer *Nathaniel Palmer* *Samuel Palmer*
b. 1775,
d. 17 Dec. 1848

= *Martha*, daughter
of William Giles of
Margate, b. 1778,
d. Jan. 1818

Sarah Palmer *Mary Palmer*

SAMUEL PALMER = *Hannah Linnell*, daughter of John Linnell
b. 27 Jan. 1805, b. 1818, d. 1893
d. 24 May 1881

William Palmer
b. *c.* 1810,
d. 31 July 1866

Martha Palmer
b. 1817

Thomas More Walter George Palmer
b. 27 Jan. 1842, d. 11 July 1861

Mary Elizabeth Palmer
b. 1844,
d. 15 Dec. 1847

Alfred Herbert Palmer
b. 25 Sept. 1853,
d. 1931

Sources:

*Stemma Chicheleana : or, A Genealogical Account of Some of the Families
derived from Thomas Chichele*, Oxford, 1765.

Raymond Lister (ed.): *The Letters of Samuel Palmer*, Oxford, 1974.
Vol. II, pp. 1021–4.

Chronological Table

Year	Palmer	Works mentioned in text (*c.*) indicates that date is approximate	Contemporary people and events
1805	Born 27 January		Battle of Trafalgar, 21 October William Pitt Prime Minister
1806			Death of George Stubbs (b. 1724) Death of William Pitt and Charles James Fox William Lord Greville Prime Minister
1807			Act abolishing the slave trade
1808	Mary Ward engaged as his nurse about this time		Outbreak of Peninsular War
1809			Birth of Alfred Tennyson (d. 1892) Birth of Charles Darwin (d. 1882) Spencer Perceval Prime Minister
1810			Riots in London in support of Sir Francis Burdett, radical M.P.
1811			George Prince of Wales becomes Prince Regent Luddite disturbances in the Midlands
1812		First recorded drawing: *A Windmill and a House, with a Man Fishing*	Napoleon invades Russia; defeated at Moscow Birth of Edward Lear (d. 1888) Earl of Liverpool Prime Minister Luddite disturbances in N. England
1813			Wellington's victory at Vittoria
1814			End of Peninsular War Napoleon abdicates and is exiled to Elba
1815			Napoleon returns from Elba; defeated at Waterloo Peace of Vienna Corn Law
1816			Anti-poverty riots in East Anglia and industrial districts
1817			
1818	Death of his mother, January Becomes a pupil of the drawing master William Wate. Samuel Palmer Senior moves to Houndsditch		

Year	Palmer	Works mentioned in text (c.) indicates that date is approximate	Contemporary people and events
1819	Sells a picture for the first time Work exhibited at Royal Academy	1819 Sketchbook begun	Peterloo Massacre, 16 August Birth of John Ruskin (d. 1900)
1820	Meets Francis Oliver Finch about this time Samuel Palmer Senior moves to 10 Broad Street, Bloomsbury		Accession of George IV
1821		*At Hailsham, Sussex: Storm approaching* *Hurstmonceaux Park*	Death of John Keats (b. 1795)
1822	Meets John Linnell		Death of Percy Bysshe Shelley (b. 1792)
1823	Meets George Richmond		
1824	Linnell introduces him to William Blake about this time	1824 Sketchbook begun	Death of Lord Byron (b. 1788)
1825		*A Rustic Scene* *Early Morning*	Death of John Henry Fuseli (b. 1741)
1826	Meets Edward Calvert and the other Ancients Buys a cottage at Shoreham, Kent; moves there with Frederick Tatham Samuel Palmer Senior moves into Waterhouse at Shoreham	(c.) Self-portrait (c.) *Harvest under a Crescent Moon* *Naomi before Bethlehem*	Power looms destroyed in Lancashire
1827			Death of William Blake (b. 1757) George Canning, Viscount Goderich and Duke of Wellington Prime Ministers in turn
1828		*Sepham Barn* (c.) *A Barn with a Mossy Roof* (c.) *A Cow Lodge with a Mossy Roof*	Birth of Dante Gabriel Rossetti (d. 1882)
1829		(c.) *In a Shoreham Garden*	Roman Catholics become eligible to sit in Parliament
1830	Helps George Richmond to elope with Julia Tatham, January	*The Magic Apple Tree* *Coming from Evening Church* (c.) *Cornfield by Moonlight with the Evening Star*	Accession of William IV Agricultural disturbances in England, 1830–3 Death of Sir Thomas Lawrence (b. 1769) Charles Grey Prime Minister
1831		(c.) *The Sleeping Shepherd*	Death of Mrs Catherine Blake (b. 1762)
1832	Writes and issues anonymously *An Address to the Electors of West Kent* Buys 4 Grove Street, Lisson Grove, London, after which he	(c.) *Bright Cloud and Ploughing*	Reform Bill passed

Year	Palmer	Works mentioned in text (*c.*) indicates that date is approximate	Contemporary people and events
1832 (continued)	visits London with growing frequency; lays foundation for his teaching practice		
1833	Falls in love with Hannah Linnell Visits Devon about this time	(*c.*) *The Gleaning Field* (*c.*) *The Shearers* (*c.*) Drawing for *Landscape Twilight*	Viscount Melbourne and Sir Robert Peel Prime Ministers in turn Oxford Movement inaugurated by Keble Slavery abolished throughout British Empire Tolpuddle Martyrs sentenced
1834		(*c.*) *The Bright Cloud*	Death of Samuel Taylor Coleridge (b.1772)
1835	Visits Dorset, Devon and Somerset Visits North Wales and Monmouthshire with Edward Calvert and Henry Walter	*On the North Devon Coast* *Culbone, Somerset* *Pistyll Mawddach* (three studies) *Mountains near the Traveller's rest, Dolgellau* *Moel Siabod from Tyn-y-Coed* *Snowdon from Moel Siabod* *Study of a Garden at Tintern* (*c.*) *Caernarfon Castle* (*c.*) *A Cascade in Shadow* (*c.*) *Conwy Vale from Gwydir Lodge, Llanrwst* (*c.*) *Llyn Gwynant and Part of Llyn-y-Ddinas*	Viscount Melbourne Prime Minister
1836	Visits North Wales with Edward Calvert	(*c.*) *View from the Bridge near Capel Curig* (*c.*) *The Valley of Dolwyddelan*	Commutation of Tithes Act
1837	Death of Mary Ward, 18 January Marries Hannah Linnell, 30 September, and begins visit to Italy with her and the Richmonds 3 days later, visiting Paris, Milan and Florence en route to Rome	*Rome from the Borghese Gardens* *Italian Pifferaro* *The Forum, Rome*	Accession of Queen Victoria Death of John Constable (b.1776)
1838	Relationship with his parents-in-law begins to deteriorate Travels with Hannah to Naples, June, and Tivoli, November	*A View of Ancient Rome* *A View of Modern Rome during the Carnival* *Villa d'Este from the Cypress Avenue* *The Cascades at Tivoli* *Ruins of the Amphitheatre, Pompeii* *The Street of Tombs, Pompeii* *Rome and the Vatican from the Western Hills* (*c.*) *View of Tivoli*	Formation of Anti-Corn Law League, led by John Bright and Richard Cobden

Year	Palmer	Works mentioned in text (*c.*) indicates that date is approximate	Contemporary people and events
1839	Returns from Italy, November; Hannah stays at first with her parents	*View from Villa d'Este, Tivoli* *A Mountain Road in Italy* *Civitella near Subiaco* *Papigno on the Nar* Copy of Raphael's *Dispute of the Sacrament*	
1840	Holiday at Shoreham, August Visits Surrey		Penny Post introduced Queen Victoria marries Prince Albert of Saxe-Coburg-Gotha Chartist disturbances in Sheffield and Dewsbury
1841			Sir Robert Peel Prime Minister
1842	Birth of his son, Thomas More Walter George, 27 January Visits Wiltshire and Dorset		Death of John Sell Cotman (b. 1782)
1843	Elected an associate member of the Old Water-Colour Society Visits Wales About this time visits Surrey, Kent, Sussex and Berkshire	(*c.*) *The Colosseum and the Arch of Constantine* *Old Farm, near Thatcham, Berkshire* *The Campagna and Aqueducts of Rome* *At Donnington, Berkshire* *Evening – The Ruins of a Walled City*	
1844	Birth of his daughter, Mary Elizabeth Visits Guildford and Wales for sketching, September and October	*Guildford* *Sketches of the Fair, St Catherine's Chapel, near Guildford*	
1845	Visits Margate, where Hannah and the children are holidaying Visits Princes Risborough for sketching, August and September	*Evening in Italy: The Deserted Villa* *A Farmyard near Princes Risborough*	
1846	Visits Kent and Buckinghamshire	*Crossing the Ford* Illustrations for Dickens's *Pictures from Italy* *Studies of Barley, Oats and Wheat*	Lord John Russell Prime Minister Repeal of Corn Laws
1847	Death of Mary Elizabeth, 15 December	*A Double Rainbow* (*c.*) *A Gypsy Encampment* (*c.*) *Landscape with Setting Sun*	
1848	Moves to IA Love Lane (later IA Victoria Road), Kensington, March Visits Kent, Surrey, Cornwall and Devon, and possibly Dorset Death of Samuel Palmer Senior, 17 December	*View at Tintagel* *Tintagel Castle, approaching Rain* *The Rock Slip near Boscastle* (*c.*) *Farewell to Calypso* *Backways near Tintagel* (two studies) *Christian descending into the Valley of Humiliation*	Chartist demonstrations at Kennington Common and elsewhere in London, and in N. England

Year	Palmer	Works mentioned in text (c.) indicates that date is approximate	Contemporary people and events
1848 (continued)		*View of Box Hill, Surrey* (two studies) (c.) *Evening* *The Water Mill*	
1849	Visits Devon, June and July, also Surrey and possibly the Isle of Wight	*Memoranda of Sunsets on the Devon Coast* (c.) *View of Clovelly, Devon* *In Clovelly Park* *Mouth Mill, near Clovelly* *Sir Guyon with the Palmer attending*	Death of William Etty (b. 1787)
1850	Elected a member of the Etching Club, 19 February	(c.) *The Willow* Etchings *The Willow, The Skylark, The Herdsman's Cottage, Christmas Robinson Crusoe guiding his Craft into the Creek*	Roman Catholic hierarchy re-established in England
1851	Moves to 6 Douro Place, Kensington Linnells move to Redstone Wood Probably visits Sussex, Surrey and Kent	(c.) *Landscape with Windmill, Figures and Cattle*	Opening of the Great Exhibition in Hyde Park Death of J. M. W. Turner (b. 1775)
1852		Etching *The Vine* or *Plumpy Bacchus*	Death of Duke of Wellington Riots between Catholics and Protestants in Stockport
1853	Birth of his son Alfred Herbert, 25 September		Earl of Aberdeen Prime Minister
1854	Elected to full membership of the Old Water-Colour Society	(c.) *An English Version of the Eclogues of Virgil* begun	Outbreak of Crimean War
1855	Consulted by Alexander Gilchrist in connexion with his *Life of William Blake*	(c.) *The Piping Shepherd* *The Dell of Comus*	Viscount Palmerston Prime Minister
1856	Thomas More Palmer runs away from home with George Richmond's son, William; the boys are caught and returned to their parents Visits Margate	*The Brothers in Comus lingering under the Vine* *The Brothers, guided by the Attendant Spirit, discover the Palace and Bowers of Comus*	End of Crimean War
1857		*A Bright Day in Autumn* (c.) *The Sleeping Shepherd* Etchings *The Sleeping Shepherd, The Rising Moon*	Outbreak of Indian Mutiny
1858	Visits Devon and Cornwall with Thomas More	Etching *The Weary Ploughman* *Grower Rock and Short Island* *Study of Waves breaking upon the Seashore, Cornwall* *Storm and Wreck on the North Coast of Cornwall*	Indian Mutiny, 1858–9 Earl of Derby Prime Minister

Year	Palmer	Works mentioned in text (*c.*) indicates that date is approximate	Contemporary people and events
1859	Visits Hastings and Devon Thomas More and Alfred Herbert contract scarlet fever, November; they recover, but Thomas More's constitution is permanently weakened		Viscount Palmerston Prime Minister Darwin's *Origin of Species* published
1860		Etching *The Morning of Life* begun	
1861	Thomas More taken by Hannah for a recuperative holiday to High Ashes Farm, Leith Hill, but dies there, 11 July. From about 18 July Palmer lodges at Elm Cottage, Redhill; then moves to a cottage in Park Lane, Reigate	Etching *The Early Ploughman* begun *The Abbey Stream* *The Streamlet* *After the Storm*	Death of Prince Albert
1862	Death of F. O. Finch, 27 August	*Wrecked at Home – a Husband and a Brother Saved*	
1863	Moves to Furze Hill House, Mead Vale, Redhill Leonard Rowe Valpy buys *Twilight: The Chapel by the Bridge*	*Twilight: The Chapel by the Bridge* (*c.*) *The Two Pet Lambs*	
1864	L. R. Valpy commissions the Milton watercolours	*Children returning from Gleaning* *A Dream in the Apennine* Charcoal sketch for *Il Penseroso* subject	
1865			Death of Palmerston; Earl Russell Prime Minister
1866	Death of his brother, William, 31 July		Earl of Derby Prime Minister First Trades Union Congress, at Manchester
1867			Irish rising suppressed Second Reform Act
1868		(*c.*) *A Towered City* or *The Haunted Stream* *The Lonely Tower*	Benjamin Disraeli Prime Minister, then W. E. Gladstone
1869		*Morning* or *The Dripping Eaves*	Disestablishment of Irish Church Suez Canal opened
1870		*The Curfew* or *The Wide Water'd Shore* (*c.*) *The Bellman* probably begun	Forster's Elementary Education Act
1871			Abolition of religious tests at Cambridge and Oxford Trade Union Act

Year	Palmer	Works mentioned in text (*c*.) indicates that date is approximate	Contemporary people and events
1872		(*c*.) *An English Version of the Eclogues of Virgil* completed	
1873			Death of Sir Edwin Landseer (b. 1802)
1874		(*c*.) Illustrations to Virgil begun	Benjamin Disraeli Prime Minister
1875	Death of Frederick Tatham		Artisans Dwellings Act
1876			
1877		*The Waters Murmuring*	Queen Victoria proclaimed Empress of India
1878			
1879		Etchings *The Bellman, The Lonely Tower*	Outbreak of Zulu War
1880	Death of John Giles	Etching *Opening the Fold* or *Early Morning*	W. E. Gladstone Prime Minister
1881	Death of Julia Richmond, January Dies 24 May	*The Prospect* completed *The Eastern Gate* completed *The Bellman* left uncompleted	
1882	Death of John Linnell	Etchings *The Homeward Star, The Cypress Grove, The Sepulchre* and *Moeris and Galatea* left uncompleted	
1883	*An English Version of the Eclogues of Virgil* published		

1

The gateway to the valley

Samuel Palmer came from an upper-middle-class family, among whose connexions had been Charles James Fox, Archbishop Wake, and several humbler members of the clergy, including an early-eighteenth-century Samuel Palmer, vicar of Wylye in Wiltshire. By the late eighteenth century their descendants were well-to-do feltmakers in the City of London. Christopher Palmer, grandfather of Samuel Palmer the artist, married Sarah Moxon, daughter of a partner in the firm of Moxon, Palmer and Norman of St Martin's Lane, Cannon Street. They had three sons – Edward, Samuel (father of the artist) and Nathaniel – and two daughters, Sarah and Mary.[1]

Little is known of Sarah and Mary. Edward, Samuel and Nathaniel were completely different from one another. Edward owned an estate in Ireland, which his eldest son sold to Lord Clanricarde.[2] Nathaniel was 'a shrewd, cold, determined man utterly impervious to persuasion and argument and utterly indifferent to the ties of kinship'.[3] In contrast Samuel, despite having commenced life in his father's firm and having purchased the Freedom of London as a feltmaker,[4] was wholly lackadaisical. Although he was an accomplished scholar, he never used his knowledge creatively; he craved only continual change, no matter what it was or where it led him. Money did not interest him. He soon left the family firm and set up in business as a bookseller and stationer, in a dingy little City shop, with a stall outside – not unlike that depicted by George Cruikshank in the fifth plate of Dickens's *Oliver Twist*. This move was unpopular with the rest of the family, and Samuel's unpopularity grew as time passed and he had to be helped out of one disastrous folly after another.

When he was twenty-eight Palmer married Martha Giles, a pretty girl who, as a dowry, brought with her a small independence. She was the daughter of a prosperous Walworth banker and stockbroker, William Giles, whose wife, Martha, *née* Covell, came from Margate. This Martha claimed to have had visionary experiences, and is said, at the age of fifteen, to have leapt from the first-floor window of a walled-in house in Margate High Street, 'disturbed by an unusual appearance within'.[5] Both Samuel and Martha were dissenters (Martha's grandmother, one of the first Baptists in Margate, was nicknamed 'Nanny Baptist' by her husband),[6] but they were married in church, as the law then required, in St Mary Newington on 12 October 1803. They set up home in an old house in Surrey Square, in the vicinity of Bedford Square and the Old

Kent Road. Just over fifteen months later, at 5 o'clock in the morning on 27 January 1805, Martha gave birth to a son; the birth was registered at Dr William Williams's Library, Red Cross Street, London,[7] the boy being named Samuel, after his father.

Little Samuel was a sickly baby, and when he was only a few months old he contracted a persistent cough that perhaps presaged the asthma which affected him throughout his adult life. His alarmed parents took him to Margate to stay with the Giles family, hoping that bathing and sea air would cure him. It did little good – Martha wrote to her husband, who had had to return to London, that 'our dear boy's Cough has prevented his bathing since you went'; but added, 'he is a lovely child'.[8] That the visit to the seaside had little effect is not surprising, considering Samuel's under-nourishment: for his first few years he was fed only on semi-liquid food. But all this was altered in 1808 when an intelligent nurse, Mary Ward, was engaged to take charge of him. She immediately changed his diet and introduced a much bolder regimen. One of the first things she gave him was a plate of salmon, and he showed his appreciation by stretching out his hands towards it.[9]

It was an age when most domestic servants were illiterate, but Mary Ward had an intimate knowledge of the Bible (a more common attainment among Baptists, whose faith she shared) and an almost scholarly knowledge of the works of Milton. Many years later, on her deathbed, she gave Samuel her copy of Jacob Tonson's edition of Milton; he added brass corners to the binding, so that he could carry it without damage in his waistcoat pocket, and, as he put it, 'after doing so for twenty years it was all the fresher for the porterage'.[10]

It had been Mary Ward's ambition to find a permanent situation in a congenial home, and she realized this in the Palmer household, although her wages were probably pitifully small, even by the low standards of the times. Her steel spectacles, which were still owned by the Palmer family in 1930, gave some indication of her penury, for they were of the 'roughest workmanship ... [with] almost hopelessly blurred lenses'.[11] But Samuel's affection amply compensated for any inadequacy of wages. She had become a second mother, a beloved preceptress and guide. This is illustrated by the well-known story of how, when looking with her four-year-old charge from a window in the Surrey Square house at the moon rising behind a group of elms, casting their shadows on the floor, she repeated to him a couplet from Edward Young's 'Paraphrase of Job':

> Fond man! the vision of a moment made!
> Dream of a dream! and shadow of a shade!

(Lines 187–8)

'I never forgot those shadows,' Palmer later told the art critic F. G. Stephens, 'and am often trying to paint them.'[12]

As Samuel grew into boyhood, Mrs Palmer took him several times to Margate. During these visits they attended chapel meetings, where they heard

addresses by a succession of lay preachers, including 'a plain Farmer', who spoke on 'As thy day so shall thy strength be.'[13] But they also attended Margate church, where one day they heard a Rev. William Bayly preach; his sermon did not make a favourable impression, for although he was 'said to be a very nice man', as Samuel told his father, '[we] heard that he was clever in every thing but in the pulpit'.[14] Samuel's earliest surviving drawing was probably done at Margate: a tiny watercolour (41 × 54 mm) of a river scene, *A Windmill and a House, with a Man Fishing* (Huntington Library and Art Gallery, San Marino, California), dated 19 December 1812. It could have been drawn by any seven-year-old, and indicates nothing of his future genius. Further sketches made during his visits to Margate include a view of Margate church for his mother's kinsman, Samson Covell, and there was some talk of sketching 'a mackarel' for the same person, but it is not known if this was done.[15]

In about 1810 Mrs Palmer gave birth to another son, William. He turned out a completely different character from his brother, more ineffectual even than their father, spineless, vain, extravagant and unintelligent. There was little real rapport between the brothers, although Samuel went to considerable trouble in later life to help William.

ঝঞ্ঝ

Samuel's father was a potent influence in the formation of his son's character. Both father and son were bosom companions from the child's earliest years and, encouraged by his father, Samuel became passionately fond of books. Even during boyhood Samuel's reading so concentrated his mind that, while never shy, he had neither time nor inclination for companions of his own age, or for outdoor games or pastimes, although he had plenty of cousins to play with had he wished. The only game he played indoors was backgammon.[16]

The stock of his father's bookshop constantly changed, and this helped to vary Samuel's reading, whether in fiction, tales of adventure and travel, religion, poetry or textbooks.[17] But he was not so omnivorous a reader as his father, who ranged at random, accumulating an infinity of facts and quotations, which he wrote out in little vellum-covered notebooks, small enough to fit into his waistcoat pocket.[18] Young Samuel read more objectively, yet was able to glean considerably from his father, who among much else taught him Latin. They often took pleasant walks together in what was then the countryside (but is now suburbia), during which they talked endlessly. Samuel's father did his best, during these peripatetic discussions, to improve his son's mind and discrimination. On Sundays and holidays the pair sometimes walked beyond Greenwich Park to Dulwich, which in later years Samuel and his friends called 'The Gate into the World of Vision'[19] because of the world of spiritual and artistic innocence which they imagined to lie beyond in an idyllic Edenic countryside.

In the bookshop, both father and son browsed lovingly among the stock,

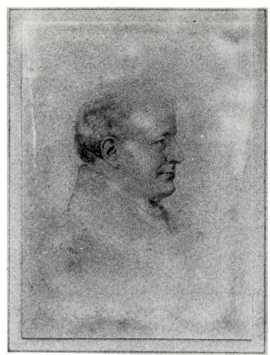

1 Samuel Palmer Senior, by John Linnell, *circa* 1840. Pencil on paper; sheet size 187 × 140 mm (private collection, England)

probably viewing it with more delight than the customers did, and even withdrawing certain favourite volumes from sale. At the same time the father constantly pointed out what he considered best in literature, and made his son memorize long passages from *The Pilgrim's Progress*. Bunyan's biblical phraseology greatly influenced Samuel, and stylistic overtones from it may be recognized in the letters he wrote as a young man. Every day his father made him learn a passage from scripture, and each day he was made to repeat from John Ray's *English Proverbs* (1670): 'Custom is the plague of wise men, and the idol of fools.' This was remote from sentiments engendered by conventional education, and explains Samuel's later contempt for many of the rules of society. When he was an old man, he remarked, 'If we merely ask ourselves "What will people say of us?", we are rotten at the core.'[20]

His reading helped the development of conversational powers well beyond his years. Later, Samuel remembered with great affection his father's encouragement, his learning, and above all his easy-going tolerance, for he spoke evil of no man, and was charitable and completely amiable – characteristics inherited by his son, often to his own disadvantage. Old Palmer's forbearance is demonstrated by the fact that, although he was a Particular Baptist (one who believes that Christ died, not for all mankind, but for a select few), he did nothing to influence his son's free choice of religion, or to dissuade him from his love of the Church of England, first implanted by his uncle Edward Palmer.

Nevertheless, it is somewhat puzzling that the boy should have been so strongly attracted to the Church, for apart from his father's persuasion, his mother was a Wesleyan, and many of the Gileses were Catholics. It is true that some of his ancestors had been clergymen, but they were sufficiently remote to have had little or no effect on him. Probably his love (and that is not too strong a word) was awakened by something he had seen or heard in a church or cathedral. Architecture, singing, ritual or simply the general atmosphere may have stirred some dormant or subconscious longing for a more visually beautiful religion than could be found in the dour chapels attended by his mother and father. After reaching maturity he never again attended a Nonconformist service.[21]

Despite his tolerant home, and what came perilously near to pampering, Samuel was not spoilt. But the birch rod that hung on the wall was more a threat than a practical instrument of correction, for it was rarely, if ever, used. Once, after some boyish mischief, when the father began an exhortation which his son thought would end in a whipping, Samuel begged him to 'talk about something pleasant'.[22] It is not known what effect the plea had, but it is unlikely that his good-humoured father birched him after such a heartfelt appeal.

ಬಿಡ

Martha Palmer had a cultured background, and her influence on her son was considerable. Her father, William Giles, who had visited China, was an amateur author, and Martha had sat as the model for the heroine Lavinia in Thomas Stothard's frontispiece to one of his books, *The Refuge*.[23] His output included several moralistic tracts, among them *The Victim, Thoughts on the Suffering of Christ, A Guide to Domestic Happiness* (published in Dove's edition of the English classics) and Amy Caudle's dialogue against infant baptism in Douglas Jerrold's *Mrs Caudle's Curtain Lectures as Suffered by the Late Job Caudle*. He was also an amateur composer, one of whose tunes was published in Peck's *Tune Book*.

Although Martha adored her husband, she never attempted to follow the tortuosities of his quicksilver mind. Extremely easy-going in both family and religious matters, she was nevertheless emotional, readily moved to tears both of joy and grief; she was self-effacing, affectionate and amiable to an unusual degree. Good-natured she needed to be, if life with her husband was to be bearable. He was indeterminate, unable to decide how to fill each day without long and futile deliberations; he was improvident, and money for household expenses was not always available. This made no difference to the amiable Martha: she still adored and admired him.

Although as yet her son had received no proper instruction in art, she thought she perceived, in some groping attempts to express divinity in his painting, a serious talent. Martha's indulgent outlook (and that of her husband) was unusual, and her son's efforts were not dismissed as they probably would have

been in an ordinary Nonconformist household. Moreover, Samuel was encouraged not only in his original efforts, but in the copying of an assortment of drawings, botanical engravings and prints of frescoes and other paintings.

The young Palmer's own aspirations at this time were literary, and he mildly resented what he saw as a misinterpretation of his 'instinct ... a passionate love ... for the traditions and monuments of the Church; its cloistered abbeys, cathedrals, and minsters, which I was always imagining and trying to draw; spoiling much paper with pencils, crayons, and water-colours'.[24] Though none of these early drawings has survived, what may be accents from some of them occur in designs in his 1824 Sketchbook, now in the British Museum. But despite their supposed misinterpretation of his instinct, Palmer's devotion to his parents remained undiminished; he appreciated especially all his father had tried to do for him. Beneath a musical composition he made later in life, he wrote:

I dedicate this work to my Father, because, not choosing to sacrifice me to Mammon with the mummery all the while of Christian prayers, with an affection rare in this day, he led my erring steps where Faith, Temperance, and Study evermore resort and wait to take the hand of those who love their charming company. And because he supported me, never once murmuring, long after that time when our fathers use[d] to thrust their offspring from their bosom at the first crude opportunity, that they may clutch their gold alone and gorge a richer feast.[25]

Samuel's desire to please his parents is further demonstrated in a note written to his mother a few days before his tenth birthday, in which, rather priggishly, he discourses 'On divulging and concealing secrets.' He ends the note: 'Let us avoid extremes; let us walk in the middle path of virtue, seeing that leads to happiness. Those who are fond of extremes, live a vicious life, and die an unhappy death.'[26]

Martha did not live to influence her son much longer. One day in January 1818, while he was on a visit to his grandfather William Giles, at Margate, news arrived from home. The thirteen-year-old boy ran joyfully to hear what it was, and his heart froze: his mother had died. Many years later he described this shock to a friend: 'I ... had the news broken to me by an uncle – it was like a sharp sword sent through the length of me.'[27]

The loss of Samuel Palmer Senior's wife, his 'most amiable and most affectionate comrade', caused him little of the agony that usually accompanies such partings.[28] On the other hand, his son was almost incapable of bearing the blow, as he was to find again to his cost in later bereavements, for he had inherited from his mother a tendency to almost uncontrollable grief. In passing into his own personality, this sensibility became even more poignant, less restrained, more agonizing, making the loss of those close to him insupportable. It was, said his son, a 'terrible scourge'.[29]

၇၃

One attempt had been made to have Samuel educated in the conventional way. It was a disaster. He was sent to Merchant Taylors School where, through their City connexions, the Palmers had some influence. He was totally unprepared for

the rough and tumble of school life; he had been given plenty of instruction in morality and literary taste and appreciation, but the physical aspect of his education had been completely neglected, so he was incapable of taking part in school games, let alone in the fights that were an inevitable part of school experience. Many years later, he confessed to having looked on big boys with misgiving, thinking they resembled baboons.[30]

At his passionate behest his parents, after two terms, removed him from the school, instead of making him stand up to its unpleasantness, humiliation and pain, and allowed him to return home. Here he developed a young-ladyish sensitivity, reading his favourite poets and authors curled up in a soft armchair; he tended to shed what he called 'delicious tears' at the sound of music. 'I cannot imagine him', wrote his son, 'as running, jumping, riding, boxing, rowing, shooting, or playing any masculine game whatever.'[31] Nevertheless, though it was hidden under a tender exterior, Samuel did not lack physical courage. Similarly, a small physique of apparently feminine softness hid a hearty digestion, and a superb mental vitality.

With the death of Martha, urgent consideration of Samuel's future became necessary. The signs seemed so clear, that it required little deliberation to settle on painting, and a drawing master was engaged – an obscure but capable painter named William Wate (died 1832). Wate probably used David Cox's *A Treatise on Landscape Painting and Effect in Water Colours* (1813) as a textbook, for the watercolours painted by Palmer at this period are strongly reminiscent of Cox's work. Such are the studies in brown wash, *Evening* (Victoria and Albert Museum) and *Hurstmonceaux Park* (private collection, England; illustration 2), comparable in Cox's *Treatise* with *Old Buildings, Lambeth and Hastings* on plate 4 (aquatints)* – dreamy topographical views, not unpleasing, but uninspired when compared with what he was to produce a few years hence. A little later he also made studies of abbeys, cathedrals, and minsters in wild and strange landscapes, illuminated by vast suns, moons, stars and planets; they presage what he was to accomplish, especially in the congenial surroundings of his country retreat at Shoreham in Kent. But for the time his real interests and his capacity for strong feeling remained unexpressed in his work. He was concentrating on the development of his technique in Wate's able if unimaginative hands, and creating work which was tamely picturesque.

Samuel also received some guidance from Thomas Stothard, the artist friend of his grandfather Giles. Stothard gave Samuel tickets to John Flaxman's lectures on the Royal Academy. Though mainly dealing with sculpture, Flaxman's lectures covered a wide spectrum; they dwelt on the importance of geometry in drawing and design, on ancient art and on the foundations it provided for the arts of Europe, and on the part played by art in disseminating sacred history and doctrine among the illiterate. He covered such subjects as contemporary English sculpture and its relationship to Greek statuary; science;

* There are three distinct series of plates in the *Treatise*: lithographs, aquatints and colour plates.

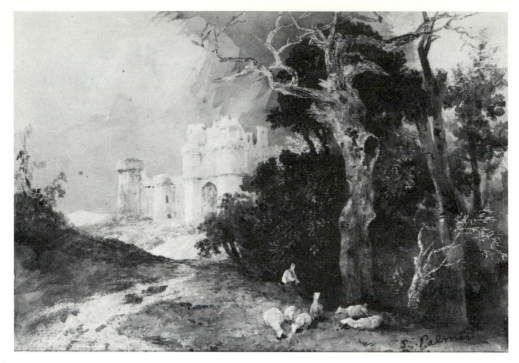

2 *Hurstmonceaux Park*, 1821. Pen and brown wash over pencil on paper; 194 × 272 mm (private collection, England)

beauty; composition; and style. He emphasized the greatness of Michelangelo, particularly in the Sistine Chapel frescoes, and devoted lectures to the work of the sculptors Thomas Banks and Antonio Canova.

Palmer derived considerable benefit from all of this, laying foundations for his appreciation of art that were in a few years to be reinforced from other quarters. In his practice he was convinced of the importance of geometry, and later instilled it into his own pupils; an instruction card exists, dating from about 1863, in which, under the heading of 'Elements of Form', he illustrates simple geometric rules applied to the drawing of basic forms.[32] And, as we shall see, his awareness and love of classical art and of its traditions were important and lasting elements in his work.

Soon after Martha's death, Samuel Palmer Senior moved to 126 Houndsditch and then, in 1820, he again moved his home and bookshop, to 10 Broad Street, Bloomsbury, taking the faithful Mary Ward with the family. It was a good situation for a bookshop, for it stood on a highway used by the multitude who walked daily between the City and the West End. But it was an insalubrious and noisy quarter, almost a parallel of Tom-all-Alone's in Dickens's *Bleak House*, and despite Mary Ward's vigilance, Samuel's health deteriorated. Nevertheless, he had taken the first faltering steps in his profession: in 1819, at the British Institution, he sold his first picture.

The British Institution had opened in Pall Mall in 1816, in premises formerly occupied by Alderman John Boydell's now bankrupt Shakespeare Gallery (pictures by British artists on Shakespearean subjects, which Boydell also used to illustrate an edition of Shakespeare). Its aim was the promotion of British art. To some extent it was a rival of the Royal Academy, and it not only provided an opportunity for contemporary artists to show their works in regular exhibitions, but also allowed young artists to copy selected old masters at a time when access to them was very limited. Just after Samuel's fourteenth birthday, he received a note from the Keeper of the British Institution informing him that one of his two pictures in the current exhibition, No. 169, *Landscape* (now untraced), had been sold for 7 guineas (£7.35), and that the buyer, a Mr Wilkinson of Marylebone, might be prepared to commission further work. 'No doubt', said the artist later in life, 'it added zest to the plum-pudding.'[33] In addition, during the same year, three of his works were hung in the Royal Academy.[34]

At this Royal Academy exhibition Samuel saw a picture which was to have a strong influence on his art: J. M. W. Turner's *Entrance of the Meuse: Orange Merchant on the Bar* (Tate Gallery).[35] Perhaps this initial contact with Turner's work was encouraged by the engraver George Cooke (1781–1834), well known for his many plates after Turner, who often called on the Palmers of an evening to talk about art with the budding painter and his father. Turner's work held sway over Palmer throughout his life, and the greater painter's influence may be discerned in many different stages of his art, for example in *At Hailsham, Sussex: Storm approaching* (1821; Yale Center for British Art; illustration 3) and *Tintagel Castle, approaching Rain* (1848; Ashmolean Museum; illustration 63). The former, in its handling, resembles Turner's studies *Storm Clouds, Sunset* (*circa* 1825) and *Venice looking East from the Giudecca at Sunrise* (1819) (both Tate Gallery);[36] the latter has affinities with George Cooke's engraving of Turner's watercolour of the subject (Museum of Fine Arts, Boston) for *Picturesque Views of the Southern Coast of England* (London, 1826, Vol. II, p. 72).

༄

Young Samuel did not give his whole attention to art, but spent valuable time in religious speculation and debate – understandably enough when there were Catholics and Nonconformists in such close proximity. Writing about it many years afterwards, he said:

I was a freethinker at 14 and spent much time in controversial reading which ought to have been given to painting. It would be affectation in me to deny that I am acquainted with the whole scope of popular sceptical reasoning, and can therefore, after my poor little storm beaten skiff has shifted about among quicksands, and treacherous floating isles, green to the eye but fatal to the feet – that after all this I can the more assuredly find anchorage where Pascal Bacon Newton and Milton lowered their cables.[37]

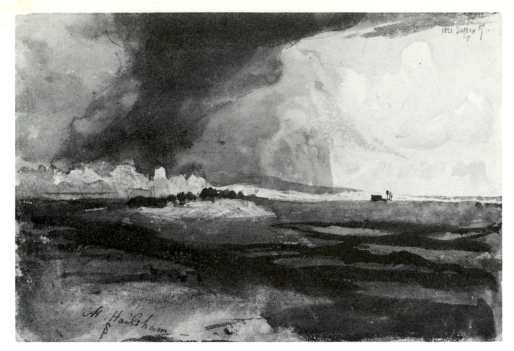

3 *At Hailsham, Sussex: Storm approaching*, 1821. Watercolour over pencil on paper; 209 × 314 mm (Yale Center for British Art, New Haven, Connecticut, Paul Mellon Collection)

His efforts were fragmented in other ways as well, for he joined an amateur musical society that met during the daytime, when he could have been using the light for painting. But he soon realized that it was affecting his work and thereafter, as he put it, he 'sang and fiddled only in the evening'.[38] Energy was also dissipated by bouts of hypochondria which began to affect him in 1820. These led to an even greater tendency than before to remain indoors without exercise, which added to his troubles; he also lacked self-discipline, for he had no set curriculum or hours of work. Behind all this Palmer discovered the Devil, whose existence he never doubted; he was convinced that Satan took up much of his time in attacks on his faith, and in attempts to distract his attention while at prayer.

But there were good influences too, one of the best being his friend the water-colour painter Francis Oliver Finch (1802–62), whose work, Palmer said, suggested 'happy and beautiful lands where the poet would love to muse: – the moon-lit glade, the pastoral slope, the rocky stream; the stately terrace and mouldering villa'.[39] It is not clear where or when Palmer first met Finch, but it was probably at his amateur musical society, for Finch was an accomplished pianist, capable of good renderings of Tallis and of Purcell (an unfashionable and indicative choice of composers), and had a striking alto voice. His influence on the young Palmer did much to reinforce the cultured atmosphere of his home. Many years later, in a memorial essay, Palmer wrote of him:

Besides modern languages and scientific acquirements he had large general knowledge. His conversation was never obtrusive, and never flagged: it was solemn, playful, or instructive, always at the right time and in the right place . . . He had read much, was familiar with the great poets and satirists; knew the philosophy of the mind, and had observed men and manners . . . Of his social and moral excellence it is difficult to speak . . . for the heart overflows with memories of his active kindness . . . Let those who knew Francis Finch be thankful; they have seen a disciplined and a just man, 'a city at unity with itself'.[40]

It was probably the high-minded Finch who helped Samuel to concentrate his efforts to realize a religio-artistic philosophy, typified by this passage from one of Palmer's private pocket-books, written between November 1822 and June 1824:

Now it is twenty months since you began to draw. Your second trial begins. Make a new experiment. Draw near to Christ, and see what is to be done with Him to back you. Your indolent moments rise up, each as a devil and as a thorn at the quick. Keep company with the friends of Publicans and sinners, and see if, in such society, you are not ashamed to be idle. Ask Christ to manifest to you these things; Christ looking upon Peter (called *Repentance*) and Peter's countenance. Christ's promise to the dying thief – the looks of both. Christ leading His blessed to fountains of living waters (which being the union of all vision, should be done as the artist's Prince); Jesus weeping at Lazarus' tomb. The three first are the chief, and are almost unpaintable – quite, without Christ. Lay up, silently and patiently, materials for them

4 Francis Oliver Finch by A. Roffe, *circa* 1850. Engraving after a photograph; engraved area 120 × 80 mm. From [Mrs E. Finch:] *Memorials of the Late Francis Oliver Finch*, London, 1865

Dughet, not generally available to the public elsewhere (the National Gallery was not founded until 1824). Many of these works were to influence Palmer's painting. For the present, Linnell drew his attention to the 'Van Leydenish qualities in real landscape' and exhorted him to 'look hard, long and continually'. Again, Palmer noted, 'I was looking with Mr L[innell] at one of Bonasoni's [*sic*] emblems, a rope-dancer balancing himself with this motto, *In medio est salus*. "Yes," said he emphatically, "for a rope-dancer; but the rope-dancer only keeps the middle that he may be not a middling, but an excessive fine performer ..."'[50] One visit with Linnell to the Dulwich Gallery produced these earnest comments:

Memoranda, day after going to Dulwich. Cox is pretty – is sweet, but not grand, not profound. Carefully avoid getting into that style which is elegant and beautiful but too light and superficial; not learned enough – like Barret.* He has a beautiful sentiment and it is derived from Nature; but Nature has properties which lie still deeper, and when they are brought out the picture must be most elaborate and full of matter even if only one object be represented, yet it will be most simple of style, and be what would have pleased men in the early ages, when poetry was at its acme, and yet men lived in a simple, pastoral way.

Girtin's twilight, beautiful, but did he know the grand old men? Let me remember always, and may I not slumber in the possession of it, Mr Linnell's injunction (delightful in the performance), '*Look at Albert Dürer.*' In what a simple way Landscape impressed the mind of Raffaelle; yet his little bits make me despair ...

The copy of Leonardo da Vinci at Dulwich is merely a head and shoulders. How amazingly superior it is in style to any portrait there. The tone of the flat blueish sky is wonderful, though it is nothing of itself. It is the colour of the soul, not vulgar paint. Ruysdael, Hobbema, Paul Potter, and Cuyp – how intense, how pure, how profound, how wonderful![51]

Most of the designs in the 1824 Sketchbook, while based on direct observation of nature, are romantic, dreamlike views of ideal English scenery, with little rounded hills, brilliant stars, vast suns and the crescent moon standing 'tiptoe on a green hill top to see if the day be going and if the time of her vice regency be come';[52] fantastic walled and battlemented cities; trees both complete and analysed in detail; sheep cropping grass and tended by picturesque peasants; mills, and little cottages, thatched and latticed:

N.B. That dark stem close behind the cottage is that dotty kind and its dots are to be an intermediate background between the rich color'd light trees and the blue sky – its branches distinguished by their darkness – whatever you do guard against bleakness and grandeur – and try for the primitive cottage feeling gospel instead of law, for we are not come unto the ma[ster].†[53]

They are not portrayals of contemporary English country life, but of an England that had passed from view centuries before Palmer's time – if indeed

* George Barret Junior (1767 or 1768–1842), painter in watercolour.
† Perhaps a reference to John xi, 28: 'The Master is come, and calleth for thee.'

it had ever existed. It was a bucolic world of the imagination, a *locus amoenus*: landscapes of the artist's imagination, like those called forth by Virgil in his *Georgics* and *Eclogues*.

Palmer developed this world further in his pen and ink wash drawings of 1825, *A Rustic Scene, Early Morning* and others (Ashmolean Museum; illustrations 5 and 6). He composed these meticulously finished works with penwork in lines of varying strength – in some places thick with glue, standing up from the paper like lines printed from a deeply etched plate, in others as light as a hair. Their landscape is based on that of Kent, which Palmer had visited, but in detail they are indebted to such artists as Breughel and Elsheimer, prints of whose works Linnell had probably shown to Palmer. Their minutely drawn details also show the influence of landscapes in miniatures in illuminated manuscripts, which he could have seen in the British Museum.

As might be expected of an artist who was an enthusiastic reader from boyhood, in almost all of Palmer's work there is a literary element, not least in this group. In an inscription on the original mount of *A Rustic Scene* he quoted from Book I of Virgil's *Georgics*, and on the original mount of *Early Morning* he wrote lines from John Lydgate's *Complaint of the Black Knight* (then thought to be the work of Chaucer):

5 *A Rustic Scene*, 1825. Pen and brush in brown mixed with gum on paper; 179 × 236 mm (Ashmolean Museum, Oxford)

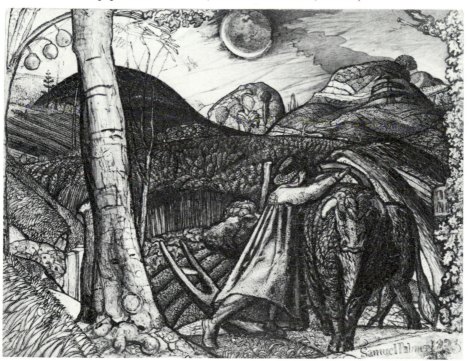

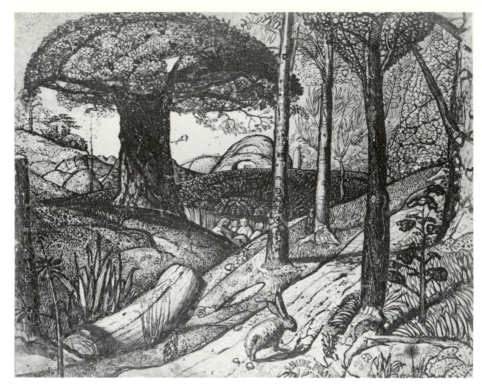

6 *Early Morning*, 1825. Pen and brush in brown mixed with gum on paper; 188 × 232 mm (Ashmolean Museum, Oxford)

I rose anon, & thought I would gone
 Into the wodde to heare the birdes sing,
When that misty vapour was agone,
 And cleare & faire was the morning.

There is also much symbolism and allusion. The hare in the foreground of *Early Morning*, for instance, probably denotes fecundity, as hares have done for centuries in Christian art. The little group of figures seated under the great umbrella-shaped oak tree, on the edge of the cornfield, might be workers at breakfast, or they may be Palmer himself with a few friends, resting amidst the abundant landscape. The drawings in this group are all richly textured – it is as if every blade of grass, every leaf, every grain of corn were individually deline-ated. Here again was something, already tried to some extent in the 1824 Sketchbook, that Palmer perhaps derived from medieval miniature painting and perhaps also from the textures in engravings by Bonasone and others.

For this vision, the advent of Linnell into Palmer's life was largely respon-sible. Before they met, Palmer had imagination which he found impossible to express in his art; he had acquired a degree of technique that hardly took him beyond convention, and he had dimly perceived a mystical relationship between art and religion. John Linnell provided the catalyst which enabled Palmer to

transform these elements into an amalgam that marked one of the watersheds of English Romantic art.

ಬಬ

So important is Linnell's part in Palmer's story that, before proceeding further, we should consider his personality in some detail. By sheer plodding hard work and force of character, he had, by the time he met Palmer, learnt to work skilfully in many branches of art. Not only did he paint in both oils and watercolour, he was also a miniaturist; he painted portraits and landscape, was an engraver, and had a lucrative practice as a picture-restorer and picture-dealer. Moreover he was a gifted teacher, whose pupils included William Beckford (author of *Vathek*) and the art critic and poisoner Thomas Griffiths Wainewright. It was probably because he descried in the young Palmer a promising pupil that he approached him and made friends with him, though at this stage he can scarcely have foreseen that this pupil would also become his son-in-law.

Linnell's religious views were completely unconventional, even within Nonconformity; he made and observed his own rules and tried to make others obey them too. It was an 'angry, intolerant religion unattached to any sect, but believed by his eldest daughter to have been revealed by God to him alone'.[54] When he married Mary Ann Palmer (daughter of Thomas Palmer, a coal merchant; she was not related to Samuel), he was determined not to be married in church, so they travelled all the way to Scotland, where different laws obtained, for a civil ceremony. The journey and ceremony together cost him £50.[55] He ruled his family like an ancient patriarch, with love and wrath, and on a regime of self-sufficiency. He ground his own flour, baked his own bread, and brewed his own beer. When his children were old enough, these duties were divided between them.

Mrs Linnell held herself aloof from most household tasks, and Linnell had even to arrange the children's cribs. She was 'denied by nature any of the traditional weapons of her sex, either physical or mental, [but] managed to environ herself with an appearance of candour, amiability, piety and friendliness and even of hospitality, a virtue which was of all things most foreign to her nature'.[56] She had no friends, and never joined her husband on social visits. She was, besides, a dabbler in medicine and many times wrought havoc among her family by her attentions. But usually Linnell was too busy to bother overmuch about what his wife was doing. He would be occupied by such matters as painting a miniature of Princess Sophia; selling a picture he claimed was by Parmigiano; painting a village scene, a landscape or a narrative picture; finishing, in Sir Thomas Lawrence's studio, an equestrian portrait of the Duke of Wellington; painting portraits of rich or aristocratic patrons; or illustrating nursery rhymes by 'Felix Summerly' (Sir Henry Cole) for his *Home Treasury*.

He overworked prodigiously, and to help him maintain his pace, imbibed large quantities of oxygen, or Vital Air, as it was then called. This could be bought

7 John Linnell in old age. From a photograph (private collection, England)

from chemists in bottles fitted with a gauge to show the contents. Although his journal[57] often records that he was 'ill' or even 'very ill', he never missed an appointment with a patron, sitter or pupil. Apart from an occasional visit to the theatre, he allowed himself no relaxation. One incident will serve to illustrate the power of Linnell's endurance. In 1822 one of his pupils, Captain Digby Murray, a keen student of the technicalities of art, offered Linnell fifty guineas (£52.50) if he would paint a circular self-portrait without interruption from other work. After careful consideration Linnell accepted, and during July and August of that year, worked on the commission for twenty-five days without a break. His bill, however, amounted not to fifty guineas but to £63, 'because of additional labour'. He maintained a resolute independence of his patrons, and if he chose, would delay the completion of a portrait for months.

It is not surprising that a man with such a strong character had defects as well. One of these was a too highly developed business sense, probably in reaction to his father, who in this respect was completely inept. The reaction, if such it was, was extreme: he trusted nobody without a signed and stringent agreement – every patron had to sign one when he commissioned work, and every employee had to sign one when he was engaged. Even established and well-known picture dealers, even the famous William Agnew, had to sign agreements when they wanted to buy his work, and were further required to pay a deposit of one third of the price on signing the agreement, and the balance before delivery. If payment was not made at the time specified, and the price of consols (in which he would invest the money) changed meanwhile, the client was charged with any loss. So anxious was he to be paid that he sometimes sent work to his

patrons before it was properly dry, packing it, for the sake of economy, in an old and dusty case. Thus the picture often arrived damaged, but as Linnell had demanded payment before delivery, the client had little chance of redress.

In pursuing his claims he was indifferent to the position of his patrons. He once painted and delivered a small portrait of the Duke of Argyll, without receiving payment. Soon afterwards he was visiting, with William Blake, an exhibition at the British Gallery and saw the Duke among the company. Nothing daunted, he spoke to him and reminded him of his debt, whereupon the Duke appointed the next day for payment. He also painted some miniatures of Princess Charlotte, and after his account had remained unsettled for some time, paid several calls at Kensington Palace to remind her of it. But with this patron he could not get an interview, although, in time, he got his money. For once he was too embarrassed to collect it, so he sent F. O. Finch for it.[58]

Linnell was a Puritan, and it was an aspect of him that Palmer was later to overlook at his peril, for Linnell practised Puritanism in most details of his life. Later he upbraided Palmer for what he read in a letter as a sneer at the religion of humble artisans (see below, pp. 120–1), and in an early letter to Palmer he reproved him for addressing him as Esquire: 'pray squire me no squires', he wrote. 'It is not my taste to be ever called squire.'[59] And while Palmer was proud of the gentility of his ancestry, Linnell gloried in the humility of his. He never went to school, his father was almost illiterate, his mother died insane, and most of his other relatives were markedly his social inferiors. The husband of one of his cousins, Mrs Barr, kept a public house near Knightsbridge Barracks; another cousin, Mrs Symonds, was married to a small farmer who lived in Portobello Road; and one of his sisters was married to a piano tuner. His own manners were far from genteel:

He had terrific sneezing bouts, which ... were audible from afar. The sound was like the wing-beats of some vast prehistoric bird with the added suggestion of an express engine anxious to be gone. If any one asked what catastrophe impended, the answer was 'It's only father sneezing.' In addition to these peculiarities ... was the wilful mispronunciation of certain simple words. Thus the word 'both' was altered to 'bo-arth'.[60]

Although Linnell drove hard bargains and busied himself with the smallest sums, he was also a generous man. He made interest-free loans to many relatives and friends, and included in these were almost daily sums to his old teacher, Varley, whose wife wrote repeatedly to say she had nothing with which to buy bread; and his gifts to his daughter Hannah, who married Palmer, were extremely generous. None of these timely loans or family bounties would have been possible without Linnell's business ability. One of his strongest critics, his grandson A. H. Palmer, stated that until he had, late in life, carefully searched through his grandfather's accounts and business papers, no one had the slightest idea of the extent of his generosity to his poor relations and to his own family. There were, indeed, thousands of gifts, big and small. All in all, A. H. Palmer considered him a 'splendid, courageous and manly tyrant', and observed that his grandfather had always been kind to him.[61]

In time Linnell's house came to resemble a factory, in which he was the manager of his studio, or 'shop', as he preferred to call it, and his numerous children the workers. They were Hannah, or Anny (1818–93), Palmer's future wife; Elizabeth Ann (1820–1903); John (1821–1906); James Thomas (1823–1905); William (1826–1906); Mary Ann, or Polly (1828–83); Sarah, or Sally (1830–1908); and the twins Thomas George and Phoebe (1835–1911). Mrs Linnell spent the majority of the day in her room while Hannah shouldered most of the housewife's duties. The other children ground wheat, laboured in the garden, painted, drew or worked on lithographs or other illustrations. Later John, James and William became Royal Academy students. They walked to Somerset House (where the R.A. schools were situated) in single file, and 'so apparelled that their advent was hailed with delight. As they announced that baker's bread was a vile and poisonous imposition, they were pelted with it; but departed, daily as they came, entirely superior and unmoved.'[62] When the four boys had grown up, they worked under Linnell's supervision as artists, and he flatly refused to allow any customer to deal directly with them, even when the eldest was thirty-nine and the youngest twenty-five. He formed them into a partnership, John Linnell and Sons, with himself as managing partner.

Such was Palmer's mentor. The picture that emerges is not ingratiating, but like him or not, Linnell was a strong and formidable character, without whom Palmer's life and art would have developed along entirely different and perhaps inferior lines.

ᔕᘉ

Another influence in Palmer's art and life, stronger for a period at least than Linnell's, was that of the visionary poet-painter William Blake. That Palmer was ripe for Blake's guidance is obvious from certain passages in the 1824 Sketchbook, which reveal an intense vision, as if, like Blake, he discerned in the English landscape the spiritual Jerusalem.

A large field of corn would be very pretty with as it were islands peeping out of it – as a clump of cottages completely inclosed and shaded by trees – the corn being high no part of the little isles in this wavy sea of purity would be seen till they were perhaps 5 or six feet from the ground – only 2 clumps of elm trees rising distinctly from the midst would be pretty – A group of different sex and age reaping, might be shewn in the foreground going down a walk in the field toward the above cottage island and over the distant line that bounds this golden sea might peep up elysian hills, the little hills of David, or the hills of Dulwich or rather the visions of a better country which the Dulwich fields will shew to all true poets.[63]

It was probably only a few months after writing this that Palmer was introduced to Blake by Linnell,[64] who had himself been introduced to him by George Cumberland Junior, son of George Cumberland the artist and aesthete. In his autobiographical notes,[65] Linnell recalls that

At Rathbone place 1818 my first Child Hannah was born Sep 8, and here I first became acquainted with William Blake to whom I paid a visit in company with the younger Mr

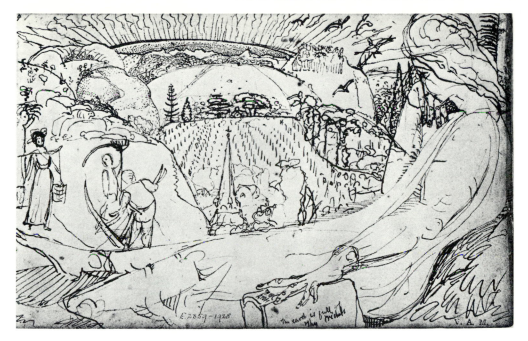

8 A page from the Sketchbook begun in 1824. Pen and ink on paper;
116 × 189 mm (irregular) (by courtesy of the Board of Trustees of the
Victoria and Albert Museum)

Cumberland. Blake then lived in South Molton St. Oxford St. second floor. We soon
became intimate and I employed him to help me with an engraving of my portrait of Mr
Upton a Baptist preacher which he was glad to do having scarcely enough employment to
live by at the prices he could obtain; everything in Art was at a low ebb then. Even Turner
could not sell his pictures for as many hundreds as they have since fetched thousands.[66]

Blake and Linnell soon became close friends, making expeditions together to
the British Museum, to an exhibition in Pall Mall, to Colnaghi's to inspect
prints, and to Drury Lane Theatre. Linnell brought friends and acquaintances
to meet Blake, among them John Constable, John Varley, Sir Thomas Lawrence
and the miniaturist James Holmes; and he introduced him to his family doctor,
Dr Robert John Thornton, who was also a publisher of elegant books,
including the great *Temple of Flora*. Thornton later published the wonderful
little wood-engravings which he commissioned from Blake to illustrate
Ambrose Philips's 'imitation' of the First Eclogue in the school edition of the
Eclogues called *The Pastorals of Virgil*; these were to have a powerful impact on
the works of Palmer and his friends. Most significant of all, Linnell commis-
sioned work from Blake, thus ensuring that his declining years were spent, if
not in comfort, then at least in freedom from penury and from the boredom of
hackwork. Two of Linnell's commissions are among Blake's masterpieces: a set
of illustrations to the Book of Job, and over a hundred illustrations to Dante's
Divine Comedy.

ILLUSTRATIONS OF IMITATION OF ECLOGUE I.

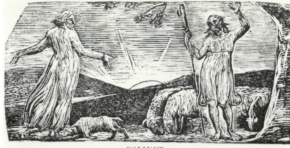

COLINET.

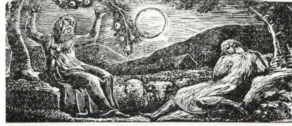

THENOT.

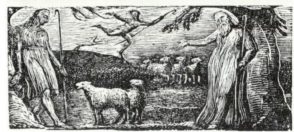

COLINET and THENOT.

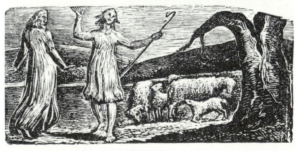

COLINET.

9 William Blake: Illustrations for Thornton's *Pastorals of Virgil*, 1821. Wood-engraving; 150/151 × 68/75 mm (private collection, England)

Linnell saw a set of twenty-one illustrations in watercolour of the Book of Job which Blake had made for an earlier patron, Thomas Butts. He was much impressed by them and suggested that Blake should reproduce them in a further set. Blake agreed to do this, and subsequently Linnell commissioned him to engrave a set of plates of the subjects, thereby giving him the opportunity to create a great, and in the opinion of some, his greatest, original work. While the Job engravings were still being made, Linnell commissioned Blake to make a series of watercolour illustrations to the *Divine Comedy*, and then to engrave them. The 102 watercolours were made in a big folio book supplied by Linnell. But Blake was able to engrave only seven subjects (and some of these remained unfinished) before he died. Yet both watercolours and engravings are a superb achievement of Blake's last years, and a mark of Linnell's kindness to him.

Blake was living in his last home, in Fountain Court, Strand (near to where the Savoy Hotel now stands), when Linnell first took Palmer to visit him: the exact date is not known. 'At my never-to-be forgotten first interview,' said Palmer, 'the copper of the first plate – "Thus did Job continually" was lying on the table where he had been working at it. How lovely it looked by the lamp-light, strained through the tissue paper!'[67] On another occasion, not long after the first visit, Palmer found Blake working on the Dante drawings.

On Saturday, 9th October, 1824, Mr Linnell called and went with me to Mr. Blake. We found him lame in bed, of a scalded foot (or leg). There, not inactive, though sixty-seven years old, but hard-working on a bed covered with books sat he up like one of the Antique patriarchs, or a dying Michael Angelo. Thus and there was he making in the leaves of a great book (folio) the sublimest designs from his (not superior) Dante. He said he began them with fear and trembling, I said 'O! I have enough of fear and trembling.' 'Then,' said he, 'you'll do.' He designed them (100 I think) during a fortnight's illness in bed! And there, first, with fearfulness (which had been the more, but that his designs from Dante had wound me up to forget myself), did I show him some of my first essays in design; and the sweet encouragement he gave me (for Christ blessed little children) did not tend basely to pre-sumption and idleness, but made me work harder and better that afternoon and night. And, after visiting him, the scene recurs to me afterwards in a kind of vision; and in this most false, corrupt, and genteelly stupid town my spirit sees his dwelling (the chariot of the sun), as it were an island in the midst of the sea – such a place is it for primitive grandeur, whether in the persons of Mr. and Mrs. Blake, or in the things hanging on the walls.[68]

Suddenly, it seemed to Palmer, he had encountered a being in whom were centred all the aspirations, artistic and moral, for which he had been groping. Here, in this poor and rather grubby old man, was the spirit of a prophet, and an artist-prophet at that. He even kissed the bell-handle of Blake's apartment before pulling it. In a letter written in 1855 to Blake's biographer, Alexander Gilchrist, he recollected him in terms which reveal as much about himself as about Blake:

In him you saw at once the Maker, the Inventor; one of the few in any age: a fitting companion for Dante. He was energy itself, and shed around him a kindling influence; an atmosphere of life, full of the ideal. To walk with him in the country was to perceive the soul

10 William Blake at Hampstead, by John Linnell, *circa* 1825. Pencil on paper; sheet size 177 × 112 mm (Fitzwilliam Museum, Cambridge)

of beauty through the forms of matter; and the high, gloomy buildings between which, from his study window, a glimpse was caught of the Thames and the Surrey shore, assumed a kind of grandeur from the man dwelling near them . . . He was a man without a mask; his aim single, his path straightforwards, and his wants few; so he was free, noble, and happy . . . His eye was the finest I ever saw: brilliant, but not roving, clear and intent, yet susceptible; it flashed with genius, or melted in tenderness. It could also be terrible. Cunning and falsehood quailed under it, but it was never busy with them. It pierced them, and turned away

. . . He was one of the few to be met with in our passage through life, who are not in some way or other, 'double-minded' and inconsistent with themselves; one of the very few who cannot be depressed by neglect, and to whose name rank and station could add no lustre. Moving apart, in a sphere above the attraction of worldly honours, he did not accept greatness, but confer it. He ennobled poverty, and, by his conversation and the influence of his genius, made two small rooms in Fountain Court more attractive than the threshold of princes.[69]

Blake's failing health did not prevent Palmer from seeing much of him during the short period between their first meeting and Blake's death in 1827. Blake regularly visited Collins's Farm at North End, Hampstead, behind the Bull and Bush Inn, into which, as a country retreat, the Linnell family had moved during March 1824. (It is still there, but renamed Wyldes.) These visits took him past the Palmers' Broad Street house, and Palmer often walked part of the way with him. (Blake chose to walk because the jolting of a cabriolet would have brought on painful attacks of diarrhoea.) Blake and Palmer visited exhibitions together, one such visit, to the Royal Academy in May 1824, being recalled by Palmer in a letter to Gilchrist. Blake pointed out a picture of a scene by Thomas Griffiths Waine-wright from Walton's *Compleat Angler*, which he said was 'very fine':

While so many moments better worthy to remain are fled the caprice of memory presents me with the image of Blake looking up at Wainewright's picture; Blake in his plain black suit and *rather* broad-brimmed, but not quakerish hat, standing so quietly among all the dressed-up, rustling, swelling people, and myself thinking 'How little you know *who* is among you!'[70]

Of Blake's work Palmer wrote rapturously, speaking of Michelangelo and 'his equal, Blake'.[71] Elsewhere he wrote what could also serve as an evocation of some of his own early works:

I sat down with Mr Blake's Thornton's *Virgil* woodcuts before me, thinking to give to their merits my feeble testimony. I happened first to think of their sentiment. They are visions of little dells, and nooks, and corners of Paradise; models of the exquisitest pitch of intense poetry. I thought of their light and shade, and looking upon them I found no word to describe it. Intense depth, solemnity, and vivid brilliancy only coldly and partially describe them. There is in all such a mystic and dreamy glimmer as penetrates and kindles the inmost soul, and gives complete and unreserved delight, unlike the gaudy daylight of this world. They are like all that wonderful artist's works the drawing aside of the fleshly curtain, and the glimpse which all the most holy, studious saints and sages have enjoyed, of that rest which remaineth to the people of God.[72]

In the practical matters of art, also, Blake profoundly influenced Palmer, as may be gathered from a later entry in his 1824 Sketchbook.

Remember that most excellent remark of Mr B's – how that a tint equivalent to a shadow is made by the outlines of many little forms in one mass, and then how the light shines on an unbroken mass near it, such for instance as flesh etc. This remark alone if generally acted upon would go a long way towards the much hoped for and prayed for revival of art . . . Now begin to finish the cornfield-picture bit by bit . . . sparing no pains to copy from the sketches carefully in pencil very faint with the utmost correctness: then perfect those lines . . . so that the objects shall be palpable and the outline very clear tho' faint. Then . . . begin to insert those masses of

little forms like the leaves of a near tree which *serve instead of shadows* and *themselves make a tint* all the while fattening up the outlines . . .[73]

There are affinities here with Blake's strongly held belief in the importance of 'line' in art, which he most likely imparted to his disciple:

The great and golden rule of art, as well as of life, is this: That the more distinct, sharp, and wirey the bounding line, the more perfect the work of art; and the less keen and sharp, the greater is the evidence of weak imitation, plagiarism, and bungling. Great inventors in all ages, knew this: Protogenes and Apelles knew each other by this line. Rafael and Michael Angelo and Albert Dürer are known by this and this alone. The want of this determinate and bounding form evidences the want of idea in the artist's mind, and the pretence of the plagiary in all its branches. How do we distinguish the oak from the beech, the horse from the ox, but by the bounding outline? How do we distinguish one face or countenance from another, but by the bounding line and its infinite inflexions and movements? What is it that builds a house and plants a garden, but the definite and determinate? What is it that distinguishes honesty from knavery, but the hard and wirey line of rectitude and certainty in the actions and intentions? Leave out this line, and you leave out life itself; all is chaos again, and the line of the almighty must be drawn out upon it before man or beast can exist.[74]

Again, Palmer wrote of trees: 'Sometimes trees are seen as men. I saw one, a princess, walking stately with majestic train . . .'[75] This was something that Blake had seen, too, and perhaps implanted in the young man's mind. In a letter to Thomas Butts, he wrote:

> What to others a trifle appears
> Fills me full of smiles or tears;
> For double the vision my Eyes do see,
> And a double vision is always with me.
> With my inward Eye 'tis an old Man grey;
> With my outward, a Thistle across my way.[76]

And in a retort to an unimaginative cleric, Dr John Trusler, author of *Hogarth Moralized* and *The Way to be Rich and Respectable*, he wrote: 'The tree which moves some to tears of joy is in the Eyes of others only a Green thing that stands in the way.'[77]

Palmer's eager young mind was at its most receptive and ready to benefit from Blake's stimulus. His condition was akin to that described by Saint Teresa as 'a glorious folly, a heavenly madness, in which true wisdom is acquired'.[78] 'Young as I am,' he wrote, 'I know – I am certain and positive that God answers the prayers of them that believe, and hope in His mercy. I sometimes doubt this through the temptation of the Devil, and while I doubt I am miserable; but when my eyes are open again, I see what God has done to me, and I now tell you, I *know* that my Redeemer liveth.'[79]

ভ

Blake and his Virgil wood-engravings invigorated not only Palmer, but also his circle of young friends. F. O. Finch saw in Blake '*a new kind of man*, wholly

original, and in all things'.[80] Another close friend in this group was the teenager George Richmond (1809–96), son of Thomas Richmond the miniaturist. Palmer first met Richmond when he was drawing in the sculpture galleries in the British Museum in 1823. He was of short stature with big hands and feet, but, to judge from portraits, had a good face. He occasionally visited Somerset House with Palmer, and for a shilling (5p.) entrance fee, would spend a little time gazing at Michelangelo's chalk drawing of Leda and the Swan, which was exhibited there during the annual Summer Exhibition of the Royal Academy.

The members of the circle also included two sons of the architect Charles Heathcote Tatham, Frederick (1805–78), a sculptor and miniaturist, and Arthur (1809–74), then an undergraduate at Magdalene College, Cambridge, and later prebendary of Exeter. Henry Walter (1799–1849) painted animals and portraits in watercolour; Welby Sherman was an engraver (fl. 1827–34); Palmer's cousin John Giles (1810–80) became a stockbroker; and Edward Calvert (1799–1883), the eldest member of the group, was for a brief period one of the finest engravers in the history of the art. The young friends called themselves 'the Ancients' because of John Giles's repeated claims that ancient man was superior to modern man. Giles was so imbued with this idea that he

11 George Richmond: self-portrait, 1830. Watercolour and body colour on ivory; 102 × 70 mm (private collection, England)

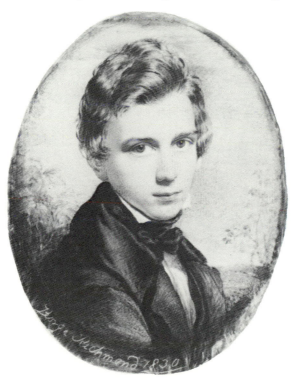

12 Frederick Tatham, by John Linnell, *circa* 1835. Pencil on paper;
190 × 146 mm (collection of R. M. M. Pryor Esq.)

affected to speak with what he imagined was medieval pronunciation, saying
that a couple had been 'marrièd', or that a coat was 'furrèd'. In the opinion of
A. H. Palmer, Giles was the 'hub of the fraternity'.[81] For although this big, burly,
but weak-voiced man had no literary or artistic attainment, he was a kindly soul
of incorruptible sincerity. He admired Blake and collected some of his work,

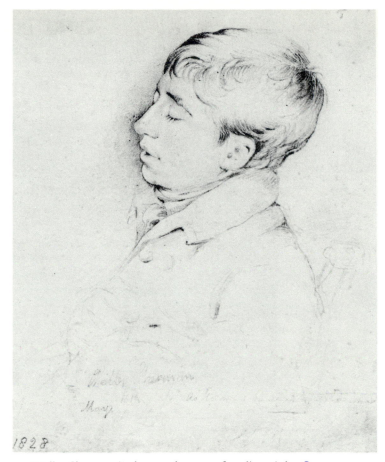

13 Welby Sherman 'as he may be seen after dinner', by George Richmond, 1828. Pencil and wash on paper; 100 × 135 mm (now untraced)

and on one memorable occasion discovered in a shop, and bought at a bargain price, the original plate of Blake's big engraving of *Chaucer's Canterbury Pilgrims* (Yale University Art Gallery).

Some of these young men fell under Blake's spell as strongly as Palmer had done. Richmond first met Blake at the house of Charles Heathcote Tatham, and afterwards walked home with him. It was, he said, 'as if I were talking to the prophet Isaiah'. Yet Richmond, unlike the gentler and more devoted Palmer, boldly argued and disagreed with Blake, to which the old man responded with good humour. Once Richmond found inspiration had left him for a fortnight, and sought Blake's advice. Blake said to his wife: 'It is just so with us, is it not, for weeks together, when the visions forsake us? What do we do then, Kate?' 'We kneel down and pray, Mr Blake,' she replied.[82] Another time Blake told Richmond, 'I can look at a knot in a piece of wood till I am frightened at it.'

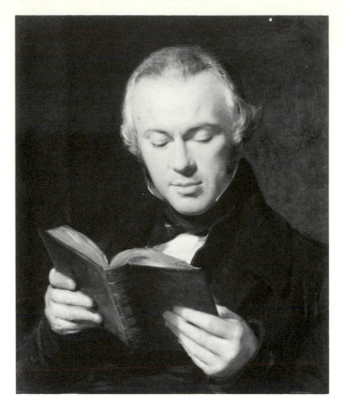

14 John Giles, by George Richmond, 1850. Oil on canvas;
6.1 × 51.4 cm (now untraced)

Frederick Tatham's view of Blake was more cautious. He was, he said, 'a Visionary, Poet and Painter, who also had a most consummate knowledge of all the great writers in all languages ... His knowledge was immense ... indomitable, proud, and humble, he carried out a sort of purpose in his life which teemed only to produce what was invisible to the natural eye, to the despising of the things which are seen; he therefore became wild and his theories wanted solidity.'[83]

Walter, Sherman and Arthur Tatham were the least affected by Blake. Calvert was a different matter. He was an ex-midshipman in the Navy, and a married man before he met Blake. He left the service on attaining his majority, after seeing a great friend killed in action at his side. He then came to London, and attended the Drawing and Life Schools at the Royal Academy. Almost the first person he met in London was John Giles, who sold some shares on his behalf. Giles felt some affinity to Calvert, for he told him about the Ancients and 'the Divine Blake', as he called him, who 'had seen God, Sir, and had talked with angels'. Not long after this Calvert found an opportunity to introduce himself to Blake, who received him kindly as if he were an old friend. He met Richmond

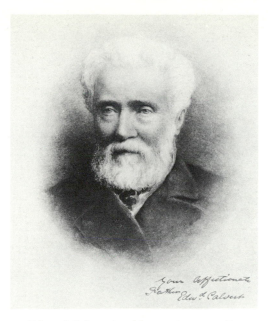

15 Edward Calvert in old age, *circa* 1870. From a photograph reproduced in [Samuel Calvert:] *A Memoir of Edward Calvert*, London, 1893

in the library at Somerset House: Calvert, looking like 'a prosperous, stalwart country gentleman, redolent of the sea, and in white trousers',[84] said, 'You must be Mr Richmond.' 'And you', replied Richmond, 'the Mr Calvert whom I have wished to see.'[85] Not long after this, in 1826, Calvert met Palmer.

Calvert soon became a dominant personality among the Ancients. In addition to being the eldest of them, he had, during his naval days, travelled widely, as far as Algiers and Greece. He was also a philosopher of a kind who, later in life, worked on theories concerning the relationship between music and colour, and attempted to reconcile the teachings of Jesus and Socrates. His appearance was reminiscent of an ancient prophet or sage and, despite his short stature, he was immensely dignified, and serious to the point of austerity. But he was also a kindly man, and for a time, under the influence of Blake, was as visionary a Christian as any of the Ancients. He saw immediately the beauty and importance of Blake's *Pastorals of Virgil* engravings: 'They are done as if by a child, several of them careless and incorrect; yet there is a spirit in them, humble enough and of force enough to move simple souls to tears.'[86] One day, when showing one of his own works to Hannah Linnell, he said, 'These are God's fields, this is God's brook, and these are God's sheep and lambs.' At which Linnell, who was present, sarcastically asked, 'Then why don't you mark them with a big G?'[87]

On the whole the Ancients did not lack humour. Palmer in particular loved to tease the others, especially the dignified and aloof Calvert; and he was always

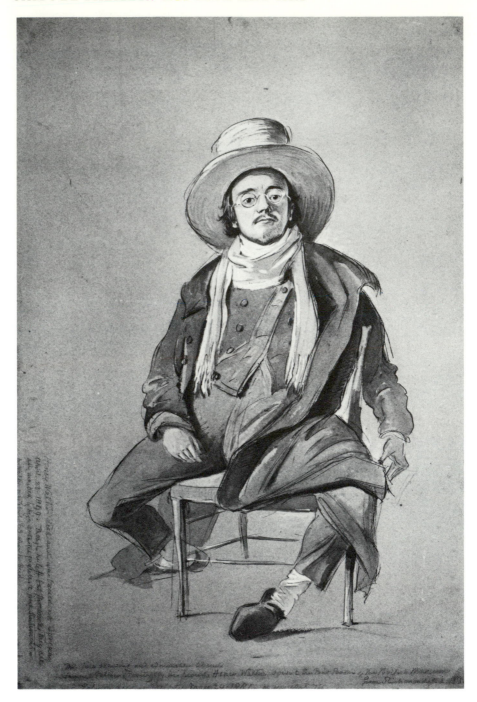

16 Samuel Palmer, by Henry Walter, *circa* 1835. Watercolour and body colour, heightened with white, and pen and ink, on paper; 542 × 366 mm (British Museum)

ready to laugh, 'sometimes uncontrollably, at his own expense'.[88] They drew caricatures of one another. Henry Walter was especially clever at this, and there is a well-known caricature of Palmer by him, wearing glasses, slippers and an enormous hat (British Museum; illustration 16). Another Walter caricature, now untraced, showed 'Richmond in the full swing of his glory': the young artist, dressed in a coat with flapping tails and an enormous high collar, performing on horizontal bars. Yet another, also now untraced, showed Palmer singing 'To Arms' from Handel's *Alexander's Feast*, with his mouth wide open like a frog, and dressed in one of his greatcoats with vast pockets. Richmond, too, made similar caricatures; one (in the Victoria and Albert Museum) depicts a back view of a long-haired Palmer with his parasol-like hat, ill-fitting shoes and bulging greatcoat, grasping an umbrella by the wrong end – it is inscribed 'Sambo Palmer'.

These, then, were the youthful Ancients who sat at Blake's feet in 'The House of the Interpreter', as (with *The Pilgrim's Progress* in mind) they called his shabby quarters in Fountain Court. It was blissful for the old man and his adoring wife, after so much neglect, to have these talented young men hanging on his words, treating him as a prophet and his humble home as something above 'the threshold of princes'. Through Blake, Palmer and his friends saw a few square feet of London transformed into 'the spiritual fourfold London in the loins of Albion',[89] and beyond it a vision in which

> The fields from Islington to Marybone,
> To Primrose Hill and Saint John's Wood,
> Were builded over with pillars of gold,
> And there Jerusalem's pillars stood.[90]

Soon they, and Palmer in particular, were to see that vision again, but this time deep in the English countryside, with crops growing in perfumed fields under a sky of tender moonbeams and myriad stars.

2 The valley of vision

During the 1820s Palmer's recurring illness – probably a combination of asthma and bronchitis – and generally delicate health made him consider settling in the country. He looked for a suitable retreat, and found it in a remote and tiny village in a Kent valley – Shoreham, in Gods Heath Hundred (not to be confused with the seaside town of Shoreham in Sussex). It is about 4 miles from Sevenoaks and 20 miles from London, an insignificant distance today, but in the 1820s involving a long trek over rough country roads, perhaps by stage waggon (or more rarely by public coach) but more likely on foot, or perhaps a little of both. As Palmer expressed it in a letter to George Richmond, 'Why do Mr Walter and Mr Calvert fancy Shoreham a hundred miles off? let them get on the road by chance and walk a bit and ride a bit and they will soon look down into the valley.'[1]

Of his move to Shoreham, Palmer wrote in later life:

Forced into the country by illness, I lived afterwards for about seven years at Shoreham, in Kent, with my father, who was inseparable from his books, unless when still better engaged in works of kindness. There, sometimes by ourselves, sometimes visited by friends of congenial taste, literature and art and ancient music wiled away the hours, and a small independence made me heedless, for the time, of further gain; the beautiful was loved for itself, and if it were right, after any sort, to live for our own gratification, the retrospect might be happy.[2]

The 'small independence' came to him by way of a modest legacy from his grandfather William Giles; it sufficed to buy him a little property in Shoreham. Apart from this his income amounted to 5s. 2d. (26p.) a week.[3]

It is not known how Palmer discovered Shoreham. Even his son did not know, but thought that he probably came upon it during one of his many long walks in the country with one of his fellow Ancients, possibly Frederick Tatham, when they may have 'looked down on the winding stream the noble elms and the ancient cottages clustering near the church tower'.[4] Tatham at any rate accompanied Palmer when, in the spring of 1826, he first went to live in Shoreham.

The two young men pooled their resources and, by frugal management, contrived to live on about 8s. (40p.) a week. Their food was mainly bread and butter, eggs and milk, supplemented by fruit and vegetables grown locally for the London markets, and by as many wild nuts – one of Palmer's especial

34

delights – as they could eat. Milk was easily obtained from the farmers, and cider for 9d. (4½p.) a gallon. Their one expensive luxury, apart from a little meat on rare occasions, was green tea, which Palmer enjoyed throughout his life. (Some time before settling in Shoreham, he had sent a letter to George Richmond headed 'How to choose Teas', in which he described the properties of Hyson, Twankey, Gunpowder and Souchong.)[5] The limited spare cash the young men were able to put aside was spent on books, postage and art materials, and, perforce infrequently, even such expensive items as gold leaf and real ultramarine. They lodged at first with a local farmer, Arthur Tooth, but soon Palmer acquired an old cottage, so dilapidated and dirty that he dubbed it 'Rat Abbey'. It is no longer identifiable, if indeed it still exists.

Samuel Palmer Senior, too, had become restless, bored with both bookselling and his Broad Street house. Moreover, his prosperous brother Nathaniel was losing patience: he had given him an allowance on condition that he did not disgrace his relations by continuing his activities in the book trade, but lived as a gentleman of leisure; he must now observe his side of the bargain, or forfeit his allowance. Nathaniel's determination was reinforced by the family's disapproval of his brother's expressed desire to re-marry.

Palmer Senior's increasing boredom with bookselling was abetted by his mounting enthusiasm for Particular Baptist doctrines, and by a compulsion to head a religious congregation to whom he could expound his own ideas, so that their 'souls might be hustled heavenwards by much sweating and thumping of cushions'.[6] He had for a time attended the Particular Baptist Chapel at East Street, Walworth; there the minister was the noted Welsh divine Dr Joseph Jenkins, and it was probably at his recommendation, when a vacancy occurred at the chapel at Otford, not far from Shoreham, that Palmer was invited to fill it. Whether he had gone to Otford before his son discovered Shoreham, and whether this led to its discovery, is not known; but it is possible.

With such absorbing prospects, Samuel Palmer Senior saw little difficulty in accepting his brother's ultimatum, so he packed his books and belongings and, with his younger son, William, and the faithful Mary Ward, took the stage waggon to Shoreham. They set up home at Waterhouse, an attractive Queen Anne house of 1704 with six large rooms plus attics and a pretty walled garden sloping gently down to the River Darent. His activities once he had taken over at Otford moved to song the rustic poet Dick Lipscombe, ostler of the local inn:

> A gentleman to Otford comes
> Led by the love of souls
> Which Muster Bradford don't believe
> Nor neither Mr Bowles
> Yet when he doth expound the Word
> His face doth always shine …

'Doubtless', remarked A. H. Palmer, 'this was perspiration.'[7]

Waterhouse saw much of the Ancients during the next few years. Rat Abbey was incommodious, so overflow guests were put up at the bigger house,

Palmer's father sometimes turning out of his bed for them. Calvert wrote home to his wife at Brixton, mentioning the warm welcome he had received: 'How kindly I have again been welcomed! And really what a Paradise this little village is! I do look forward in the summer to our coming down for a fortnight. Lodging is cheap. Mr Palmer could not, though he wishes it, accommodate us all with beds, as he does me at present.'[8] Later, when Calvert's little son Willy was poorly, Palmer put him up at Shoreham to convalesce. Calvert's mother wrote appreciatively to him: 'I am much obliged by your saying that my dear family . . . are well. I am longing to see them. I hope they did not omit to add my thanks to their own for all your kindness to my dear little Willy when you took him into Kent. In all probability it saved his life.'[9]

Blake was once a guest of the Palmers at Shoreham. He (and perhaps Mrs Blake) travelled with Mr and Mrs Calvert and Palmer in a heavy covered stage waggon hauled by a team of eight or ten horses. On arrival, the Calverts were given the best room at Waterhouse, and Blake (or the Blakes) put up at a house nearby. Samuel, who had vacated his own room for the occasion, slept at the village bakery. The next day found Blake sitting in the chimney corner with the elder Palmer opposite smoking a churchwarden pipe, talking 'of the divine gift of Art and Letters, and of spiritual vision and inspiration, and of what they termed "the traverse of sympathy"'.[10]

This talk led to the subject of ghosts, and Palmer Senior spoke of one which was believed to haunt Shoreham Place. Calvert suggested that the party should investigate it and after dark they all set out, Blake among them. When they arrived they found the deserted house distinctly spine-chilling – even more so when they heard a slight sound of tapping and rustling. Calvert, whose naval training had given him a cool head, went towards the spot where the noise seemed to be coming from, while Palmer flashed a lantern – to disclose a snail climbing up the mullion with its shell tapping against the window. On another level, Blake gave a remarkable demonstration of his clairvoyance. Palmer had left to catch a coach to London. After about an hour Blake said, putting his finger to his head, 'Palmer is coming; he is walking up the road.' 'Oh, Mr Blake,' said one of the others, 'he's gone to London; we saw him off on the coach.' Blake was silent for a little, and then said, 'He is coming through the wicket – there!' A few moments later, Palmer walked in to tell them that the coach had broken down.[11]

Other friends and relatives of the Ancients visited Shoreham, among them Palmer's drawing master William Wate, Charles Heathcote Tatham and John Linnell. The Palmers' frequent visitors must have strained their resources and loaded Mary Ward with considerable extra work. But Palmer's father was at this stage determined to observe his brother's injunction that he should live as a gentleman, and apparently did not worry unduly about the consequent drudgery devolving upon his faithful retainer. If he thought of providing extra help he was discouraged by the behaviour of a village woman he had earlier engaged. One day he pointed out that she had put a dirty plate on the table: she

picked it up, spat on it and wiped it with her apron. 'Never let me see you do that filthy trick again,' shouted the old man, for once moved to anger. The woman was astonished by his outburst, and seemed to have no idea what she had done wrong.[12]

Hospitable though they were, the Palmers did not – indeed could not – make themselves responsible for all the expenses of the Ancients. Richmond, for instance, wrote in his diary how he

entered upon the lodging hired for me by Palmer at one 'Barhams', a nice old labourer who had a bright and busy wife with 2 daughters. My Rent was 2 shillings [10p.] a week including service. My Room was a spacious one with a fine bed in it at one end and 2 clear windows at which I could work the room was blamelessly clean and the white Curtains of the Bed and at the Windows gave a bright and cheerful aspect to the room, the wall of which was nicely whitewashed. It was believed that john Wesley once held a little meeting in this room.

In a notebook he wrote a few more details of his expenses, commenting that he had 'learnt to live on 10s 6d. [52½p.] a week paying Lodging Washing and I see an occasional small alms . . . The outlay for Candles shows how deep into the night of summer months my studies were carried, once or twice I worked through the whole night, and then took my bath in the pretty [River] "Darent".'[13] Two shillings a week for lodgings was reasonable even for Shoreham in 1827. In a letter written in May of that year, Palmer stated that such rates varied from 2s. to 3s. 6d. (10p. to 17½p.) a week.[14]

ᘒᘓ

The Ancients' interest in Shoreham was on the whole subjective and artistic. In their Valley of Vision they paid less attention to the real Shoreham of farms, labourers, farm implements, country crafts, wildlife and poverty than to what they saw as its spiritual dimension. They were of course well aware of what went on around them, but they preferred to portray country folk living in a state of happy humility, content amidst a God-given domain of abundance; they certainly did not see them as what Palmer called 'the Strephons and Chloes of the coffee-house poets',[15] but their portrayals were far removed from the under-paid and struggling labourers of reality.

In this Palmer's imagination closely resembles that of Virgil in the *Eclogues*: they each created worlds of their own, artificial it is true, but serious neverthe-less. Casting aside the familiar world, Palmer made an Arcadia to his own taste, peopled with shepherds and their kind, who parallel the imaginary Corydons and Damons of Virgil. While Virgil used his pastorals and songs as a creative medium through which to examine man, his loves and his yearnings in a Utopian world, Palmer, in his visual pastorals, attempts to show the divine vitality of nature and man's relationship to it.

In discussing Palmer's wood-engraving *Harvest under a Crescent Moon* (*circa* 1826; illustration 17), his son pointed out various technical and interpretative

17 *Harvest under a Crescent Moon, circa* 1826. Wood-engraving;
26 × 77 mm (private collection, England)

shortcomings, and remarked that 'None of the Ancients seemed to know how
reaping was done; or its deft manipulations.'[16] On the other hand, there was a
deep religious symbolism in their work, especially in Palmer's. The golden seas
of corn seem sacramental, and the crescent moon holds its darker area of
earthshine like a monstrance holding a Host. A similar vision is present in much
of the contemporary work of the Ancients: Richmond, Calvert, and to some
extent Welby Sherman (whose best work was engraved after designs by Palmer)
each depicted scenes of pastoral bliss in rich moon-drenched country. Some-
times, especially in Calvert's engravings, the work has strong classical
overtones and a deeply erotic content, as in his engravings *The Bride* and *The
Chamber Idyll* (illustration 18) and his lithograph *Ideal Pastoral Life*.[17]
Elsewhere the mood is devoutly Christian, as in Richmond's engraving *The
Shepherd* and in his temperas *Christ and the Woman of Samaria* and *Abel the
Shepherd* (Tate Gallery, illustration 19); but Richmond, too, produced erotic
work, such as the oil and tempera *The Eve of Separation* (Ashmolean Museum)
and the watercolour *The Blessed Valley* (private collection).[18]

Palmer's spiritual vision reached its apogee at Shoreham, enabling him to
develop themes already present in his work, for instance in studies in his 1824
Sketchbook and in the pen and ink and wash drawings of 1825, and leading in
time to the almost hallucinatory brilliance of such masterpieces as *The Magic
Apple Tree* (1830; Fitzwilliam Museum; illustration 21) and *Cornfield by Moon-
light, with the Evening Star* (*circa* 1830; British Museum; illustration 22). In
these and contemporary works it is as if he were striving to depict the
'Immanuel's Land' seen by Christian and Hopeful on their journey in *The
Pilgrim's Progress*: 'the delectable Mountains, which Mountains belong to the
Lord of that Hill', in which were meadows, gardens, vineyards, orchards and
cool fountains, where shepherds tended the sheep of the Lord, within sight of
the Celestial City.

All this Palmer saw for a brief period in the Kentish landscape, which he
translated into painted songs of innocence, exalting the little hills into spiritual
domes, a farm-worker into a Good Shepherd tending his flock beneath a vast
moon, the corn harvest into a harvest of souls. Ruth strides over the Weald after
gleaning; a shepherd sleeps in the doorway of a barn, dreaming perhaps of the
child and his mother before whom his spiritual predecessors had knelt in the

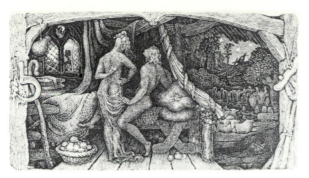

18 Edward Calvert: *The Chamber Idyll*, 1831. Wood-engraving;
41 × 76 mm (private collection, England)

19 George Richmond: *Abel the Shepherd*, 1825. Tempera on oak
panel; 230 × 308 mm (Tate Gallery)

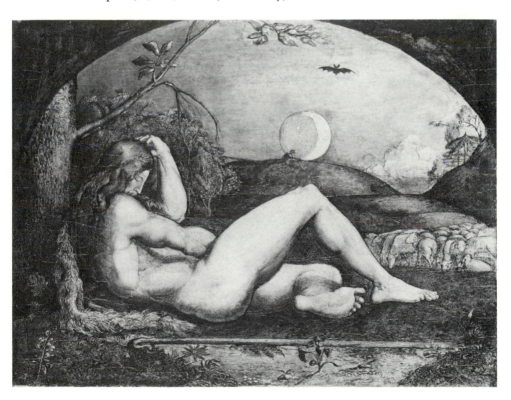

glimmering light of a stable in Bethlehem (*Ruth Returned from the Gleaning*, *circa* 1828, Victoria and Albert Museum; *The Sleeping Shepherd*, *circa* 1833–4, private collection). Everywhere is peace, abundance, and honest, rewarding toil. It is as if a Christian golden age were expressed through the vision of this altogether English artist, with accentuations gathered from his knowledge of the work of Pieter Brueghel and Adam Elsheimer, and most of all from his friend William Blake, who had imagined Joseph of Arimathea among the rocks of Albion, and Jerusalem and the Lamb of God in England's green and pleasant land. Moreover, not only did Palmer, like Brueghel and Blake, depict the scriptures in his native landscape; he also placed them in a setting of rich and almost erotic abundance, close to that of the *Eclogues* and *Georgics*, and unifying the Christian and Virgilian traditions. With many others, Palmer believed that the seeds of Christianity were already apparent in classical times, when Virgil in his Fourth ('Messianic') Eclogue 'struck his lyre in prophecy' (see illustration 99).[19] Palmer's moonlit rustics in *Coming from Evening Church* (1830; Tate Gallery; illustration 20), returning home after Evensong during Rogationtide with flowers in their hands, can readily be imagined chanting lines from Virgil instead of a Christian vesper hymn, and making a song of praise to the Saviour out of their litany of the joyous crops, vines wedded to elms, the kine, the bees and the evening star.[20] The vision is archaic, like a miniature in a fifteenth-century Book of Hours; the branches meet overhead like a primitive Gothic arch, the perspective is foreshortened. But the grave villagers – bearded sages, statuesque women, and quiet children – are what grip the attention most. They are like inhabitants of St Giles's Land or Cockaigne: dream-folk who inhabited the *locus amoenus* of Palmer's mind.

Some of the poems Palmer composed in his 1824 Sketchbook provide verbal parallels with this painting, as in this passage:

> And now the trembling light
> Glimmers behind the little hills, and corn,
> Lingring as loth to part: yet part thou must
> And though than open day far pleasing more
> (Ere yet the fields, and pearled cups of flowers
> Twinkle in the parting light;)
> Thee night shall hide, sweet visionary gleam
> That softly lookest through the rising dew:
> Till all like silver bright;
> The Faithful Witness, pure, and white,
> Shall look o'er yonder grassy hill,
> At this village, safe, and still.
> All is safe, and all is still
> Save what noise the watch-dog makes
> Or the shrill cock the silence breaks
> – Now and then. –
> And now and then –
> Hark! – once again,
> The wether's bell
> To us doth tell
> Some little stirring in the fold.[21]

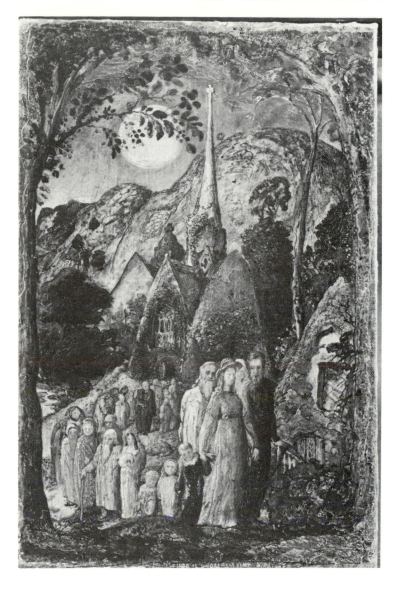

20 *Coming from Evening Church*, 1830. Tempera on paper mounted on panel; 305 × 197 mm (Tate Gallery)

Another poem begins:

I
With pipe and rural chaunt along,
 The shepherds wind their homeward way,
And with melodious even song,
 Lull to soft rest the weary day.

2
>Low lies their home 'mongst many a hill,
> In fruitful and deep delved womb;
>A little village, safe, and still,
> Where pain and vice full seldom come,
> Nor horrid noise of warlike drum.[22]

Such was the effect on Palmer the Londoner of this 'Valley of Vision', so hidden from the world that, as Calvert said, it looked as if the Devil had not yet found it.[23] In the great city Palmer had smelt corruption; here for a time, though the period was all too brief, he grasped innocence. So strong was his idealism that for the moment he was determined not to commercialize his art. To George Richmond he wrote,

I will not infringe a penny on the money God has sent me, beyond the interest, but live and study in patience and hope. By God's help I will not sell away His gift of art for money; no, not for fame neither, which is far better. Mr Linnell tells me that by making studies of the Shoreham scenery I could get a thousand a year directly. Tho' I am making studies for Mr Linnell, I will, God help me, never be a naturalist by profession.[24]

Later Palmer altered his mind (or at any rate his practice) about much of that. Meanwhile Richmond replied encouragingly:

I was delighted to hear of your inflexibility ... for though it is certain *you will not* any more than Mr *Blake* get a thousand a year by it yet you will have what he had a contentment in your own mind such as gold cannot purchase – or flimsy praise procure – Mr Linnell is an *extraordinary man* but he is not a Mr Blake.[25]

Palmer had at this time no doubt of the divine inspiration of his work, and his conviction produced many effusions in his notes and letters; one of the most impressive seems to lift him into a state of mystical rapture approaching that of St Francis of Assisi receiving the impression of the stigmata on Mount La Vema:

At Shoreham, Kent, August 30, 1826. God worked in great love with my spirit last night, giving me a founded hope that I might finish my *Naomi before Bethlehem* [now untraced] and (to me) in a short time ... That night, when I hoped and sighed to complete the above subject well (it will be my maiden finished figure drawing), I hoped only in God, and determined next morning to attempt working on it in God's strength ... Now I go out to draw some hops that their fruitful sentiment may be infused into my figures ... August 31. We do or think nothing good but it has its reward. I worked with but little faith on my *Naomi before Bethlehem* this morning and succeeded just in proportion. After dinner I was helped against the enemy so that I thought one good thought. I immediately drew on my cartoon much quicker and better ... Satan tries violently to make me leave reading the Bible and praying ... O artful enemy, to keep me, who devote myself entirely to poetic things, from the best of books and the finest, perhaps, of all poetry ... I will endeavour, God helping, to begin the day by dwelling on some short piece of scripture, and praying for the Holy Ghost thro' the day to inspire my art. Now, in the twilight, let Him come that at evening-time it may be light. God bless my father and brother and poor dear old nurse; who, though a misled Baptist, shall sing among the redeemed for ever ... The last 4 or 5 mornings I thank God that He has mercifully taken off the load of horror which was wont so cruelly to

scare my spirits on awaking. Be His great name ever blest; He persists to do me good, spite of myself, and sometimes puts into my mind the unchangeableness of His promise, the reality of future things. Then I *know* that faith is the *substance* of things hoped for, the *evidence* of things not seen ... Wednesday. Read scripture. In morning, ill and incapable, in afternoon really dreadful gloom; toward evening the dawn of some beautiful imaginations, and then some of those strong thoughts given that push the mind [to] a great progress at once, and strengthen it, and bank it in on the right road to TRUTH. I had believed and prayed as much or more than my wretched usual, and was near saying 'what matter my faith and prayer?', for all day I could do nothing; but at evening-time it was light; and at night, such blessed help and inspiration!! O Lord grant me, I beseech Thee grant, that I may remember what THOU only showedst me about my *Ruth* ... Thursday. Rose without much horror. This day, I believe, I took out my *Artist's Home*, having through a change in my visions got displeased with it; but I saw that in it which resolved me to finish it. Began this day with scripture. Friday. So inspired in the morning that I worked on the *Naomi before Bethlehem*, which had caused me just before such dreadful suffering, as confidently and certainly as ever did M. Angelo I believe.[26]

The characteristics of religious self-examination are also apparent in Palmer's sense of conflict between the flesh and the spirit. Writing to Richmond on 14 November 1827, he speaks of

the jaded halts of intellect tugging up the hill of truth with the sun on her head and this excrescent wen of flesh broiling on her back: for tho' the eclipses of thought are to me a living inhumement and equal to the dread throes of suffocation, turning this valley of vision into a fen of scorpions and stripes and agonies, yet I protest, and glory in it for the sake of its evidence, of the strength of spirit that when inspir'd for art I am quite insensible to cold, hunger and bodily fatigue, and have often been surprised, on turning from work to find the fingers aching and nearly motionless with intense cold.

Yet he was equally ready to abandon himself to sensuous appreciation, and in the same letter writes of having

beheld as in the spirit, such nooks, caught such glimpses of the perfumed and enchanted twilight – of natural midsummer, as well as, at some other times of day, other scenes, as passed thro' the intense purifying separating transmuting heat of the soul's infabulous alchymy, would divinely consist with the severe and stately port of the human, as with the moon thron'd among constellations, and varieties of lesser glories, the regal pomp and glistening brilliance and solemn attendance of her starry train.[27]

This duality of view is vividly reflected in Palmer's self-portrait of *circa* 1826 (Ashmolean Museum; frontispiece). He painted only a few portraits, but this one is a masterpiece, evoking deep aspects of his personality – an air of carelessness, indicated by his neglectfully tied neckerchief and general lack of grooming, contrasting with obstinacy of character expressed not only in his firm chin and mouth, but in the enquiry and timidity in his eyes. In this psychologically penetrating study he shows the combination of self-doubt and introspection with eccentricity and ruminating dogmatism which so strongly determined his character.

Not only in his art, but in everything connected with his life, Palmer had grown zealously religious. His reading included Isaac Barrow's *Exposition of the*

Creed, William Law's *A Serious Call to a Devout and Holy Life*, Joseph Butler's *Analogy of Religion* (an attempt to link the dogma of Christian salvation with the evidence of the created world) and John Flavel's *Husbandry Spiritualized or The Heavenly Use of Earthly Things*. Flavel used the practice of husbandry to illustrate aspects of Christianity, and one of his sentences provides what almost amounts to a definition of Palmer's own attitude: 'That the world below, is a Glass to discover the World above.'[28] Elsewhere occurs a passage which must have caught Palmer's attention, since it fortuitously, but not inappropriately, includes his own name:

> The learned *Twisse* went first (it was his right)
> Then holy *Palmer* . . .[29]

For this nineteenth-century Palmer had indeed become a holy Palmer. He made a little chapel and vowed 'to get the print of the Venerable Fisher and his fellow-martyr Sir Thomas More, and hang them cheek by jowl in my little chapel, that they may frown vice, levity, and infidelity out of my house and out of my heart.'[30]

ໜ

Certain key works of this period merit further discussion. *The Magic Apple Tree* depicts a landscape enriched by both Ceres and Pomona, with a shepherd (or shepherdess: the figure is somewhat ambiguous) playing his pipe beside his flock. Trees growing on banks on either side meet overhead in a rustic allusion to an ogee arch. In the centre of the composition a church spire emerges from the abundance of fruit and corn, pointing towards the heavenly Paradise, of which this earthly plenitude is a reflection. This watercolour also provides an example of an aspect of Palmer's technique that dominated much of his work at all periods: an extensive use of stippling and dotting, employed here to represent the golden fields of corn and some of the foliage of the trees, and to convey the fleece of the sheep.

Cornfield by Moonlight, with the Evening Star is a much more freely drawn work, although a certain amount of dotting is used on the moonlit heads of corn and on the distant hills. The lonely shepherd heading homeward with his dog has something of the character of a pilgrim. The cresent moon, with earthshine on its dark area, and glistening Hesperus light the nocturnal sky and make the landscape glow as in the opening lines of Book I of Virgil's *Georgics*:

That makes the Fields of Corn joyous; under what Sign, Maecenas, it is proper to turn the Earth and join the Vines to Elms; what Care is requisite for Kine, the Nurture for breeding sheep and lesser Cattle; and what Experience for managing the frugal Bees, hence will I begin to sing. Ye brightest Luminaries of the World, that lead the Year sliding along the Sky; thou Bacchus and fostering Ceres, if by your Bounty Mortals exchanged Chaonian Maste for fattening Ears of Corn, and mingled Draughts of Achelous with the invented Juice of the Grape: And ye Fauns propitious to the Swains, ye Fauns and Virgin Dryads both come tripping up together: Your bounteous Gifts I sing.[31]

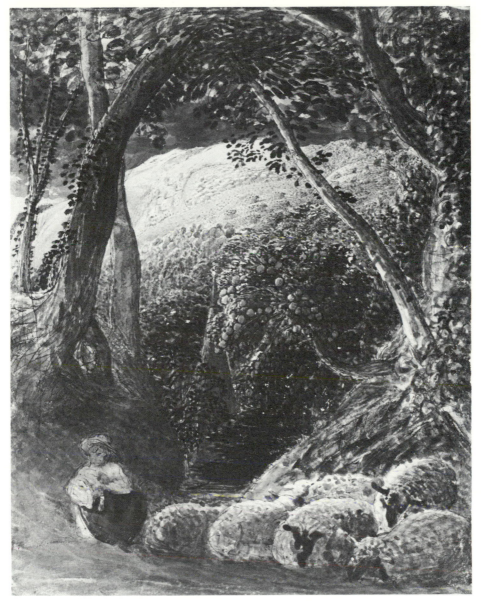

21 *The Magic Apple Tree*, 1830. Watercolour and body colour with gum, and pen and ink, on paper; 349 × 260 mm (Fitzwilliam Museum, Cambridge)

The other poet nearest to Palmer's heart, and a lifelong subject of study and inspiration, was Milton. There are surely echoes of *Paradise Lost* in works such as *In a Shoreham Garden* (*circa* 1829; Victoria and Albert Museum; illustration 23), one of a small series of watercolours executed around this date, in thickly applied body colour, reminiscent of the impasto of oil painting.

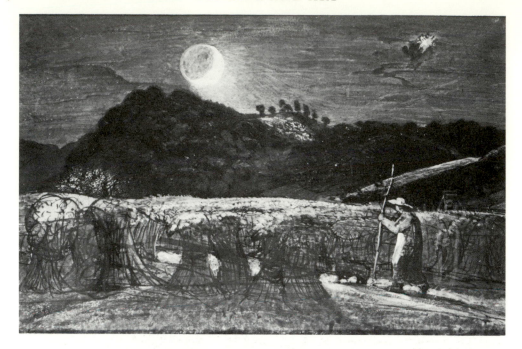

22 *Cornfield by Moonlight, with the Evening Star, circa* 1830.
Watercolour and body colour, with pen and ink, on paper;
197 × 298 mm (British Museum)

Flours worthy of Paradise, which not nice Art
In Beds and curious Knots, but Nature boon
Powrd forth profuse on Hill and Dale and Plaine,
Both where the morning Sun first warmly smote
The op'n field, and where the unpierc't shade
Imbround the noontide Bowrs: Thus was this place,
A happy rural seat of various view;
Groves whose rich Trees wept oderous Gumms and Balme,
Others whose fruit burnisht with Gold'n Rinde
Hung amiable, *Hesperian* Fables true,
If true, here onely, and of delicious taste . . .

(Book IV, lines 241–51)

Further dimension is imparted by the almost floating figure in red and white in
the background; like a figure from a dream, it is disturbing and ghostly, while
serving also as a focal point to lock the composition together.

 Not all of Palmer's Shoreham work reached this level of intensity. The
drawings *Sepham Barn* (1828; Ashmolean Museum; illustration 24) and *A Barn
with a Mossy Roof* (*circa* 1828–9; Yale Center for British Art; illustration 25),
while still highly imaginative, are also accurate representations of the landscape
and its buildings. In the first the barn and a nearby haystack are drawn in some
detail and strongly highlighted with white body colour; the rising landscape

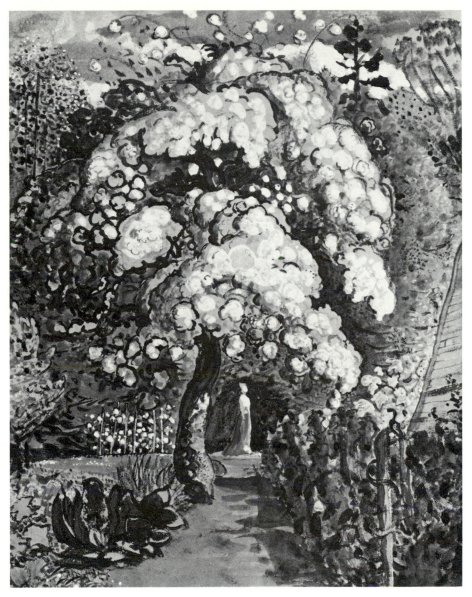

23 *In a Shoreham Garden, circa* 1829. Watercolour and body colour on prepared board; 279 × 222 mm (by courtesy of the Board of Trustees of the Victoria and Albert Museum)

behind is suggested by a dark wash, and most of the remainder consists of controlled scribbles. For a work so lightly executed the effect is strangely satisfying. *A Barn with a Mossy Roof* is much more detailed, and extensive use is made of dotting, dappling and stippling, especially in the portrayal of the thick growths of moss and lichen on the decaying thatch.

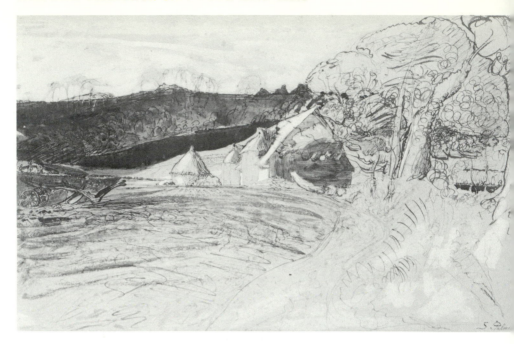

24 *Sepham Barn* (also known as *Barn in a Valley*), 1828. Pen and
brush in indian ink over pencil, heightened with white, on paper;
281 × 445 mm (Ashmolean Museum, Oxford)

Palmer combined great detail with scribbling and dotting in some brilliant
studies of trees in Lullingstone Park, near Shoreham. These were probably
made for John Linnell, to whom he wrote on 21 December 1828:

Milton, by one epithet, draws an oak of the largest girth I ever saw; – 'Pine and *Monumental
Oak*' [*Il Penseroso*, line 135]: I have just been trying to draw a large one in Lullingstone; but
the Poet's tree is huger than any in the park: there, the moss, and rifts, and barky furrows,
and the mouldering grey, tho' that adds majesty to the lord of forrests; mostly catch the eye
before the grasp and grapple of the roots; the muscular belly and shoulders; the twisted
sinews.[32]

Such attention to detail is typical, and Palmer covered many of his sketches with
minutely observed notes. In this he was following one of the central tenets of
his mentor, William Blake, who said 'it is in Particulars that Wisdom consists
& Happiness too', and 'I hope that none of my Designs will be destitute of
Infinite Particulars.'[33] He was also anticipating a way of looking at things that
was to be important in the work of such artists as Graham Sutherland and John
Minton, who played a major part in the revival of Romanticism during the mid-
twentieth century. The same letter enlarges on the relationship of Palmer's art
to nature's 'Infinite Particulars':

I have begun to take off a pretty view of part of the village, and have no doubt but the
drawing of choice positions and aspects of external objects is one of the varieties of study

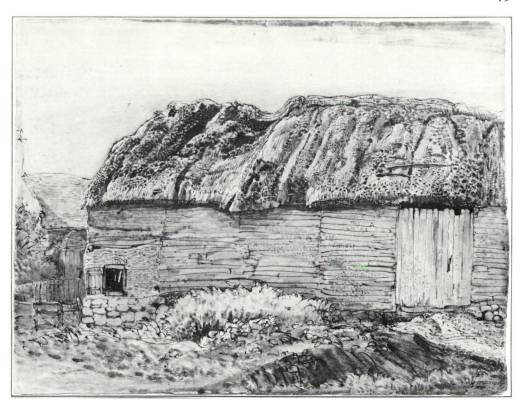

25 *A Barn with a Mossy Roof, circa* 1828–9. Watercolour, body colour tinted with gum, and pen and ink, on paper; 278 × 375/377 mm (Yale Center for British Art, New Haven, Connecticut, Paul Mellon Collection)

requisite to build up an artist, who should be a magnet to all kinds of knowledge: though, at the same time I can't help seeing that the general characteristics of Nature's beauty not only differ from, but are, in some respects, opposed to those of Imaginative Art; and *that*, even in those scenes and appearances where she is loveliest, and most universally pleasing. Nature, with mild, reposing breadths of lawn and hill, shadowy glades and meadows, is sprinkled and showered with a thousand pretty eyes and buds and spires and blossoms, gemm'd with dew, and is clad in living green. Nor must be forgot the mottley clouding, the fine meshes, the aërial tissues that dapple the skies of spring; nor the rolling volumes and piled mountains of light; nor the purple sunset blazon'd with gold; nor the translucent amber. Universal nature wears a lovely gentleness of mild attraction; but the leafy lightness, the thousand repetitions of little forms, which are part of its own generic perfection; and who would wish them but what they are? – seem hard to be reconciled with the unwinning severity, the awfulness, the ponderous globosity of Art.[34]

In this passage Palmer seeks to justify his idealistic outlook as a painter, stating his firm belief that a literal representation of nature is incompatible with the requirements of imaginative art. His outlook here recalls that of his great predecessor Claude Lorrain, whose influence can be discerned in his work at

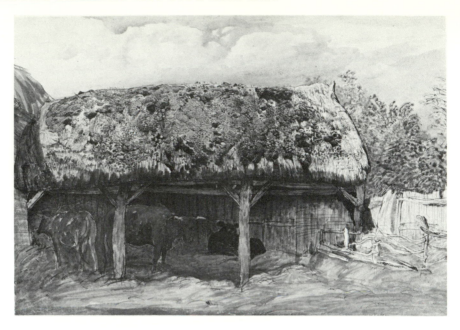

26 *A Cow-Lodge with a Mossy Roof, circa* 1828–9. Watercolour and
body colour with gum, and pen and ink, on paper; 267 × 375 mm (Yale
Center for British Art, New Haven, Connecticut, Paul Mellon
Collection)

many points, for example in *Evening in Italy: The Deserted Villa* (1845; private
collection, England; illustration 54), in his etchings and in the Milton and
Virgil designs of his late years. In 1875 Palmer wrote of Claude: 'Ordinary
landscapes remind us of what we see in the country; Claude's of what we read
in the greatest poets and of *their* perception of the country, thus raising our
own towards the same level.'[35] Whenever he put this precept aside, as in some
of his early Italian studies, his art suffered, becoming at best pedestrian, at
worst lacking in confidence. Fortunately such lapses were rare.

Palmer was forever studying, always questing, always humble. At
Shoreham he became fascinated by the study of foreground detail, and the
love of such detail remained when, as an old man, he stood in his garden,
leaning on his staff, admiring a fine specimen of great white bindweed. In
1844, several years after he had left Shoreham for good, he wrote:

To get a vast space what a world of power does aërial perspective open! From the dock-leaf
at our feet to the isles of the ocean. And thence, far thence into the abyss of boundless
light ... Foreground with sunset distance in full sunset blaze. Foreground against distance
... slight sketches of applicable foregrounds ... Advance the foreground early. Think
more than work upon distances. Always be ready on a separate paper to set down in the
places they occupy appropriate figures, birds or cattle, which may happen to pass and
always keep these with the principal study.[36]

The nature of Palmer's response to landscape led him to become imbued with the spirit of another work of literature, which the Ancients read aloud to one another: John Fletcher's pastoral drama *The Faithful Shepherdess*, his first encounter with it, he said, disturbed his 'male lethargy ... when there I found, in black and white, all my dearest landscape longings embodied, my poor mind kicked out and turned two or three somersaults.'[37] 'The sleeping shepherd' became one of Palmer's favourite subjects. His first version of it was the pen and wash drawing made at Shoreham *circa* 1831–2 (Whitworth Art Gallery; illustration 27), which shows the shepherd asleep on a bank with his flock contentedly grazing nearby. A crescent moon shines behind trees reminiscent of those drawn by the early Romantic painter Alexander Cozens. There are several literary sources which may have fed Palmer's imagination in this work, but considering his love for *The Faithful Shepherdess*, it can safely be assumed that this passage was one of them:

27 *The Sleeping Shepherd, circa* 1831–2. Pen and brown ink and brown wash, with gum, on paper; 157 × 188 mm (Whitworth Art Gallery, University of Manchester)

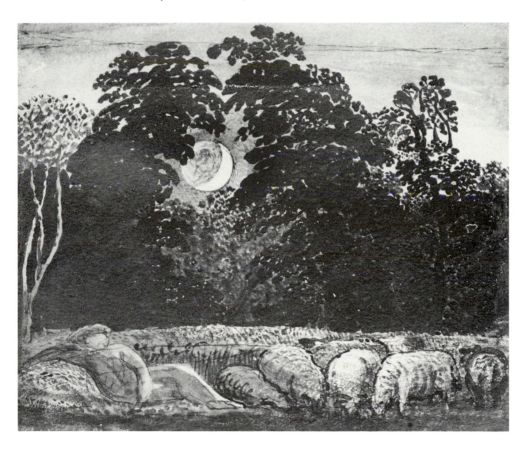

> Choose where thou wilt, whilst I sit by and sing,
> Or gather rushes, to make many a ring
> For thy long fingers; tell thee tales of love, –
> How the pale Phoebe, hunting in a grove,
> First saw the boy Endymion, from whose eyes
> She took eternal fire that never dies;
> How she conveyed him softly in a sleep,
> His temples bound with poppy, to the steep
> Head of old Latmus . . .

(Act I scene iii)

ည

Though little of it appears in their art, the Ancients naturally had some experiences of ordinary village life and contact with local people. We find Palmer writing to Linnell that 'My Father inquired about the hops of Mr Love one of the best farmers hereabout, and a large grower, of whom several of the villagers have what they want for growing; and he says they will be about a shilling [5p.] per pound; by *about* I suppose he must mean from 11 to 13 pence.'[38] But the Ancients were never really intimate with the villagers; they never allowed themselves to forget that they were classes apart, talking what amounted to a different language from the vernacular of the villagers. Indeed, when they were not sentimentalizing them, they tended to look upon them with detached amusement. Writing many years later, in 1870, Palmer recalled

a very poor old man in Kent who had been a smuggler [the Shoreham district was formerly a notorious haunt of smugglers]. Life had passed roughly, yet he had one, only one comfort left, a *rat-pudding*! He took no steps to catch them; but, governing his appetite by patience, calmly awaited the desired return of the village rat-catcher. Then, having carefully cleaned, skinned and prepared his delicacies, the difficulty was always where to borrow a saucepan; for the petticoat government of his wife and daughter debarred him from the use of his own utensils. However, he always found some neighbour or other kind enough to supply him, and at last he sat down, with a thankful heart I believe, to the only solace left him until the last one of the sexton and the spade.[39]

Admittedly Shoreham seems to have had some odd characters. This reformed smuggler was one 'Master' Penn, another of whose oddities was to take laxative consisting of a bolus of cobbler's wax. 'One day', recalled Palmer later in life, 'he made too big a one and it stuck.'[40]

Elsewhere Palmer cited Shoreham villagers' behaviour to express his doubts of the capacities of 'the masses': 'Spare Kitty Harman who "showed" her suitor "the door which the carpenter made", gave it as her opinion that, though the Shoreham villagers did not "think small beer" of themselves, they were after all, little better than "Bush Papists". One night alas! they sheared very closely one of her pet white poodles and then beplastered him with pitch . . . Are the many *ever* civilized?'*[41] Nevertheless, when he was old, Palmer recalled

* 'Show the door' – dismiss unceremoniously; 'think small beer' – have a poor opinion; 'Bush Papist' – an opinionated but ignorant lay theologian.

some pleasant associations with the Kentish people. In 1878 he wrote how 'About 40 years ago I dined with Mr Daniel Whibley farmer at Edenbridge and saw the old manners, – the farm labourers clumping in in their many-sounding hobnails, and dining cheerily at the side tables, – instead of meditating rick-burning while they eked out a quarter meal of baker's bread be-alumed and rancid bacon under a hedge.'[42]

Other aspects of Shoreham produced a less idyllic mood: the weather, for instance. To Linnell, Palmer related in 1828 how

The harvest began with rain and gloom so as to spoil its beauty and it is now so wet that for the present they have left off reaping and are very much afraid for the corn . . . it has rain'd so long that we may expect an alteration very soon, and I hope that to meet you in our lanes with no danger of sticking in mire or being swept away by torrents: though in the Farningham road the water has been three feet deep and the fruit carts were stopp'd, I have heard of no accidents near us.[43]

Palmer wrote frequently to Linnell from Shoreham, pouring out his heart in matters of art and giving copious news of life in the country. At this time there was close rapport between the two men, with little hint, if any, of the difficulties that were later to develop between them. In one of his letters he tells Linnell:

The Hop-picking is begun, and I shall be very much disappointed if you do not come and see it: especially as this is the only time I can with certainty promise myself the pleasure of studying it in your company and with your assistance. Pray come if you can – if so, do not write to Shoreham as I hope to call on you in a day or two.[44]

As the last sentence indicates, Palmer returned to London from time to time, so he was not living a completely rural existence. In about May 1826 he was at Broad Street, and wrote to Linnell with news of Blake, who had been unwell: 'Mr Blake is better, and is getting strength; he has been visited by Dr Thornton, who says that Mr Harrison [a bookseller] has lost the opportunity of selling two or three copies of the Job through not having one to shew.'[45] But London visits seem to have been infrequent, for in several letters to Richmond and Linnell Palmer asks them to procure art materials for him. In any case, as they were made on foot, they were tiring. Towards the close of the Shoreham period such visits fell off almost completely. Writing to Richmond in October 1834, Palmer says emphatically:

I purpose never again to see London again by daylight when I can help it – though I would gladly visit the great national dust hole once more if it were only to enjoy the grand Rhinish tea festival [Richmond visited the Rhineland in 1834]; and at that celestial assembly Mrs Richmond our fair Hebe will want every particle of her present health and spirits to bear the task of dealing about bowl after bowl of the Oriental Nectar to the Gothic Mythology which will surround her.[46]

ଧ୍ୟ

At Shoreham the late summer of 1827 was saddened by the news of Blake's death on 12 August. Richmond, who was in London, sent the news to Palmer.

—Wednesday Eveng

My Dr Friend

Lest you should not have heard of the Death of M^r Blake I have written this to inform you – He died on Sunday Night at 6 Oclock in a most glorious manner. He said He was going to that Country he had all His life wished to see & expressed Himself Happy hoping for Salvation through Jesus Christ – Just before he died His Countenance became fair – His eyes Brighten'd and He burst out in Singing of the things he Saw in Heaven. In truth He Died like a Saint as a person who was standing by Him Observed – He is to be Buryed on Fridayay at 12 in morng. Should you like to go to the Funeral – If you should there there will be room in the Coach.

Yrs. Affectiony
G Richmond

Excuse this wretched scrawl.[47]

Blake was buried in an unmarked grave in Bunhill Fields, Finsbury, and Richmond, Calvert and Frederick Tatham were among the mourners. Palmer was not there. His grief at bereavement was always overwhelming, and possibly that kept him away. Or it may simply have been that Richmond's letter, written on the Wednesday, three days after Blake's death, did not reach him early enough to allow him to travel to London in time.

In the months following Blake's death, Linnell's health declined steadily. One day when he visited the Bank of England to collect his dividend, he found he was so weak that he was unable to wait at the counter and had to go home without it. He tried all kinds of remedies, including vapour baths and riding, to no avail. By December 1827 he was consuming twelve bottles of oxygen daily in an attempt to maintain his working capacity. Soon he found it quite impossible to continue the daily journeys between Cirencester Place and Collins's Farm at Hampstead. Eventually he decided that his problems would be best solved by setting up home in Bayswater; a suitable house, owned by a Mr Clarke, was nearing completion, and negotiations for its purchase were opened. The contract was signed on 3 March 1828, and the Linnells moved in five days later. Linnell hired a coach to transport them from Hampstead, having argued the fare down to 14s. (70p.) for the whole job – including as much luggage as could be crammed in, in addition to the family. Collins was given £5 compensation for the unused remainder of the lease of the farmhouse.

The Bayswater house was pleasant, but almost as soon as he had moved into it, Linnell's mind was forging ahead with the idea of building a house in the same district to his own specification and design. This notion was elaborated and the results minutely annotated in a thick volume inscribed *Building Book*, prefaced by this note:

Resolved after much consideration to build a House in Porchester Terrace for three reasons first because the house I now occupy is not large enough for my Family and business nor substantially enough built to take upon a lease and also too expensive. 2^nd That there is no house to be had at any price that I can afford that will suit or in the place I should choose. 3^rd There is Ground to be had in Porchester Terrace nearly 200 feet in depth for 6 shillings per foot frontage with every prospect of the place being likely to improve in

value and *respectability* being open both behind and in front – and likely to remain so. 4th That *by going about it in a proper manner* a House may be built that will be suitable for my business and Family and also be a good property – and not cost so much as the rent of a smaller and less convenient one as the money will yield a better return to me in this shape than in the funds which are now high. 5th The excitement arising from the novelty and interest of building a house for the first time in planning it and entering as much as possible into every detail of the concern may be the means of altering my health which so much requires it.[48]

Charles Heathcote Tatham offered his professional services for the realization of Linnell's dream, but they were declined. As Linnell refused to use any architect, and as he had little or no experience in house design and construction, his whole method was vitiated by amateurism. His first design was described by his grandson A. H. Palmer as 'revoltingly hideous' as well as expensive and uncomfortable. He tried again, 'securing an expanded and curiously pretentious version of an ugly suburban villa'.[49]

A. H. Palmer calls the building of this house 'one of the most extraordinary episodes of almost all biography' – an exaggeration, but the story is extraordinary notwithstanding, and Herbert's account of it is worth quoting *in extenso* as a further indication of the character of Palmer's future father-in-law:

The scheme was entirely based on the possibilities of barter and it was the first undertaking of a series of building adventures each representing a bitterly contested battlefield in which the honour would have been equally divided if it had not been for the enormous waste of his time involved in watching (from an ancient campstool) throughout almost all the working days – time which became of very great pecuniary value. Confidence, goodwill between employer and employed and immemorial custom were all swept away from the very beginning.

The time lost in correspondence connected with this his first venture, together with sketches, plans, written agreements (and most violent disagreements) besides weeks of Linnell's own manual work thrown in, represented even at the lowest rate of his professional earning, a very large sum of money. There was loss instead of gain. Wherever there was the slightest opportunity for barter he sprang upon it and another written agreement was added to the series interminable even thus early in his career.

Through his ignorance and interference a quantity of work had to be torn down or dug up and replaced. And through his personal and aggressive surveillance of the labour the workmen were sometimes sullen and unwilling or departed. Of gratuities there were none.

His mind did not seem to be divided in the common way between suspicion and distrust of many and unbounded confidence in one person or a few. He trusted no one and believed very few.

To oversee the Bayswater work he appointed a thoroughly well qualified surveyor introduced by Frederick Tatham. To keep this surveyor in order he appointed his usual lawyer.

If it had been a vast public building instead of a 12 room and ugly villa (plus a large studio), 38 Porchester Terrace, greater precautions could not have been taken. But most of them defeated their own end.

It was a far cry to that invention of Louis Jacques Daguerre (three years older than Linnell) which revolutionized the whole world [photography]. To a carpenter or a plasterer the temptation of securing a faithful portrait of his wife and children (especially by a well-known painter and Royal Academy exhibitor) was very great. It was when Linnell

persuaded a contractor to trade material or labour for a landscape 'sketch' that thunder clouds arose on the horizon for this avarice took him by the throat as to the interpretation of the word.

As to 'Respectability' which had apparently tinged his Utopian anticipation, that soon went by the board. There arose in its stead a reckless disregard of professional caution even after his studio received illustrious and fastidious folk. He painted and varnished his own front door, spent days personally and fruitlessly wrestling with the roof of a most expensive summer-house, explored the bowels of his wells (gravel below clay) and with his head poked into the new and rebellious sewer gave direction for the removal of a bundle of rags contributed by some neighbour . . .

He was constantly tempted to make alterations and expensive improvements without reckoning the cost; till the day suddenly came when he found his cash resources had fallen very low. The facilities for barter had in one case ended in a lawyer's letter.

But through sheer dogged courage and a grasp of detail for which he was pre-eminently always remarkable he had attained his end. The battlefield was cleared and though victory was not decisive, he had got his heart's desire. But with a widespread reputation that none envied . . .

Everything still depended on his health but quarrels, disagreements as to the relative values of the bartered merchandise and the constant writing of defensive or aggressive letters sometimes of great length seemed to act upon him as a gentle restorative . . .

On the 19th September 1830 (more than a year after the excavation of the foundations had begun) Linnell and his family moved into the new house and slept there for the first time.[50]

Linnell first visited Shoreham before he moved to Bayswater. He found the village more beautiful than he had imagined and was as enthusiastic about it as the Ancients. In August 1828 he wrote to Palmer:

I have found so much benefit from my short visit to your valley, and the very agreeable way in which we spent the time that I shall be under the necessity of seeing you again very soon at Shoreham. I Dream of being there every night almost and when I wake it is some time before I recollect that I am at Bayswater . . .

How I shall recompense you for your kindness I know not but I am so set upon the thing that I am induced to run the risk of imposing upon it to the utmost until time affords me some opportunity of testifying my sense of your hospitality – for though I have been at many places on visits I never was anywhere so much at liberty . . .[51]

Shoreham had worked its magic on Linnell, an unlikely man to have fallen under its spell. He saw, and probably for the first time realized, the depths of meaning of Palmer's simple idealistic country life. After much overwork, and struggles with poor health, with a largely recalcitrant family, looked after by his incompetent wife, the tranquil countryside acted on him like a tonic.

Linnell did not bother overmuch how he got to Shoreham. Once during 1829, having recovered his health during previous visits, he travelled there again in the company of George Richmond. The coach went no nearer to Shoreham than Morant's Court Hill, some miles away. Awaiting him there, on Palmer's instructions, was a strangely dressed figure with a wheelbarrow. Without more ado, Linnell climbed into this and, to the astonishment of the

coachman, guard and passengers, but completely indifferent, was wheeled downhill and on into the village.

Linnell had once expressed to Palmer's father some unease at Samuel's retreat into the country. 'Mr Linnell', wrote Palmer Senior, 'foretells that your voluntary secession from artists will end in the withering of art in your mind. He had known it to be so.'[52] But having experienced the delights of Shoreham, Linnell said no more, realizing that here Palmer had found a *genius loci*, an inspiration beyond price.

ͷͻ

A crisis disturbed the tranquillity of the Ancients in January 1830, when Richmond ran away with Frederick Tatham's beautiful sister, Julia, whom he married soon after at Gretna Green. The elopement was aided and abetted by Henry Walter, who loaned Richmond £12, and by Palmer, who not only lent him £40 but gave the couple shelter at Shoreham after their return. Richmond, always meticulous in money matters, repaid Palmer's loan, with added interest of $3\frac{1}{2}$ per cent, by the end of the year. It is possible that Palmer himself was smitten with one of the Tatham sisters at about the same time; some have read this in a remark by his son that in 1829 he went through 'a great sorrow', presumably because his advances were not reciprocated.

There were also darker shades on the horizon. Moved by riots and rick-burnings by farm labourers, which disturbed his tranquil imaginings of rural religious idealism at Shoreham, Palmer began to interest himself in politics. His opinions were right-wing, and this was one reason why his relations with Linnell later deteriorated, for Linnell's views were entirely Whig. In 1832, the year in which the Reform Act was passed to amend parliamentary representation, Palmer wrote, had printed, and circulated *An Address to the Electors of West Kent*; presumably not many copies were printed, for until recently none was known to survive (see Appendix 1). It was unsigned. Palmer, as an owner of property at Shoreham, qualified as a voter and felt fully entitled to speak his mind. On the title page was printed: 'Whatever charity we owe to men's persons, we owe none to their errors.'

The complete *Address* is a major new piece of evidence of Palmer's values, politics and ability as a writer. It expresses throughout a deep fear that changes and reforms would carry the contagion of revolution. He was convinced that the Church was endangered by a brotherhood of the English Radical and the Gallic Jacobin, a combination he saw as a recipe for anarchy. In calling for opposition to change he urges the idea of 'holy patriotism', and returns again and again to the French Reign of Terror, a repetition of which could be avoided in England by resistance to change – specifically, by choosing the Tory candidate in the present election. Yet the Reign of Terror happened more than a decade before Palmer was born, so this apprehension was not engendered by contemporary events; perhaps his fear of a French threat derived initially from

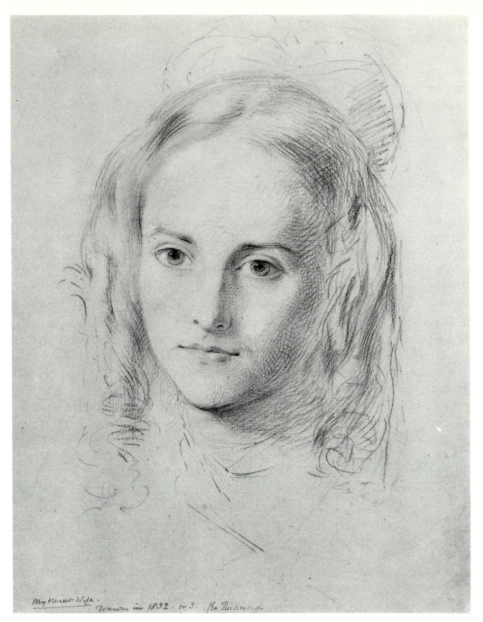

My dearest Wife. — *drawn in 1832 · or 3. Geo Richmond*

28 Julia Richmond (*née* Tatham), by her husband, George Richmond, *circa* 1832–3. Pen and chalk on paper; 330 × 267 mm (private collection, England)

the standard nursery admonition of his childhood that 'Boney will come for you if you don't behave'.

Blake would hardly have agreed with the views expressed in the *Address*, and it is an indication of how in one area at least the two men were poles apart.

Blake's view of the French Revolution was clearly expressed when he walked through the streets of London wearing the red bonnet of liberty.

The *Address* must have been written hurriedly, for the syntax is very rough and was probably not corrected in proof. Yet it is also fluent and vigorous, and full of conscious rhetoric. Palmer uses sarcasm, luridly depicted forebodings, familiar biblical figures, urgent entreaty and patriotic warmth to drive his points home. Some passages are carefully controlled, terse and clear. There are references to the Bible and to the writings of Milton and Swift, and to charismatic events in English history like Crécy and Agincourt; and an echo of Blake in the mention of the Spirit of Albion.

The Maidstone Gazette for 11 December 1832 (No. 1810), in which passages from the *Address* were reprinted, criticized it stridently. Because it upheld tithes, it was thought to emanate from 'the pen of a Reverend Divine', who was attempting to 'hide his cassock under a veil of mystery, and misrepresentation', and readers were urged to 'treat all its wild declarations and frothy nothings, as a certain other gentleman in "black" [the Devil] did the shearing swine "great cry but little wool"'. The contents of Palmer's pamphlet were described as 'False statements, weak arguments, accusations, and charges, as groundless, as they are base – gross invectives, and foul vituperations, all of them striving for the mastery, and all of them couched in Billingsgate phraseology, or copied from the more elegant vocabulary of St. Giles's.' Palmer's appeals had little or no effect, for Sir William Geary, the Tory candidate, came bottom of the poll.

As with politics, so with religion, Palmer and Linnell were poles apart, and what at first were little wisps of disagreement developed in time into storm clouds that burst around Palmer's head. It would be no exaggeration to say that Palmer was a Church of England fanatic. At this period of his life nobody was secure from his zeal. In 1828, for instance, he wrote to Richmond,

I hope, Sir, that the Lord will confirm you and comfort you in true and sweet affiliation to the Apostolic Church which only has Bishops and pastors (tho' many drones and wolves) in which only are the efficacies of the holy sacraments, the authority of absolution and blessing, the delegated power of Jesus Christ, the eternal shield against the gates of Hell, The chief corner stone which was set at naught of the builders; the rock St. Peter, the indissoluble foundation of the apostles and prophets, stronger than the pillars of the world and the fabric of the universe and the gift of the Holy Ghost. Tho I believe the free and sovereign Spirit doth shed forth some glimmering of his beams on those who thro' ignorance or perverse education are without the fold and who half averted from that healing light, half givn over to their own imaginations, have not yet giv'n up to seek and to feel after the God of their father's tho' shock'd and stumbled among the dark mountains in a dim and twilight hemisphere of wanderings and doubts. Let us pray for each other that we may have grace to pass thro' this wicked world without losing suddenly or slowly our souls and understandings among its treacheries and wonderfully deceitful snares.[53]

Palmer even subjected the formidable Linnell to his religious exertions, in

passages in letters which, his son thought, were 'a great error of judgment considering that Samuel Palmer knew John Linnell's implacable ferocity towards the Church of England'.[54] Palmer's tactlessness was extreme: a man of Linnell's Nonconformist persuasions would not have taken kindly to a high-church effusion such as this, occasioned by Richmond's visit to the continent during August 1828:

If Mr Richmond crosses Mount Cenis [on the road into Italy] I am afraid I shall envy him sadly except in this, that when drawn by the vesper bell along the twilight valleys he enters the holy gate just as the organ strikes up, and listens to such heavenly voices in trine or solo, such tremulous breathings of symphonic swelling and relapsing with imperceptible gradations, such angelic dialogues of the two quires answering each other, such consummations of enraptur'd chorus, such lofty fugues, such loud hosannahs and Alleluias as may seem to hallow the sacredness of dusky aisles and cloisters and shrines and pictur'd chapels – when he sees and hears such delicacies, when he follows the processions of the dead or hears the organ waked at midnight – who knows but he may fall down and worship *the Beast*, for so we must in this age approve our saintship, by such low abuse of the only church (tho' alas how much corrupted, the frail and erring yet undivorced spouse of Christ) the only church which Christ had upon earth from His ascension to the times of the reformers; tho I consider not the reform'd episcopal churches, emancipated as they are from popish usurpation, sophistry and will worship, to the abruptions from the old Catholic church, but members of her body reflourishing in more primitive vigour and health and youth, and I am not without *some* hope that the old trunk may shed its leprosy, the pope doff his insolent crown of universal bishoprick, and so at last, before Christ's second coming we may be led by the healing and uniting sanctification of the blessed Spirit to be indeed *one* happy fold under *one* Shepherd Jesus Christ the Righteous, by the merit of whose blood hoping we may all stand acquitted at his dreadful advent.[55]

Calvert, with what Palmer saw as his continual backslidings into paganism, was a constant worry. There were reassuring periods: 'Mr Calvert', he wrote to Richmond on one occasion, 'I found as I prognosticated ... risen from temptation, and finishing with surprising rapidity, the effect of prayer, a beautiful and luxuriant design of the cider pressing: a wood engraving.'[56] But Calvert soon slid back again. In a later letter to Richmond, Palmer wrote:

I cannot help daily anxiety for a dear friend of yours and mine who though the most amiable and conscientious of men – if he knew what was right and true – we have beheld now for years remaining in deliberate hostility to the gospel of Christ – do let us pray for him and at all seasonable opportunities not contend with but 'perswade' him 'knowing the terrors' as well as the unspeakable mercies of our Lord – for if translated out of natural darkness into the marvellous light of the gospel I think he would be an ornament to the Christian profession – but alas! it seems he *cannot* believe because the darkness hath blinded his heart and his children however good they become in other respects will remain hoodwinked in that darkness if 'Salvation' do not 'come to his house' 'through the faith that is in Christ Jesus.'[57]

ഗ

The happy atmosphere of Shoreham was overcast from another quarter. Palmer Senior was anxious for the future of his weak, vacillating young son, William. It was concluded that rural Shoreham offered William no opportunities to embark upon a suitable career, so his father returned to London to set about the urgent matter of finding him one.

The first steps in this quest had been taken when William was articled to Frederick Tatham as an apprentice sculptor, but this – it was to become a regular pattern in William's affairs – did not prosper. So in 1829 his father consulted Frederick Tatham's father about William's future. Charles Heathcote Tatham advised him to have the young man trained as an engraver and Samuel Palmer Senior wrote to Linnell to enlist his help: 'Mr C. H.

29 William Palmer, by George Richmond, *circa* 1835. Pencil on paper; 229 × 184 mm (Thos Agnew & Sons Ltd)

Tatham kindly takes my son with him to London and says he will try to get him a situation as an engraver. As Cooperation sometimes is very valuable it might occur to you that you could second such a kind invitation.' But William soon threw engraving aside; as his nephew rightly said, 'he wrecked seriatim, every effort made on his behalf'.[58] Worse was to come, for soon William got himself into deep trouble with a black sheep among the Ancients, the engraver Welby Sherman. Like the other Ancients, Sherman was a regular visitor to Waterhouse, and Palmer was especially kind to him: a generosity that was not to be repaid.

Sherman was in financial difficulties, or, as Palmer expressed it, in a 'most critical situation at this particular time', probably through borrowing money from his brother. Palmer wrote to Linnell, asking if he could find work for his friend and perhaps intervene in the crisis: 'Perhaps if your health permit you would address a line to Mr Sherman's elder brother disswading him from pressing this wretched business – they have talked of using FORCE – it might prevent the destruction of one from whom I have had reason to feel the strongest affection and regard.'[59] Linnell, a more rigorous judge of character than Palmer, did nothing.

Palmer allowed Sherman to make a mezzotint, *Evening*, after one of his own works, and an engraving of another work, *The Shepherd*, which he allowed him to sell for his own benefit.[60] 'If Mr Sherman have finish'd his print,' wrote Palmer to Richmond, 'he needs not wait till I see it, but may bring it out directly if he please, as the more copies are sold the sooner the plate will be his own.' He goes on to refer to Sherman's engraving *Samson and the Lion*, probably after a design by Richmond:

Both with respect to finishing the shepherd and selling the impressions of the Samson I am sure he may freely apply to Mr Linnell's kindness for advice. Could not some means be devised by the 'Blessed' in council assembled [the Ancients] for selling some impressions of Samson? ... I am at present two pounds behind the half year and therefore cannot possibly do anything at this instant; but shall take a dividend next month and if I can wring a little out of it shall be very glad if Mr Sherman will begin another little job for me ... I hope while there is a Saviour, a Comforter, a throne of grace, a very present help in trouble, a sure answer to prayer and the command of Jesus to pray for our daily bread Mr Sherman will not suffer the devil to make him doubt and waver and falter any more about money for if there were no other right way of getting it we should find it dropp'd for us in the street and other peoples' eyes would be holden from seeing it till we came and pick'd it up. ONLY BELIEVE.[61]

Palmer's high-minded optimism and kindness had no effect on Sherman, who finally showed his true nature in 1836, at the same time exposing William Palmer in his. On 12 September John Giles wrote to Palmer:

I am sorry to inform you that I think Mr Sherman has behaved in an improper manner to your brother William. He and your brother played a game at billiards. The odds were £100 to £12. Here Mr S. won £100. They laid another wager, odds £300 to £1. Here Mr S. wins £300, other similar bets to the amount of £75, Mr S. always being successful. The above

amounts and £25 paid by W. P. to Mr S. for rent making another £500 formerly William Palmer's money is now the property of Mr Sherman. I have informed Mr Richmond of this, he was very much shocked, and with his usual kindness, has proposed to go with me to night to your brother, to ascertain whether we can succeed in prevailing upon William to settle the wreck of his property (I hope about £700) upon himself and Wife by a trust deed. His Wife is not yet delivered.

Mr Sherman is in France. I am sorry to say that the law does not take cognizance of any gambling transactions, so that none of the £500 can be recovered.[62]

With unbelievable recklessness, William had thrown away much of the small capital which, like Samuel, he had inherited from his grandfather William Giles. He was earning nothing and, as he had married about a year before and his wife was pregnant, he was near to destitution. It was all beyond the comprehension of Samuel; the fact that his friend, whom he had tried to help, had fleeced his weak brother by calculated sharp practice, was hurtful in the extreme.

ॐ

Given all his troubles, it is not surprising that Palmer's intensity of vision began to diminish. The countryside he portrayed was still rich, but it was closer to nature, less exalted, than before. In some ways his technique had improved. His portrayals of skies and clouds were equal to those painted by the best of his contemporaries: the great billow cloud with bars of cirrus passing in front and behind in *The Bright Cloud* (*circa* 1833–4; City of Manchester Art Gallery; illustration 30) is especially brilliant. Great richness of technique was used to realize *The Shearers* (of the same date); in this Palmer combined oil and tempera so as to render every nuance of texture, from the light on the distant hills and in the sky to the detailed depiction, almost Dutch in its realism, of the group of implements at the right. There is also an advance in the drawing of the figures, the shearers and their helpers; rarely if ever before this had Palmer portrayed figures so convincingly in movement. But the mood of his work was changing as is evident in *The Gleaning Field* (*circa* 1833; Tate Gallery; illustration 31). It is as if Palmer had himself participated in the Fall and been expelled from Paradise, finding himself outside the wall of the locked sacred garden. Just as in *Paradise Lost*, after the Fall, Adam looked out and saw

> ... a field,
> Part arable and tilth, whereon were Sheaves
> New reapt, the other part sheep-walks and foulds
>
> (Book XI, lines 429–31)

so Palmer now depicted scenes like *The Gleaning Field*, showing man fulfilling the scripture 'In the sweat of thy face shalt thou eat bread.'[63]

Yet even in such scenes he was at times capable of renewed intensity, as in *The Shearers* (*circa* 1833–4; private collection; illustration 32), one of his best pictures. The landscape of golden harvest is seen from within a barn and framed

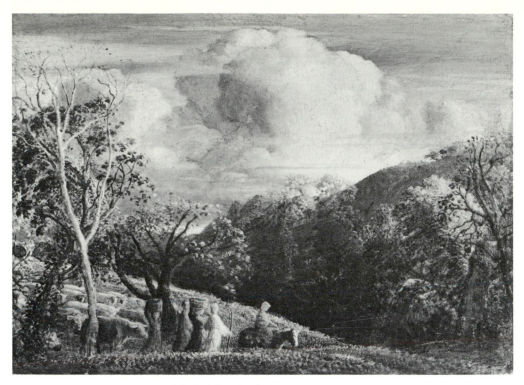

30 *The Bright Cloud, circa* 1833–4. Oil and tempera on mahogany
panel; 23.2 × 31.7 cm (City of Manchester Art Galleries)

by trees, which combine with the great timbers of the barn doorway to give
the impression of a rough Gothic arch, as in the earlier *Coming from Evening
Church* and *The Magic Apple Tree*. Beneath it men and women clip the sheep
and collect the fleeces into sacks. Some of the figures seem to echo those of
Blake; the young man in a striding posture resembles the figure in Blake's 'The
Traveller Hasteth in the Evening' in *The Gates of Paradise*, and the woman
holding a sack closely resembles several figures in *Songs of Innocence and of
Experience*. The group is charged with latent energy and suspense, as if they
were about to begin some primitive dance, a harvest equivalent of Nijinsky's
Rite of Spring.

At this time Palmer was anxiously endeavouring to improve his art. He
listed his faults and strivings in his notebooks in paragraphs of self-exami-
nation and resolutions; for example,

Some of my faults. *Feebleness* of first conception through bodily weakness, and consequent
timidity of execution. No first-conceived, and *shapely* effect. No rich, flat body of local
colours as a ground. No first-conceived foreground, or figures.

| Whites too raw. | Greens crude. |
| Greys cold. | Shadows purple. |

RIDGES OF MOUNTAIN ALONG OPEN COUNTRY.[64]

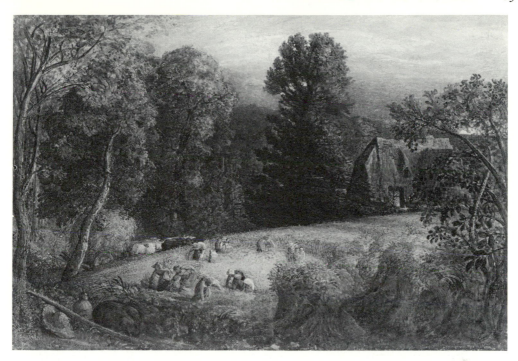

31 *The Gleaning Field*, *circa* 1833. Oil and tempera on mahogany panel; 33 × 45.7 cm (Tate Gallery)

His self-accusations are somewhat puzzling, as his recent works had betrayed none of the faults he mentions. It may be that he had lapsed temporarily and had subjected himself to minute analysis in order to subdue undesirable tendencies. If so, he probably destroyed the offending work. Or he may be referring to the onset of a change of style.

It is possible that after a period in which he was deeply influenced by Blake, Palmer moved to a style and vision more in accord with his own personality. This is a recognizable pattern: masters of strongly individual vision have rarely been followed by close successors (Michelangelo is an obvious example), and Blake did not found a school. His *Pastorals of Virgil* wood-engravings, actually among his slighter works, were the chief source of what immediate posthumous influence he had, and that influence was dissipated within a few years. Intellectually he was beyond the Ancients' reach; Palmer for one understood little of this side of him. His influence on the younger man was tenuous, and it is not surprising that much of what was owing to him in Palmer's Shoreham work quickly waned.

ᘓᘓ

Palmer's considerable gift as a correspondent became apparent during the Shoreham years. According to his son, writing was his favourite form of

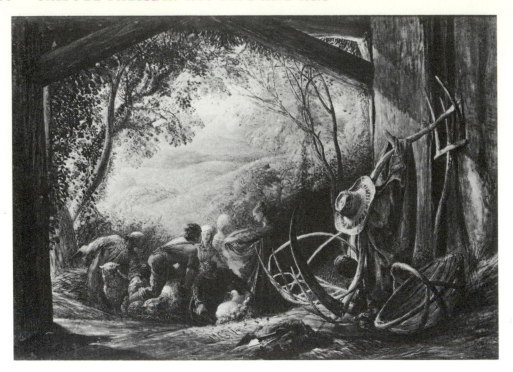

32 *The Shearers, circa* 1833–4. Oil and tempera on heavy oak panel;
51.4 × 71.7 cm (private collection, England, on loan to the Tate
Gallery)

expression, and his letters confirm this. A. H. Palmer goes so far as to say that
'He wrote with his right hand and painted with his left.'[65] His handwriting,
always clear and legible at this period, varied from large, bold calligraphy
written with a swan pinion, to tiny copperplate, perfectly written with a crow-
quill. His language was vigorous and invested even dull, everyday subjects with
interest. Yet (as we have already seen in his correspondence about religion) he
frequently betrayed a naïvety and tactlessness which, while not intended to be
controversial or offensive, sometimes invoked displeasure from the recipients.

He also had a liking, characteristic of his period, for obvious jokes and puns –
something he shared with Linnell. 'I beg pardon for delaying to answer your
kind letter,' he writes to Linnell; 'On Saturday I forgot; and on Monday no
letters go out. It is the first time I ever *jump'd over a post* in my life; but not the
first time that a post has jump'd over me. What a magic is procrastination! –
missing the post I jump'd over it, and by jumping over it I miss'd it. I wish I
had *run against it*, but it *ran* against me, and ran too fast to let me catch it.' In
another letter to Linnell, he writes: 'I will immediately inquire about horses
and asses – there are plenty of *brutes* in Shoreham, but no asses that I know of
except myself – and *I* don't answer the description – for I cannot say that I am
yet *able* to *Draw*, tho' certainly most *Willing*.'[66]

Again in common with his contemporaries, he sometimes seems overpreoc-
cupied with his health. But in his views he was well in advance of the opinions
of his day, and anticipated twentieth-century principles. On 14 October 1834
he writes to Richmond:

I hope you have some contrivance by this time for getting wholesome bread – Consider
what a responsibility you incur by aluming up your children's entrails every day to a
wrought iron rigidity. Even occasional costiveness by hardening the fæces which should
have passed first – prevents the timely passage of such as are in a wholesome state and
renders the whole system an alembic of excrement! But I know what people would say – Ah!
he's got some queer notions, hasn't he? – but I would rather have queer notions than queer
motions. While the poor soul flaps about in the cage of the body the more open that cage is
kept the better. When one ought to have a motion and can't I always think the cage feels
sensibly more narrow – My Grandfather died at eighty-two having a most excellent natural
constitution – and the doctors said he would have seen a hundred if he had minded his
bowels. As to taking physic it is the Crown of the art of Health a little is quite necessary and
we should always have it by us – but diet – diet is the thing – diet and gymnastics – Look at
Pregnant women sitting all day on sofas and cushions thimbling away at babies' caps and
lace trumpery instead of bustling about the house and going to market – jammed up in their
tight stays – why doctors are obliged to physic them forever – they are so costive and withal
they can only pass slimy motions which do them no good while the hardened and still
increasing fæces which ought to be got rid of are as tense as a bronze cast in the mould of
their peristaltics. You may laugh at this as you like or say it's filthy talk but it's too serious
and too true. Why there's Mrs. Baily [probably the wife of Richard Baily, the Shoreham
carrier] she's so big that she looks as if she had got the dome of St Peter's under her apron –
there she is bustling about all day like a girl – well she'll just drop her kitten into the basket
without any caudle or parade and in a day or two be just as well as ever again.[67]

Meanwhile the Linnell family were growing up, worked hard by their father,
girls and boys alike. Even the smallest of them, Phoebe, who when she was fully
grown was no more than five feet tall, had to carry heavy cans of water for the
Porchester Terrace garden, a duty that affected her hands for life. The younger
children had no toys, but there were plenty of drawing materials which served
both for recreation and as a groundwork for their future careers, for they all
became professional artists.

Among the girls the best artist was Linnell's eldest and favourite daughter,
Hannah, who as a small girl had welcomed William Blake to Hampstead and
had sat on his knee, listening to his recitations of *Songs of Innocence*. She was an
attractive girl, lively and sturdy, if somewhat diminutive. Like the eldest
daughter in many other nineteenth-century families, she was called upon to do
much household work, attending both to the other children and to the family
needlework. Since at this stage in her life she had a quiet and acquiescent nature,
she was given rather more than her fair share, and soon her health began to
suffer; it was not helped by her mother's amateur attempts to prescribe
medicine:

With the sense of humour which distinguished them, the Fates had obsessed Mrs Linnell for
life with the conviction that her wisdom qualified her to give unlimited advice, but more
especially good medical advice, accompanied with pills and draughts of her own manufac-

ture. Her sole equipment was a small abridgement of the *Materia Medica* and an obese but hopelessly obsolete volume on family doctoring. Thus armed, she crippled one leg of her eldest son for life and nearly killed one or two of her daughters. As Hannah succumbed more and more to nursery drudgery she became a good subject for experiments, but her constitution and courage were far too vigorous to allow serious permanent harm.[68]

It is not surprising that Hannah wanted an independent life, away from continual toil – even though it was less burdensome and restricting than that suffered by many elder children among her contemporaries. She was not quite fifteen when she fell in love with the 28-year-old Palmer, who broke the news to her parents. Linnell's laconic diary entry for 6 July 1833 reads: 'Palmer's first hint about Hannah.'[69]

Linnell approved of Palmer's suit, but Mrs Linnell did not. The young couple (or Linnell) prevailed, but so great was her mother's discouragement that Hannah was able to write only one love letter to Samuel, and that was composed and delivered in secret.

Tuesday June 14

My dear dear Mr Palmer,
 I take a few moments to write to you because I think it will please you to hear that my affection so far from decreasing in your absence increases daily. I think of you more than ever and look forward to your coming back with stronger emotions of joy than I before now felt. I feel unhappy when you are absent. I want your conversation and society which is dearer to me than any other. I want you of an evening to walk with. Yesterday evening I took a delightful walk with poor Uncle George who is ordered up here for his health, but I could not help wishing I was with you walking through those delightful places we so much enjoy. Oh a Summer evening walk with you is beyond every thing delight. I am afraid you will remember me only as a poor pale creature forlorn and miserable with all my enthusiasm and ardour worn out but I can assure you it is far otherwise. I have now recovered my health with this nice warm weather and am as lively and sprightly as ever.
 I could write much more but am afraid if I stay I shall not be able to send it at the time you mention and though few are the words yet you will remember that they come with sincerity and truth from one who is yours most faithfully and affectionately for ever
 Hannah Linnell
P.S. You must excuse the bad writing as no one knows of it. I have written it by stealth expecting every moment to be discovered. Do not trouble to write again nor you must not expect another from me.[70]

One aspect of their daughter's relationship with Palmer distressed the Linnells: her entry, under his influence, into the Church of England, a move which her younger sister Elizabeth followed. To the strongly Nonconformist Linnell this was anathema, but at first he took the blows with dignity. Later, however, they added fuel to his already furiously fanatical antipathy to the Church. But his initial reaction was more courteous than that of one of his brothers-in-law, an ignorant, prejudiced and foolish piano-tuner, a Baptist whose extreme beliefs smacked of religious mania. He jealously watched the deepening intimacy between Linnell and Palmer, and, conscious of the wide class difference between Palmer and himself, wrote to Linnell: 'I see you are at enmity with [the

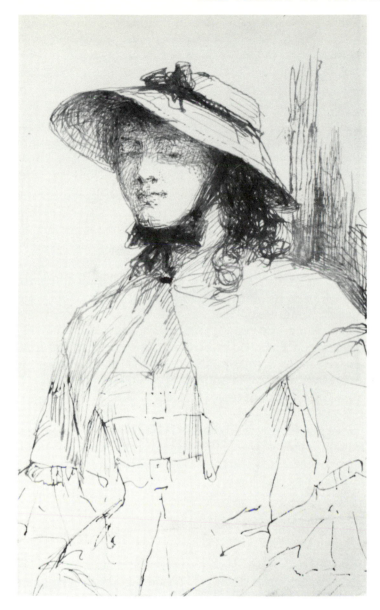

33 Hannah Palmer (*née* Linnell), by George Richmond, *circa* 1838.
Pen and ink on paper; 168 × 114 mm (collection of R. M. M. Pryor
Esq.)

Baptists] or you would never have suffered a Babbler to have taken your
children to a Popish church [St Paul's Cathedral] to poison their minds ... or
any other than Baptist.'[71] Linnell sprang to Palmer's defence, coldly answering
his brother-in-law, 'So far from Mr Palmer being a vain Babbler as Mr B. calls
him, he is in the estimation of all who know him a worthy and amiable man

holding perhaps strong opinions and rather too much leaning to popery (and who does not hold some) he has never taken my daughters anywhere without my permission.'[72] In view of some of the criticisms that have been levelled at Linnell for his intolerance this defence of Palmer is significant; at this point in their friendship the older man was showing what was for him great indulgence towards his future son-in-law. As A. H. Palmer wrote:

Hard as it may be in the midst of tragedies to come, the early kindness of John Linnell to Samuel Palmer should never be forgotten for it was the kindness of a man harried and perplexed by domestic troubles which almost all wives would have averted – harried till he broke down. Physically and in other ways he was completely altered for the worse.[73]

Palmer was still selling hardly any of his work, and his weekly income was only a few shillings. It became clear to him that if he was to make headway in his life and art, he would have to move back to London. In 1832, therefore, he drew once again on his small savings, and bought a house in the capital – 4 Grove Street, Lisson Grove, a ten-room dwelling not far from 20 Lisson Grove North, the home of Frederick Tatham. Here, in addition to painting and between occasional visits to Shoreham, Palmer began to establish a practice as an art teacher.

Grove Street was an unattractive quarter. In Shoreham, amid idyllic surroundings, Palmer had been remote from the rush and noise of urban life; he was here subjected to many of its forms: the yells of street traders, the twanging notes of street pianos, the fustiness of neighbour prostitutes. The only constant factor at Shoreham and Grove Street was Mary Ward, who moved with him to keep house.

Palmer had for long harboured romantic dreams of marriage. Perhaps cooler appraisal might have spared him much later disappointment and pain. As it was, his view of the married state was entirely optimistic, so it was with great joy that, soon after his move to Grove Street, he became engaged to Hannah Linnell, planning to marry her as soon as he could.

ಐಜ

During the mid 1830s Palmer tried to find another potent *genius loci*. But, except to some degree in his etchings and in the watercolours related to them, he never again attained the Shoreham exaltation. During the next twenty-five years he undertook numerous sketching expeditions (see above, Chronological Table). He did find other localities that would have provided sufficient subject-matter to a more or less topographical artist; they afforded him a wealth of detail, but did little to rouse his imagination. In some ways Kent was an unlikely area to have inspired him so deeply, for his own preference was for wilder places, like Dartmoor.[74] So it is not surprising that when he first began to look for new subjects, in about 1833, it was to Devon that he turned. He went there again in 1835, this time also visiting Somerset, and in both counties he made some excellent studies, among them *On the North Coast of Devon, Lundy*

Island in the Distance (Metropolitan Museum of Art, New York) and *Culbone, Somerset* (National Gallery of Victoria, Melbourne; illustration 65).

In 1835 and 1836 he visited North Wales, where for a time he found inspiration in the scenery. This is especially evident in a number of paintings of Welsh waterfalls, such as *A Cascade in Shadow* (private collection, U.S.A.) and *Pistyll Mawddach*, of which there are three versions: a preliminary study in pencil and wash (private collection, England), a watercolour (Yale Center for British Art), and an oil painting (Tate Gallery; illustration 34). His son said these studies contained his whole heart;[75] in all of them, particularly the last, he produced work comparable with the paintings of such eighteenth-century artists as Richard Wilson and John Robert Cozens. The convincing portrayals of the rocks, the trees, and above all the water and the spray of the cascades equal the best in the tradition of English landscape painting.

Welsh castles provided further stimulus; his studies of them vary from shadowy brooding sketches of those at Harlech and Conwy (examples are in the Yale Centre for British Art, the Art Gallery of Greater Victoria, Canada, and the City of Manchester Art Galleries) to more highly wrought watercolours like that

34 *Pistyll Mawddach, North Wales*, 1835. Oil on canvas, 40.6 × 51.4 cm (Tate Gallery)

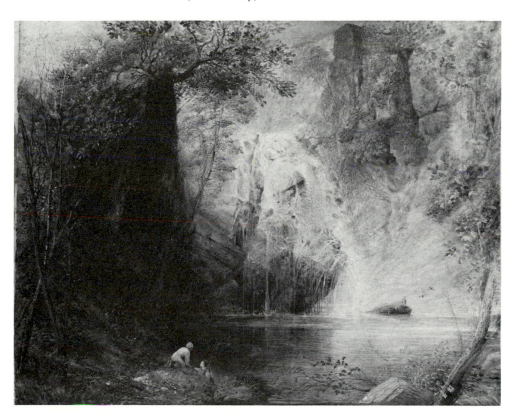

of Caernarfon (now untraced; illustration 35). In this last he used a composi-
tional device that he was to employ frequently in later work: a flock of jackdaws
or starlings coming to roost in one of the towers. There is also a slight narrative
element in *Caernarfon Castle* – fishing boats lie keeled over at low tide and a
single fisherman at the shore hauls in his nets, while three horses and carts cross
the shallow waters of the River Seiont. This interest in narrative was to become
a more evident preoccupation in the years ahead.

The Welsh mountains also provided him with potent subjects, giving rise to
the impressive studies *View from the Bridge near Capel Curig* (City of Manches-
ter Art Galleries), *Moel Siabod from Tyn-y-Coed* (illustration 36) and *Llyn Gwyn-
ant and Part of Llyn-y-Ddinas* (both Yale Center for British Art); the more
lightly conceived *Conwy Vale from Gwydir Lodge, Llanrwst* (City of Manchester
Art Galleries) and *The Valley of Dolwyddelan* (Yale Center for British Art); and
most powerfully of all, the Turneresque *Snowdon from Moel Siabod* (Art Gallery
of Greater Victoria, Canada; illustration 37), in which Palmer captures the
drama of the weather as well as the grandeur of the scenery.

Palmer's work in Devon, Somerset and Wales illustrates a continuity in his
methods, for he still uses dappling and scribbling techniques, as in *Culbone,
Somerset*; and there is still meticulous detail, anticipating Preraphaelite

35 *Caernarfon Castle, North Wales*, 1835 or 1836. Watercolour and
body colour, pencil and black chalk, on paper; 286 × 429 mm (untraced
since 1982)

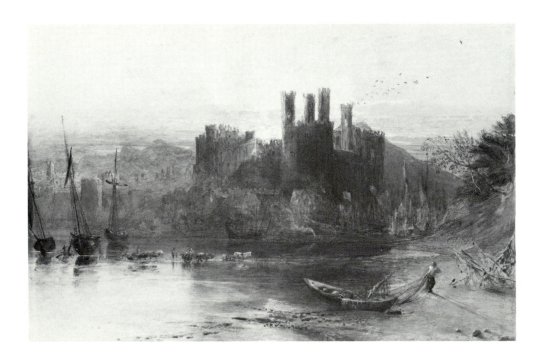

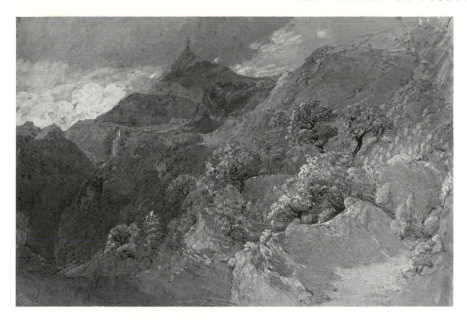

36 *Moel Siabod from Tyn-y-Coed*, 1835 or 1836. Watercolour, body colour, and pen and brown ink over pencil, on paper; 378 × 476 mm (Yale Center for British Art, New Haven, Connecticut, Paul Mellon Collection)

intensity in *Study of a Garden at Tintern* (Ashmolean Museum; illustration 38), in which individual blades of grass and leaves are painstakingly drawn, yet surrounded by less detailed areas so as to concentrate attention on the finished part. The detailed notes on the drawing read:

A study at Tintern drawn on the spot – S. Palmer. Weir End/In one part of the wall the interstices had been fill'd with mortar so that the breadth of stones/and of mortar between were of the same colour – this was at gradation from the marked divisions/to a mingling together in which the distinctions of stone were almost lost –

Similar areas of great detail, surrounded by controlled scribbling, occur in several studies of Tintern Abbey (examples are in the Victoria and Albert Museum and the Yale Center for British Art) but here Palmer uses extensive dotting and dappling, especially on the distant hills, which closely relates these works to many of his Shoreham landscapes.

On his first Welsh tour Palmer was accompanied by Calvert and they were later joined by Henry Walter; in 1836 Calvert was with him once more. In a letter to Richmond written on his way home at the end of the first tour, Palmer conveys something of the exuberant, receptive spirit which was activating his work at this time and enabling him to make light of the chore of picture-cleaning that he had been forced to undertake to supplement his income. He was so hard up that he had to beg the loan of £3 in order to return home, but he still seems unperturbed by his poverty, despite his plans for marriage.

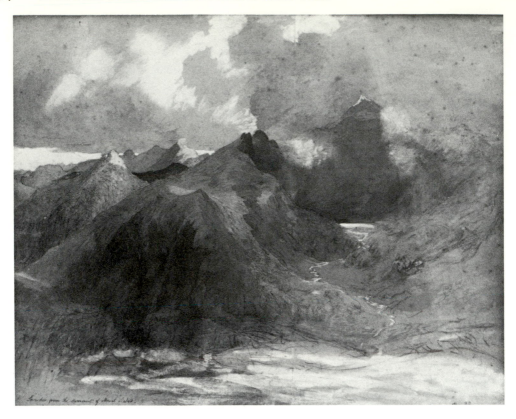

37 *Snowdon from Moel Siabod*, 1835 or 1836. Watercolour, pencil and body colour on paper; 375 × 468 mm (Art Gallery of Greater Victoria, Victoria, B.C., Canada)

Tintern very deep Twilight *Wednesday August 19th, 1835*

The address for letter is to us at Mr. William Hiscock's – Black Lion, Tintern Abbey, Monmouthshire

My dear Sir

Our Ossian Sublimities are ended – and with a little more of McPhersons mist and vapour we should have had much more successful sketching – but unfortunately when we were near Snowdon we had white light days on which we could count the stubbs and stones some miles off – we had just a glimpse or two one day thro' the chasms of stormy cloud which was sublime – however we have this evening got into a nook for which I would give all the Welch mountains, grand as they are, if you and Mrs. Richmond could but spare a *week* you might see Tintern and be back again. The Bristol Stages start daily the fare I believe is low and there is a steam boat daily thence (only three hours' passage) to Chepstow, within 6 miles I think of the Abbey – and such an Abbey! the lightest Gothic – trellised with ivy and rising from a wilderness of orchards – and set like a gem amongst the folding of woody hills – hard by I saw a man this evening literally 'sitting under his own fig tree' [Micah iv, 4] whose broad leaves mixed with holyoaks [hollyhocks: see illustration 38] and other rustic garden flowers embower'd his porch. Do pray come – we have a lodging with very nice people under the walls and three centuries

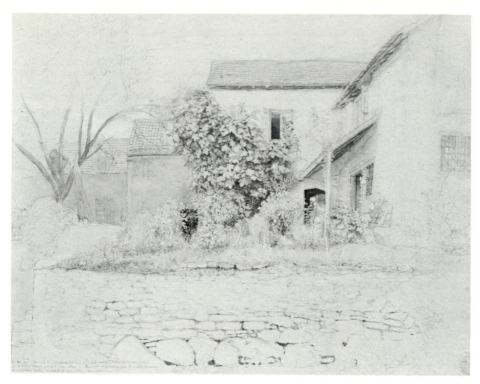

38 *Study of a Garden at Tintern*, August 1835. Pen and ink, black chalk, watercolour and body colour on paper; 372 × 475 mm (Ashmolean Museum, Oxford)

ago might have been lulled with Gregorian Vespers and waked by the Complin to sleep again more sweetly – but the murderer of More and Fisher has reduced it to the silence of a Friends' meeting house. Mr. Walter was shown the inside and says it is superb. After my pastoral has had a month's stretching into epic I feel here a most grateful relaxation and am become once more a pure quaint crinkle-crankle goth – If you are a Goth come hither, if you're a pure Greek take a cab and make a sketch of St. Paul's Covent Garden before Breakfast. Addison speaks of the Cathedral of Sienna (one of the richest in the world) as the work of barbarians – clever savages almost – what a 'Spectator' – he could not bear too *lofty* and *pointed* a style – pity he died before the æra of Doric watchhouses Ionic turnpike gates and Corinthian ginshops! – his taste outran his age – ours hobbles after –

Thursday Eveng. Poetic vapours have subsided and the sad realities of life blot the field of vision – the burthen of the theme is a heavy one I have not cash enough to carry me to London – O miserable poverty! how it wipes off the bloom from everything around me. Had I conceived how much it would cost I would as soon have started for the United States as Wales – but I have not worked hard – seen grand novelties and enlarged the materials of imagination – if I could but sell a picture or clean another Opie or two or – but I am all in the dumps 'shut up and cannot come forth' and feel as if I alone of all mankind were fated to get no bread by the sweat of my brow – to 'toil in the fire for very vanity' – If you've a mangy cat to drown christen it 'Palmer' – If you could oblige me by the farther loan of three pounds my Father will repay you I dare say if you can call at Grove St. – but I shall very soon be in town myself only – I want enough both to bring me home and enable me to stay a little longer in case I should find subjects which it would be short-sighted policy not to secure – but I hope not to spend so much – If the Movement Party want a professor of drawing in the

Marylebone Charity Schools pray canvas for me.*Things are come to a crisis now and I must begin to earn money immediately or get embarrassed – horrid prospect – the anxieties of debt on the back of the perturbations of aspiring studies. The refuge I know is in Faith and Prayer – but is daily bread promised to those who overspend their income – which I am afraid is now my case – however I was deceived by the strange misstatements about cheap living in Wales – otherwise my muse should have donkeyfied upon thistles from Husky Hampstead this summer – with a log at her leg. Well! I must come to London sell my pianoforte and all my nice old books – and paint the sun, moon and seven stars upon a signboard I suppose – would I could get it to do! I find I am writing strange stuff and boring you with my own selfish troubles so I'll have done. If you can favor me with the three pounds would you have the farther kindness to send it as soon as possible and with a very full and legible direction on the letter – what if it should miscarry! I must stay at Tintern and go to plough – could you send by return of post? The candle is going out as did the light of my mind some hours ago, so I must wish you miserably good night.

Mr. Walter desires me to give his love and say that he wishes to return directly but not having the means would be obliged if you would make it up a Five Pound Note – I will pay the postage of this when I see you – With kindest love to Mrs. Richmond and such old friends as you may happen to see I remain

 My dear Sir
 Your affectionate friend
 Samuel Palmer.†[76]

It is not clear what had happened to Calvert when Palmer was writing this letter; he was comparatively well off, and could presumably have saved Palmer from having to ask Richmond for a loan if he had still been with him.

Palmer was still working hard when he returned to London after the 1835 tour and was still much in love with the pretty young Hannah. He referred to both work and love in a letter to Linnell, written from Hackney on 28 September:

Dear Sir

 I had just succeeded in setting a model in my room – Scythe etc when Mr Williams of Hackney came in and invited me so very pressingly to go and spend a day with him at Hackney that I could not resist and as he is going away into the country for a long time and we shall not see each other again he insists on my staying at Hackney tonight and I cannot get away by any means – now as I said I would be at Bayswater yesterday eveng to read I thought if I did not let you know of this movement they might be alarmed and think some wild beast had devoured me – I have not had a holiday for a long time and as my materials are prepared in perfection the syringes ready and the model set for another picture I hope a day at Hackney from which *I cannot get off* will give me fresh vigour for a new set in of work – There is a degree of pressing which one cannot refuse without offending ones friends – otherwise I would not disappoint in the evening reading Mrs Linnell, and that *very dear person* whom I hope never wilfully to make uneasy as long as I live

 I am Dear Sir
 Your obliged affectionate Servant
 Saml. Palmer.[78]

* Palmer's irony: the Marylebone Charity School at this time would not have included drawing in its syllabus, let alone have appointed a professor. The 'Movement Party' refers to people who wished to improve or reform the charity schools.

† Not everything on their tour was as poetic as Palmer suggests in the first part of this letter. In later life he reminisced to Richmond that 'Dear Walter and I found it rather stomach-trying, when our ancient landlord, the parish clerk of Dolydelan, was spitting the whole time we were breakfasting.'[77]

During his tour of Wales in 1836, perhaps with his proposed embarkation on family life in mind, Palmer wrote a long letter to the young Richmonds that was full of gratuitous advice about the upbringing of their children. (They evidently took it in good part, for there is no trace of a rejoinder.) He draws on his own upbringing, during which a birch rod hung on the wall as a threat; a preoccupation with corporal punishment recurs from time to time in his correspondence, and rather than subscribing wholly to the widespread nineteenth-century belief that to spare the rod was to spoil the child, he recognizes that fear of punishment alone is an effective means of discipline:

See therefore the worst of your children as they grow up, be yourselves not the censors but the caterers of their pleasures. While it is their pleasure to romp, romp with them; and whip them for vice and disobedience. I am glad when I think of your children – dear friends of mine I hope some day – to know that you both have the good sense to despise the super Bible, super Solomon, stupid, twaddling sentimentality – the French Revolution philanthropy which would disuse the Rod. I agree with you that continual beating is barbarous and ought to be bestowed on the parents themselves who have managed clumsily enough to find it needful: – but depend upon it, fear, of one kind or other, as well as hope is necessary to move either adults or babes to effective wisdom and goodness. With sunshine before, and a thunder cloud behind, we make way. I believe the dread of ultimate bodily correction is the only real bugbear to children – while on the other hand a thousand are the pleasures and holidays which may be made for them, by great skill, even their learning may be given them in sugar – The right hand may shower indulgence if the left hand hold the rod – but the parents who will not correct their children always become their slaves or their dupes.[79]

Serious advice is interlarded with jocular passages, including a specimen of what Palmer describes as a 'bit of Twilight poetry':

<div style="text-align:center">

EVENING
'Then Evening comes at last, serene and mild' – THOMSON
Dedicated to George Richmond Esqre.

———————

</div>

When each has been working all day like a horse,
And Master looks crusty, and Mistress looks cross;
He combing his mind, and she knitting her stockings;
The door beat with craftsmen and carpenters' knockings,
And the maids in and out, and the candles want snuffing,
And Babbington's come from his errands all puffing:–
Then vow you'll not stand it; but get out your Handel;
And a kind friend will call in and give you some scandal:
When gone, get your Jebb and your Knoxy so deep,
And quiet at last, – you will fall fast asleep.
Then Mistress will pinch you, and say 'At least when
'Mister Palmer's not here, you might chain up at ten:
'And *I* know some persons who'd beg him to go
'At half after nine, let him like it or no!'
You rise, with a yawn that would swallow an ox;
And leisurely lengthen the latches and locks:
When Hark! – A low tapping at which your heart fails

'You're the first friend I've called on since come from North Wales'
Then some Art, and some gossip, and free will and fate
Will sweetly refresh you for 'sitters at eight'.*[80]

This letter is an interesting example of the immense trouble Palmer often took over his correspondence; and in addition to the letter itself, beautifully written in tiny, meticulous handwriting, there exists a copy written with equal care and a heavily corrected draft which itself would have involved many hours of work.[81] In everything he did, Palmer had an inexhaustible capacity for taking pains.

১৩৫১

As Blake's influence waned the Ancients began to follow divergent artistic and social paths. Age was probably an important factor in the change; they had lived in an atmosphere of adolescent or post-adolescent romanticism which could not have lasted and which they were fortunate to have sustained for close on ten years. It had enabled them, and Palmer especially, to produce their best work, but change was inevitable.

Richmond abandoned his visionary work and settled in London, where he became a fashionable and successful portrait painter, working so hard that he often made himself ill. Calvert, who had bought a house in Park Place, Paddington, devoted himself to an idealistic paganism which he tried with varying degrees of success to express in paint, at the same time working on verbose and unintelligible hypotheses of religion and of the arts. The more conventional Richmond was startled one day to receive a letter from Calvert containing the passage, 'My poetic loves have been associated more fondly, first and earliest, with Pan and the rustic Deities – elemental natures – thence upwards through impulsive and Dionysiac energies. I have been busied with the beautiful Antique Myths; ever in an upward course of purpose, and in vows to the Muses and Apollo.'[82]

Henry Walter married, and when one day he returned to Shoreham with his wife, presumably to show her the happy scenes of his youth, he cut the village idiot, with whom he had previously always exchanged a friendly word. The simple rustic, telling Palmer about it, burst into tears and said that Walter 'had a *woman* with him'.[83] Francis Oliver Finch lived an exemplary life, and continued to the end of his time to paint pretty landscapes that were heavily dependent on the style of Claude Lorrain. He evidently lost any Blake-like ideals that he may have had, and when his wife wrote a memoir of him, Blake was not even mentioned – probably because of his dismissal (after a short adherence) of Swedenborgianism, a faith more permanently embraced by the Finches. John Giles became increasingly immersed in the world of commerce and became a close friend, indeed a sort of honorary member, of the Richmond

* Babbington was probably a servant or odd-job man; Jebb and Knoxy were probably two precursors of the Oxford Movement, Bishop Jebb (1775–1833) and Alexander Knox (1757–1831). Their *Thirty Years' Correspondence between Bishop Jebb and Alexander Knox* was published in 1834.

family. The Tathams went their own ways, Frederick in art and Arthur in the Church. Sherman disappeared completely after the billiards episode; his ultimate fate is unknown.

Yet the Ancients did not disband entirely. For some time after the Shoreham years a group continued to foregather at monthly meetings in one another's houses, bringing recent examples of their work for mutual criticism. After the discussion, their wives and children joined them to enjoy music, poetry, conversation and supper. 'How well I remember', wrote Calvert's son, 'the amiability of Richmond, the modest reserve of Walter, or of Finch, the conscious twinkle in my father's eyes, and the oddity and humour of Palmer, who interested and amused everybody, especially at supper, when, perhaps, the goose was too savoury, or the emancipated Guinness too ebullient!'[84]

ॐ

In January 1837 Samuel Palmer Senior decided, despite his earlier promises and determination, to eschew the life of a gentleman of leisure and to become a bookseller once more or, failing that, to open a school. In this he was motivated partly by a desire to find employment for William, and partly by a wish to re-marry (the identity of his intended bride is unknown). This precipitated a family crisis, with Samuel between the opposing parties, trying to keep the peace. In desperation he wrote to his Uncle Nathaniel.

It gives me much pain to inform you that my Father has determined again to try the book trade. About three weeks since he took a house 29 Harcourt Street New Road near Paddington Chapel Rent 45.0.0 per annum. As this may be my last communication on this distressing subject I should wish to put you in possession of my Father's real feelings which I have the best opportunity of knowing as he speaks unreservedly to me and without suspicion that anything he says will be repeated to you – except that when I shewed him your letter he desired me when I should answer it to say that he did not reply to your last letters because he imagined both of yours to be in answer to one of his. My Father has more than once expressed to me his thankfulness for your past kindness and has declared that his letters to you were not dictated by an intention of insult or defiance but were written merely with that sort of familiarity with which he has been accustomed to write and speak and which he thinks becomes natural from near relationship and habits of brotherly intimacy from childhood however different the circumstances of each may afterwards become. It was he says in the spirit of unpremiditated confidence that he mentioned his desire to marry (O! for a wife – the joy of my life etc) when I mentioned that you did not bind him never to marry, but restricted the annual allowance to the term of his remaining single – my Father said he had informed you in a former letter that should he marry he would honestly inform you of it immediately but that you still declined to assist him. But notwithstanding all your former kindness – which my Father has been ever ready to acknowledge it appears to him a real hardship that you induced him to give up the trade in Broad St Bloomsbury – however little it might have produced without your assistance and to retire from all connections and means of livelihood for twelve years by promising to support him as long as you were able without adding any other condition – and that

now you have made conditions which had he known them at that time might have induced him to pause before he threw himself until old age out of all the means of maintenance – in other words that you have now refused to perform that promise in the confidence of which he long ago relinquished trade and has been living ever since without apprehension of the sudden destitution which has now befallen him. I beg dear Uncle that you will understand me hitherto as not myself the speaker, but merely as giving you what I think the tenor of my Father's conversations with me. I should myself have been very uneasy for my Father's sake at the apprehension of a second marriage had I thought there was the probability of such a thing but I did not oppose it because I knew it was one of those sudden fancies with which my father has now and then been visited and which by letting it alone would die a natural death.

With respect to my father's letters I should indeed be grieved if I thought him capable of offering deliberate insult as the return for all your benefits – but well knowing his strange and excentric habit of writing to all persons I am the more inclined to believe his express disavowal of an offensive intention – and I fear that the very passage in one of his letters which he adverted to when he said that he had already given you that satisfaction about marriage which you desired by assuring you that he would immediately give you notice of it should it occur, may have been interpreted in some sense different from that which it was intended to convey. I think my Father's inclination to go into trade has been much strengthened by the hope of giving employment to my Brother who had nothing to do but is now his assistant.

The movement seems to me partly to be explained by the sudden power with which a new pursuit has before from time to time seized my Father's affections he has pursued with unremitting and exemplary industry one line of conduct for several years and then as suddenly turned to something else. My opinion as to this movement is most decided. I think it a false and ruinous step and till it was too late spared no perswasion – no endeavour to prevent it – and I have written this not to extenuate its imprudence but to put you in possession of *facts* to show you exactly what my Father has really felt and spoken in unreserve – that in case he should in after time see things differently your mind may not be embittered by any groundless anger – but that being angry where there is cause you may be enabled to mete out the judgment of justice and the judgment of charity. I lament bitterly what my Father has done and grieve to think that he may probably spend the closing years of life in the struggles of penury after so long having enjoyed ease and a tranquil mind through that kindness for which as his son I cannot but remain your obliged and affectionate Nephew – [85]

In this typically verbose but remarkably controlled letter Palmer shows an impressive side of his character, not only as a would-be peacemaker, but in his perceptive assessment of his father's personality, which he is able to view objectively despite their father-and-son relationship and despite his strong affection for the older man. This is particularly evident in the closing sentence of the first paragraph. He is also tactful to his uncle, begging him to understand that he is merely reporting his father's feelings, modestly taking little credit for his own part in the events. It is a rare instance – particularly rare in those times – of a younger member of a family dealing maturely with an older member over family problems; and it is very unlike the way in which he was later to deal with his father-in-law.

But despite Palmer's skill and tact, Nathaniel's patience had reached its limit.

He replied on 31 January, saying that he could see no benefit, only misunderstandings, arising from an interview:

I exact no vow from [my brother] of perpetual celibacy, but as I deem that man dishonest who marries, not possessing the means, or not having the rational prospect of obtaining them by his own exertions, to maintain a wife, and as I do not feel called upon by duty or affection to supply them, I on these grounds say if my Brother takes again a wife he must look to his own resources to maintain her. All I ask my brother to do, is to assure me that while he receives pecuniary assistance from me he will not marry.

Nathaniel also clearly stated, quite reasonably, that his brother's previous efforts in trade having proved abortive, he would not give him any money to set up again. He had already made him an allowance sufficient to enable him to live as a gentleman, and if he became a bookseller again, or opened a school, he would not give him another shilling.[86]

As if these anxieties were insufficient, bereavement was at the same time tugging at Palmer's heart. The death of his beloved nurse, Mary Ward, seemed to symbolize the close of his youth, the happiest period of his life. He recorded the event in a memorandum.

Jany–18–1837 at about ¼ past–4 I asked Mary Ward to bid God bless me – and to kiss me (as I kissed her) she said 'May the Lord bless you forever and ever' and kissed me quickly several times on the cheek though so exhausted – my Brother William asked her to bless him and kiss him – and she said 'May the Lord God Almighty and Jesus Christ' – here her voice failed – and she kissed him on the cheek – My dear Nurse and most faithful servant and friend Mary Ward died at 5 minutes to five o'clock 18th Jany. 1837 the same day of the same month on which my Mother died confined to bed 11 days.[87]

As a parting gift Mary gave Samuel her copy of Tonson's edition of the poems of Milton, which he treasured to the end of his life. His son presented it to the Victoria and Albert Museum (from which it has now apparently disappeared). A. H. Palmer made a percipient assessment of what Mary Ward had meant to his father:

Much consideration of my father's life, character, and work has convinced me that to his nurse, Mary Ward, he owed more than he himself, or anybody else, ever realized. If, after his mother's death, he had been left to his father's ineptitude in all practical matters, and to the care of mere transients, he would have been utterly helpless and might have turned out to be utterly different for I never knew him make a piece of toast or pot of tea or drive a nail. From his childhood to her death he was completely dependent upon Mary for his domestic comfort. It is quite another thing to be completely dependent on mere mercentary service. But he had every wish anticipated. He was sure of deep sympathy in every grief; sure of her delight at every small success. Was it not a great matter to find every penny of an income which, in average hands, would have been hopelessly inadequate, spent with care and skill in the great proletariat markets of London, so that each meal was a feast? Also without doubt Mary took upon herself the making of the outlandish clothing of her master; for no tailor or seamstress would have condescended to carry out such orders. It was to Mary Ward's intense sympathy and love that the child, the youth, the man, owed more than he could repay except by returned affection. We have seen her as a girl influencing the whole of his art by pointing out the shadows of the elms. Even earlier (according to him) she powerfully

influenced his physical well-being. Why should there not have been wisdom and good counsel throughout as well as devotion and love?

In spite of the father's great disinterestedness and kindness and solicitude for his son's mind, in some ways he was utterly unstable. Therefore, perhaps, the greatest benefit of all conferred by Mary Ward upon my father was that he was entirely free from the impact of those small daily worries and long lists of little things to be remembered or feared and which wore down the vigorous Linnell to the breaking point. Palmer, on the other hand, could devote himself to the culture of that mental and spiritual soil whence sprung all that has given him his reputation. His nature was one which complete sympathy and complete understanding might have led to unalloyed happiness and to an extension of that tranquillity which, for a few years, he found on the banks of the Darent. But thenceforth with all these things he had to do without.[88]

It is not surprising that within the year Palmer was married. He and Hannah Linnell were espoused, at Linnell's insistence, not in church but by civil ceremony at the Court House, Marylebone, on 30 September 1837; Hannah was nineteen, Samuel thirty-two. Having allowed his religious convictions to be overruled, Palmer went through life burdened with what he considered a form of apostasy. Even as late as the year before his death he made this entry in his commonplace book: 'Register of Samuel Palmer's Birth is at Dr Williams's Library, Red Cross Street, London. His parents were married at St. Mary's Newington London . . . S.P. was married at the Court House, Marylebone, he a Churchman.'[89]

3

Italian interlude

Samuel and Hannah began life together with a long visit to Italy, one that Palmer had planned and looked forward to for nine years. Richmond had already been abroad, to France and to the Rhineland, several times, and by the middle of 1837 had preparations well in hand for a tour of Italy with his wife and their little son, Tommy. Palmer was determined to accompany them and if possible to take Hannah.

Linnell approved of the idea, but it took all the young couple's powers of persuasion, aided by Mrs Richmond's, to overcome Mrs Linnell's objections. She had only ever made one long journey, and that was to Scotland when she married Linnell. In her opinion the plan was dangerous and foolhardy: 'Out of the profundity of her ignorance she raked banditti, rivers of lava from an irate Vesuvius, wild cattle, overturning diligences, fever, sunstroke, indigestion and damp beds.'[1] Though (as events proved) her fears were partly justified, her capacity to exaggerate risks into inevitable disasters strengthened the persuasions of the others. Richmond and his wife visited the Linnells before the Palmers' wedding, and reported to Samuel their impressions of the prevailing attitude. They had 'heard nothing of *decided objection* . . . to your foreign tour. I don't think the advantages were as present in their minds as the disadvantages of spending as much money as it would cost for uncertain good . . . I think Linnell is . . . really inclined to do all that is kind as well as fair.' Julia Richmond had spoken to Mrs Linnell, who seemed 'quite to have made up her mind to relinquish all opposition, and I think will do anything she can to make Anny [Hannah] happy. She cannot yet see the advantage that you hope for in your tour.'[2]

But so determined was Palmer to make the trip that he was even prepared, if necessary, to leave his bride at home. On another visit to Mrs Linnell and Hannah, Julia Richmond again reported to Palmer: 'I did not speak one word to Anny . . . I should not like to be thought to influence her mind. Mrs Linnell thinks she would break her heart if you were to go without her, poor girl she sits and hears all so quietly. I pity her for I know what her feelings must be.'[3] Eventually Linnell, irritated at his wife's continuing opposition, and to put an end to the matter, did with her what he did with all his clients and his workpeople: he made her sign an agreement. Ripping a piece of paper from an old insurance policy, he handed it to her with a pencil and compelled her to

write, 'I approve of their going on the Night Coach to Dover and crossing the Channel the next morning.'[4]

By this time Richmond was a successful artist earning £1,000 a year. He understood the world better than Palmer and was quick to adapt himself to it. Probably he looked back on the visionary world at Shoreham with some embarrassment, if not contempt. 'We all wanted thumping', he wrote, 'when we thought in a dream of sentiment we were learning art – and depend on it a few thigh bones broken about the heads ... would have have done us good'.[5] While Richmond was making material progress, Palmer was still struggling to get on, still scraping together a few pounds so as to make the Italian trip possible. Richmond, had he wished, could have made the journey in comfort, and not, as he once put it, compelled to live on a 'franc a day'.[6] In the event Palmer would have been unable to undertake the journey but for a loan from Richmond, who was thus able to reciprocate Palmer's generosity to him at the time of his elopement.

Mrs Richmond told Samuel that her husband would take letters of recommendation to the most distinguished people in Rome, and hoped that Palmer also would benefit from them. But despite much personal charm, Palmer was socially too maladroit and absent-minded to benefit from Richmond's introductions. Sanguine though he was in many ways, he had no illusions about himself as a socialite, though he entertained hopes of Hannah: 'Anny will do very well for society as she has great presence of mind and carries herself well but "I – the dogs bark at me as I halt by them" [*Richard III*, I.i.23] and the time is not yet come for throwing my crutch at them if I were so disposed.'[7]

ಬಿ

Before leaving England, Palmer arranged for the bulk of his affairs to be managed by Linnell. William Palmer, who in July 1837 had at last secured a permanent situation, as an assistant in the British Museum, was left in residence and in charge at Grove Street. These and other arrangements completed, the two couples and Tommy Richmond embarked for Calais in the bows of the paddle steamer *Lord Melville* at midnight on 3 October 1837, Hannah with a present of £10 from her father in her handbag, but little else. They disembarked at a quarter to three on the afternoon of 4 October, and Hannah and Samuel wrote at once to inform the Linnells that all was well with them and that Anny was no worse for the voyage.[8] A few days later they were in Paris, installed at the Hotel Rossignol, after travelling all night 'through the most dreary wastes'.[9]

Hannah again wrote home from Paris, describing visits to the Louvre and to the gardens of the Tuileries, and mentioned a forthcoming visit to an unnamed friend of Richmond's who promised to show them prints and drawings. And she recounted how they had dined in a rather grand restaurant on four courses and fruit, wine and brandy for 1s. 8d. (about 9p.) each. She was impressed by the glitter of the glass and lamps and the crowded long tables; but she was not

so happy with the cooking – meat 'cooked in the French way, covered with sauce and curiosities which I leave'.[10] Palmer added to this letter, mentioning works they had seen in the Musée du Louvre, two of which especially impressed him: Titian's *Pastoral Concert*, then believed to be by Giorgione, and Veronese's *Marriage at Cana*. He also mentioned visits to the churches of St Eustache ('Notre-Dame des Halles') and St Louis (Chapel of the Invalides). Thoughtfully he included a reassuring note about Hannah, saying how well she was standing up to the journey and that, despite its fatigues, she was 'better than ever', which augured well for the remainder of their travels.

They hoped, he said, to reach Florence in twenty-one days, but apparently it took twenty-four. They left Paris by carriage on 13 October; by the 25th they had reached the Simplon and on the 29th, Milan, where they visited the Cathedral and saw Leonardo's *Last Supper* in the Refectory of Santa Maria delle Grazie. On 6 November Hannah sent further news to her parents:

We are now at Florence the truly glorious city. We saw the gates Michael Angelo called the gates of heaven [by Lorenzo Ghiberti and Andrea Pisano, on the Baptistery] and they well deserve the name, they are covered with the most beautiful bas reliefs. We also saw the church Michael Angelo is buried in [Santa Croce] and another very wonderful church with frescoes by Andrea del Sarto [Santissima Annunziata].

Curiously – and betraying her home-bred outlook – she says the frescoes had 'all Mr Mulreadys kind of finish and beauty of colour'.* The architecture of Santissima Annunziata, too, impressed her considerably: 'The walls of this church are inlaid in the richest manner with precious stones, Jasper etc. – the outside is built of white marble inlaid with black, and although it has been built 360 years is glittering and bright; indeed the whole city looks as if it were built last year.'[11] They also visited the Uffizi Gallery, where among much else they saw works by Raphael and Albrecht Dürer, in Hannah's opinion 'beautiful beyond anything we have seen'. In Florence they met an (unnamed) English artist who advised them about getting cheap lodgings, and told them how for as little as 2½d. (about 1p.) he could sit in the pit at the opera, which kept him warm and was cheaper than lighting a fire in his lodgings. Other compatriots they met in Florence included the sculptor John Gibson and the landscape painter Andrew Wilson.[12]

The Palmers arrived in Rome on 14 November, and Hannah wrote home to say that on the morrow she would begin 'the joyful business of colouring the Michael Angelos in the Sistine'.[13] This refers to a commission from her father to colour and correct a set of his own lithographs of Michelangelo's frescoes in the Sistine Chapel, for which she was to receive 6s. 9d. (34p.) per lithograph. She was also to make small coloured copies of Raphael's frescoes in the Vatican Loggias. Believing that the Italian visit would be of short duration, and ignorant of the amount of work involved, Linnell thought these would be easy and pleasant tasks for his daughter as well as providing her with a little extra

* William Mulready (1786–1863), Irish genre painter; elected R.A. in 1817.

money. Such was far from the case: the commission was to lead to trouble and exhaustion for both Samuel and herself. In addition, there was acrimony for Samuel from his father-in-law that was later to lead to estrangement; for Hannah there was impaired health and permanently wrecked eyesight.

As yet all was joyful, and Hannah wrote that she felt 'more and more happiness in Mr Palmers company every day'; that she was 'very very happy, Mr Palmer is kinder to me than even I could have expected'; and (to her sister Lizzy) that 'I am so happy with my dear Palmer; we have not had one quarrel yet and I do not think there is any fear with so kind a creature.' To her mother she wrote,

> I must tell you now, that the propriety of our marriage is a thing I never doubt of for a moment; for if Mr Palmer had come abroad without me, you would have lost me altogether; as I am quite sure I should not have lived, and rejoice daily in being married to him, and being where I am; and consider myself highly favored in having this great opportunity for improving in every way ... I feel more and more grateful to Papa every day for allowing me to come ... [I] am fatter, and better than I have been in my life. Had Papa withheld his consent to our marriage I should by this time have been far otherwise.[14]

But within a week or two the shadow of parental friction fell over their happiness. At this stage it did not amount to much, but it presaged trouble. Linnell wrote to Hannah on 5 December 1837:

> Your letter from Rome, which we received on Saturday last came very seasonably for we were nearly exhausted with anxiety about you, Mamma was quite restless, Lizzy was out of spirits, and even I who am so hard hearted was beginning to dream. Your letter however has quite revived us all and we hope you will not long endure any anxiety on our account, for now we know where to write we shall send you a letter once a month at least and beg that you will not fail to do the same for us. If Mr Richmond writes once a month also we may hear from you every fortnight, by each writing in the alternate fortnight. I will gladly pay all expenses of letters when you return ... If you will attend to my wish about writing every alternate fortnight I think your anxiety about us at Bayswater – I will not say Home because your home must be felt to be wherever your husband is – may be kept in due bounds – of course we shall be delighted to see you again and though you shall never want a home while we have one ourselves, yet I wish you to feel more independent and like a vigorous young offset take good root and flourish. Write again as soon as you receive this and say as little or much as you please ... Why did not that Bartholomew Pig Palmer write? was he so tired going half way up the hill that he has not yet got over it. I fancy I can see him going up like one of the German Clock figures, three steps on and two back, his pockets weighing him down.[15]

Palmer did not mention these mild scoldings and hints about his possessiveness when he replied to Linnell, but treated his father-in-law to a description of the Roman scene, interspersed with comments about the poor lighting in the Louvre, the badly hung pictures in the Uffizi, and the comparative merits of oil and fresco. To Mrs Linnell he sent a mildly apologetic note:

> I am very sorry for the alarm you suffered on Anny's account – but henceforth we shall write punctually once a month – though the roads etc. may make our letters arrive sometimes a day or two later. I am afraid we cannot controul the time of Mr Richmonds writing so as to make intelligence reach you once a fortnight, but still we shall not be likely both to write at

the same time, and that there will be continually some news about us coming in, but if you express a wish in your next letter that we should write once a fortnight we will do so.[16]

For the present Palmer dismissed the danger signals from his mind; indeed he may not have been conscious of them, for Linnell had hitherto been one of his closest and most trusted friends, and his own insouciance may have prevented him from realizing that Linnell would view his eldest child's husband in a different light from his erstwhile protégé. Instead he gave his attention to more immediate matters, which included the social life of the colony of English artists in Rome. Among the people they met were the Welsh artist Penry Williams, who specialized in Italian subjects; Joseph Severn, the friend and biographer of John Keats, and a friend of George Richmond; the sculptor Richard James Wyatt; William Collins, R.A., and his wife, next-door neighbours of the Linnells at Bayswater; and the Swiss painter Thomas Dessoulavy, who had settled in Rome, and who, knowing about local customs, was a pillar of strength to the inexperienced Palmers. Some of the group met regularly at dusk for dinner in a *trattoria*, where the Palmers joined them and enjoyed the cheerful and intelligent conversation (and saved the expense of a fire in their lodgings). Palmer sent Linnell a plan of the table showing where everybody sat, including a Mr McDonald who took umbrage and left when he was teased about the dreary sound of Scottish bagpipes.[17]

ನಿಲ

Already, along the road from Florence to Rome, Palmer had begun to make sketches of castles, scenery and meteorological effects, which he hoped soon to be able to work into saleable drawings. From the moment he entered Italy there was a dramatic change in his work, greater than at any other point in his career. What had remained of his visionary outlook in the studies made in Devon, Somerset and Wales in the mid 1830s was almost completely put aside. There is some continuity of technique: the dappling, dotting and scribbling of the earlier work remains, and so does the loving attention to detail, especially in the shape, foliage and bark of trees and in the portrayal of clouds and skies. Otherwise – especially with respect to large works – the painting might be by a completely different artist from the painter of the Shoreham pastorals. They are topographical studies rather than interpretations. This was probably an involuntary change, like his earlier alteration of vision (see above, p. 65). Away from the surroundings and influences that had hitherto affected him, his receptive nature responded to the brilliance and intensity of Italian and other grand European art, which for the time being drove from his work its most precious element, its English pastoralism. This was, after all, a not uncommon experience among artists of simple inborn inspiration when faced with Italian grandeur.

In his initial attempts to portray the wide panoramas of Roman architecture Palmer seemed to be floundering. *Rome from the Borghese Gardens* (Victoria and Albert Museum; illustration 39) is an example. The trees, sky and distant landscape are all convincingly rendered, but in his drawing of the architecture Palmer not only has considerable difficulty in getting the perspective right, but many of the buildings, especially those in the foreground, have the character of models or children's toys, rather than architecture. If only he could have realized it, he was straining the inspiration of his intimate muse so far that it disappeared under these grandiose and not altogether successful tableaux and prospects. He seemed to realize this in later stages of the Italian tour, but for the present he was overwhelmed.

Drawings of less extensive scenes, like the watercolour of *The Forum, Rome* (collection of Sir Trenchard Cox; illustration 40), are much more successful. The more intimate prospect (though the accent is on architecture rather than on landscape) is closer in both conception and handling to views taken in Wales and Devon, such as *Caernarfon Castle* (illustration 35), and indeed to some subjects from the Shoreham years, such as *Sepham Barn* (illustration 24). Other successful works include some figure studies Palmer made not long after his

39 *Rome from the Borghese Gardens*, 1837. Watercolour and pencil, heightened with body colour, on paper; 397 × 564 mm (by courtesy of the Board of Trustees of the Victoria and Albert Museum)

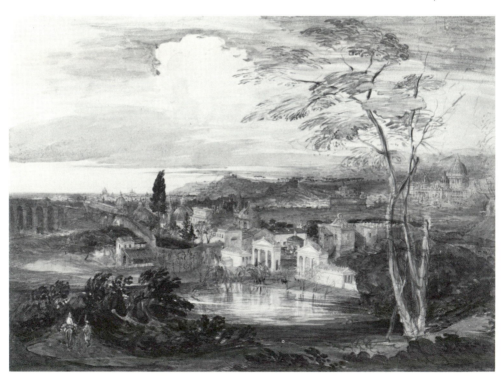

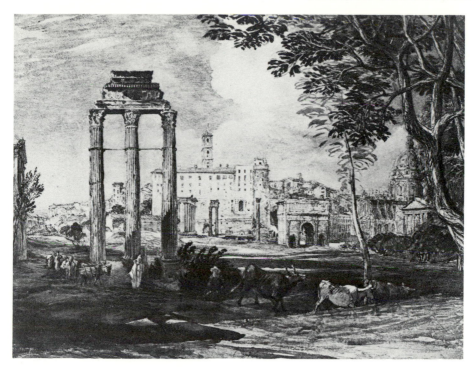

40 *The Forum, Rome*, 1837. Watercolour and body colour over pencil on paper; 311 × 416 mm (collection of Sir Trenchard Cox)

arrival in Rome, such as *Italian Pifferaro* (The Art Museum, Princeton University).

Many of Palmer's large Italian watercolours are painted with infinitely pains-taking care; for example *A View of Ancient Rome* and *A View of Modern Rome during the Carnival* (both City Museums and Art Gallery, Birmingham; illustrations 41 and 42). But, although they are much more confident achievements than *Rome from the Borghese Gardens*, the rendering of perspective still taxed his ingenuity. He found that he could not always take in a wide panorama from one viewpoint, as he explained to Linnell:

I have had a hard grapple with ancient Rome – for I was determined to get the whole of the grand ruins, which I believe has not yet been done. I got a little pencil sketch of it from a window, fixing the height of the horizon – then composed from it at home as I imagined it ought to come if all of it could be seen, and then worked the details from the tower of the capitol where I saw everything – but 150 feet beneath me. I also took great pains to arrange it so as to be a companion drawing to the Modern Rome – but then came the grapple – for having of course no foreground and the distance being full of subject I found the greatest difficulty in composing one that was simple enough and quite of a piece with the subject. I knew that if I did not do it at the time I should never have courage to tackle it. I tried many experiments – suffered intensely for two or three days, became yellow and so thin that I could pull out my waistcoat 3 inches from my body – but being determined to do it or die –

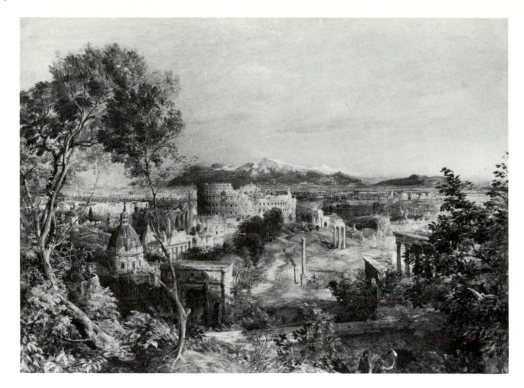

41 *A View of Ancient Rome*, 1838. Watercolour and body colour over pencil on paper; 411 × 578 mm (irregular) (City Museums and Art Gallery, Birmingham)

it came suddenly all right – and I hope to exhibit it with the other at Rome if we winter there. Where the subject has no foreground – I now, after the first sitting, before the effect of the whole is weakened by the investigation of the parts – make a little sketch at home of the picture it suggested and then go to work from nature.[18]

In the heady Shoreham days, as we have seen, he told Richmond that he would 'not infringe a penny on the money God has sent me, beyond the interest'.[19] Now, perhaps spurred on by Richmond's success, and in an attempt to prove to Linnell that he was worthy of his daughter and able to support her, he strove to paint work that would be more readily marketable than his intensely visionary creations. He had hoped that by selling on the spot, he could finance his Italian visit. In this he was disappointed, for he sold only one work during the whole two-year tour. Nevertheless, both he and Hannah each had a picture hung in the 1838 Rome Academy; but neither found a buyer. Palmer expressed growing discontent to Linnell:

I think I could sell, if I could once come in contact with the buyers; but *that* is the difficulty. All who know us by sight, know us as nobody, and as creatures whom nobody knows; and the free terms of intercourse here make such exclusion seem the more disgraceful. I have not keen introduced to a single person but Mr Baring . . . Here we stand like two little children,

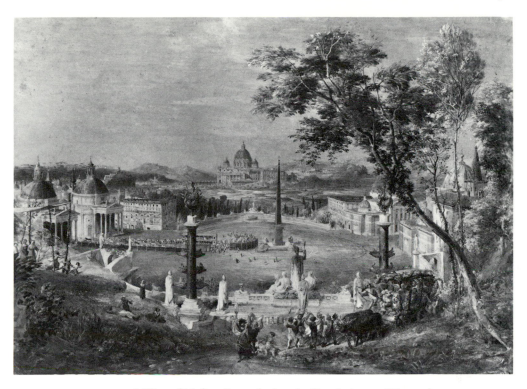

42 *A View of Modern Rome during the Carnival*, 1838. Watercolour and body colour over pencil on paper; 409 × 578 mm (irregular) (City Museums and Art Gallery, Birmingham)

snubbing their noses flat, at the glass of a pastrycook's window – longing not for the pastry and sweetmeats of life but for that supply of simple wants which we cheerfully trust that Providence will give us, but for the attainment of which we must use all means. Mr Richmond has had the whole visiting circle of Rome open to him and if he had been a landscape painter would have found the advantage of it.[20]

The single introduction he mentions, to John Baring (son of the banker Sir Thomas Baring and brother of Charles Baring, Bishop of Durham), did bring Palmer a commission – to make a copy (now in a private collection) of his watercolour *Modern Rome during the Carnival*. Baring paid Palmer 40 guineas (£42) for this, but Linnell was not much impressed:

I congratulate you sincerely in having sold a drawing for about half as much I suppose as it is worth. However as that is much the best way of giving away Drawings, when for two you get the price of one, you may for the present be content, and if you get the fellow commission [for a drawing of Ancient Rome] you may say two works are sold as happy preludes to the swelling out.[21]

Later there was a small commission for Hannah to make a copy of Raphael's *Dispute of the Sacrament* in the Vatican; in the event it was painted by Palmer, as Hannah was too poorly to do it. There was, alas, no second commission for

Samuel, and another artist received the commission for the drawing of Ancient Rome. But the couple received some encouragement from Linnell, and relations between Bayswater and Rome for the present continued on a cordial footing, Linnell writing:

I am quite delighted you are both well. I think that is the best part of your news for I am sure your enjoyment of nature and art must be great ... do not therefore hurry yourselves with your works but consider your journey altogether as some great work of art which, having many parts, requires rest occasionally to prevent your leaving off entirely before it is finished; and though I do not wish you to stay an hour beyond what is necessary, yet now that you are where you are, take time enough and consider well the end of your exertion like a mental painter who, though he finishes the parts as he goes, yet keeps the vision of the whole vividly before him.[22]

Characteristically, Palmer poured out more of his true feelings to Richmond, at the start of a four-month visit the Palmers made to Naples and its surroundings:

My mind has for the last year been soured and choaked with disgust at the thought that of all the things whatsoever with which I have formerly taken great pains – because this is of all times the age in which pains-taking meets with least reward – I wish I could get back again all the long letters which at sundry times I have written to sundry persons – that I might burn them in a heap? – No – that I might elaborate them into the most polished mellifluence, and publish them ... and then in double disgust leave the arts and literature altogether, and then in triple spite take lodgings in the city and work a little money about on the stock exchange and turn a penny by the little daily fluctuations – and so rot.[23]

Linnell, in his somewhat blunt way, was trying to help the Palmers through his commissions. At the beginning of February 1838 he wrote to Hannah about the colouring of his Sistine Chapel lithographs: 'Please do not hurry over the set you are doing for me as I assure you I will most honestly remunerate you for whatever time you spend upon them and if Mr Palmer will give you any assistance I shall be glad to have it at any price he will charge me.'[24] But this question of cost led to considerable troubles, caused by Palmer's vacillation. Despite having fixed the price of the colouring of each Michelangelo print at 6s. 9d., Linnell rather uncharacteristically seems to have left Palmer some latitude in arriving at a final cost, for in June 1838 he asked that it should now be fixed, together with that of the Loggia drawings, 'that I may know what else I can afford'. To Hannah he wrote:

What I said about the price of your drawings was to Palmer as that is his affair now. I know that under the circumstances of separation from us here you would not think anything too much to do. I would not for a moment think of taking advantage of your better feelings, but Palmer understands business and life and will see that I am right in wishing to have that part settled now.[25]

But this embarrassed Palmer, who sent a prolix reply, calling the matter 'unpleasant and difficult'.[26] Linnell, more direct and outspoken, became irritated; and if only Palmer had realized that what his father-in-law wanted was a direct reply to a direct question, at least one possible cause of future tension would

have been avoided. His motives were honest, sensitive and kindly; he was properly grateful to Linnell; Linnell was easily irritated and impervious to shades of feeling – and Palmer signally failed to understand how to deal with him. He wrote one meandering sentence after another, setting out the cost of travelling, lodging and eating in Italy, he detailed his plans for economic living on their return; and in the end he arrived at a total of £17 11s. [£17.55] for fifty-two Loggia drawings. This was cheap enough; even so, he could not resist adding a placatory word, in case he had overdone it: 'As you perhaps have in your mind something like the price you expected to give; if it be considerably less than the price mentioned by me, I shall be quite contented with it.'[27]

Not only was Palmer confused by having to price his father-in-law's commissions, he was also bogged down by them, as he had to give continual help to Hannah. Largely because of this a third of his time in Italy – 242 out of 626 days – was spent in Rome. The great city, beautiful though it was, afforded no setting for Palmer's pastoral ideals, and the amount of time spent there prevented him from covering ground not already hackneyed by thousands of previous artists. Yet in other ways Linnell's commissions had a positive effect upon the couple, keeping Hannah cheerful and eager when she was working on them. She was indeed in the highest spirits; out of reach of her mother's amateur doctoring, her health was now excellent. At home she had been dizzy every time she rode in a coach; now she had become a seasoned traveller, for the time being enjoying every minute of the tour.

ഇരുള

Some of Palmer's lack of progress in Rome must be attributable to his eccentric appearance. He was completely unconscious of the effect that his odd clothing, made by his dear Mary Ward, had on those he met; many people found him distinctly risible and were little disposed to take either him or his work seriously. His oddity appeared the greater when he was seen in the company of the elegant and socially accomplished Richmond:

There could hardly have been a greater contrast (save in low stature) than the suave courtly but otherwise dictatorial young man of eight and twenty, and the shabby but handsome little fellow who carried half his possessions, literary and artistic, in his enormous pockets, together with a store of nuts which he cracked with the strong teeth which he kept all his life.[28]

The size of those pockets may be imagined from the fact that when he arrived in Italy, he remembered that he had forgotten to return a book he had borrowed from Henry Crabb Robinson; he wrote to Linnell asking him to look it out and return it for him, only to discover it in a corner of a pocket in the coat he was wearing.[29] Here in the midst of Roman fashion he went about in a costume in which, during one of his Welsh tours, he had been mistaken for a pedlar.[30] Nor was this the end of his oddities about clothing. He felt the cold during the Roman winter and writes of wearing, indoors, in addition to two flannel waistcoats, a

flannel gown, two frock-coats, two pairs of stockings and a waterproof cloak. Most curious of all, Hannah said that Samuel was wearing one of her flannel petticoats. Nothing is said of how she coped with the cold. Palmer told the Linnells of a method he had evolved for repairing stockings, so that there was no need to darn them:

it is to cut out of the leg of an old stocking a piece large enough completely to sole the new and to tack it firmly but neatly on . . . when the false sole began to wear there would be plenty of stuff in the old legs to make others and the time taken in tacking on a nice new sole would not be a tenth of what is now dragged out in cobling raggedness.[31]

෨෧

Though the lack of commissions does not seem seriously to have distressed him, Palmer was disturbed by news from home of his property and of his relatives – little of it reassuring. As early as January 1838, Linnell had sent news of Grove Street and of Samuel Palmer Senior, and in this case it was welcome, for there had been a reconciliation with Nathaniel:

. . . your second floor in Grove Street is let to an elderly gentleman named Palmer 'I don't know if you ever heard of such a mon'; he has lately been engaged in teaching young Ideas how to shoot by the week upon very liberal terms [he had opened a school in Speldhurst Street, London] – he now retires upon a pension from his Brother with whom he was at variance but is now reconciled.[32]

Palmer was doubly happy to read a note from Mrs Linnell explaining that the reconciliation had been brought about partly by the good offices of Linnell, who had written to Palmer's father. A chance meeting between the two Palmers completed the *rapprochement*.

But the ground floor at Grove Street remained vacant. According to Linnell the want of a copper was hindering the letting of it, and the house needed painting. Palmer, hopeful as always, asked Linnell to tell his father to have a copper installed, which 'need not cost more than 15 or 20 shillings [75p. or £1]', and asked Linnell to have the painting done by his own tradesmen, and pay for it out of monies – interest and rents – being held on his behalf by his cousin John Giles.[33] In the event Palmer's 'sapient Papa and Brother', as Linnell called them, spent £2 on the copper. As he told Palmer, 'The odds I fear are against you at present but with some of your clever manoeuvering we may be able to keep things tolerable.'[34] After this experience, Palmer was well advised to accept Linnell's suggestion that all incoming monies should be paid into Linnell's hands during Palmer's absence and that William Palmer should render quarterly accounts to him as his agent.[35]

Later Palmer wrote to his brother expressing disappointment that part of his house remained empty. This would, he said, 'make a sad difference' to him, and he exhorted William always to display a notice stating that accommodation was available.[36] But it was well for his peace of mind that he was unaware of the true

position in Grove Street, for the first floor of the house next door had been hired by two prostitutes who, as William Palmer told Linnell, attracted 'the notice of passers by with language and actions which [could not] be mistaken'.[37]

Notwithstanding his job at the British Museum, William Palmer continued his eccentric career, and Samuel could not have been pleased when Linnell told him:

... before I leave the subject of your affairs, Mr P., I must tell you one bit of news which I am sure you cd. not guess at – Mr W^m· Palmer has a little girl about 3 or 4 years old, and thereby hangs a long tale. I don't mean to the child for all we know at present is that it has a head, or it may be presumed so, for Mrs. L. discovered the fact of her existence by seeing the bonnett hanging in the passage, and, with similar sagacity to the Doctor who declared his patient had eaten a horse because he saw a bridle and saddle under the bed, she concluded Mrs Palmer had a child in the house belonging to the said bonnet, and so it turned out, though it had then just turned in to Bed. Well the story is the child is a foundling; it was taken to the workhouse and it was there seen by Mr and Mrs Wm. P. and adopted as their own, brought to your house and is now lying ill with the small pox – this is multum in parvo is it not?[38]

Despite the reconciliation with Nathaniel, Samuel was not spared anxiety for his father who, not long afterwards, in June 1838, set out on another of his madcap schemes, becoming pastor of a small religious community of nine members at Aylesbury. In connexion with this Palmer Senior had a pamphlet printed, *On the Formation of a New Church*, price 1d. (Appendix 2). It was inscribed with his old address, 10 Broad Street, Bloomsbury, and was widely distributed beyond his Aylesbury congregation. It is notable chiefly for naïvety of thought and expression. Having decided to become the shepherd of the Aylesbury flock, Samuel Palmer Senior decided also to sell his home, a task he entrusted to William. On hearing of this, Samuel told Linnell that he did not want his father's furniture to be sold, but would take it himself at a broker's valuation; especially he wanted the sofa and the terrestrial and celestial globes, and the kitchen utensils; he asked Linnell to make the offer.[39]

He hoped that his father would return to Grove Street, and indeed by the following May Mrs Linnell was able to tell him that Palmer Senior had 'resigned his charge and is expected in town shortly, what his next step will be we know not'.[40]

Another source of trouble was Robert Foreman, a carrier, one of Palmer's Shoreham tenants, who had not paid his rent. Palmer refers to this in a passage which begins with some optimistic 'ifs'. 'If Mr Baring gives me another forty guinea commission for Ancient Rome and my house lets well and Foreman pays – [I] hope to make a stand against calamity.'[41] Poor Palmer! Foreman did pay in time, but Samuel sold no more works in Italy, nor did his house let satisfactorily; it was disappointment almost all the way.

The money they had taken with them to Italy ran short after some months and Samuel and Hannah found that they were living more frugally than other artists, who seemed prosperous by comparison. Linnell was alarmed. 'Pray tell me what you mean Samuel,' he wrote, 'by the gloomy picture you Draw of your

funds, tell me how much money you have spent ... have you begun upon the money borrowed [from Richmond] and if so how much is gone.'[42] In reply Palmer set out the position:

As the travelling to Rome swamped my own money ... we were obliged to begin upon the other on our arrival there, and having been abroad ten months, have, remaining in hand two of Mr Richmonds 20 pounds notes, 29 pounds of Mr Baring's money, Annys ten pound note, and the two pounds Mr Richmond paid her [it is not known what for], and 6 pound 18 shillings English money – total 87 pounds 18 shillings [£87.90].[43]

In those days this was a considerable sum, but about six months later, in January 1839, Palmer found it necessary to ask Linnell to send him 'two of Herries's £20 notes'[44] (private banknotes for travellers, like modern travellers' cheques); John Giles, he said, would pay for them out of money he was holding for Palmer. In acknowledging the notes, Palmer commented that 'Money will run out, tho' we indulge in no sort of extravagance ... we have not stinted ourselves in getting sufficient fuel (for the weather has been very cold) nor in wholesome food.'[45]

In the meantime adversity continued to stalk Palmer's affairs at home. On 23 December 1838, Linnell reported that

Mr Palmer Senr drank Tea and supped with us the other Evening, sends his love to you both, is quite well, never saw him better. William is well also – Grove St is still as it was, no cash – taxes swallow all. They are the parlez vous as eats us up. J. Giles is not pleased with proceedings there ... perhaps he may say something about what he thinks. However before you return distinct directions must be given as to what is to be done.[46]

All this detracted from Palmer's enjoyment of Italy. He had set out with starry-eyed idealism, expecting to find 'the fruition of the old dream of primitive ploughing with the lovely cattle ... The vintage, remote and lofty little cities, each with its own ancient associations; and a shy joyous unspoilt peasantry guiltless of mercenary sittings.'[47] Nevertheless, he must have realized a little of this dream, for he did embody it in his work – but much later in his life, in his etchings, in his Milton watercolours, and in his Virgil illustrations.

ಬಿಇ

Throughout the Italian correspondence between the Palmers and the Linnells there is a continual note of advice both sought and unsought: Palmer and Hannah seek counsel from Linnell on almost every problem, Palmer proffers exhortation to Linnell's children, and the Palmers write to Mrs Linnell and her father, Thomas Palmer, saying how much they are looking forward to seeing them again and attending to their improving conversation. Even for those days of the dominant and domineering paterfamilias and of adulation of the wisdom of age, the effect is one of dreary obsequiousness. The only person who comes well out of this aspect of the correspondence is the patriarchal Linnell. Undoubtedly he is sharp, sarcastic and at times downright unkind, but he alone

appears to have strength of mind and character: he asks nobody's opinion, although he is free with his own admonitions. By contrast, Palmer seems incapable of making a single decision without consulting his father-in-law. It is as if he looked to Linnell as a strong father-figure to compensate for his weak real father. He was thirty-three at the time, but was capable of writing to Linnell like a lost child: 'I am very much obliged by your careful and excellent advice which I will attend to, and endeavour to follow: and I hope from time to time you will communicate any suggestions that arise in your mind – as I am out of the way of instruction and left to my own resources.' Again, 'I wish we could have [a letter from you] every three weeks – for I find your remarks and suggestions about art very refreshing and can not get them by word of mouth.'[48]

There is a world of difference between the servile tone of Palmer's letters to Linnell and the more confident, jaunty tone of his letters to Richmond, Calvert and other friends. At the same time it is noticeable that the elevated note so characteristic of his early letters has disappeared. But he was still free with advice to others. Even during and immediately after the Shoreham years, he was offering gratuitous counsel to the Richmonds, not only on the up-bringing of their children (see above, p. 77), but also on what they should do on their first visit abroad. In his Italian letters he was even more free with exhortations to the Linnell children: the boys were told not to grunt, little Polly how to open her mouth and recite: '... take some beautiful little poem, like Cowper's rose, and read a verse of it VERY SLOWLY that you may be sure you can pronounce every word perfectly: then read it again, minding your semicolons, commas, and every little pause. Take breath at the beginning of a sentence that you may not want breath between the stops.'[49] And so on.

Never did Palmer offer advice to Linnell, who was the great oracle and dispenser of wisdom. Notwithstanding present apparent cordiality, a marked change had taken place in the relationship of the two men. Before the marriage, Linnell's attitude to Palmer was respectful, both to the man himself and to his work. That is evident not only from Linnell's early letters to Palmer and from his sharp rebuke to the brother-in-law who criticized him, but also from the fact that he considered it worth while to encourage him as a painter and to accept him as a son-in-law.

Religious matters, particularly his dislike of the Church, were seldom far from the surface of Linnell's letters. There had always been religious differences between him and Palmer, but the absence of Samuel and Hannah in Italy, perhaps because he feared the effect of the close proximity of the Catholic Church, blew them up to heroic proportions. In a letter to Mrs Linnell, written on 22 December 1838, Palmer spoke of 'a continued reciprocation of intellectual pleasure with Anny and the establishment ere long of a happy home with only the wooden bridge [spanning the Paddington Canal] between us and for a communication with Mr Linnell yourself and the whole family more intimate and cordial than ever'.[50] Linnell chose to take this mention of

the wooden bridge as a veiled reference to their religious differences, which he made explicit in a letter written on 4 January 1838:

Upon these subjects we can freely communicate, but being a heretic you know my limits are narrow or I should have written more, but one cannot assume the right or feel the propriety of using that familiarity which friendship dictates, where the parties feel themselves to be hereditary legislations upon the most important subjects and members of a celestial aristocracy ... It is all very nice what you say about home at Grove Street and your visits to Bayswater with only the wooden Bridge to get over etc. – but it appears to me there is another Bridge which you have assisted in building and keeping in repair for some years and which is rather a barricade than a means of communication. I mean that Asses Bridge of Superstition built with nothing but the rubbish of human tradition – obscene, false and fraudulent ... but what is worst of this Bridge is that it is built across the common foot path where there was an excellent Road made by divine Authority.[51]

To this, Palmer replied with more dignity than caution: 'I will only say most sincerely and affectionately we are for peace: "To hold the truth and peace" be our motto for they are divine sisters who if *equally* honored need never quarrel with, or supersede each other.'[52]

In the parts of his letters addressed to Elizabeth Linnell, Palmer several times put in a word for the Church of England. He looked forward to the treat in store for him when he could go again to St Paul's Cathedral with Hannah and Elizabeth and

gaze upwards once more into the sublime obscurity of its dome, and to enter into its courts ... full of thanksgiving and praise for the mercies which have attended us through our pilgrimage ... Anny and I intend to go to St Pauls if possible every Sunday afternoon ... I never hear its music, which I prefer to all other of every kind, but I seem to advance in art.[53]

Such comments underline the fact that while Palmer deferred to Linnell on matters of money, social behaviour and even art, he was positively and provocatively independent in religious matters. Apart from this, weakness undermined all his relationships. He even tended to give in to Richmond in opposition to Hannah's wishes, as when Julia Richmond and Hannah saw some shop-soiled Valenciennes offered for sale at a bargain price. The two girls excitedly proposed that they should buy it, but Richmond (Palmer's junior by four years) vetoed the purchase, and Palmer meekly acquiesced.[54]

In mitigation it could be said that Palmer must have been encouraged in his manner to Linnell by his father-in-law's demand for complete openness: a demand that found a ready and incautious response from Palmer's always ingenuous and confiding nature. Not long after the Palmers arrived in Italy, Linnell had expressed concern at the paucity of mail. He now complained that more than six weeks had elapsed since he had received a letter, and it was essential to hear more often if Mrs Linnell's health was not to suffer. After mentioning that his wife and son Tommy had been ill, he continued: 'I tell you all that you may know I keep no secrets which would, I am sure, make you more anxious if you perceived a concealment of facts. So pray do the same with us. We cannot expect everything to be favorable any more than the weather to be always fair.'[55]

There had in fact been several signs that Hannah's health was under strain. In the spring of 1838, Palmer had to buy 'a bottle of Macassar for her hair which has been coming off lately in spite of the lamp oil with which in our disconsolateness she was fain to anoint it'.[56] At about the same time Hannah told her parents, apropos her father's commissions, that she 'was getting rather poorly, with the constant mental application to which I was unused, as at home I always had change of employment. It is very fatiguing to copy from the lofty ceilings where the things are mostly in the dark.'[57]

However, the condition of her hair improved, and by July she was able to tell her mother that, after changing to a large-toothed comb and using a new oil, she now had 'a thick curly and cleaner head of hair than I ever had in my life'.[58] What she did not tell her parents was that she had recently been seriously ill. She and Samuel had decided that, as the illness was of short duration, her life had not been in danger, and she had completely recovered, they would not alarm the Linnells by mentioning it. They also besought Mr and Mrs William Collins, who were returning to London, on no account to tell them; however, this attempt at independence failed – Mrs Collins was a compulsive chatterer and soon let the cat out of the bag. She later denied having mentioned Hannah's illness, but it is a difficult to imagine how the Linnells could have heard of it otherwise.

Linnell wrote in strong, though still kindly, terms to Palmer, pointing out that in refraining to mention the illness, even after danger had passed, he had shaken the Linnells' faith in the sincerity of his and Hannah's accounts of their well-being, even of their happiness. He continued with a quotation from Milton on scriptural authority, and added some remarks on his religious differences with Palmer. He also offered to help the couple with the cost of lodgings, food, clothes and wine, and to pay for Italian lessons for Hannah.[59] Palmer thanked Linnell for this offer of help, and explained why the news of Hannah's illness had been withheld, but at the same time probed the still open wound of religious controversy, instead of allowing it to heal quietly. And in this context he abandons his servility:

Every one knows more exactly what his own opinions really are – than he can by the last nicety of expression or explanation convey to another – though he may perhaps not be so well able to trace the consequences to which they lead as a person of superior sagacity. I know distinctly the shape and boundaries of some few theological doctrines which I have ventured to investigate and have been led solemnly, sincerely and steadfastly to embrace – *and think that those opinions do not in the least interfere with a cordial honest and affectionate intercourse with your family*. The opinions which you *suppose* me to hold, probably might – and I believe that from your superior acuteness you are better able than myself to trace opinions into their practical development – but I do not think you know what my opinions really are – but reason (truly perhaps) from false data ... Now I will avail myself of your invitation to be plain in criticising *you*. I think you are somewhat suspicious – and this tends a little to shut the heart and chill the affections ... I do not deserve to be distrusted, and was never an insincere friend – but the surest way to impair sincerity is to suspect it.

But even after this, Palmer reverts to his other tone: 'We have again read through your letter . . . and are more and more pleased with it. No one could read the beautiful observations on sincerity without being wiser and better for it.'[60]

If the tone of Palmer's communications to Linnell on non-religious matters was subservient, the letters he wrote to Mrs Linnell were curious indeed, almost as if they were lovers. He was obviously trying to ease her mind of anxiety, but they are strangely ardent.

I wish you could spend a day with us here, perched up in our nest at the head of a mountain valley . . . I have often longed to be in the country with you, for if I might praise myself so much, I should say we had a kindred taste for the rustic poetical, and hope some day we shall together thread the garden'd labyrinths of Kent, and on the thymy downs, by twilight, listen to the distant shepherd's pipe or village bells. However, I suppose my life if spared will be a busy one refreshed by few shades of contemplative seclusion, but hope that some of those few may be spent in your society. As I suppose this is the crisis of my professional life I am never easy but when at work; but if I once get a niche among the very good and very sorry painters who are eminent in London I will . . . work intensely hard for a fortnight which is intensely delightful and then for a couple of days be as quiet as a mouse not touching or thinking about my pencil: and those days I should like to spend with intellectual ladies. An intellectual and poetic lady is a very rare animal, much more rare than a blue-stocking; and when found I know how to prize her. Anny and I hope for much of your society on our little holidays; but you must get over your dread of boats, and drownings, and moving accidents by flood and field; for a day of recreation or a day of rest is turned into a tantalization worse than lying down on pins and needles if it be poisoned by one grain of care. I think anxiety is all a delusion.[61]

〄

Palmer's spirit had always alternated between exaltation and despair, but in Italy, despite the interest and beauty he found there, his pessimistic moods seemed to occur more often: probably this arose from frustration at his inability to find a spiritually satisfying realization of his art. Although during the first flush of marriage he wanted to show Hannah's parents that he was a good husband to their eldest and favourite daughter, he seemed unable to resist sending them dispirited messages. He interpreted the demand for full information very liberally, and they were alarmed to read such soul-baring passages as this:

It is . . . very difficult to do ones duty – very difficult to do anything well, from the blacking of shoes upwards. This one begins to find at thirty, when as [Edward] Young says, in some stanzas which every one should learn by heart, 'Man suspects himself a fool.'[62] My own life has been embittered these two months, by a searching of heart which comes on every evening, to find out whether I really am or am not a fool in grain. Where is the golden autumn of life? We are first green, and then gray; and then nothing in this world, and as far removed from the next generation as the busy people of Pompeii.[63]

The Linnells, though they tried to help, found his pessimism difficult to comprehend. Mrs Linnell entreated him to keep up his courage and not to be too anxious, as his health depended on it. She was sure, she wrote, that he did everything to make Anny happy and that his talent would ensure success; they

should not deny themselves comforts but must let the Linnells know if they wanted anything. Linnell reminded them that he bore responsibility for their success, so they must tell him how their funds stood, as Mrs Linnell thought they must be badly off and starving. And to Palmer he added, 'I laugh at such nonsense, knowing you of old – you starve; you would eat the geese of the Capitol first.'[64]

But Palmer's depression may have had a more fundamental cause than artistic frustration and shortage of money. Here and there in the Italian correspondence are what appear to be hints that Samuel and Hannah were not really living together as husband and wife. In one letter Palmer writes, 'Anny has a total wash, twice every day – she tells me.'[65] In another he says that he returned from a sketching expedition and 'found Anny safe in her bed under our gauze curtain like a bird in a net.'[66] Considering that it was the almost invariable custom of the day for a married couple to share the same bed, the question occurs whether their marriage was consummated before their return to England.

Hannah became pregnant soon after their return, and she suffered a series of miscarriages in addition to two further successful pregnancies. Methods of contraception were crude in those days, and Palmer is unlikely to have approved of using them; so, if the couple had had sexual intercourse during the Italian tour, Hannah would almost certainly have become pregnant. There is no evidence that she did, and it is hardly likely that nothing would have been said about it – at least to the Richmonds – if she had. Much more probably they abstained while they were abroad, so as to avoid the complications and expense that a pregnancy would have entailed. Such inconveniences were brought home to them by the birth of Mary Richmond in Rome late in 1837 – not only by the confinement and birth, which brought Julia Richmond's health near to breakdown, but by the difficulties of weaning and the hundreds of other troubles incidental to caring for a babe in arms so far from home. It is possible too, taking into account Palmer's personality and religious tendencies, that he harboured a distaste of sex except for the purpose of procreation. He once wrote to Richmond of children being 'kept from the nurture and admonition of the Lord, and . . . brought into the world to gratify a momentary pleasure that they may perish body and soul forever.'[67]

In some other ways the Palmers were far ahead of contemporary manners and customs. Not only did Hannah wash all over twice a day; Palmer did too. 'We are both inveterate body-washers,' he told Richmond in 1838, 'and I now think of the whole human race as spiritually divided into the converted and unconverted; and bodily, into washers and stinkers.'[68] And the followng year he wrote, again to Richmond:

I suppose daily body washers are peculiarly tempting to vermin – not greasing or obstructing their delicate little probosces – but in spite of the fleas I still bless the day when Mr. Tatham taught me to 'wash my person' daily instead of weekly – and think the bath – next to food and fuel – the most necessary as well as the most luxurious of the bodily disciplines. Clean linen only whites the sepulchre – clean flesh is a temple for clean and

comely thoughts – and it is from the bath or wash tub that cleanliness should radiate through a house – as amenity and benevolence of manners and conduct should proceed from real sincerity and simplicity of heart.[69]

He was also still preoccupied with diet and digestion, as this passage from a letter to Richmond shows:

Now a word about macaroni – do you know that eating macaroni pudding ... quite upset my cast iron digestive organs and made me ill for a week and I think your illness at Rome quite accounted for by your eating that vile rubbish which I think was only invented to spoil the appetite for good wholesome meat – I believe it to be most constipating to the bowels and very hard of digestion – I have been several times going to write to you about it but a press of work has hindered me – but pray think of it and instead of physicking with seidlitz powders – try the blessed bowel opening fruits such as grapes, figs etc. – with which this favored country abounds. Italy is a blessed country for mind and body and if we made full use of it we should go back as much opened in our bowels as in our minds.[70]

On a less sympathetic note, his early interest in corporal punishment seems to have developed into a preoccupation with flagellation as a stimulus. In 1839 he wrote to Linnell of 'a most beaming-faced young priest – who seemed to have humbled the symmetry of an Antinous with that genuine mortification and unallegorical self-flagellation which I most sincerely and seriously approve and intend to practice upon my own shapeless trunk, as soon as I get on a little and my spirits are able to bear it!'[71] If that passage is read in conjunction with Palmer's obsequiousness to Linnell, it becomes doubly significant. Not only does he, lacking confidence, look with submission to the father-figure for advice, but he now writes, with a probably subconscious desire to propitiate the stronger character, of literally lashing himself. Of Linnell's reaction to all of this there is no trace, but it may be assumed that he would have considered it unmanly at least, and that the expression of such opinions helped to colour his attitude to his son-in-law.

৩৩

In Italy Palmer often grumbled that his friends did not write to him. This was especially true of Edward Calvert, whose silence deeply disappointed him. As the time approached for the Palmers' return, Linnell reported that he had seen much of the Calverts. 'They desire their kindest love to you both – he has *strong* desires of writing to you, but the fits do not last long enough to produce a letter and now he consoles himself that it is too late as you will be moving homewards.'[72] This prompted Palmer to send a restrained protest to his old friend.

I do not want to come back to England – having it to say that in a two years absence you would not write me one line ... I am afraid something *must* have happened in all this long time ... I think I have hit it! – it just occurs to me that you have made some new friendships and acquaintances since I left and have forgotten the old ones.[73]

Calvert is supposed to have sent Palmer a letter later in 1839, but there is now no trace of it; perhaps it was never posted. Or perhaps he took Linnell's advice: 'I told Mr Calvert, who has written his letter to you but cannot make up his mind to send it, that he had better direct it Post Restante Paddington, that you may be sure of having it when you return.'[74]

Samuel and Hannah were cheered by news that Hannah's younger brother James might be joining them. Palmer wrote to James, telling him that he had 'jumped for joy' on hearing the suggestion and looked forward to the amount of work the three of them could get through. But then came the inevitable exhortation, much of it good advice, but also containing the usual bromides:

Union is strength and a three-fold cord is not easily broken – only mind when you have no Papa and Mamma to take care of you – to be careful about catching cold etc. The journey and residence here are *quite safe* with care – but care you must take – for an hours carelessness may cut you out of a month's work. Learn as much colloquial Italian as you can before you come, for you will find little leisure here – there will be such a crowd of splendid things pressing upon you on every side – don't *grunt* at the caution I have given you and I have no doubt that your travels will be full of the richest enjoyment and the most rapid improvement.[75]

In the event, James stayed at home; probably Mrs Linnell felt that she could not bear to think of another of her offspring amidst the imagined dangers of Italy.

ॐ

The Palmers travelled to Naples early in June 1838, having crossed the Pontine Marshes with loaded pistols in the coach, as the brigands feared by Mrs Linnell were indeed active at the time.[76] Their travelling companions included a Mrs Claxton, and Hannah told Julia Richmond (who, with her husband, had gone to Florence) that 'We had a very hot journey also an additional inside passenger, a grey hound Mrs C— had brought; you may judge the number of fleas I caught each day.'[77] But the fleas were worse in Naples, as Palmer told his brother William:

We breakfasted at a first-rate Caffei at Naples but always got a days supply of fleas in a few minutes – and though you get used to them and by a daily slaughter reduce the standing number to about 40 or 50 – they sometimes when unusually active or where they all begin to take their sanguinary meal together – make you very cross.[78]

The fleas were bad, the mosquitoes were worse:

I got to sleep for about an hour and then was gradually waked by what was at first only a gentle irritation but increased to a torment. I got up every midnight and walked about – rubbing myself all over with laudanum vinegar and soap by turns but all would not do – great lumps were raised by the poison of these little creatures ... All this time ... even the covering of the gauze [mosquito net] was almost unbearable and if one or two got shut in by the curtains – farewell sleep![79]

Among pleasanter circumstances, in Naples as in Rome they met several interesting people, including Edward Lear and Thomas Uwins, R.A.; they came across Lear again late in the tour, at Civitella, where Hannah remarked on his good flute playing.[80] In Naples, too, they paid an exciting visit to an English man-of-war, H.M.S. *Pembroke*, which was anchored in the bay. On this outing they were accompanied by Henry Wentworth Acland, a friend of Richmond, who later became Regius Professor of Medicine at Oxford. Samuel was much impressed by the order and cleanliness on the ship, and when the band played *Rule Britannia* while he and Hannah were descending to the lower deck, he felt his 'heart throb with anxious fondness for our poor old country'.[81]

Conditions in Naples were in some ways more difficult than in Rome. Both food and lodgings were more expensive, and the streets were not so safe: Palmer had been cautioned against allowing Hannah to draw out of doors. This, she told her father, was discouraging, and made her feel that she was wasting a grand opportunity. And then follows the usual plea for advice, prompted by her husband:

If you would in your next letter give me some advice as to the best way of spending my time during our excursions to Sorrento Salerno etc I should be very glad. I should not thus have troubled you my dear Papa, only Mr Palmer wished me to open my mind and tell you all my troubles and these are indeed all.[82]

The artless Palmer was encouraging his wife to look to the father-figure for advice and guidance, and not, as he should have done, to himself. It is almost as if he wanted Linnell to shoulder every burden, however small, on his behalf, even the guidance of his attractive young wife. It became steadily more inevitable that when they returned home, Hannah's father's influence carried more weight with her than her husband's.

From Naples the Palmers went on to Pompeii, where they spent a short period during July 1838, before going to Corpo di Cava, about 29 miles away; from here they had a distant view of a minor eruption of Vesuvius. At one stage they had trouble with a dishonest driver, who, because of what he alleged was a bad road, refused to carry them the full agreed distance. Palmer reported:

I inquired of some gentlemen if the way were good for a carriage and finding that it was, and seeing that no gentle means would make the driver move, and not liking to have our luggage turned out at the mercy of a rabble in the dusk of evening, I digged my eyes into the driver's and roared in his face that if he did not go on immediately, I would not give him one grain. This had the desired effect ... It was all a trick, for the road was excellent and not very steep.[83]

Which shows that when not dealing with Linnell, Palmer was capable of behaving decisively and even aggressively.

တၵ

The Palmers returned to Naples during September and arrived back in Rome in October. Later in the same month they visited Pozzuoli, and from mid Novem-

ber to late December they were at Tivoli. To judge by his output at this time, Palmer's work was little affected by his troubles. Indeed, with one or two exceptions there was considerable improvement on what he had done soon after his arrival in Italy. The Villa d'Este at Tivoli provided him with some of his most successful Italian subjects. As soon as he saw it he was filled with enthusiasm. 'But for the inexhaustible Villa D'Este we should long ago have seen you', he told Richmond. 'Distances swarm everywhere but here are the finest trees and foregrounds combined with them. I have been finishing a drawing of the grand pines and cypresses with Tivoli and the Campagna behind.'[84] If Palmer experienced any renewal of his earlier inspiration during his Italian visit, it was here; many years later he wrote, 'One might draw the cypresses in the Villa D'Este for a year and not exhaust them.'[85] Claude Lorrain, one of the great influences in his art, was very much in his mind at this time: 'I saw over the campagna this evening a first rate Claude Sunset – the golden horizon melting upwards into a delicate azure a little lighter than itself – turning my back on it I saw a superbly rich temple [probably the Temple of Vesta] from which rills a light cascade – glittering like living gold.'[86] Towards the end of his life, when he was painting his great Milton watercolours, that scene was to come back to him (see illustration 94).

He portrayed the towering cypresses in one of his finest Italian drawings, *The Cypresses at the Villa d'Este, Tivoli* (Yale Center for British Art), a study he probably used for one of his most Claude-like watercolours, *View from the Villa d'Este, Tivoli* (Ashmolean Museum; illustration 43), in which he appears to have overcome completely the difficulties with perspective he had experienced earlier in the tour (admittedly the townscape is far simpler than in *Modern Rome* and *Ancient Rome*). The cypresses appear again in a watercolour of the reverse view, looking towards the Villa (Victoria and Albert Museum); this work is carried nearer to completion than the Ashmolean watercolour, although in both there are areas of scribbling and of lightly applied washes, which serve as in his earlier works to throw up the focal area, in this case the cypresses. Dappling and dotting are in evidence in both works, especially in the portrayal of textures in the surrounding trees and undergrowths, and the hazy distances are successfully indicated by skilfully applied washes.

The cypresses are depicted yet again in *The Villa d'Este from the Cypress Avenue* (Pierpont Morgan Library; illustration 44). In this, only one tree is completed, the others and the view of the Villa being drawn in black chalk, largely in outline, but in parts shaded. Some wash has been added and a few highlights on the building indicated with white body colour. Some of Palmer's happiest work is realized in this way; he has stopped at just the right point of disclosure, when further development would have increased the detail but decreased the viewer's aesthetic satisfaction.

In a lightly executed, more general *View of Tivoli* (Philadelphia Museum of Art; illustration 45) both dappling and washes are again much in evidence. The sky is well observed, with bars of cirrus, and sunbeams playing across them.

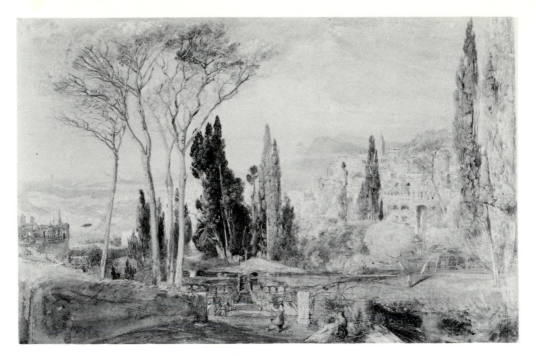

43 *View from the Villa d'Este, Tivoli*, 1839. Watercolour and body
colour over pencil with pen and ink and a little gum on paper;
335 × 504 mm (Ashmolean Museum, Oxford)

Perspective is again firmly controlled, although the portrayal of the cascades at
the right of the composition is unconvincing; it seems likely that they were
painted from memory rather than from direct observation, for they lack the
immediacy of the waterfalls Palmer painted in North Wales in 1835 and 1836.
By comparison with this *View of Tivoli*, the watercolour of *The Cascades at Tivoli*
(Toledo Museum of Art; illustration 46), is a confused composition which
seems to show Palmer at his least confident. Certain details are well done, for
instance the trees on either side of the foreground, whose foliage recalls studies
made at Shoreham; but the whole of the central area is muddled and the water-
falls are execrably painted.

Palmer also made a few watercolours of Pompeii, such as *The Street of Tombs*
(Victoria and Albert Museum) and *Ruins of the Amphitheatre* (Fine Art Society,
London; illustration 47), but they are a trifle stiff, and not in the same class as
the Villa d'Este studies. The presence of staffage (accessory figures), particu-
larly in *Ruins of the Amphitheatre*, imparts a slightly narrative element, probably
indicating an attempt to emulate similar works by Turner, such as *Childe
Harold's Pilgrimage – Italy*, which Palmer may have seen when it was exhibited
at the Royal Academy in 1832.

A similar narrative element is also present in the excellent large watercolour

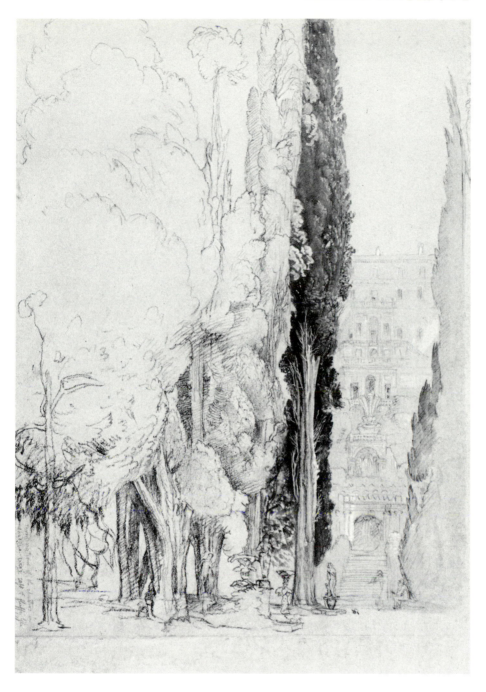

44 *The Villa d'Este from the Cypress Avenue*, 1838. Black chalk and watercolour on paper; 457 × 319 mm (Pierpont Morgan Library, New York)

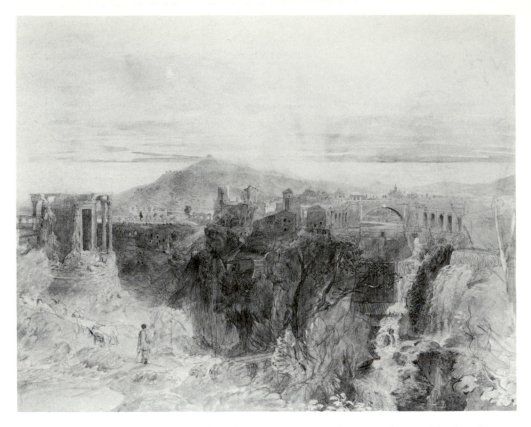

45 *View of Tivoli*, 1838 or 1839. Pencil, watercolour and body colour on paper; 327 × 416 mm (Philadelphia Museum of Art, Philadelphia, Pennsylvania)

Rome and the Vatican from the Western Hills – Pilgrims resting on the Last Stage of their Journey (Fitzwilliam Museum; illustration 48; preparatory drawing in the Yale Center for British Art). In this, Palmer again firmly controls the perspective and achieves a most accomplished result, using a group of cypresses at the right to bring a vertical accent into what would otherwise have been a comparatively monotonous horizontal composition. Dappling and dotting are used brilliantly to portray various textures, and the light drawing of the cityscape successfully conveys the haze of distance. The sentiment recalls work by Nicolas Poussin, which Palmer knew from visits to Dulwich Gallery (for example *Santa Rita of Cascia*) and of which he would have been reminded recently during his visit to the Louvre on the way to Italy.

ಜಜ

Not unnaturally, as month followed month, the Linnells wondered when their daughter and son-in-law were coming home. Already in July 1838, while they

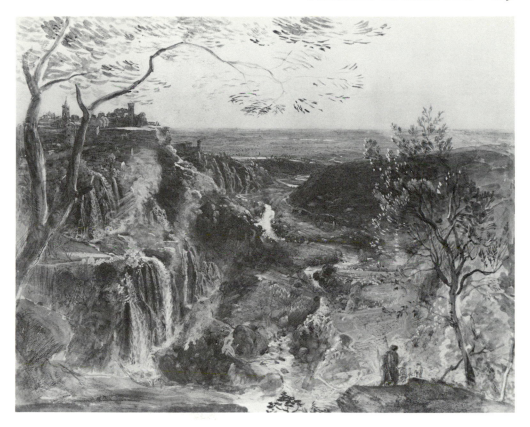

46 *The Cascades at Tivoli*, 1838. Watercolour, body colour, pencil and black crayon on paper; 330 × 419 mm (Toledo Museum of Art, Toledo, Ohio)

were still in Naples, Palmer had written to say that 'in about a month all our steps will be homewards'. There were certain studies he wished to make on the way back, and 'As the travelling expenses in such a journey are very high – and board and lodging not very much more than at home, it would be very bad policy not to secure all the grandest points which lie in our way – but those secured, the sooner home the better I shall like it.'[87] Both he and Hannah had written continually about the joys of home and homecoming. But then Hannah hinted that they might be staying in Italy another summer;[88] and Linnell responded with a fierce attack on the supposed motives of his son-in-law. His letter, dated 6 January 1839, arrived in Rome on 22 January:

I begin to fear, that you anticipate spending another christmas in Rome before you return, notwithstanding all your profession of attachment to the Goose of old England, and that you have inveighed Hannah into the conspiracy as she very cooly talks of spending the summer in Florence now, and the next letter I suppose will be written to break the Ice respecting another winter in Rome, and if so I fear there is some ice to [be] broken near your heart Mr. P., for I assure you that it will [be] inflicting a great cruelty on Mrs. L. if she does

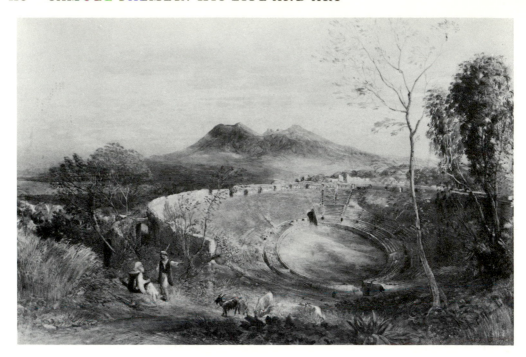

47 *Ruins of the Amphitheatre, Pompeii*, 1838. Watercolour and body colour on paper; 317 × 489 mm (courtesy of the Fine Art Society, London)

not see Hannah this ensuing spring ... I say not this to distress or perplex you but if you propose staying another year in Italy now, I shall never be able to place confidence in you again, but must believe that it was intended from the first start ... All Hannah's assurances in writing will go for nothing with me if she says she can stay another winter in Rome before returning [to] England. I shall conclude it is the effect of undue influence because it is against nature.[89]

Mrs Linnell and Elizabeth joined in the protest, though in milder tones, and Palmer replied with immediate reassurances, saying that his

proud Old Adam winced a little at the extraordinary epithets which you are pleased to apply to our proceedings ... and the attempt to swallow all these and a plate of roast pork and timballo de gnocchi at the same time, nearly choaked me. – Nor did they sit very easy on my stomach till after a cup of coffee this evening – when I began to think how foolish it always is to reply hastily to any charges or insinuations – or till one is in a temper to do it with the meekness of a female chicken dove. In accents peaceful as the cooings of that gentle animal I will therefore endeavour to proceed.[90]

For the moment Palmer's soft answer apparently appeased Linnell, who replied:

I was not aware untill I read your last letter received yesterday how blessed it is to be fat ... You have proved this to me by the sweet temper in which you received and discussed the asperities of my irritable fibre ... I therefore calculate that out of the abundance of your

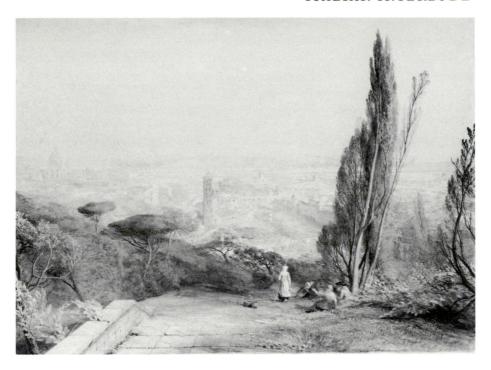

48 *Rome and the Vatican from the Western Hills – Pilgrims resting on the Last Stage of their Journey*, 1838 or later. Watercolour, body colour and ink on paper, lightly squared in pencil; 523 × 716 mm (Fitzwilliam Museum, Cambridge)

meekness and suet that you will make all possible allowance for me as you know how many things I have to attend to which distracts the mind and thus the temper.[91]

But on one point Linnell was adamant – his commissions must be completed. If they were not, he said, he would not forgive Palmer.

Linnell was becoming obsessed with the Loggia copies and Sistine Chapel prints. Time and time again he harried the Palmers with questions about their progress. In one of his replies Palmer promised that *'No Effort of Mine shall be wanting* to their completion ... but I fear there is little hope of drawing being allowed before Lent.' Advice on how to proceed and how to overcome difficulties came in plenty from Linnell. Complaints came too; yet he retained a fatherly concern for Hannah, and assured her, 'I would not risk you one days illness to get the Sistine Chapel finished.'[92]

Hannah worked very hard to get through this task and Samuel went out of his way to help her. In addition to her father's commissions, she made copies of other works, including Titian's *Sacred and Profane Love* in the Villa Borghese. 'My copy is more than a foot long; and I find my chief delight in getting these things is anticipating the pleasure of showing them to you. Mr Palmer thinks you will jump for joy at this.' She said they were writing to Florence for

permission to copy a Titian in that city, and added that she was now having Italian lessons from a captain in the Swiss guards.[93]

Palmer wrote to Linnell that they were both working on the Sistine Chapel engravings, and added flatteringly: 'Of all engravings ancient or modern – yours convey beyond comparison the best idea of the *general* character and effect – and when merely washed with the appropriate colours are more enriched than I could have imagined.' In fact Linnell's lithographs (based on early line engravings, for he never visited Italy) are far from brilliant, and poorly detailed. Sets coloured by Hannah, who had the advantage of working from the originals, are infinitely improved, and many discrepancies were corrected. Even Palmer, after praising the lithographs extravagantly, talked of modifying their chiaroscuro, and said that he found many of the figures in the original different in drawing and action. He warned Linnell not to expect too much of them:

To get them exactly right would take as long as to make a new drawing – which Anny actually did of one of them this morning – to go through the whole in either way would occupy some months – so I believe the utmost that can be done is to add upon the prints the *general* form – *general* colour and *general* effect.[94]

He also mentioned technical difficulties in copying the Raphaels, which Linnell now told them he wanted so that he could base a set of engravings on them.

In his next letter,[95] while telling Linnell of the immense trouble he had been taking over the prints, he reported how Linnell's prints differed from the originals, but quickly added a propitiatory passage: 'In the above information about the Sistine you will not mistake any criticism on the prints as derogatory from you.' And he thought it sagacious to add that he had himself 'rejected the most tempting weather for my own studies and have shut myself up in that cold chapel devoting all my energies to the work – and I have done it with cheerfulness and delight'.

Hannah was again weakened by overworking in the trying Roman climate; she became so tired from walking to and from the Vatican that she was compelled to make the journey by coach. To keep up her strength, Palmer gave her a glass of port at midday, and spoke of dosing her with gentian. Linnell suggested that in order to forward his commission, Palmer should get help from some other artist. So with the assistance of the German engraver Lewis Grüner, whom he had met in Rome, Palmer found an Italian who would be willing to execute the Loggia drawings for 4 scudi (about 85p.) each. But Linnell considered this too high, given that the results might be unsatisfactory. He would not go above 2 scudi. He also bestowed some gratuitous sarcasm on the Palmers: 'I am exceedingly obliged by your exertions upon the M. Angelo's and perhaps ought to be contented, especially as my dear Hannah's improvement has made her time too valuable now to bestow it upon such copies as the Loggia without a far greater remuneration than I had anticipated.' But Palmer refused to have anything to do with abating the Italian's price, which was, he said, 'the very lowest he would take'.[96]

Despite his sarcasm, Linnell appears for the present to have been satisfied and even said that, although the family would be delighted to see Hannah again, 'we shall not be particular to a few weeks if necessary for her comfort and that you may have time to complete what you intend'.[97]

ಬಂ

Palmer wrote enthusiastically of the works of art he saw, such as Raphael's *Madonna of Foligno*, the tapestries in the Vatican, and a Titian (with figures by Giovanni Bellini) owned by Baron Vincenzo Cammucini, *The Feast of the Gods*. Palmer wanted Hannah to copy the Titian in watercolour, but previous applications had been refused. Finally Joseph Severn promised to try his powers of persuasion and succeeded in obtaining permission, Cammucini commenting that 'he could not refuse a small watercolour by an English Lady'.[98] Palmer's reaction to this piece of news must have startled the staid Linnells: 'When Mrs Richmond suddenly told me the news it had such an effect upon me that I screamed – fell flat upon the floor and kicked like a lady in hysterics – then seizing a tambarine performed a Bacchic dance with agility which would have astonished you!'[99] This was Palmer's fun, but it was hardly the way to command the esteem of his in-laws, particularly the literal-minded Mrs Linnell. At the same time he was at pains to tell Linnell that, although Hannah would spend a week or ten days copying Cammucini's picture, he would ensure that Linnell's commissions were not neglected; he would 'go to the Sistine or remain in Rome if necessary the same number of days longer than we should otherwise stay, to work with her at the Vatican'. He gave an account of what the Italian visit and incidental travelling expenses had cost up to that time – between £172 and £175 in sixteen months. He thought it had all been worth while. Then, as if a little afraid of the effect the account of his excitement would produce, he says:

You must not suppose because I sometimes tumble down in extacies that I am sporting in a fool's paradise. While Providence spares my health which is better than ever it was and otherwise blesses us – I *will* go into extacies sometimes and will not be checked by any body ... but I am a little staggered by seeing as I have just seen – a young artist who cannot draw and who says that the Last Judgment at the Sistine Chapel is a mass of rubbish, getting two 50 guinea commissions from the Russian Ambassador and an introduction to the Duke of Sutherland – while my drawings in the Exhibition have been as yet unproductive.

It was at about this time that the Rev Edward Thomas Daniell, an East Anglian collector, traveller and amateur artist, commissioned Hannah to make a watercolour copy of Raphael's *Dispute of the Sacrament* (private collection, England). Linnell sent the news:

If you can accomplish it ... Mr Daniell says he will give you twenty five pounds for a watercolour Drawing by Hannah alias Mrs P. of the dispute of the sacrament a fresco by Raphael [Vatican, Stanza della Segnatura]; it appears possible to me that by tracing or

reducing Volpato's [Giovanni Volpato, 1733–1803] print a tasteful and expressive, not elaborate Drawing might be made in ten days by My dear Hannah and for such a work (Mr D. does not expect more) 25£ would pay you.[100]

The commission came providentially, for as usual, the Palmers were short of money. But the task of painting it actually fell to Palmer, for Hannah was taken ill – too ill even to complete the Loggias. As Palmer put it, 'the Vatican air to use her own words "is a poison to her" but as according to the common fate of things we have just learned the art of copying frescos as we are going to leave them'.[101] By 10 May Hannah was able to report that 'Mr D[aniell's] fresco has finished famously, is very like the original, as well in colour and effect as also in the look of the material.'[102] Palmer's copy is indeed a very handsome piece of work, a masterpiece of its kind inasmuch as it reduces a large fresco and its handling to the size and technique of a miniature. It is not known if it was painted on the base of a tracing, as Linnell suggested, but however it was realized, it is impressive and shows a highly accomplished aspect of Palmer's mastery of technique.

Concerning the Loggia copies, Palmer told Linnell that Hannah had been to work on them 'from a sick bed to do them for your sake with the zeal of a martyr – yet she has repeatedly told me that it would kill her to complete them'.[103] She was plagued with nightmares brought on by the difficulties of her tasks. One night she dreamed that every object she drew – even buildings – must contain nose, mouth and eyes; another night she dreamed that in her copy of the Titian, somebody had sponged out trees which she had copied with great pains, and awoke crying. It was as if she were on the edge of a bad neurosis. As for the Sistine prints, Palmer reminded Linnell that there were forty of them, and that the colouring of each took several hours. He apologized in advance for the results, and made little attempt to disguise his sense that Linnell's expectations were unreasonable:

Do not expect refinements of articulation or expression where the size is so small and the originals are so different – the utmost I can do is to make them relatively to the originals – like little vigorous sketches from nature done before breakfast. I am dispirited to think how much will be expected from us here – how easy it is at a distance to fancy cartoons from the Sistine – studies recollections of effect and color etc – and how difficult it is to get thro' what *must* be done.[104]

<p style="text-align:center">∽∾</p>

Samuel did his best to rally Hannah, but she thought that if she did not leave Rome immediately, her health would be affected beyond recovery. 'I have', Palmer told Linnell, 'been fagging by myself in the Sistine chapel with great pains and study to enable you to bring out colored sets which can be honestly put forth as general likenesses of the frescos and have taken Anny over – (always in a coach) four mornings to help the work through.'[105] Hannah herself de-

scribed the effect which the air of Rome had on her, air that caused half the garrison of 1,600 soldiers at the Castel S. Angelo to spend part of the summer in hospital. She took eggs and wine for tonic, and rode wherever she could – all to little purpose, for as soon as she got to the Vatican she felt exhausted, and standing for even a minute made her feel as if she had got out of bed for the first time after a severe illness.[106]

Before he learnt the full extent of the deterioration of Hannah's health, Linnell advised her to take things more easily. He was convinced that what he called the 'hard fag at the C[ammucini] Titian' had spoiled her appetite more than the atmosphere of Rome. She should remember that too much hard work would knock anybody up, and he ended 'let Palmer fag, it does him good'.[107]

Even Albin Martin was recruited to help with Linnell's commissions. This friend and pupil of Linnell had travelled out from England to join the Palmers at the end of February 1839. He now added his voice to Palmer's, and told Linnell quite frankly that, given the present atmosphere of Rome, and with Hannah's health in its present condition, he was asking the impossible. 'The only way', he said, 'to give you an idea of the colour of the Frescos will be to colour the prints that they have of them, which I think will be almost as well as making drawings from them which was the way in which this undertaking was first began.'[108] Only when he heard Martin's account of the extent of their difficulties was Linnell at last convinced; he wrote at once, telling Hannah that he was filled with remorse at causing her to stay in Rome longer than necessary, thanking Samuel for his work on the Sistine prints, and urging them to leave Rome as soon as possible.[109]

But on 23 May 1839 Hannah was able to report that the Loggia copies were finished. On the whole she was pleased with them. Samuel had helped by preparing them in chiaroscuro for her to colour, or by revising and retouching them where necessary. She had been so ill at one stage, she said, and so had Martin, that they feared they would have to leave Rome without completing the work but, the sirocco giving way to the tramontana, they had recovered in time.[110] The letter also brought news that the travellers were leaving Rome and visiting Cevara near Subiaco, Terni and Florence on the way home. Palmer mentioned that living had been more costly during what he called 'the Loggia struggle', as they had been compelled to eat all their meals at the *trattoria* instead of preparing them themselves, and Hannah's weakness had compelled them to use coaches. It therefore seemed likely that their latest £20 would not last, and Palmer asked Linnell to send two more of the Herries £20 notes.

Palmer did not seem very happy at the prospect of returning:

When we once get clear of Rome all we do in nature will be a flying fight – trying however to get all we can in the few hasty strides which remain between us and – Billingsgate! If I cared much what became of me I should be sick at heart with the thought of coming back to filthy smoke and black chimney pots – but I am afraid I am too old for Art – however I will try what I can do – and think I know my weak points: – two or three gaps which must be filled up – if I ever get on my legs and become a painter – after all this struggle – I may perhaps

gasp out the little life that is left me pretty quietly – and find your society and conversation, which I value more than ever – an over compensation for the stench of gas and oppression and weight of air in the spirit depressing – hope-crushing – energy cheating neighbourhood of London.[111]

Notwithstanding the mildness of his recent letter, Linnell wrote much more excitedly just over a fortnight later. He was seriously alarmed by what he read of the effect of the Roman climate on his daughter, and turned his wrath on Palmer.

When I urged completion [of the Loggia copies] I knew nothing of its being such a dangerous operation, which it appears only to have been at the late period it was thought of and notwithstanding all you attest to the contrary, I am perswaded you never were favorable to the commission. I do not impute the same feeling to Hannah – but it appears to me she has been worn by hard application until the Air of Rome was too much for her.[112]

In addition, and to Palmer this was the unkindest cut, Linnell addressed a note to Albin Martin, saying that he held him 'responsible in some measure for my dear Hannah's welfare while you are with the happy pair'. At this even the dutiful Hannah rushed to Samuel's defence:

Mr Palmer feels a good deal hurt with your letter to him and I must say I do not think he deserves it as he has taken the greatest care of me indeed dear Papa the most affectionate and solicitous care, and from the first, instead of being against the commission of the Loggias, zealously stood up for their commencement and completion and at Rome when Mr Martin with me thought it impracticable . . . urged trying our utmost although losing his spring for the Country. Giving that cheerfully up he went for your sake with us working and taking pains with what he did both at the Sistine Chapel and the Loggia and with the greatest pleasure. Nor would it have been mentioned again if you had not thought to the contrary. Dear Papa and Mamma do excuse anything I may have written that you do not approve of . . . but as long as I live I will never desert Mr Palmer when in difficulty and distress and mean even to a parent to respectfully and affectionately say when I cannot agree with them, which I never can with what you say to Mr Palmer.[113]

Samuel, with justifiable exasperation, countersigned a little note written by Martin, 'Samuel Liar'. But loth to leave it at that, he wrote a long letter to Linnell, showing more spirit than hitherto. What stung him most was a suggestion from Linnell that, on their return, while Palmer was getting the house ready and his affairs in order, Hannah 'must' stay with her parents for a time. To this Palmer reacted with a vigour that he would have done well to adopt much earlier:

I think I perceive in this and other passages that you expect us on our return to live under a sort of parental control. I do not like the word '*must*'. You know very well that there is no one to whom I have so often resorted for advice as yourself. But neither Anny nor myself can receive suggestions in any other 'shape'. Her filial affection and veneration will I hope always remain – her *obedience* is transferred to me and in whatever circumstances I may be placed. I hope never to be obliged to barter or sell that kind of manly liberty which is consistent with humility or meekness . . . As to the Sistine and the Loggia I shall say no more of what I have felt or done because you declare your disbelief in all I say. To mention my own

leanings at all in the matter would come with an ill grace from me, and there is now a double reason for abstaining if it is to be marked with the stigma of falsehood.

Palmer even went out of his way to remonstrate with Mrs Linnell. The talk of 'intellectual ladies' and all the rest of such flattery is cast aside as Palmer addresses her trenchantly for the first time:

Let me *conjure* you to correct that unjustifiable and distrustful anxiety which at once embitters and falsifies your views of the future. *You* WRITE calmly, Mr Linnell excitedly; but I know very well that Mr Linnell's distress half arises from daily witnessing *your* unhappiness. *Why* should you be unhappy? Your daughter is well and unhurt, and has spent nearly two years in acquiring intellectual and moral power, and experience which will by the blessing of Divine Providence, lead her safely through the mazes of life. If you could have the advantage of a few such months of travel and adventure you would see the unreasonableness of all such hideous surmisings. Anny never thinks of the morrow, but endeavours to provide for it by doing the duties of to-day. How odd it is that her cheerfulness – uniform cheerfulness has supported and cheered *me* in all times of depression and yet that this happy being has been unconsciously the cause of such hideous apprehensions. I hope you do not directly or indirectly attack Mr Linnell for letting her go for all your unfavourable prophesyings have been falsified and Mr Linnell has so many things to irritate and exhaust him that a continual annoyance at home will embitter if not shorten his life. You must excuse this plainness for I write as a sincere friend to him and to you, and though you carefully avoid expressing it in your letters out of kindness to Anny, yet I know what goes on at Bayswater as well as if I were there. Your family has been blessed beyond almost any other with health and prosperity – and you are almost beyond anyone else anxious and apprehensive. Excuse this for it is *true* and meant kindly.[114]

But Samuel and Hannah soon dropped their strong attitude. In one attack they had exhausted their reserves, and in their very next letter Hannah expressed uneasiness at what she had written, and begged for advice 'for improvement of every kind and for future success in art'. Palmer hastened to reassure them about Hannah's health, which had been completely restored after leaving Rome. He gave a cooler account of his part in Linnell's commissions, and excused his previous anger on the grounds that he had written his 'last letter in haste at Subiaco – where I was tortured with fleas – roasted by day and boiled by night'. He then went on to talk of their future plans, remarking how close Hannah would be to Bayswater. He concluded,

I have left off snuff-taking – and am become a really steady hard working man – I take great sleeps after any exhausting labour so that I am very strong and well and hope shortly to pay you a visit – and will bring Anny if you will swear not to take her away from her rightful owner and your affectionate Son in law. S.P.[115]

But Palmer's strong stand had came too late to save his relationship with Linnell. He had made too many propitiatory gestures, had sought his advice, shown his dependence upon him and flattered him unceasingly. He had even strained his hand in completing Linnell's commissions, so that for a time he was unable to write, and Hannah had to be his amanuensis. By his conciliatory attitude he had exposed himself to Linnell's contempt; from now on the father-in-law seemed to consider him as little more than a puppet, an irresolute charac-

ter to whom his daughter must for ever be tied. Palmer had not yet ascended to the summit of his spiritual Calvary, but he was on its approaches, and he had placed himself there.

<p style="text-align:center">ಬಿಂದಿ</p>

When the party reached Subiaco, Martin was quite ill; by the time they reached Civitella in July 1839, he had lost weight alarmingly, and was suffering from continual biliousness, inability to eat, contraction of the colon, and stoppage of the bowels. He was in considerable pain, which was mitigated by the application of five leeches; and a few weeks later he took to his bed again, 'with violent pain in the head which gave way only to sixteen leeches and very lowering treatment'.[116] His health did not mend completely until he got back to England. Palmer was also unwell: his appetite disappeared and he was overcome by lethargy, brought on, there can be little doubt, by overwork. In addition he was disillusioned about Italy, and now felt that, once back in England, he would not easily be persuaded to leave it again. But he rightly guessed that in time such feelings would disappear, and only pleasant memories would remain.

They hurriedly cleared out of Civitella when they discovered that what Palmer described as a 'putrid fever' was raging nearby. Hannah saw two corpses being carried to burial, 'one yellow – the other green and spotted',[117] and when the servant at their inn sickened they left immediately. Palmer's account of this, and of scorpions and of venomous snakes, must have caused his apprehensive mother-in-law great alarm; nor would she have been amused by Palmer's story of a nocturnal incident at Subiaco. Hannah had woke up during the night with a swelling on the spine and thought it was a cancer; Palmer rushed downstairs to get water and salt to bathe it and in the morning spoke to Martin (who was himself now much better) about seeking medical advice, when, as he said, 'Mr M. was so shockingly unpoetical as to suggest that it was ... only a bug-bite!!!!! and so it turned out to be.'[118]

Linnell's reply to Palmer's outspoken letter of 23 June arrived while the Palmers and Martin were staying at Papignia, near Terni, in the middle of August. Its modified though still bantering tone would have provided proof to a less docile nature than Palmer's that Linnell was more likely to defer to strength than to weakness.

I do not feel disposed to say much in reply [to your letter] ... as I consider such touchiness of disposition calculated to stop all free intercourse and bring all society to legal formality. It is killing a fly with a sledge-hammer to take up my friendly expression and doubt as to your being favorable at any time to the execution of the Loggias – all I expressed was that it appeared to me it was against the grain, that you felt it a task, though you wished it done out of kindness to me. This was not accusing you of direct falsehood but only of a little self-deception in perswading yourself that you were perfectly willing to do what you had rather not, one of the commonest things in the world and which people accuse each other of every day without offence. As to our anxiety about our dear Hannah you can be no

judge; you must wait until you are in such circumstances before you can sympathize suf-
ficiently and I cannot retract anything I have said upon that point, feeling that by your own
account I was justified in supposing that she was suffering from too hard application. This
also was not accusing you of any thing more than indulging her perhaps in her desire to do
more than she ought or was able, and which you ought to prevent as a conservative gover-
nor; but I see you are radical in what touches you nearly as all men are. You like manly liberty
for yourself – but support systems which refuse manly liberty to others ... And so you are
offended with the ... last invitation to Hannah to stay with us at Bayswater ... It was not
the first time I had mentioned Hannah's coming to us, and at other times if not the last, I
said with your permission ... Now do my dear Palmer therefore once more consider the
nature of some of your political Idols and do not talk about manly liberty untill your
perceptions are more in unison with the divine Milton on such subjects as affect the liberty
of the whole world.[119]

In reply to this, Palmer protested that he had not been touchy, that he was not
intolerant, that he had concealed nothing, that he was the creature of no
political party, and that 'the very base on which you have reared all this fabric of
suspicion – is the lavish unreserve – I may *now* say *imprudence* – with which I
have at all times opened my mind and heart! – However open they are – and
open they shall be; unless you oblige me to shut them up.'[120] But in his reply to
Mrs Linnell, his tone is once more propitiatory. He calls her 'My Dear Mrs
Linnell or My dearest Mamma', tactlessly enters on a eulogy of anticipation at
the prospect of taking her to a service in St Paul's Cathedral, and continues, 'I
scarcely know one person with whom I so much wish to live in perfect amity as
yourself – and I should be the last to suffer even religious differences to freeze
up the heart or dry the flow – the overflow of its cordial streams – in the spirit of
honest unreservedness but of the sincerest peace and love.'[121]

Palmer wrote again on 25 August,[122] broaching the possibility of remaining
in Italy until early 1840, so that he and Hannah could arrange more studies in
Florence before coming home; he made the fatal mistake of seeking Linnell's
opinion of this plan. He also returned to Linnell's wish that Hannah should
stay with her parents on her return, while Palmer got 4 Grove Street ready for
her. The best arrangement, he thought, would be to have the house prepared
before their return so that she could help him to get work ready for the spring
exhibition of the Royal Academy. He would rather sell out his few investments
'than start – separated from Anny'. Hannah added a final maladroit twist in a
passage which she ought to have realized would alarm her parents, especially
her mother. 'Under Mr Martin's tuition', she wrote, 'I have learned to fire off
pistols with real gun powder and a ball in it and we take aim at the olive trees';
though she felt it expedient to add that this was 'always after working hours'.

To disturb Palmer's equanimity further, Linnell wrote of troubles at Grove
Street. Mrs Baker, a carpenter's wife, had taken William's foster-daughter for a
walk, and for some unexplained reason, instead of taking her home again,
delivered her to the workhouse. The representative of this institution, a Mr
Carter, even more inexplicably brought a charge of barbarous treatment against
'Mr Palmer of 4 Grove Street Lisson Grove'. Linnell was present at the hearing,

held at the workhouse by its board of guardians, which dismissed the charge. Linnell, in jocular mood, suggested that Palmer ought to change his name 'to Pallegrino or Pellerin, for you stand a chance of being greeted at the Grove when you return by "There he goes" instead [of] see the conquering hero comes', and advised him to have a brass plate put above the knocker with '*Samuel* Palmer' prominently inscribed on it.[123]

Commenting on this episode, Palmer made some disparaging remarks about Baptists and about the education of the working classes, none of which was likely to please his in-laws. After saying that if it had happened while he was in London he would have set off with his knapsack to Shoreham, he continued:

Of one of the parties accused and acquitted I know little but from all I do know believe *both* are most unlikely persons to do anything of the sort. Mrs B[aker] the immerser of linen was herself 'immersed and saved' about 1½ years ago by the 'Rev^d J Burns ... All I know of the dislikes and loves of this amiable 'mechanics' institute' is as follows. The accused parties lodged with a schoolmaster who was also by my Father's persuasion 'immersed and saved' about the same time with the washerwoman. The unbounded brotherly love expressed by the schoolmaster for his lodgers was on their having turned from wine to 'winegar' altho' he received I believe a just consideration for their sudden departure to keep my house – then – the birch was brandished – or as the party might more likely express it 'the sword of the Lord and of Gideon.' and as those who approach a 'baptistry' have often to my knowledge to fish all their lives after in troubled waters – perhaps the above was the 'beginning of strife'.[124]

But a few weeks later Palmer was again obsequious, and with considerable fatuity both referred to their differences and suggested sweeping them under the carpet – a way of dealing with them that was hardly likely to suit a forthright man like Linnell:

I look forward with earnest longings to more of your instructions in art which I have found to be beyond price and which I now hope to avail myself of to better purpose than formerly. We had better make a rule not to talk about subjects on which we cannot agree and then I believe as there are so many on which we agree cordially that I shall every day become more truly and warmly yours affectionately Saml Palmer.[125]

There was some warning of what he might soon expect to hear from his father-in-law in a short and sarcastic letter from Mrs Linnell in reply to his remarks on Baptists and artisans, his earlier raptures on St Paul's and his hope that she might accompany him there:

Many thanks for your kind expressions of regard and interest for my welfare. I shall be glad to accompany you to hear beautiful music and to see beautiful buildings, but these are not likely to alter those views I have so long had of the Church of Christ. The more I search the Scriptures the more I am persuaded that every true believer in Christ is a member of His Church, and I think it right to unite with that assembly where I find the most primitive discipline and worship. I expect to find more of the poor than the rich disciples of our Lord as it is said 'not many noble are called,' but though they may be but carpenters or washerwomen – if they are really followers of that which is good I ought to rejoice to be united with them. I have no more paper.[126]

Linnell's comments to Hannah on Palmer's appeal for advice about the possibility of extending their Italian sojourn burst like a thunderclap:

I have no doubt but that Mr Palmer thinks (if you do not) that we are very selfish people in wishing so much to see you again after so short an absence as two years, and knowing the unavoidable bias of our wishes I cannot understand how he can ask my impartial advice upon the subject of your longer stay in Italy, unless it be in the hope of being able to extract some argument therefrom for a further long sojurn in that land where he said he first saw real sunshine and has at last felt it ... I think my dear child that you ... believe that Mr Palmer contemplates returning this year. He may not be exactly aware of it himself, he may fancy that he is debating this question when he is only hunting for an excuse to stay ... As to your paying us a visit at Bayswater I entirely relinquish the thought, so Mr P. need not fear my interference with any of his domestic arrangements ... Pray remember me to Mr Martin who is so industrious in teaching the young Huzzies how to shoot. I rather suspect he sides with your naughty good man in enticing you to learn to kill time ... you said last winter how you should like to spend the summer in Florence and because I anticipated the addition of the winter also, which has now been expressed by Mr P., how unreasonably suspicious he thought me when I said he was only breaking the ice for another season in Italy. So it appeared to me and so it appears to me now, for he mentions a season for returning which I cannot believe he can intend, and which he knows will furnish abundance of too plausible reasons for stay[ing] and even going southward again. These are all mean stale tricks, which are so successfully practiced chiefly by the despotic party and by all parties I am sorry to say when opportunity offers.[127]

To Palmer Linnell expressed himself with even greater vigour, and took up Samuel's recent ill-advised remarks about Baptists and artisans, which had clearly touched a raw nerve:

Were you to take as much pains to confound things good and bad together in Art as you do in Religious and political affairs you would be more likely to turn out a Raff than a Raffaele. Do the 'great principles' which as a Christian you feel obliged to hold, compel you to sneer at the Mechanicks because they have an institution for their improvement without assistance from the government and are you compelled by the same werry large principles to mock the Education of the poor when afforded by government gratis ... The man is no worse for having 'horny fists' through working at the same trade as Joseph the descendant of David, or the woman for being an immerser of cloth in suds, or for herself having been immersed in water if she believed it necessary to her salvation – none of these things are fit to be ridiculed. It is vulgar to do so.

It seems that Palmer still could not bring himself to direct talk; he replied to Linnell in terms of self-pity mingled with attempts at conciliation:

I think people take me for a walking walnut-tree or a piece of odoriferous gum that gives out its full sweetness in bruising. To any observations bearing on religion or politics I had better offer no reply as I fear offence has been taken which was never meant at occasional allusions to those strife moving topics – and if neither party entertain hope of converting the other silence is not only innocent but commendable forbearance.[128]

After further explanations about what he had meant in his letter, a request for three more Herries £20 notes, and some advice to Mrs Linnell to go into the country for a change, he continued, 'At this happy close of our political differences I hope you will do my lambship the justice to observe that notwithstanding the strong language you have applied to me and my notions – I have never retaliated.' One can only say that he was mistaken not to have done so, for,

perceiving his irresolution, Linnell returned to the attack in his next letter, taking up a claim Palmer had made that he was related to the family of Charles James Fox:

You say you are related to the Fox family. I thought so. It is a pity you were not named Fox Palmer instead of Samuel. It would be so characteristic of your doubles and turns in argument . . . here in the last letter . . . you pretend to be innocent of all provoking Language and take great praise to yourself for not roaring like a Lion – whoever heard a Fox do so. No he gains his points by . . . sly means and grinning like a Fox. It appears from the excellent character you give yourself that you need not use the prayer recommended by Burns in one of his letters 'The Lord send us a gude conceit of ourselves' – so for reasons named in my last I shall not attempt to alter your comfortable state of mind, and have only to add that here are the 3 £20-notes which you wrote for, from my own resources, and as it appears that you are really coming home I will arrange all money matters when you arrive.[129]

ɷ

At Florence, on the homeward journey, Palmer was enchanted with everything he saw. He was particularly impressed by some trees painted by Giorgione – probably in *The Judgment of Solomon* and *The Trial of Moses*, both in the Uffizi Gallery. He intended to make a 'slight copy' of them, thus getting what he called 'a year's experience in tree painting in a day'. Both Giorgione and Titian impressed him, and each of them, especially Giorgione, had a considerable influence on some of his later painting. Palmer himself realized that such contacts introduced irreversible changes of direction in his work, as he indicated in a letter to Linnell written on 14 September:

I am wholly absorbed in art and so imbued with love for the landscape of Giorgione and Titian that I can never paint in my old style again – even though I may paint worse – so conscious am I of liability to self deception and the wide difference between admiring and imitating. You must not expect Titianesque sketches as latterly I have been merely collecting materials from nature (all however with a direct view to finished pictures) without composition and alteration. I feel however that my knowledge of the phænomena of nature is much increased. We have I think got between us all the characteristics of the *material* of Italian scenery – the color who but Claude could get?[130]

Palmer's preoccupation with nature at this juncture is well illustrated by the watercolour *A Mountain Road in Italy* (Rijksmuseum; illustration 49), probably executed in north Italy on his way home during autumn 1839. The impressively accurate rendition of the natural quintessence of the scene is achieved by methods he had used ever since the Shoreham years: dotting to indicate the texture of the herbage, a sparing use of flecks of opaque white to indicate highlights, and a closely observed treatment of trees and leaves.

Though he was always responsive to the attitudes of others and to external events once they engaged his attention, Palmer fortunately seems to have had the capacity to remain oblivious to them while his work was going well. Just as earlier in the tour worrying news from home did not upset his equanimity as an artist, so now, with misunderstanding and growing hostility from his father-in-

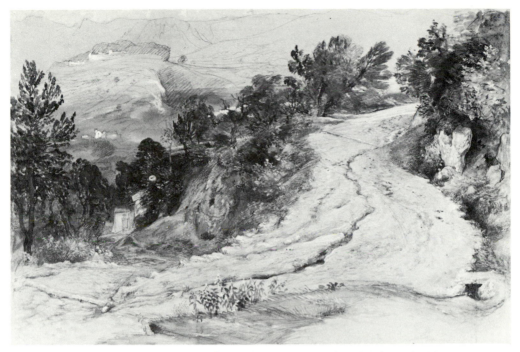

49 *A Mountain Road in Italy*, 1839. Watercolour heightened with
body colour on paper; sight size 298 × 454 mm (Rijksmuseum,
Amsterdam)

law, he produced some of the best work of his Italian visit. In at least two
drawings of hilltop towns, *Civitella near Subiaco* (Whitworth Art Gallery;
illustration 50) and *Papigno on the Nar* (Victoria and Albert Museum; illustra-
tion 51), he created work comparable with drawings made at the close of the
Shoreham period and just after. The landscape in each is beautifully composed,
and the architectural perspective, especially in *Papigno*, is confident and well
constructed. Again he uses dappling and dotting to indicate olive groves,
boscage and other details, and once more the focal area is surrounded with
controlled scribbling and light washes. The undergrowth in the foreground of
Papigno, with its intertwined briars, despite light drawing and brushwork, is
firmly indicated.

While he was in Florence Palmer again attempted a panoramic cityscape, this
time with greater success than in the views he painted soon after his arrival in
Rome, though his handling of perspective on this scale was still somewhat
shaky. The view in *Florence* (Victoria and Albert Museum) is taken from neigh-
bouring heights, looking across the River Arno. The central area is dominated
by the dome of the Cathedral with Giotto's tower and the dome of the Baptis-
tery to the left. To the right are the Palazzo Vecchio and the Ponte Vecchio and,
in line with the Cathedral, the Ponte S. Trinità. The Palazzo Pitti and Boboli
Gardens are in a dark area at the right, on the near side of the river. Again lack of

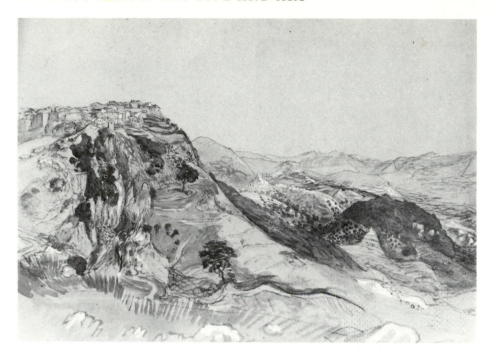

50 *Civitella near Subiaco*, 1839. Black chalk, watercolour and body colour on paper; 294 × 425 mm (Whitworth Art Gallery, University of Manchester)

definition, in the foreground and in the distant landscape, directs attention on to the focal area of the cityscape.

Hannah's health had improved since she left Rome: by mid September, at Florence, she was 'better and fatter than during the whole of her travels',[131] and was able to do further work for her father – copies of works by Michelangelo, Titian and Andrea del Sarto. Apart from one or two sketches taken in France on the way home, these were the last works the Palmers made during the Italian tour. On 29 October they set out for England. In Palmer's last letter from Florence to Linnell he gave in and agreed that Hannah could stay with her parents for a few days on her return: 'As Anny will be very tired with her journey and probably sea-sick I should be much obliged if you would let her recruit for a few days at Bayswater while I see about a bed and make the Grove St. rooms habitable.' Later in the same letter, as they crossed the Alps, Palmer adapted *Paradise Lost* for a *cri de coeur*: 'We have crossed the Alp and left Italy!! "Farewell happy fields where joy forever dwelleth. Hail railroads! hail!"'[132]

At Paris the couple received a letter from Linnell,[133] in which he instructed Hannah: '. . . come if possible from France to London by the steamer, as by that you avoid all custom house bother at Dover – bring all you can straight to Bayswater when (as Mr Palmer speaks so pretty) you shall be welcome to stay as long as *he* pleases'. On 27 November 1839 the Palmers and Martin crossed the

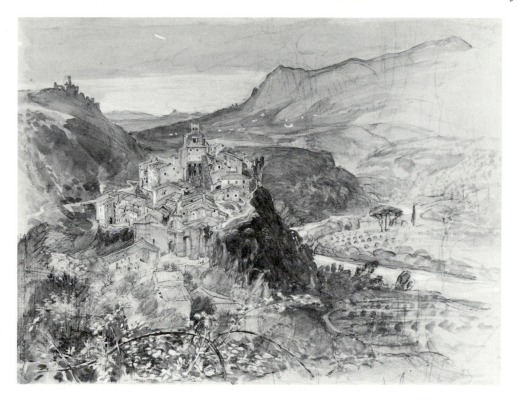

51 *Papigno on the Nar, between Terni and the Falls of Terni*, 1839.
Watercolour and pencil, heightened with body colour, on paper;
316 × 421 mm (by courtesy of the Board of Trustees of the Victoria
and Albert Museum)

Channel. The Richmonds, from whom they had parted at Tivoli, had left Italy
before them. The family had visited Venice, and on the way there, between La
Porta and Ferrara, their coach had overturned; but they all escaped unhurt, and
Richmond made a drawing of the scene after the accident. From Venice they
crossed the Alps to Munich and Mannheim, and thence to Rotterdam, where
they embarked for England. Unlike Palmer, George Richmond had derived
both social and professional advantage from the trip.

ༀ

On his return Palmer found other unpleasantness as well as strained relations
with his in-laws. In February 1839 he had written to his brother William,[134]
requesting him to ask his wife to look after his drawings, 'and in case any of
them have been taken down – to see that no *corners* of any kind come against the
back of the canvas'. Poor Samuel might as well have said nothing, for his
slippery brother had pawned them all, as he explained in a letter.

Having through illness and other unlooked for exigencies been placed in circumstances of perplexity and distress, I regret to say that some time ago I borrowed for my relief, the use of some of your pictures, not doubting but that I should be able to restore them before your return to England – but a party who owed me a considerable sum of money has gone away, I cannot ascertain wither, without paying me, and I grieve to say has left me no alternative but the enclosing of the ticket giving on the pictures, for the present, but you may rely on my remunerating you as speedily as possible ...

I hope you and your wife will return well home but I do not intend to see you again after you receive this note, until I can meet you with money in my hand – embarrassment alone led me to avail myself of your pictures without your knowledge, but influenced by the fullest certainty that I should myself have been able to regain the pictures ere your return – But I have been left in the trying exigency which this note exposes and must throw myself on your indulgence for some little time – I shall (for the present) avoid an interview, as it could not but yield pain to us both.

I have thought of emigrating to New Zealand or some distant place where I may begin life anew and be free from objects which cannot but give me painful associations. However *I promise you* should I determine on this course I will not go till I have paid you with interest the sum which the recovery of the pictures may demand, and believe me Brother though my unhappy circumstances have betrayed me to action unworthy of myself, I shall never forget that there is a barrier fixed before the extremes of baseness which honor will not let me pass.[135]

There is no record of the money ever having been repaid, and Palmer redeemed the pictures himself. This incident raises a question about a later transaction which involved William Palmer: his sale of Blake's notebook (known as the Rossetti MS) to Dante Gabriel Rossetti in 1847 for half a guinea [52½p.]. It has usually been assumed that Mrs Blake gave William the notebook, but in view of other incidents in his devious career, it seems likely at least that he stole it, probably from Samuel. A. H. Palmer seems to have thought so, and referred to the matter in a letter as 'the disgraceful activities of S.P.'s brother re a Blake ms'.[136]

His brother apart, Samuel had many problems to face in settling down at last to married life. For the present Linnell had his way, and Hannah stayed at Bayswater while her husband had his pictures released by the customs and sorted out the muddle into which the affairs of his Grove Street house had been allowed to fall through the ineptitude of his father and the roguery of his brother, and despite Linnell's efforts. But with Hannah the Linnells overplayed their hand. Having succeeded in getting her to Porchester Terrace, Mrs Linnell felt the benefit of her presence and help, and Linnell determined that she should stay there indefinitely.[137] Samuel and Hannah dismissed the idea, and determinedly set about making their home at 4 Grove Street, as they had always intended. In this Palmer might have read another lesson. After refusing to allow Hannah to live for a time at Porchester Terrace on her return, he had given way – probably as much against her inclination as his own – and in so doing he had made further difficulties for them both, which then forced him to adopt an even stronger line than he had taken in the first place. Hannah's copies of Raphael were hung in a place of honour in the Linnells' dining-room, in company with a group of Blake's Job drawings.[138]

Palmer wanted to revisit Italy, and for a year or two after his return home he felt fairly confident that he would be able to do so. He never did, and as disillusion overcame him, he knew that he never would. He had to content himself with snatches of nostalgia, with painting recollections such as *Evening in Italy: The Deserted Villa* (private collection, England; illustration 54), and with giving a penny to any passing organ-grinder's monkey so that he could exchange a few Italian words with its master.

4 The battle of life

The signs for the practical side of the Palmers' home life were not propitious. Hitherto Mary Ward had dealt with all of Samuel's domestic matters, and now he was married to an inexperienced young woman, who could do little beyond plain sewing and who knew nothing about cooking (once while they were in Italy Palmer had procured a duck, which he then had to prepare and cook himself). So it is not surprising that housekeeping in their Lisson Grove home was slipshod; much of it was left to Peacock, a slovenly maid. But for the moment Samuel seemed happy enough, and did not see (or chose not to see) that much was amiss.

Palmer's household accounts were extremely amateurish, and in places completely disregarded simple arithmetic – although he counted arithmetic among his favourite recreations. They make a striking contrast to Linnell's ledgers and cash-books, in which every transaction, however small, is accurately recorded, including, for example, such items as a gift of 5s. (25p.) to a gypsy woman who had given birth to a baby in the grounds of his house. In later years the affairs of the Palmer household were gathered into some kind of order – though not altogether according to Samuel's taste.

In August 1840 Palmer returned briefly to Shoreham for a holiday with Hannah, Mrs Linnell and Hannah's siblings. They were later joined by Linnell, who made up the party to eight; it seems that they had for the time being patched up, if not settled, their differences. In a letter to Linnell, just before his arrival, Palmer seems almost festive, recovering some of the carefree bucolic zest of his younger years. He sent Linnell news of the accommodation he had found for his family – at the Sevenoaks house of 'that blessed farmer and yeoman Mr Townsend with whom Mr Richmond lodged'. He described what rooms were available, and the

Splendid Kitchen garden Pears Figs Mulberries Filberts wall fruits of all sorts – an apple tree [Townsend] just walked round and gathered 40 bushels profusion of poultry – meat when wanted – for sitting room and the great bed room with service – only twelve shillings per week!!! ... Mr Townsend's teems with fruit poultry cyder milk cream etc. fine spring water. Turkeys run about the front garden and the rabbits are *so* tame that they will feed out of a stranger's hand – there is also a keyed bugle for the lovers of music ... The boys are getting as strong as the Homeric Heroes – John nearly turn'd over a rock which would have done credit to Ajax. Willy's mouth is elongated in a perpetual smile – and Lizzy is getting as fat as a butcher's wife.[1]

When the main party went down to Kent, Linnell as usual struck a bargain with the owner of a two-horse fly to convey them and their baggage to Sevenoaks, insisting that he take a less direct route than usual, involving the ascent of a steep hill, so as to avoid paying a toll. On the return journey he tried to make a similar bargain with the owner of a furniture van which was returning empty to London. But this time Mrs Linnell refused to concur, doubtless thinking of the pleasure that an arrival in such style would afford her fashionable neighbours at Bayswater.

Apart from such brief vacations, Samuel and Hannah were now setting about earning their living, though not with conspicuous success. They hoped particularly for commissions for oil paintings. With this in mind, they prepared their canvases, ground their colours, and waited with a starry-eyed optimism for clients who never came. If it had not been for Palmer's pupils, whose numbers steadily increased, and help from Linnell, the Lisson Grove household would have been impoverished.

Palmer was a gifted teacher and seems to have been highly successful in inculcating the practice of watercolour painting into his pupils. Miss Louisa Twining, a member of the family of tea and coffee merchants and later a well-known social worker, studied with him during the 1850s, and recalled that during lessons 'It was not only a rich treat to watch him painting the beautiful pictures which were developed out of his imagination from day to day, and formed the lesson . . . but also to listen to his original and striking conversation, combined with the profoundest rules and directions concerning art.'[2] One such exemplary watercolour, painted for Miss Twining, is *A Bright Day in Autumn* (1857; City Museums and Art Gallery, Birmingham; illustration 52).

Louisa Twining kept a notebook for her lessons (now in the Ashmolean

52 *A Bright Day in Autumn*, 1857. Watercolour and body colour over pencil with some gum on board; 195 × 430 mm (City Museums and Art Gallery, Birmingham)

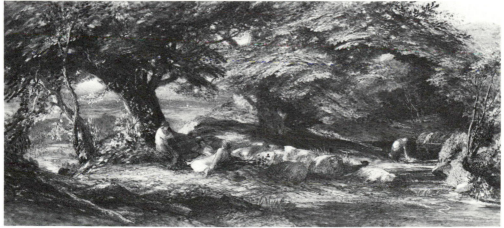

Museum). Headed 'Notes taken during the Lessons in Watercolour Painting from Samuel Palmer to Louisa Twining', its 59 pages list colours and papers recommended by Palmer and ways of making a tint, followed by details of the lessons. These are followed by a further series of notes in Palmer's hand, illustrated by rough sketches to accentuate various points. An extract from Miss Twining's notes conveys some idea of Palmer's immense care in imparting guidance:

First lesson was of a vista in Kent (my copy given to Free Library collection, High St., Kensington).

Sky of view in Kent – first wash pure Gamboge, or Indian yellow; partly over hills, softened into the landscape; then streaks of darker yellow whilst still damp. Pure indigo streaks & up to the top. Pink madder streaks; 3 prismatic colours, but none bright*est* except the yellow. A brighter red would be chrome & pink; some vermilion in streaks, not so celestial as madder. 2$^{\underline{d}}$ wash of Indigo. Indigo only for twilight Skies. First wash Raw Umber over foreground, grove & up to Cornfield. Light red & Indian Red for part of distance. Wet Bistre over middle green Trees.

Do not let an intervening object destroy continuity in a form behind it; preserving forms carefully, & lightest sides of Trees softer.

Blotting paper for taking out too much from brush.

Miss Twining was a favourite pupil, and as late as 1864 Palmer was still advising her about her painting. Apparently she had asked for the loan of one of his watercolours to copy; he replied:

If you can think of, or rather if you can set your heart upon copying anything of mine, let me know, and I will contrive some means of sending it. I don't wish it to be made a matter of business; and please let the lending of it be between ourselves. I don't mind sending two or three, as I know your conscientious carefulness and habits of order; *but*, having carefully considered what you have done hitherto, I strongly advise you not.

You should now go on, as you would have done with me, to make *use* of the degree of imitation you have mastered; to study the manner in which the best masters *applied* it to nature; and how they simplified [nature's] intricacy and, when necessary, did the most in the least time; which is particularly desirable in your case, whose time is so occupied with still better things.

If you could paint a robin red-breast perched on a twig, and finish it so highly as that we could tell what o'clock it was by the reflection of the dial of the village church in its eye, you would have done a work less noble and natural than Gaspar Poussin in that small picture in the National Gallery, with the sheep coming forward in the shady lane [*Landscape near Albano*]. Such works lead you to detect large arrangements of light and shade in nature, and so to take hold of nature in its practicable moments.[3]

Palmer was able to express himself fluently and this gift helped him enormously as a teacher – indeed it was his conversational power almost as much as his instruction that made him welcome in many households. Nevertheless, with characteristic lack of confidence in himself, he charged very low fees: for a lesson lasting two or two and a half hours, a guinea (£1.05); for a lesson of one hour, half a guinea; for an hour's lesson in his own house, 7s. (35p.).[4] His teaching practice was helped by recommendations from his friends, particularly

George Richmond. Through Richmond Palmer was engaged by James William Freshfield, solicitor to the Bank of England and for a time M.P. for Penryn, as a drawing master for his children. Soon after he began work with them Palmer was able to report that 'the Miss Freshfields will draw, very well indeed – they set out with taking pains'.[5] But in his heart he knew the limitations of what he could impart to such pupils: 'What inspired young ladies think they may accomplish after a course of lessons is what can barely be approached by life-long study.' In short, he found himself frustrated by the amateurishness of his pupils – and of their parents, who, he said,

in nine cases out of ten ... don't want real teaching for their daughters, but some fine, touched-up drawings to show, in which they do not repeat themselves, but their masters. I have no reason to complain, having always, in London, had as much teaching as I could desire; but it is my full conviction that a good bold quack with plenty of tact, a comely presence, and well-cut Hoby boots, would beat any real artist out of the field – as a teacher. I mean as to the figure he would cut on Schedule D [income tax].[6]

But such considerations did not prevent him from taking extra pains with special pupils, like George Richmond's daughter Julia, to whom he wrote:

All who draw from Nature *must* be exact.

Talent is shown by rapid exactness. Genius is sometimes developed through slow exactness at first – that whether fast or slow it *is* Exact and is called genius when it most *exactly* embodies sublime conceptions.

All educational acquisitions which have not exactness are in my opinion worse than useless, – so much injury is done to the mental structure by the bad habits acquired in the obtaining of those so called acquirements.[7]

It is sad to have to record that, despite all his efforts, Palmer never had a pupil who was really worthy of him. It was not until well into the present century, in the work of such artists as Graham Sutherland, F. L. Griggs, John Minton, Robin Tanner and Paul Drury, that his influence on British art became apparent.

ფ

Palmer's experience of Italy and of European art was never far below the surface of his work during the years following his return. He painted a number of works based directly on his Italian studies, for example *The Campagna and Aqueducts of Rome* (1843; private collection, England) and *The Colosseum and the Arch of Constantine, and Alban Mount, from the Palatine, Rome* (*circa* 1843; Ashmolean Museum; illustration 53). He also began again to paint English landscape, bringing his newly acquired outlook to bear on the little hills of Kent and on the rolling scenery of Buckinghamshire, Surrey and other areas of southern England. All of these are interesting, some even poetic (though lacking the visionary qualities of his earlier work), but at this period Palmer is at his most lyrical in such works as *Evening in Italy: The Deserted Villa* (1845; private collection, England; illustration 54), in which his Italian experience is blended

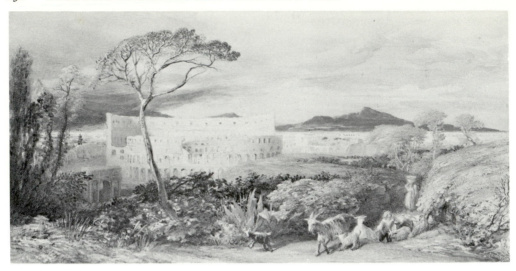

53 *The Colosseum and the Arch of Constantine, and Alban Mount, from the Palatine, Rome*, 1843 or later. Watercolour and body colour over traces of black chalk on paper; 203 × 399 mm (Ashmolean Museum, Oxford)

with English landscape, and has accents inspired by the paintings of Claude Lorrain. *Evening in Italy*, though small in scale (187 × 406 mm, what Palmer called his 'Little Long' size), is richly detailed and charged with a bittersweet melancholy, a *tristesse* akin to that of Claude's *Landscape with Psyche at the Palace of Cupid* (usually known as *The Enchanted Castle*; National Gallery, London). The villa in Palmer's picture is not based on a particular building, but like Claude's is an amalgam of several he had seen in Italy. He also began to draw on other experiences, as in *Landscape with Windmill, Figures and Cattle* (*circa* 1851; Victoria and Albert Museum; illustration 55), in which he looks back to earlier impressions received when he visited the Dulwich Gallery with Linnell and saw work by Ruisdael, Hobbema, Paul Potter and Cuyp, and remarked 'how intense, how pure, how profound, how wonderful'[8] he found them. *Landscape with Windmill* recalls Ruisdael's skies and landscapes, such as *Landscape with a Blasted Tree* and *Landscape with River and Pines* (both Fitzwilliam Museum).

In short, Palmer's work was becoming more eclectic; yet it has a continuity of expression. The treatment of trees and foliage, the continuing use of dotting, dappling and controlled scribbling are still there, less evident than during his early years, but prominent enough to stamp the work with his own personality. This individuality is the strength of the work of his middle years, and in places it led to the creation of a masterpiece, like *Tintagel Castle, approaching Rain* (probably 1848; Ashmolean Museum; illustration 63).

It is remarkable that, with all his domestic and financial anxieties, Palmer was able to produce creative work at all, let alone work of this quality. He may have been incompetent in his relationship with his father-in-law, inadequate in

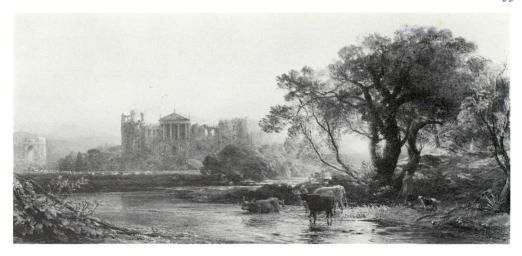

54 *Evening in Italy: The Deserted Villa*, 1845. Watercolour and body
colour on paper; 187 × 406 mm (private collection, England)

55 *Landscape with Windmill, Figures and Cattle, circa* 1851.
Watercolour heightened with white on paper; 537 × 756 mm (by
courtesy of the Board of Trustees of the Victoria and Albert Museum)

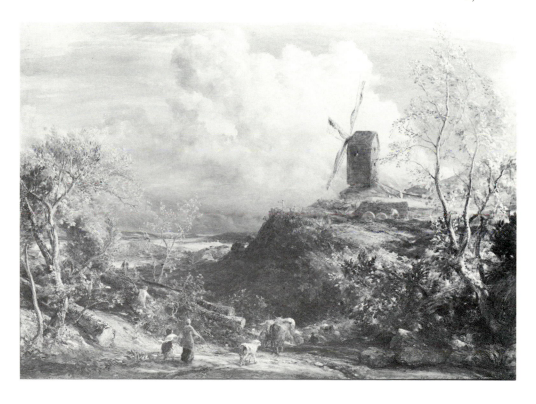

dealing with his finances, socially awkward, but in his art he never wavered. One aspect of it may seem more impressive than another, but it is certain that his work was always worthy of his skill. That in his middle years it was created in conditions always of strife, and sometimes of high tragedy, is a measure of his unfailing artistic integrity.

ᘒᘒ

Though Palmer's domestic life became unhappy, his friendship with the other Ancients, and with Richmond in particular, continued. Richmond prospered while Palmer continued to struggle, but it made little difference to their mutual regard. Richmond never forgot the help Palmer had given him when he eloped. To a somewhat apologetic invitation Palmer had sent to him, Richmond replied,

I will excuse all things *but your* asking me to excuse anything. Do you remember who lent me £40 to get married with, who gave me and mine a hearty welcome and a house at Shoreham, when such a welcome and house were most needed, and think you my dear Palmer that the kind friend who has done all this and much more is the one to excuse 'the roughness of things'. I will take your rebuke as if you had meant it (altho' I know you have not), and try to live in a large house as if I had none.[9]

Nevertheless, the Palmers were painfully conscious of the difference between their near penury and the prosperity of the Richmonds. When they had been using some furniture lent by a friend and the time came for its return, they searched Wardour Street for some cheap but serviceable replacements. Having taken delivery of them, Hannah wrote to her father: 'Mr. Palmer thinks that as Mr. Chance [Linnell's nephew by marriage, James Henry Chance (born 1810); he was a picture-framer among other things] is so intimate with Mr. Richmond it would be better not to say anything to him about it as to Mr Richmond it is not well to confess yourself obliged to be economical . . .'[10] This has been seen as evidence that Richmond had jettisoned the ideals of the Ancients,[11] which may or may not be true (and most indications are that his attitude to his old friend was brotherly); what is more revealing, Hannah's note indicates that circumstances had forced poor Palmer to go back on one of the principles on which his upbringing had been based: 'if we merely ask ourselves "What will people say of us?" we are rotten at the core.' It was not the last principle which circumstances forced him to reject. But at least he repaid Richmond's Italian loan, probably with the help of Linnell, and Richmond's feeling on the subject was, he told Linnell, 'entirely kind and satisfactory'.[12]

In 1842 occurred another event which though joyful, added its weight to Palmer's responsibilities. This was the birth of Hannah's first child, Thomas More Walter George, who appeared on Palmer's own birthday, 27 January. His first two names were those of the sixteenth-century English martyr, since canonized, whose portrait, together with that of his contemporary, John Fisher, had hung in Palmer's little chapel at Shoreham. Thomas More was not a

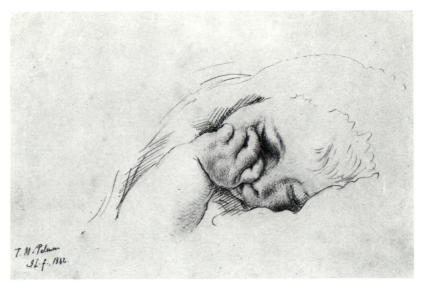

56 Thomas More Palmer as a baby, by John Linnell, 1842. Pencil on
paper; sheet size 182 × 230 mm (private collection, England)

strong child, and for the sake of his health the family visited Thatcham in
Berkshire in the autumn of 1843. There Palmer painted several studies,
including *Old Farm, near Thatcham* (Williamson Art Gallery and Museum,
Birkenhead; illustration 57). Another contemporary study, *At Donnington,
Berkshire, the Birthplace of Chaucer* (untraced since 1843), he gave to Linnell in
payment of a debt of £5.[13] it was the only work by Palmer ever to hang on
Linnell's walls.[14]

ॐ

A new worry arose from Palmer in the 1840s when his relatives asked him, as
the elder son, to take his father in as a permanent resident at Grove Street. There
was much unpleasantness about this. Samuel Palmer Senior had little or no
income, and was reduced to selling his books and piano in order to pay for food
and lodgings. Once this source was drained, said Palmer, it looked as though
the whole responsibility would descend on him.

Without success, he tried to get his father a post in the newly formed London
Library, for which he sought Linnell's help. He also mentioned the possibility
of a situation in the British Museum Library, 'but not being in communication
with my Brother I have not the means of hearing'.[15] Understandably the matter
of the pawned pictures was still rankling. Again he tried to enlist Linnell's
assistance, but this time it proved unnecessary, for a few months later a laconic
message arrived announcing his father's marriage to a Mrs Mary Cutter, aged
forty-eight, a self-supporting silk-weaver with a home of her own.[16] Once again

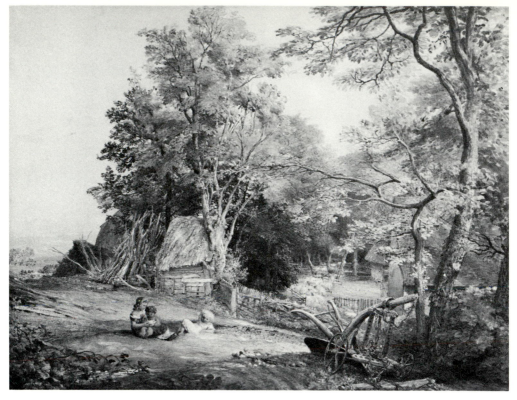

57 *Old Farm, near Thatcham, Berkshire*, 1843. Watercolour and body
colour on paper; 394 × 445 mm (Williamson Art Gallery and Museum,
Birkenhead)

the elder Samuel had disgraced his family by introducing trade into their midst,
but this time their shame was tempered with relief at the knowledge that at last
somebody else was supporting him.

During the course of these events, financial anxieties continued to harry
Palmer, prompting him to make futile and pathetic attempts to economize:
'Supposing lessons stop, and nothing more is earned – avoid snuff, two candles,
sugar in tea, waste of butter and soap . . . But it is more difficult at present to get
than to save. Query. Go into the country for one month to make little drawings
for sale?'[17] This was something Linnell had advised against earlier, when
Palmer was in Italy and made a similar suggestion. 'I do not like it', Linnell had
written, telling Palmer to teach rather than indulge in pot-boiling.[18] But the
nagging shortage of money continued. At the beginning of 1842 he wrote in his
notebook: 'Income, God willing, of 1842 ✚. He giveth food to all flesh, for
His mercy endureth for ever.' And a few pages later:

Our professional experience, 1842. February 3, I went to the British Gallery, and found
both my pictures and one of Anny's rejected. March. Mr Ruskin and others were shown our
drawings. Mr Nasmyth was to name me as a teacher to Admiral Otway. I offered Miss B—,

Addison Road, to teach one pupil for 10s per annum. [This was a school.] Went to British Artists, and found one picture hung near the ceiling, another rejected, and Anny's *Job* rejected. Mine were the same pictures I sent to the B[ritish]: Gallery, for the new frames for which I had paid £5 8s. [£5.40].[19]

For the moment, Palmer gave the major part of his attention to teaching, taking advantage of introductions by Linnell. Some of these were to influential people, like the barrister and author Sir George Stephen and his wife (Sir George had earlier helped Linnell in his attempts to sort out Mrs Blake's affairs). However, far from being an emollient to Palmer's anxieties, such contacts led to an increase in his torments of apprehension and indecision. Soon after he had begun giving lessons at the Stephens', Lady Stephen invited Hannah to accompany her on expeditions into the country, and repeated the invitation many times. For various domestic reasons she had to refuse and Palmer, afraid that these refusals would give offence, turned to Linnell for a decision:

I want you to write a note to Anny telling her what you think of it ... The great obstacle with Anny would be the apparent necessity of letting the baby out of her sight in Lady Stephen's nursery sometimes ... I will try to come over this eveng. – but as Lady Stephen will most likely see Anny tomorrow morng. should feel obliged if you will tell Anny [who was at Margate] by a prompt line what you think of this oft repeated invitation – the baby-leaving-in-nursery will be the obstacle – and on the other hand how can Anny refuse without perhaps damaging a valuable connexion?[20]

There is no record of what Linnell advised, or of the outcome of this social dilemma.

The Palmers' disappointment in their attempts to sell oil paintings soon led Palmer to give his whole creative attention to watercolour, often in combination with tempera and body colour – a medium which suited him better, although he was unable to see this himself. Much later he spoke with regret of having been forced by circumstances to eschew oil painting: 'I could not help thinking ... that had the picture fanciers of that day given only a *little* encouragement, there need have been no watercolours. But it was not to be.'[21] His future career as a watercolour painter was finally determined in 1843, on his election as an associate member of the Society of Painters in Water-Colour.[22] The joy of this was enhanced by the sale, for £30, to the Art Union of his *Evening – The Ruins of a Walled City* (untraced since 1843). Linnell greeted the news by sending his son-in-law a bantering note whose facetiousness barely disguises contempt: 'S.P.U.R.I.C. to B.P.S.P.W.C. ... U but and ME it is all fiddle D D; I.O.U. no N.V.' This can be deciphered as: 'Samuel Palmer you are I see to be President of the Society of Painters in Water-Colour ... but between you and me it is all fiddle de-dee; I owe you no envy.'[23] Palmer's election was a decisive step forward in his professional career, a recognition, however small, of his professional standing and ability, and one might have expected his father-in-law to be pleased by the news. If he was, he betrayed nothing of it.

The birth of Thomas More enabled Palmer to test some of his speculations about marriage and family life. He also seized upon what he saw as an opportunity to realize vicariously the ideals and ambitions which had eluded him, and set out from the beginning to make the boy a paragon of virtue, learning, morality and devotion, allowing nothing for the natural high spirits of childhood.

On his sketching tours, or while Hannah and the boy were holidaying at Margate, he wrote to little Thomas More, telling him of some of the wonders he had seen, but overloading everything with depressing moral exhortation. Even allowing for Victorian mores, it is dismaying to read a passage like the following, written to a child aged two and a half:

You must not teaze Mamma to read you this letter when she is busy – but if you are still a very good boy and do what Mamma tells you AT THE MOMENT I dare say she will read you a bit now and then. The way to become good is to pray to the Good and Blessed God to make you good – and then to try yourself how good you can possibly be – Good boys do what they are told to do whether they like it or not. If they are told to do what they do *not* like to do – they do it *directly* – and then they feel very happy – and when their Papas come home again they love them very much indeed – I am much obliged to you for the letter you sent me – and I take care of it – and suppose that you also will take care of my letters – for when you grow up to be a young man – I shall die and my body will be put into a hole and you will never see me again while you live in this world – and perhaps then you will like to look at some of the letters I have written to you. But if we love the Blessed God – and do what He has told us to do – we shall *come to life again* – much better and happier than we are now – and Papa and Mamma and Thomas More and little Sister will live together and make each other happy – and never do any thing that is wrong – and never die nor go away from each other any more.[24]

To urge a child of two and a half to be good while making him aware of his parents' mortality is unpleasantly like moral blackmail, and (if he understood it) must have undermined Thomas More's happiness and confidence. The most charitable construction to put on Palmer's exhortation is that he really thought he was acting in his son's best interests and was completely unaware of the hideous risk to which he was subjecting the child's morale.

The little sister mentioned in the letter was the Palmers' second child, Mary Elizabeth, who was born in 1844. She was a sweet little girl, who brightened the home with her pretty and affectionate ways. But again, though he treated her more sensibly – or more likely, showered less attention on her – he displayed scant understanding of the infant mind. When she was little more than a year old, he urged Thomas More (who could read when he was three) to teach her to recognize letters. But the method he suggested was more likely to frighten her than to teach her anything.

Poor little Mary cannot read: and she will never be able to read if she do not learn her letters. Now I wish you to help me to teach her. When you were as little as Mary. I used, every day to show you some of the letters and ask you what they were called. You should get a large A and

B and C out of the box of letters, and ask Mary what each one is called, and tell her, if she does not know. You may play at PEEP BO! with the letters. Hide the letters behind a book:- then, suddenly pop one of them up – so that Mary may see it – and call out its name very loudly, and then ask Mary to call out. When she has done so drop that letter behind the book, and pop up another: only do not begin with more letters than A B and C. When I come home how delighted shall I be if you have taught Sister Mary a few of her letters![25]

More loaded persuasion follows, but the reward here is the approval of a titled lady, not the blessed peace of mind during bereavement of a child who has been dutiful to his parents: 'I hear that Lady Stephen came to see you, and I hope you had been a good boy that day; for Lady Stephen loves good boys very much.'[26] And not only Lady Stephen, but the Good Shepherd, liked them, although it seemed He had scant sympathy for naughty little boys, who courted a frightening fate:

Our Blessed Lord Jesus calls himself the Good Shepherd; and you have been baptized and made one of His lambs. Now some of the lambs of this Good Shepherd grow careless and do not mind what he has said to them and run away from the fold; and that great Wolf the Devil catches them and eats them up. Little children, therefore should pray every day to the Lord their Shepherd to keep them safely from the claws of that cunning and hungry beast – who is always lurking and watching just outside the fold to snap up any stray lambs or sheep and rush away with them to his dismal den. Therefore, if the Devil puts it into your head that it would be very pleasant to do something naughty or something which you have been told not to do – do not listen to him for one moment, but lift up your hands to your good Lord and say 'O! Sweet Shepherd I will not do this naughtiness – take me up in Thy Arms and drive the Wolf away'.[27]

In some of his letters to Thomas More, Palmer betrayed an odd ambivalence in his beliefs. 'Jesus was very kind to every-body', he wrote in one of them; yet in the same letter he warned Thomas More that 'The bad people must all see Him too – but it will be only for a moment, on the judgment day; and then he will say "Depart from me you who do wicked things".'[28] It would not have been surprising if the little boy had wondered how these two ideas of the Good Shepherd could be reconciled.

In September 1844 Palmer set off to sketch in the Guildford district of Surrey, and from there he went on to Wales for three weeks. This was just after the birth of his daughter, an event which had given him more happiness than he had experienced for some time, so he could look forward with real pleasure to his return home. The notes he made at this time, animated by a preoccupation with the beauties of light, seem to convey his newly raised spirits.

Guildford 1844. The lights in nature are more distinct from the shadows (however modified by reflection) than in pictures. The shadows are very deep relatively to the lights, yet seem clear and full of reflected light. This quality is worth a most serious effort. It is much seen in shady lanes. The want of it gives a dismal, indoor look to the picture. Cast shadows across

lanes &c. are not hard, or cut out, or all of a depth – some very dark and sharp winding up to the emphasis against the brilliant light. With these are intermixed tender, transparent shadows, and half-shadows, in every variety of intermixture and gradation. But the first thing that struck me on coming here was the POSITIVENESS, INTENSE BRIGHTNESS, and WARMTH of the LIGHTS; and that the SHADOWS are full of REFLECTED LIGHT, though very deep ... The cast shadows travelling over the figure-like ground develop the forms and emphasize them. They do not so here, from the slightness; but in nature, the living chequer-work of the shadows and their pungent lines often develop and emphasize the principal forms, while they light up the whole with a dance and dazzle of splendour ... The shapes of the focal lights and touches must be thoroughly understood and drawn to give any chance of imitating the vivid splendour of nature's lights. The shadows in nature are very deep compared with the wonderful light; and themselves, nevertheless, are clear, beautiful, and clean in colour, and full of reflected light, warm or cool. The smiting of the light upon the shade is accompanied by its opposite, viz. endless play and gradation. Nature seemed WARMER than ever, but with a perpetual interplay of greys.

Some of the conditions of the glitter in sunshine IMPORTANT: Holes of dark. Cast shadows; as well as the incessant play of the common shadows.

To a black or dark animal and a white one, all the landscape – excepting stubble fields and suchlike – will be a MIDDLE TINT.

Glitter of a white or very light object will be helped by its SQUARENESS of shapes, GENUINE MIDDLE TINT of its BACKGROUND, a mass of something relieving dark near it, and the play of CAST SHADOWS and HOLES of dark, which are the enrichment of nature's breadth. These, I think, govern and mass the varieties of colour in banks of wood etc., and make smooth, enamelly hills precious.[29]

During the same year Palmer wrote out, in pencil and pen and ink on a sheet of grey cardboard, some of his problems and some suggestions for overcoming them, and set down his plans for future work. On one side of the sheet he wrote:

WHITE in FULL POWER from the first
Remember blazing days wherein it makes midd-tint local colors in sunshine seem dark
AND GRAYS COOLER THAN WHITE –
WHITE NOT TONED WITH ORANGE but in juxtaposition with the PRIMITIVES
DEADLY DARK BROWNS LAID ON AT ONCE
SIZES – SKREENS 8th Imp[erial] LONG – perhaps upright with base of frame measuring $17\frac{1}{2}$ inches – imp[erial] with frame $17\frac{1}{2}$.
KITCAT* – peculiar shapes as ◯ or ⬭ in pairs –
To get vast space what a world of power does Aerial Perspective open!
– from the dock leaf at our feet – far – far
 away to the isles of ocean – and thence
 far thence into the abyss of boundless
 light – —— O! what heavenly grays does this suggest
 one flat tint relieves very distinctly from another
Stothard spoke of the value of flat tints
For luxurious VEGETATION combined with ROCK – BORRO[W]DALE and the banks of
 KESWICK – living at LODORE – crossing the mountains thence to WATEN[D]LATH occurs
 that 3 forking rock

* A portrait, less than half length, but including the hands. So called from the Kit-Cat Club, an early eighteenth-century club of Whig politicians and literary men, the dining-room of which was hung with them. The measurement was 914 × 711 mm.

ALSO here are (or were) very grand fir trees-sycamores etc
 CRAYON READINESS for SKIES and EFFECTS
 D.V.
The RETREAT GLOVER'S CHART OF AERIAL and
TEXTURAL PERSPECTIVE CLAUDE'S UPRIGHT SLIPS*
WHITE BUILDING in FULL SUNSHINE – RIGID IMITATION of relative and neighbour darks
and colors
Foreground with Distance in full Sunset Blaze – for Corpo di Cava
SUNSET BEHIND TREES – for Deserted Villa [see above, illustration 54]
LANE with TREE SHADOWS and FLARES of LIGHT and Figure
FOREGROUND against DISTANCE
ONE BIT OF MIDD DIST WOOD MOST RIGID
SLIGHT SKETCHES OF APPLICABLE FOREGROUNDS
 LOCAL COLORS OF DISTANCES–done with a SUB PALETTE Yellow Red Blue
over the bright
R[A]W UMBER MADD[ER]; BROWN Ultra[marine] Ash preparation –
STIPPLE or LABOURED VIOLENT
ADvance the foregrounds early On the strong preparers work
Think more then work upon most tenderly Particularly on
distances distances –
If spared to 1845 September a batch of Imitation
WHITE BLACK and GRAY manifest the colours – and the colors
 give White Black and Gray beauty and a value as colour
 Mr. Cristall†

On the other side he wrote:

The dazzling sunrise light when sun is [illegible] less. – against dark angular mass of near
rock and also [?] against dist[ant] city or prospect
The streaky sunrise light – or that which is gen[erally] painted like streaky colors on plumage
Begin Four large viz – The 2 Park Place sunsets – 3 Joshua (Harlech) and 4 The [illegible] –
 LARGE
The Clear Cloudless Sunset – and do with tree stems – and sun shining through –
1 LONG – Clear sunset Avernus – and gray temple
2 Naples from Vomera Intense Italian Evenings light
3 The Corpo di cava Mountains [tiny sketch]
4 The hour after sunset – Harvest Moon rising
5 The Gleaning Field
6 Bay of Baiae
7 Children run
2 MIDDLE SIZE FLIGHT into EGYPT
 and Roman sunset – (on Rome)
NB Grey mist and cloud effects on mountain reserve
 for 8th Imp[erial] and ¼ Imp[erial] – or afterwards
 also Jacobs Dream – Noli me tangere – and
 Angels appearing to Shepherds

* The retreat – perhaps a reference to the tendency of some colours to recede in a composition.
Glover's chart – presumably a working chart invented by the landscape painter, John Glover
(1767–1849). Claude's upright slips – probably a reference to Claude's use of *coulisses*; see below,
p. 156.
† The landscape painter Joshua Cristall (1767–1847).

NB – The unhotpressed Royal London Board (Newman's) measures 21¾ full by 17¾ rather
 full and cuts into 6 Long Shapes measuring 10⅞ by 5⅞ and half an eighth
THE EIGHT SUBJECTS. SUNSET ON ROME – CIAVARA – FLORENCE – ST. MICHAEL – CORPO
di CAVA – DESERTED VILLA – NAPLES – CHILDREN RUN – BUILDING THE SHEAF – BAY of
BAIAE – [30]

From the references to Borrowdale, Keswick, Lodore and Watendlath it seems
possible that Palmer visited the Lake District at about this time, or at any rate
knew something about the beauties of the area. On the other hand, the words
'are (or were)' perhaps indicate that his knowledge was second hand rather than
immediate; and the fact remains that there are no Lake District studies that may
be confidently assigned to him.

Palmer returned home from his Surrey tour with some valuable and heavily
annotated studies, such as *Guildford* (Yale Center for British Art) and *Sketches of
the Fair by St Catherine's Chapel, near Guildford, Surrey* (Victoria and Albert
Museum). But little of his work sold; his income for 1844 was the smallest he
had known since he returned from Italy.

He began to collect, on odd pieces of card and paper, notes of fugitive effects,
which he kept in a special portfolio labelled 'Written Memoranda'. He was
always an indefatigable annotator, not only in his notebooks and on sheets of
paper, but on sketches and drawings, like *Studies of Barley, Oats and Wheat*
(1846 or 1847; The Art Museum, Princeton University; illustration 58), in
which the annotations occupy almost as much space as the sketches. The minute
observations, written down on the spot, take account of every nuance of colour
and light; one need look no further to understand why Palmer's painting is so
convincing:

Wheat – general scheme The golden-amber-or greenish straw The midd tint – ears darker
and more red – Looking against sunset light the transparent husk of the ear forms a thin
golden halo round it – the ears being darks off the transparent tone of the straw this is varied
with high poppies sometimes almost as high as the corn – with purple & white flower &
blue – sometimes little tendrils of flowers entwine the stalks of the straw.

Palmer was equally fastidious in preparing his art materials when setting out
on sketching and painting expeditions. Before a visit to Margate in 1845, for
example, he made a detailed list of how his materials ought to be packed:

Put into thick brush case a portcrayon with black and white chalk and a hard and soft pencil.
Put into basket at back, a tin box containing reserve colours, and ivory palette. Then throw
in the tubes or take them in Mr Walter's box, and upon them, water bottle without case, and
dippers to fix upon palettes. Above lay the thick brush case, sketching stool, sketching folio,
into which slip the two palettes (large wooden) and two extra pencils: (the above will all slip
into red bag). The autumn cloak and umbrella.[31]

This visit to Margate, in the late summer, was partly in order to join his family,
who were spending an extended holiday there from May to October. He
studied wild flowers and meditated on the effects of sunsets, at the same time
enjoying the surrounding landscape, dominated by fields of wheat and dotted

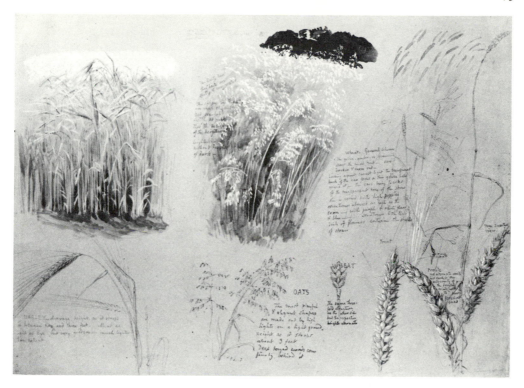

58 *Studies of Barley, Oats and Wheat*, 1846 or 1847. Pencil and
watercolour, heightened with body colour, on paper; 274 × 381 mm
(The Art Museum, Princeton University, Princeton, New Jersey)

here and there with windmills. He also spent a month at Princes Risborough in
Buckinghamshire, where he made studies for one of the best works he painted
during the mid 1840s, *A Farmyard near Princes Risborough* (Ashmolean
Museum; illustration 59). This shows his continuing concern with texture,
especially in the mossy thatch and tiles, and the wooden boards of the build-
ings. The ground beneath the tree at the right, counterchanged between light
and shadow, is a feature he often used in his middle and later years. Another
version (Victoria and Albert Museum) was exhibited at the Water-Colour
Society in 1846, but it was returned unsold and twenty years later still had not
found a buyer. It is no wonder that the artist spent so much time speculating
about his work and analysing it, as in this passage from one of his notebooks; it
is interesting to note that figures and narrative interest come late in his list of
desirable elements:

1st. SUBJECTS. A subject should be interesting either from its BEAUTY, or ASSOCIATIONS, or
BOTH; OBJECTS or SCENES, intrinsically BEAUTIFUL.
 Claude brought together things in which all men delight. Majestic trees, sunny skies,
rivers with gentle falls, venerable ruins and extensive distances. His ground was soft for
pasture or repose. The accident which most quickens such beauty, is LIGHT.

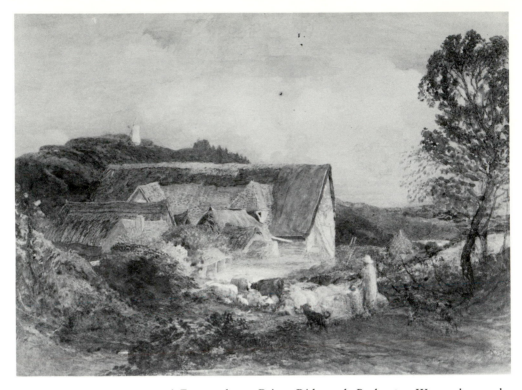

59 *A Farmyard near Princes Risborough, Bucks*, 1845. Watercolour and body colour, over traces of pencil, on paper; 268 × 368 mm (Ashmolean Museum, Oxford)

2nd. SUBJECTS in which ELEMENTS, or their combinations or secondaries, are the principal matters, as such in which are expressed DEW; SHOWERS or MOISTURE; THE DEEP-TONED, FERTILIZING RAIN-CLOUD; DROUGHT, with its refuge of deep, hollow shade, and a cold spring; the BROOK; THE GUSHING SPRING, or FOUNTAIN; AERIAL DISTANCE.

3rd. LIGHT either produced by its great enforcer cast shadow, or by great halved opposites, as when the sun is in the picture.

4th. DARKNESS, with its focus of coruscating light, and a moon or lanthorn. The precious and latent springs of poetry are to be found here.

FIGURES, which in landscape are adjunct, should if possible be in ACTION, and TELL A STORY.

PRUDENTIALLY it is important (1) to ATTRACT the EYE. These attract the eye – BROAD EFFECT; STRONG CONTRASTS, as warm and cool, bright light and deep shade; VIVACITY; SPARKLE; FRESHNESS; EMPTY and FULL.

(2) TO FIX THE ATTENTION by FULNESS and INTRICACY;

(3) TO AWAKEN SYMPATHY by doing what WE STRONGLY LOVE.

(4) TO DELIGHT by close IMITATION at least on the points which first meet the eye, and by EXECUTION.[32]

This was all very well, but there seemed to be nobody whose eye could be attracted, whose attention could be fixed, whose sympathy could be awakened,

or who could be delighted. Palmer tried to provide potential patrons with the best he was capable of producing, but they turned away, supremely uninterested.

He even made sketching trips to his beloved Kent, but the *genius loci* refused to function. Nevertheless, some of his letters to Thomas More contain descriptions of scenes reminiscent of the Shoreham spirit.

When they have loaded the last waggon, sometimes the children ride home upon the very top of it, singing and shouting for joy. And that night, in the old farm house all the poor people who have been reaping so many days in the hot sun till they are as brown as hazel nuts – all these merry reapers have a good supper together with music and song and dances. They worked hard for their master, and now he makes them happy. Well, dear Thomas – you and I have a Master; the Lord Jesus; and He has sent us into His field to work every day; we are to pull up the weeds of naughtiness and to sow seeds of goodness and kindness – that is, we are to try every day to do something that is good and kind in order to please Him.[33]

Even in this tiny and rare flutter of the old sacramental feeling Palmer had enjoyed as a young man, Thomas More was not allowed to escape a conventional object-lesson in holiness. At this time Palmer found no gateway back into the Eden he had known as a young man. The sense of paternal responsibility and his pedagogic instincts precluded that.

ಌ

Largely on account of the strain of his responsibilities and worries, Palmer fell ill in the autumn of 1845,[34] and during the following year he had an attack of asthma severe enough to prevent him from going out at night; he was often left with 'neither breath nor strength to walk to Bayswater', as he told his father-in-law.[35] There were also signs that Thomas More's health was unusually delicate. In 1846 Palmer mentioned his 'emaciated diseased look', but went on to say that he did not want medicine, except an iron tonic. Hannah sometimes took him to Margate for sea bathing (as Samuel had been taken as a child), and Palmer would join them there. Evidently Linnell paid for these holidays, for Hannah, in one of her letters (in which she appears to class him with the Deity), writes of an improvement in Thomas More's health, and adds, 'This is a great blessing for which I feel great thankfulness to God and to you for so kindly helping us to procure it.'[36]

Clearly Linnell was seriously worried about Hannah's circumstances, married to someone he saw as impecunious, apparently ineffectual and probably improvident. So it was more than idle curiosity that prompted him to ask Palmer's cousin and adviser, John Giles, for details of his son-in-law's finances. Giles gave Linnell some of the information he asked for, but when asked for more, reacted with vigour:

Stock Exchange 12 May 1845

Sir You have no right to ask me about Mr Palmer's affairs and if I had done as I ought I should not have answered you, but I was induced to answer you, from your saying *'secrecy will be the worse for Mr Palmer.'*

I am sorry that I told you anything

I have acted unfairly towards Mr Palmer and I write this to tell you first, that I feel I have done wrong, and next that you must never again ask me any questions about Mr Palmer's affairs, because if you do, I will not answer you.

Believe me Dear Sir Yours very truly

John Giles[37]

Linnell had behaved with unforgivable interference. But Palmer, by accepting help from him, and by his compliant posture, was at least partly responsible for creating a situation which made such conduct possible.*

Mainly because of his teaching, Palmer's income increased considerably after 1845. By 1848 two-thirds of it came from lessons, but his circumstances were still far from easy. He managed to sell a few works, forty-five altogether between 1843 and 1853, at an average price of just under £16. This was very little, in quantity and price, for a professional painter. It fell pitifully short of what his forceful father-in-law was getting, and his contemporary Richmond was already selling dozens of portraits each year, usually at over £26 each.[39]

In 1846, Palmer received a commission from Charles Dickens to produce four vignette illustrations for his book *Pictures from Italy*. Given Dickens's fame, the commission perhaps made Palmer think that his luck might be turning; but he still clutched at Linnell for advice:

If they ask me what I charge I shall not know what to ask ... I should wish to do them cheaply but have not a notion about price. If you could give me a guess by return of post I should feel obliged and I will come over and speak to you about it as soon as possible but at present cannot leave.[40]

Palmer made the designs, for which he drew on sketches and memories of Italy, and they were engraved by a journeyman. The subjects depicted are *The Street of the Tombs: Pompeii, The Villa d'Este at Tivoli from the Cypress Avenue, The Colosseum of Rome* and *The Vintage*. The last is a most poetic little design, comparable to some of Palmer's visionary work, especially in its original drawing (private collection, England). It was designed to surround an area of type, an idea Palmer probably derived from Blake's *Songs of Innocence* (see illustrations 60 and 61).

Dickens was pleased with the illustrations, although Palmer was not his original choice. He had asked Clarkson Stanfield to do them, but Stanfield withdrew on religious grounds; about to be received into the Catholic Church, he did not agree with the views on the Church Dickens had expressed.[41] Dickens wrote an affable note to Palmer.[42] But while the designs were in progress there was a risk that something – exactly what is not known – might go wrong with them, and Palmer was almost reduced to a nervous wreck. However, all was set to rights pending a meeting with the publishers (Bradbury and Evans), and

* Palmer had also accepted financial help from Linnell in connexion with his father's affairs, as is shown on a receipt:

Mr Linnell gave me up to the 27 December [1845?] the whole of the money for my Father – Samuel Palmer.

£2.2.6[38]

60 *The Vintage*, design for an illustration for Charles Dickens's
Pictures from Italy, 1846. Pencil and brown watercolour heightened
with white on tracing paper laid down on card; 136.5 × 77 mm (private
collection, England)

Samuel confided to Linnell that 'This has cheered me and quite revived poor
Anny – I am as weak as a rat and a spectacle to the little boys in the street as I
totter along – but have got home from Willesden without catching cold and if
the dreadful day Tomorrow can be got thro' hope of recovery.'[43] In addition,
Palmer had the greatest difficulty in making the professional block engraver
understand what he required. A. H. Palmer owned some proofs pulled from the
blocks which he described as being 'covered all over with suggestions and

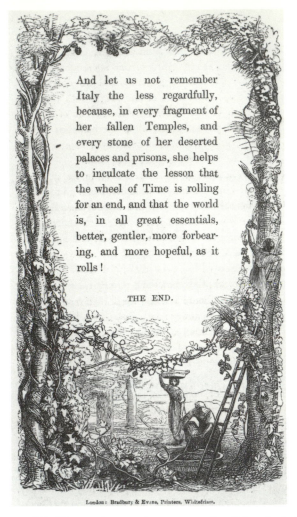

And let us not remember Italy the less regardfully, because, in every fragment of her fallen Temples, and every stone of her deserted palaces and prisons, she helps to inculcate the lesson that the wheel of Time is rolling for an end, and that the world is, in all great essentials, better, gentler, more forbearing, and more hopeful, as it rolls!

THE END.

London: Bradbury & Evans, Printers, Whitefriars.

61 *The Vintage*, by a trade engraver after Palmer's design, as published in Charles Dickens's *Pictures from Italy*, 1846. Wood-engraving, 133 × 75 mm (private collection, England)

appeals, manifestly impossible to follow by any wood engraver, however excellent'.[44] The illustrations appeared in the first edition of the book in 1846, and have appeared in most subsequent editions.

For advice with problems connected with sales and commissions Palmer turned to Linnell again and again. In 1846, for example, the dealer Charles Tooth visited him to buy pictures from him and Hannah. During a discussion of prices, Tooth asked how much Palmer would charge for a further copy of the Cammucini Titian copied by Anny in Italy. 'I told him', said Palmer in a note to Linnell, 'she would do it at any price you considered about the mark.'[45] What was infinitely worse, Palmer even allowed Linnell to tamper with his paintings,

in this way subjecting his art as well as his business affairs to the whim of the father-figure. There is no evidence that this happened often, but that it happened at all indicates how abject to Linnell Palmer became at this stage of his life. He refers to Linnell's tampering, apparently with perfect equanimity, in his note about Charles Tooth, saying, 'You told me after you had touched on the little picture with the children under the trees that you thought anyone would gladly have it at £12 12s. od. [£12.60].' A. H. Palmer recalled another instance; mentioning his father's small Shoreham-period panel (now untraced) on which Welby Sherman based his mezzotint *Evening*,* he claimed that Linnell painted out the moon. He also says that Linnell later made a practice of retouching work by his sons and daughters. He adds: 'That my father consented to all this willingly I altogether disbelieve.'[46]

The clattering workaday atmosphere at Grove Street made further inroads on Palmer's resilience. Washing, scouring, sweeping and cooking went on all around him, and he was in a continual state of apprehension about the safety of his old books, plaster casts and relics of the Kent years. He was saved from complete despair by his ability to withdraw into his mind, his art and his books, in which, however misleadingly, he could secure a sense of unity and peace. One cheerful aspect of his external life was his continuing cordial relations with other former Ancients. Richmond has already been mentioned, but Calvert too, serious-minded and taciturn though he was, still kept in touch with his old friend. After visiting him one day, Palmer wrote, 'My visit to you was one of the little oases (if the word have a plural) in the desert of life: since then I have been up and down the sand hills as usual.'[47]

But such compensations did not overcome his fundamental desolation. He had placed himself in the grip of Mr and Mrs Linnell, which tightened ever more firmly. Worst of all, however, his dreams of becoming a successful artist, like his friend George Richmond, were shattered; and the disappointment was mutual, because Hannah's efforts failed too: 'The poor little couple at Grove Street,' wrote his son, '. . . turned picture after picture with its face to the wall. The brave girl's high spirits at her artistic prospects were quenched at last and for ever for her pitiful little oil subjects were rejected wherever she sent them.'[48]

୨୦୧

In December 1847, the Palmers' little daughter, Mary, became desperately ill. Though she was only three, her loving ways had won the hearts of those around her, and she was Hannah's favourite child, much more beloved than her son. Her illness devastated her parents, and as usual in times of crisis, Palmer turned to Linnell.

* Impressions are in the British Museum and the Victoria and Albert Museum.

What would you do if you were in my case – I find – one end I had in view in having two medical men – hoping thereby to get a double attendance during the day entirely frustrated as they only meet in consultation. Mrs Richmond told me that Dr MacIntyre gave them 3 visits for a guinea [£1.05] – but on my paying a guinea this morning – (the fourth visit and 2nd guinea) Dr MacIntire immediately took his farewell.

However Dear Mary has passed such a bad night with almost incessant coughing that I am seriously alarmed. – Dr MacIntire said that if she passed well through the next 24 hours she might get through it and I am cut to the heart to see how they have begun.

I can see there is a great difference of opinion between the two doctors – Dr. Mackenzie says he has no doubt she will get through it – that there is every prospect of it – but how comes it then that the old cough has returned with redoubled violence? every cough is a dagger to me – I hear it as I write this moment – Dr Mackenzie says he has attended several children in this complaint and never lost one – but he treated it at first as a cold and after two days said she was convalescent –

Would you take the case out of Doctor Mackenzie's hands? – against that there is to be said that his skill is piqued upon making good his prognostic and taking every pains for her recovery – and perhaps it is a fatal attack and as well in his hands as any one else's – I am afraid Doctor Mackintyre would not take the case out of Dr. Mackenzie's hands if it were offered to him – nor am I sure we should be better off – for Dr. Mackenzie has *watched it from the beginning* – I am in a horrible perplexity and should much like to know what you would do in my case – I EARNESTLY trust Mrs. Linnell will be able to see us today – I have sent for both doctors – I remain in an agony of distress ...[49]

Mrs Linnell callously ignored Samuel's impassioned plea that she should come to him and Hannah. In an extremity of grief he wrote to his mother-in-law in terms 'the most strongly and indignantly expressed of any which he ever wrote',[50] but this too failed to produce response. Yet again he wrote craving her to come, saying that Dr Mackenzie had on the previous night given his daughter six drops of laudanum, 'which Anny thinks has caused the sad state of dear Mary this morning – We have both with one consent – dismissed Dr Mackenzie and depend upon Dr Mackintyre – but alas I fear too late.'[51]

He was right. Mary Elizabeth died on 15 December at six in the evening, aged three years and nine months. By this time Mrs Linnell had at last arrived, and was present with Samuel and Hannah when her grandchild died. Palmer described the scene in his notebook:

Her mother was sitting at the end of the bed when Mrs. Linnell said 'I think she is gone.' Anny put her face close to Mary's, but could hear no sound of breathing. Her eyes were open and fixed, but her face turned deadly pale ... SHE WAS DEAD. Mrs. Linnell closed her eyes. The last I saw of her dear gray eyes was in the afternoon, when I watched them. The lids closing a little over them made it seem like a mournful and clouded sunset. She had appeared for the most part unconscious for two or three days, but on the morning of the day she died Anny was going to bed, when she held up one trembling arm and then the other. Anny put her head down between them, when she held her tightly round the neck for about a minute, and seemed to be thus taking a last leave of her mother. She had done so to me about two days before. She bore her sufferings and took her physic with the greatest patience, saying in the early part of her illness. 'I will take it to please you, dear Papa,' and sometimes said the same to her Mama before I came up.[52]

At the burial, at Nunhead Cemetery of All Saints, Palmer was supported by John Giles. For some time afterwards kindly Edward Calvert spent every evening with Samuel and Hannah, and nearly fifteen years later Palmer remembered his stoical sympathy, drawn from his naval experiences: 'Life is like the deck of a line of battle ship in action – there is no knowing who will go next.'[53]

Hannah's grief was a torment, and she dwelt with melancholy on every relic; she had plaster casts made of the child's hands and made a cushion cover out of her clothes. The atmosphere of the house in Grove Street had become too poignant for the Palmers to continue living there; for Samuel, besides Mary Elizabeth's death, it held painful memories of the death of Mary Ward. Moreover he had never been free of asthma in Grove Street. So they began to search for a new house, bearing in mind the six-year-old Thomas More's educational needs and the proximity of Palmer's pupils.

A little picturesque cottage was found that seemed to suit them, 1A Love Lane (later renamed Victoria Road), Kensington, then separated from London by open country. Its appearance may have helped temporarily to remind Palmer of the 'primitive cottage feeling' of years before. It was only threequarters of a mile from Porchester Terrace, so Hannah's strong homing instincts were not stretched beyond endurance. She began to sketch again, and often visited Kensington Gardens. In an undated letter to her father, she described the idyllic prospect of the place: 'I sit and think of you every morning under the cedars in Kensington Gardens. The sheep so tame that they come all round us and the birds singing gloriously overhead. I take my work and my camp-stool and we are out 3 hours every morning.'[54]

In the summer of 1848 Palmer toured Cornwall and Devon, sketching; this was probably when he made his studies for *Tintagel Castle, approaching Rain* (illustration 63). The customary proselytizing letter was sent to Thomas More. After describing the grandeur of Cornish scenery, Palmer told the boy that he was old enough to check himself when he wanted to sin, and once more used emotional weapons on him:

The hand which is now writing this letter must before many years have passed away be stiff and cold in the grave – and you will then perhaps remember how earnestly I longed that you might grow up and be a good and holy man and how we used to pray together ... that the Lord would make you so. O! try hard – for it is worth the struggle – dear Mary is praying for us that we may go and be with her always.[55]

Another letter, written from Devon during August, warns Thomas More that cruelty to flies and insects grows into cruelty to cats, then dogs and horses, 'and to their fellow creatures. Sometimes they finish all by Murder, for which they are themselves hanged on the gallows. So I hope my dearest boy that you will keep watch upon yourself – NOW – while yet so young.'[56]

A letter to Calvert from the same tour affords a pleasant if muted reminder of Palmer's capacity for fresh observation and spontaneous enjoyment. He writes of the pleasures of the country around Plymouth and farther afield, in Devon;

recalls earlier days; and ends with a tribute to the north Cornish coast and to Tintagel Castle, which was 'a mouldered ruin in the days of Henry the Eighth':

Some turreted fragments which remain are very quaint and strange. I found the people, as you said, very human and civilized; spending a very pleasant week in a lone cottage among the hills, close to a rocky, sea cove. The goat was milked in the kitchen, and two pigs always came in to be scratched the wrong way of the bristles. It seems with them a pleasure equivalent to honours and titles among mankind.[57]

To Hannah he wrote with great tenderness, with something of the honeymoon affection of their Italian days. It is a piquant moment, for love was soon to turn to discord. 'Your charms my dear Annie are no weak inducement to lure me back. To me you are fairer than at 17 and though by this time I have got pretty well used to your scolding your love is always fresh and always precious. I hope to prove myself worthy of it by renewed exertions in Art.'[58] With hindsight, his son commented: 'Deluded dreamer!'[59]

The year 1848 ended with a further bereavement, for Samuel's father died on 17 December, aged seventy-three. 'The first gush of tears', he wrote, 'came with the thought, "How he loved my childhood's soul and MIND – how he laboured to improve them, sitting in the house and walking in the fields!".'[60] Next year Henry Walter died at Torquay. Palmer was too harassed by work to attend his friend's funeral. 'I wish I *could* get down to poor dear Mrs Walter,' he wrote to George Richmond, 'but I can see no way of escape as I have begged off and begged off with pupils, faithfully promising after the exhibition work to go on regularly – and fixing the days – in fact I am MISERABLY HAMPERED'.[61]

Summer 1849 found Palmer once again in Devon, proceeding 'very leisurely; no luggage, but one spare shirt. Sketching portfolio with *thin* plate-paper, and Richard and Wilson's thin brown paper, which would weigh lightly. In pocket, case of pencils and black and white chalk, and the three chromes, and blue and browns for slight indications of local colour on the brown paper.'[62] To Richmond, who had hoped to join him, he expressed his pleasure at the prospect of seeing his friend, and mentioned that lodgings were available; but he was not at all well, and

though I should be glad to see you here and really think the place beautiful yet I am now arrived at that stage of infirmity which prevents my imparting pleasure to any one, having nearly lost the use of my legs – and perhaps the use of speech from want of practice. I crawl out with a boy to carry my things (being so weak) and crawl back again – *walking is out of the question* – I *must* stay a week longer to complete the few scraps I have in hand, and had desired then just to get a peep at Watermouth near Ilfracombe – but that will now be I fear out of the question – as my holidays are nearly up – only a fortnight left –

Soon, however, he felt better and was able to sail 'round as far as Ilfracombe – waterfall into the sea – then back, and landed at Combe Martin, walking home to Berrynarbor'. He also saw a little of 'South Devon – loveliest of lands!

And, but for the rain, we should have tracked its infinite richness, till it becomes the enamelled footstool of Dartmoor.'[63]

෨෬

Cornwall and Devon provided Palmer with a variety of subjects, and his accounts of them range from simple drawings in pencil and charcoal, amply demonstrating his continuing excellent draughtsmanship, to more developed studies such as *The Rock Slip near Boscastle* (Yale Center for British Art; illustration 62), *Backways, near Tintagel, Cornwall* (two studies, private collections, England), and the magnificent *Tintagel Castle, approaching Rain* (Ashmolean Museum; illustration 63). Closely related to the latter is the smaller *View at Tintagel* (British Museum), which was probably used as a study for it, taken from a somewhat different viewpoint. In *Tintagel Castle, approaching Rain* Palmer shows the deep influence of Turner, which becomes evident when the

62 *The Rock Slip near Boscastle*, 1848. Watercolour over black chalk, heightened with white, on paper; 241 × 270 mm (Yale Center for British Art, New Haven, Connecticut, Paul Mellon Collection)

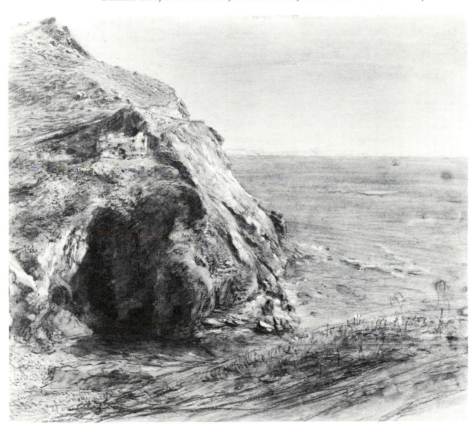

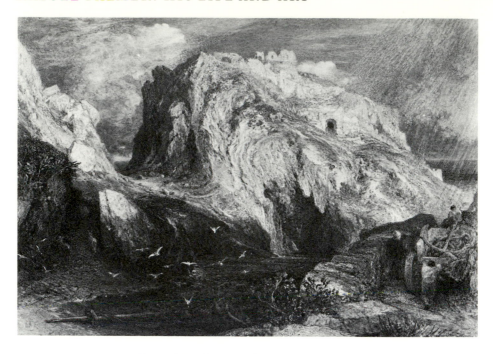

63 *Tintagel Castle, approaching Rain*, 1848. Watercolour mixed in places with gum, over traces of pencil and black chalk, on paper; 302 × 440 mm (Ashmolean Museum, Oxford)

portrayal of meteorological effects and rocky landscape is compared to Turner's in such works as the plate of Tintagel in *Picturesque Views of the Southern Coast*, engraved by George Cooke.[64] But Palmer has transformed Turner's influence, as he transformed that of Claude, Ruisdael and others, into a *coup d'œil* chiefly characteristic of himself.

As Palmer wrote to Edwin Wilkins Field (1804–71), the law reformer and amateur artist: 'It strikes me that Turner injured his grand version [of Tintagel] by unreality in the rocky bluff.'[65] Palmer's version aims at a more accurate representation of the landscape, at the same time using his continuing dotting and dappling to impart his own view of the many textures. Yet for Palmer accuracy did not imply photographic verisimilitude; in the same letter, discussing Blake's engraving of *The Canterbury Pilgrims*, he gives further indications of his own views on visual reality and what they implied:

How we feel and love the integrity of a work through all its parts. When a matter of fact man looks at that print he says 'What horrid horses! – horses in Chaucer's time were like horses now, were they not?' Quite true – yet substitute orthodox animal painters' horses – and it would be a righteous artistic Auto de Fe to throw the thing horses and people and all into the fire.

Something of the same kind may be said of Claude's cattle; yet Richard Wilson warning a friend against quacks, bade him never listen to a man who laughed at Claude's cattle.

View of Clovelly, Devon (Metropolitan Museum of Art, New York; illustration 64) and the now untraced pencil studies *In Clovelly Park* and *Mouth Mill, near Clovelly, North Devon*[66] are among other sensitive studies probably made in Devon in 1849. There is also a page of *Memoranda of Sunsets on the Devon Coast* (The Art Museum, Princeton University), on which profiles of the coastline and shore are drawn with rapid, direct and broad brush strokes *au premier coup* (applied without further preparation), and considerably annotated. In most of these studies there is at least a resemblance to Palmer's work during the late Shoreham years and the period before he visited Italy. In *View of Clovelly* in particular, the handling of the pencil and wash recalls that in such studies as *Mountains near the Traveller's Rest, Dolgellau, North Wales* (Yale Center for British Art) and *Culbone, Somerset* (National Gallery of Victoria, Melbourne; illustration 65), both made in 1835.

Of finished works of this period, one of the most interesting is *Farewell to Calypso* (Whitworth Art Gallery; illustration 66), because of its obvious debt to Claude: it recalls the designs *Coast Scene with the Rape of Europa*, *Coast Scene with the Landing of Aeneas* and *Sea Coast with Christ calling Andrew and Peter*.[67] In each of these the composition consists of a hollow foreground seashore in a bay flanked by trees, with a ship or ships as central motifs; the resemblance is

64 *View of Clovelly, Devon*, 1849(?). Pencil and brown wash on paper mounted on card; 270 × 380 mm (Metropolitan Museum of Art, New York)

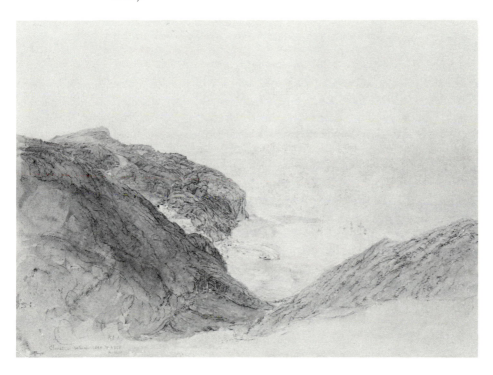

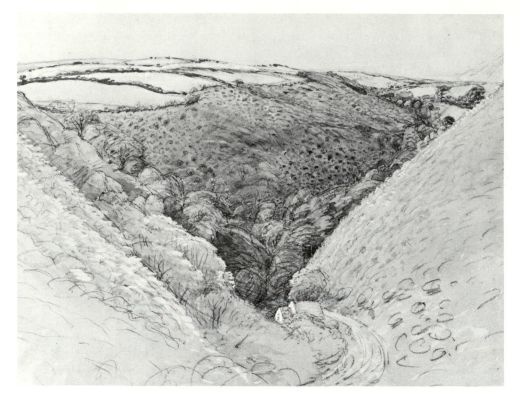

65 *Culbone, Somerset*, 1835. Charcoal, watercolour and body colour on paper; 292 × 387 mm (National Gallery of Victoria, Melbourne, Victoria, Australia)

clearest in *Sea Coast with Christ*, in which the gesticulating figure of Christ resembles, in pose and position (though on the opposite side of the composition), Palmer's Calypso. In addition Palmer has adopted a compositional device frequently used by Claude, a series of planes or *coulisses* to lead the eye, as in stage scenery, into the distance. In *Farewell to Calypso* besides a slope at the left (itself a frequent feature of Palmer's compositions), there is another, rather more distant, at the right, and two more planes in the farther distance, indicated by light washes. It is interesting that Palmer was dissatisfied with this work and in his notebook admonished himself to 'Forswear HOLLOW Compositions like *Calypso* ... and forswear great spaces of sky.'[68] He was right; this is one of his less successful pictures, and his work is always better in tighter compositions, like *A Farmyard near Princes Risborough* (illustration 59) and *Tintagel Castle, approaching Rain* (illustration 63).

 During these years Palmer began to develop the narrative content of his work, following a fashionable trend. Whether he really liked this ingredient in his paintings, or included it mainly with a view to sales, is not possible to determine. But the fact remains that with few exceptions, his best work has

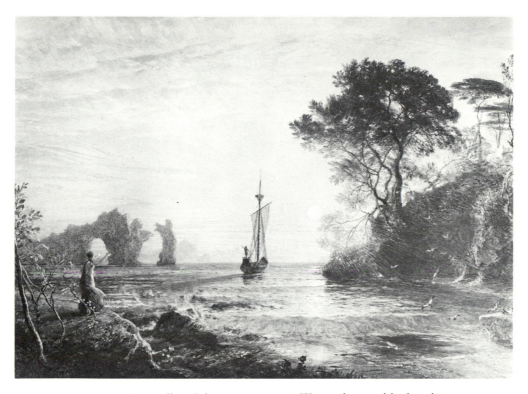

66 *Farewell to Calypso*, 1848 or 1849. Watercolour and body colour with touches of gum and gold paint, on paper; 528 × 744 mm (Whitworth Art Gallery, University of Manchester)

little if any narrative content. Here and there it occurs in some above-average works, such as *Evening* (*circa* 1848; private collection, England) and *Crossing the Ford* (1846; collection of M. J. Barclay Esq.), which are realized in brilliant and finely controlled technique. The story-telling component is not particularly strong – especially when compared with the narrative paintings of artists such as Ford Madox Brown (1821–98) and Richard Redgrave (1804–88) – the main concentration being on the landscape; but it gives *Evening* considerable charm. A father, scythe over his shoulder, returns from work with his dog, while two of his young children run to greet him, and his wife, in the light coming from their cottage, guides a baby's unsteady footsteps towards him. In other works of the late 1840s, for example *A Gypsy Encampment* (National Gallery of Scotland; illustration 67) and several studies of harvesters at work, narrative adds little to the conception, the figures being little more than staffage.

Palmer seems to have had no special gift for inventing narrative interest. But when narrative was provided by favourite works of literature, he responded powerfully, and in his final years much of his output derived from such sources. From the late 1840s on, his discerning and wide-ranging reading bore fruit in

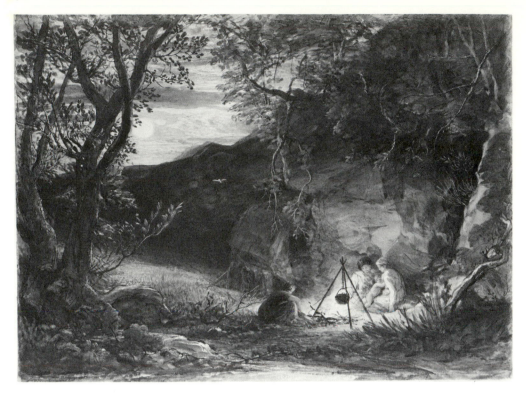

67 *A Gypsy Encampment*, 1847 or 1848. Watercolour and body colour on paper; 384 × 513 mm (National Gallery of Scotland, Edinburgh, Helen Barlow Bequest)

many works. Spenser's *Faerie Queene* gave rise to the watercolour *Sir Guyon with the Palmer attending, tempted by Phaedria to Land upon the Enchanted Islands* (1849; private collection) and Defoe prompted *Robinson Crusoe guiding his Raft into the Creek* (1850; City Museum and Art Gallery, Stoke on Trent). One of the most spectacular early manifestations of this development is taken from an especially influential work, Bunyan's *The Pilgrim's Progress*: *Christian descending into the Valley of Humiliation* (1848; Ashmolean Museum; illustration 68). It illustrates the point when Christian has left the Palace Beautiful and is setting out down the mountain path into the Valley of Humiliation, beyond which is the Valley of the Shadow of Death. He is looking back at the tower of the palace; behind it in the distance, picked out by a shaft of sunlight, is the walled town where he began his pilgrimage. The Delectable Mountains, with sheep grazing on their slopes, lie between the town and the palace. Beyond the valleys a promising bar of light shows from beneath the heavy and portentous clouds. It is a large work – 519 × 714 mm – but Palmer has managed it with great skill. Overall the design owes much to the threatening and rocky landscapes of Salvator Rosa.

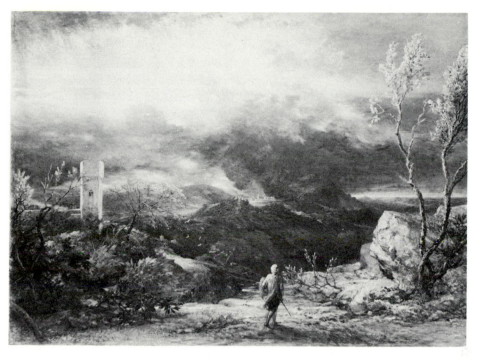

68 *Christian descending into the Valley of Humiliation*, from *The Pilgrim's Progress*, 1848. Watercolour and body colour mixed in parts with gum and touched with gold, on paper; 519 × 714 mm (Ashmolean Museum, Oxford)

Yet at this period Palmer's best work is still pure landscape: the powerful *Tintagel Castle, approaching Rain* (illustration 63), *View of Box Hill, Surrey* (collection of the late A. A. Miller Esq.; illustration 69), *At Redhill* (Ashmolean Museum), and quickly executed little watercolours, painted *au premier coup*, such as *A Double Rainbow* (1847; City Art Gallery, Temple Newsam House, Leeds) and *Landscape with setting Sun* (collection of Dr Milo Keynes). In these sketches he draws near to the Shoreham spirit; they may be paralleled with such late Shoreham works as *Bright Cloud and Ploughing* (*circa* 1832–3; City of Manchester Art Galleries; illustration 70) and *Drawing for 'Landscape Twilight'* (*circa* 1833; Victoria and Albert Museum). Further, Palmer's continuing use of dotting and dappling again illustrates the continuity of his technique.

Palmer's fortune declined in inverse ratio to that of his father-in-law; Linnell was now a rich man. He was dissatisfied with his Porchester Terrace house and with the Bayswater district in general. His prosperous and expanding 'business' as a painter enabled him to realize his dream of building a large country

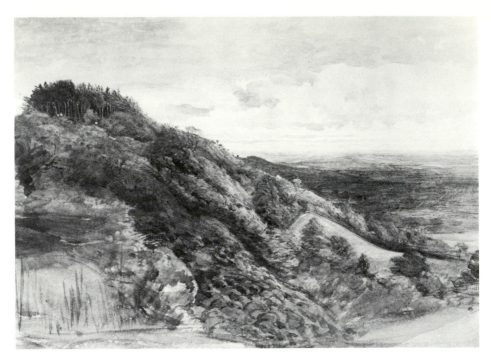

69 *View of Box Hill, Surrey,* 1848. Watercolour on paper;
260 × 368 mm (collection of the late A. A. Miller Esq.)

70 *Bright Cloud and Ploughing, circa* 1832–3. Brown wash on paper;
sight size 93 × 111 mm (City of Manchester Art Galleries)

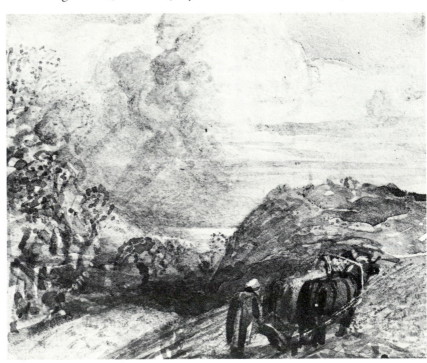

house surrounded by its own land. To achieve this he acquired a property at Redstone Wood in Surrey, on which he built a house, using the same method of agreements and barter as he had used for the Porchester Terrace house. It contained two studios on the first floor, each 40 feet long (and separated by a lobby full of plaster casts, and a lavatory); one was for Linnell's use, the other for his sons. There was also a large library, and a drawing-room 60 feet long that could be divided into two by a folding partition. The well-wooded grounds were beautiful, and became something of a bird sanctuary; lawns and flowerbeds near the house merged imperceptibly into the landscape. The Linnells moved into the Redstone Wood house on 15 July 1851.

5 A harvest of tragedy

The Palmers did not stay long in Victoria Road. One important factor deciding them to move again was the rapid deterioration of the district. Where there had once been orchards and hayfields, there were now crops of stucco-encrusted terrace houses; fragrant meadows had given way to stinking sewers and the peaceful drone of bees to the shrill squeaks of cockroaches. Moreover the Victoria Road cottage was itself inconvenient and in a state of disrepair; an old friend of the family remembered Hannah's warning to walk carefully in case the floor should give way and precipitate her into the cellar.[1] But probably the main reason for the move was that Hannah was developing ideas of gentility, for which the cottage provided an incongruous setting.

They eventually found a house in a nearby cul-de-sac where the decline of the district was at least less evident: 6 Douro Place, to which they moved in 1851. In itself it really was little better than the cottage. It was too small to allow Samuel a studio, and for a workroom he had to use what had previously been a front drawing-room looking out on to a row of dreary houses. It did have the southern aspect which Palmer preferred to others, but if he wanted a breath of fresh air, he had to lean out of an attic window.[2] All this was made worse by the fact that, because of pupils, he could rarely escape into the country. And modest though the cottage was, the rent was higher than in Victoria Road.[3]

These disadvantages were exacerbated by Hannah's insistence, probably prompted by the splendours of Redstone Wood, on replacing the simplicity of their life with a more stylish routine. She engaged two servants – necessary perhaps, given the many pupils who visited the house and added to the domestic work, but a necessity Palmer would willingly have dispensed with. Moreover Hannah, like her mother, was a poor manager. She was far from frugal, she did no housework, and she spent much of the day exchanging polite calls and writing letters – the occupations of a woman of means. She also devoted time to fine needlework, determined to maintain her appearance in fashionable Kensington despite her inadequate dress allowance.

The household was further upset by the series of miscarriages which undermined Hannah's health during the 1850s. However, one pregnancy was successful, and their third and last child, Alfred Herbert, was born on 25 September 1853; he was named Alfred after the king and Herbert after George Herbert, the seventeenth-century religious poet.[4] Palmer once hinted that the

second name was given on Linnell's instructions,[5] though in view of Linnell's Nonconformity it seems odd that he should have chosen to name his grandson after a divine who so prominently espoused the Church of England.

Herbert was a sickly child for at least the first year of his life, and in 1855 he was seriously ill. 'We have indeed much reason for thankfulness', wrote Palmer to Mrs Richmond during his recovery, 'when after fever and insensibility we see our poor Herbert amusing himself with his old playthings and playing his old tricks.'[6]

૨૭

In his painting during the 1840s and 1850s Palmer continued along much the same lines as he had been following since the Italian visit. He even painted one or two oils, such as *View of Box Hill, Surrey* (1848; Galerie Jan Krugier, Geneva), but most of these have disappeared. A large quantity of canvases, stretchers, panels and pictures in various stages of completion were found in the house after his death, and there seems little reason to doubt that they were part of the bonfire A. H. Palmer made of his father's effects at Sennen in Cornwall in 1909 before he left England to live in Canada. This destruction included sketchbooks, notebooks and original works, and lasted for days. A. H. Palmer gave his reason for it in a letter to Martin Hardie: 'On the eve of starting for Canada, I burnt, on the Carn [at Sennen], a great quantity of my father's handiwork — handiwork which he himself valued more than that work which the public could understand. Knowing that no one would be able to make head or tail of what I burnt; I wished to save it from a more humiliating fate.'[7]

As with all his ideas and plans, Palmer made copious notes about oil painting and its technique in a special book; for these particular notes he drew on discussions with his deaf and dumb friend John Reed, an expert in oil painting, who was godfather to Alfred Herbert. For example:

Mr R[eed] most kindly painted in one day before me an oil sketch from my 'Margate' sunset — the mottled sky — to *show* me his method and processes, of which he had before, with the same kindness, imparted the general principles. His sketch seemed to me to possess some of the finest qualities of Venetian painting; and some of those points on which, before, I had felt doubtful (particularly the cool reds and the heightenings with white, afterwards toned, during the progress of the work), I saw to be important points of a great scientific whole.[8]

'"Margate" sunset' refers to *The Water Mill* (1848; Ashmolean Museum), which has a mottled sky of a kind Palmer called 'Margate mottle' because he began to use the effect there.[9] John Reed's techniques were not always reliable: in a letter to George Richmond in August 1866, Palmer described how an oil picture that Reed painted one evening flaked off the ground during breakfast the next day.[10] Later Palmer added some comments to his observations of Reed's handling of colour:

Inferences from the following combined with my own notion. A brilliant white ground. First painting, white, black, and grey. A little copal and spike oil, with very stiff white, painted freely and boldly with hog-tools [hog's-hair brushes], so as to get a permanent thread and texture, from which the successive paintings should become less and less impasted, filling up to a rich, solid, waxy, surface (in appearance). Second painting by various means got up to the intended colouring as soon as possible, only cooler than intended, and the blues and greys kept very fresh.[11]

Notwithstanding vexations and shortcomings in his personal affairs and personal relationships and in his health, he continued to maintain his artistic ideals and subject them to minute scrutiny:

Never hurry for exhibitions … What are the secrets of a proper rapidity. 1st? Decision in the first design – seeing the *whole at once*. Trying after indicative formation of the central difficulty. After a studious and careful preparation, instead of aiming at finish aim to execute the mental vision with as little manipulation and as much inventive energy as possible; doing only what I see … A more large and general system of study from nature; less task-work and fatigue. Investigation of effects, WAITING till they present themselves; then trying to catch them thus:

1st. (A) A very small sketch of the Proportion of Darks in pencils or chalks: (B) A small coloured sketch of the same, merely for use, but the more complete the better as a *specimen* of the class of effect. Have an eye to the above this year, D.V., but let the ETCHING be the point of most painstaking.

2nd. Sunsets or the like on some bold principle, or one sunset and one moon and firelight of the same story. Look carefully over Devon and Cornwall sketches for smaller subjects.

A deep, Gray Day a good subject. Coincident with other things will be an attempt at a New Style …

Why do I wish for a NEW STYLE? 1st. To save time. 2nd. To govern all by broad powerful chiaroscuro. 3rd. To ABOLISH all NIGGLE. The MEANS. 1st. To work from a bold sepia sketch carried on so far that figure and everything should be already decided. 2nd. Not to be solicitous about the brightness of little specks of light, so as to hinder the full sweep of a great brush by which should be attained the full and right effect at a distance.

My chance of standing with others in execution will be to find my way to it by certainty of effect and parts in first design. 2ndly. By not in any way evading *FORM*. 3rdly. by painting with large and broad gradation (v: Gaspar Poussin), suggesting minutiæ by large work. NEVER FORGET TINTORET's scheme of CAST SHADOW.[12]

Not only did he analyse his work and his motives, but he constantly drove himself to work harder, with an almost joyful embrace of a bleak regime.

I have risen at 7 – breakfasted at ½ past … so I have begun, in a small way, to reform, and mean to get it all half an hour earlier if I can, and to keep to it inflexibly, so far as I am concerned … Of all things, early bed and early rising are most distasteful to me; but believing myself to have been ill-used and unjustly neglected as an artist, as well as in many other ways, I am willing to tax my strength to the uttermost to benefit my family; and, perhaps, by not over rating my own powers of will but cultivating them to the last, may make this house a model of morning industry.[13]

But of a 'new style' there was little noticeable evidence at this time. His work continued to develop as it would probably have done in any case. There are, it is true, such exceptions as *The Piping Shepherd* (*circa* 1855; Ulster Museum; illus-

tration 71), in which a high finish is combined with broader brushwork than had usually been evident before. And a little later there was a persistent tendency to use bright, hot colouring, perhaps inspired by memories of effects of Italian sunlight, as in the big watercolour and body colour composition *A Dream in the Apennine* (1864; Tate Gallery; illustration 72) and *The Sleeping Shepherd* (*circa* 1857; Fitzwilliam Museum; illustration 73). Apart from these considerations there was no sudden change.

Palmer's greatest step forward in art at this period was not in painting but in etching, and in this he ultimately recaptured a measure of the visionary outlook of his younger years. It is obvious that he realized this himself when in the note quoted above he said 'let the ETCHING be the point of most painstaking'. He had considered suitable subjects as early as 1849, during another tour of Devon and Cornwall. 'I ought', he said, 'to watch the operations of husbandry. The MONTHS would make a good book of etchings.'[14] His first etching was completed in 1850. Entitled *The Willow*, the small design (90 × 67 mm) was based on the reversed composition of a watercolour of the same subject painted at about the same date (City of Manchester Art Galleries; illustration 74). It is a pleasing little work, but not one of great originality; however, on the strength of it Palmer was elected a member of the Etching Club on 19 February 1850. A non-exhibiting society, this was an exclusive association of professional etchers, among whom were several academicians. At a time when the art was little regarded in Britain, these practitioners pooled their resources to publish periodical collections of etchings, some of them miscellanies but more often with a common subject or theme, such as *Songs and Ballads of Shakespeare*, Milton's *Il Penseroso*, and Goldsmith's *The Deserted Village*. Any profits were allocated by ballot. Palmer was elected to the Club after he had been admonished by Thomas Creswick for ruling some of the lines in the sky instead

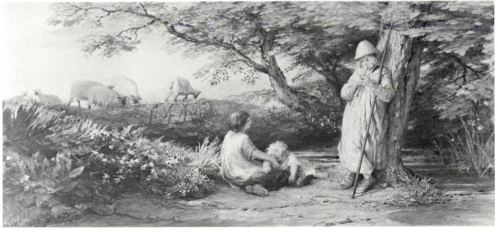

71 *The Piping Shepherd, circa* 1855. Watercolour and body colour on paper; 185 × 399 mm (Ulster Museum, Belfast)

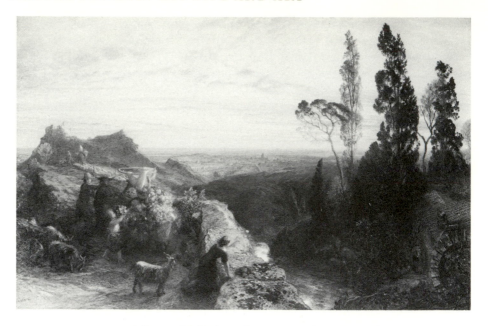

72 *A Dream in the Apennine*, 1864. Body colour and watercolour, with traces of glue, on paper mounted on panel; 660 × 1015 mm (Tate Gallery)

of making them freehand.[15] *The Willow* gave Palmer an opening into a new and vital means of expression, and one that was to lead to some of the best work of his maturity.

As with every artistic venture he undertook, Palmer went into the technique of etching with great thoroughness and attention to detail. Nevertheless there were so many difficulties that even his almost limitless patience was tried; at first his attempts were 'a scramble of uncertainties from beginning to end'.[16] But in time he overcame the problems and learnt to turn even accidents and mistakes to good purpose. Recalling his work on the etching *The Skylark* (1850; illustration 75), he wrote:

I used to sit down to etching with becoming gravity, though the work had sometimes a rather negative bearing; for I remember once spending a whole day in nearly burnishing out a sky that was overbitten. The perverse acid *would* bite skies and nothing else; but being spared to attempt another, I humbly trust to go half through the copper.[17]

Among the worst of his troubles were those arising from printing from the etched plates. He never mastered this part of the art and was constantly driven to distraction by attempts of the trade printers who printed them for the Etching Club editions. Of his own attempts to take proofs of his etching *The Morning of Life* (begun 1860–1; illustration 76), he wrote:

I spent several days working and proving in London in a ghastly frame of mind, owing, for once, not to my own clumsiness, but to the detestability, both as to thinness and quality, of

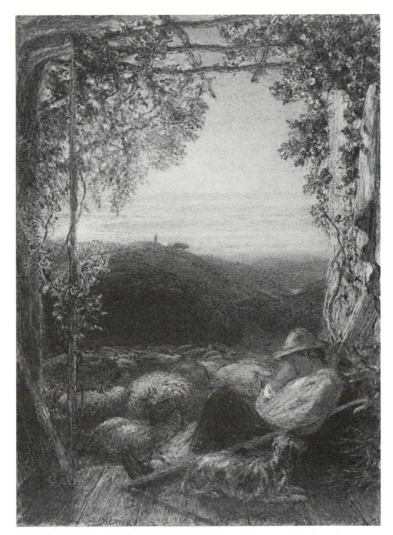

73 *The Sleeping Shepherd, circa* 1857. Watercolour and body colour on paper; 245/248 × 178 mm (Fitzwilliam Museum, Cambridge)

the old, scraped, Club copper on which [my etching] was done. I gave myself up for lost on Saturday at 5.30, but, by a desperate perseverance, had singed the last neck of the hydra by 6.15 ... My wretched plate bent up like an earwig disturbed in an egg-plum.[18]

Later the printing problems were overcome, but for many years the difficulties continued.

Palmer held strong views on every aspect of etching: retroussage, for example. This is the process in which the lines of an inked plate are strengthened and enriched by lightly laying a piece of folded muslin on the surface before taking an impression, so as to draw up the ink. He had considerable reservations about the

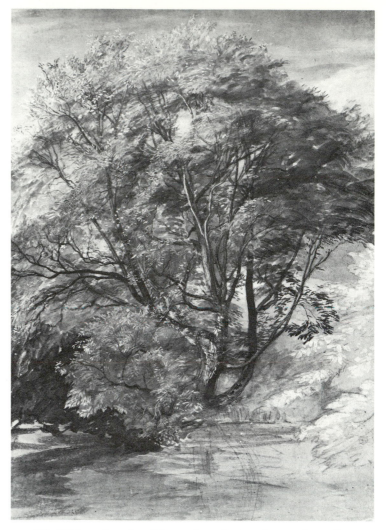

74 *The Willow, circa* 1850. Watercolour, body colour and pencil on
paper; 370 × 265 mm (City of Manchester Art Galleries)

extent to which this ought to be used, as he wrote to his friend Thomas Oldham
Barlow, the etcher and mezzotint engraver:

For myself I doubt whether etching in the old sense of the word is not almost superseded by
the new art of *retroussage* added by the printer upon a comparatively slight fabric. Some-
times it has been very effective, but, in most instances, is so inferior to linear etching as to
become quite another art: but then, as it produces an effect quite as satisfactory to the public
eye in about one fifth of the time, it beats linear etching out of the market. It seems to me
that the charm of etching is the glimmering through of the white paper even in the shadows;
so that almost everything either sparkles, or suggests sparkle. Now this is somewhat like the
effect of a purely white ground under an oil painting. The *demonstrable* difference may be
small, but the real deterioration of a dark ground is universal; and not to quote irreverently,

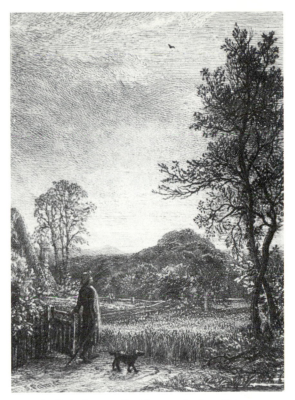

75 *The Skylark*, 1850. Etching; etched surface 95 × 73 mm (private collection, England)

76 *The Morning of Life*, 1860–1. Etching; etched surface 136 × 206/208 mm (private collection, England)

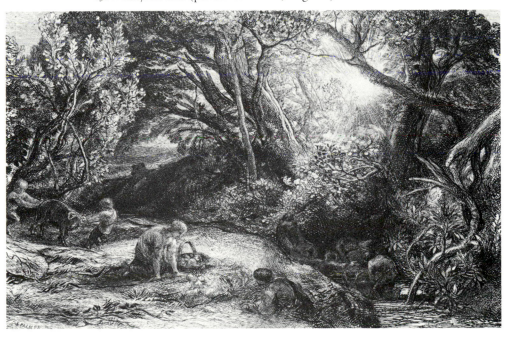

is 'a darkness that may be felt' [Exodus x, 21] if it cannot be proved. Well, *retroussage*, if not kept within narrow bounds, extinguishes those thousand little luminous eyes which peer through a finished linear etching, and in those of Claude are moving sunshine upon dew, or dew upon violets in the shade.[19]

'Those thousand little luminous eyes' recalls the continual use of dotting and dappling in Palmer's paintings and drawings, and shows that he was thinking of etching in similar terms. Of his painstaking work on his etched plates, A. H. Palmer said that

Those who have seen him sitting, sable in hand, hour after hour behind the tissue paper, pencilling in varnish silver cloudlets round a moon; or have seen him revelling in the ferocity of the seething mordant with which he sometimes loved to excavate an emphatic passage will not wonder that he achieved only thirteen etchings; and they will think, perhaps, that the measure of his celebrity, in this his favourite branch of art, is well deserved.[20]

The first half-dozen of Palmer's thirteen etchings are small: *The Willow, The Skylark, The Herdsman's Cottage* (illustration 77), *Christmas, The Vine* (two small subjects on one plate; illustrations 78 and 79) and *The Sleeping Shepherd* (illustration 80). All have a gentle pastoral poetic quality comparable with work done at Shoreham, especially *Christmas* and *The Sleeping Shepherd*.

The subject of *The Skylark* was inspired by two couplets from Milton's *L'Allegro*, one of Palmer's favourite poems:

> To hear the lark begin his flight,
> And singing startle the dull night,
> From his watch-towre in the skies
> Till the dappled dawn doth rise.

(Lines 41–4)

In this etching Palmer is to be seen working on similar lines to designs of John Constable: it shares details with Constable's *Cottage in a Cornfield* (Victoria and Albert Museum), which was reproduced in 1845 in a mezzotint by David Lucas that Palmer may have seen. It is more likely that the similarities are fortuitous, but they show a similarity in outlook.

Christmas was likewise inspired by verse, in this case a sonnet by John Codrington Bampfylde:

> With footsteps slow, in furry pall yclad,
> His brows enwreathed with holly never sere,
> Old Christmas comes to close the wanèd year,
> And aye the shepherd's heart to make right glad;
> Who, when his teeming flocks are homeward had,
> To blazing hearth repairs, and nut-brown beer;
> And views well pleased the ruddy prattlers dear
> Hug the grey mongrel; meanwhile maid and lad
> Squabble for roasted crabs. Thee, sire, we hail,
> Whether thine aged limbs thou dost enshroud
> In vest of snowy white and hoary veil,

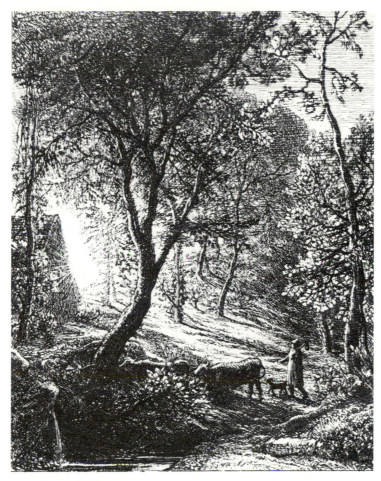

77 *The Herdsman's Cottage* or *Sunset*, 1850. Etching; etched surface
97 × 76 mm (private collection, England)

> Or wrapp'st thy visage in a sable cloud;
> Thee we proclaim with mirth and cheer, nor fail
> To greet thee well, with many a carol loud.

This etching shows the continuing influence of William Blake on Palmer, for
there are several points of comparison with No. XVII of Blake's *Pastorals of
Virgil* wood-engravings. The pose of Palmer's shepherd folding his last sheep
resembles that of the elder shepherd in Blake's design, and each has a cottage
and a sheep-pen, though differently positioned. Another similar shepherd
figure appears in Blake's wood-engraving No. V.

The Vine or *Plumpy Bacchus* illustrates lines from Shakespeare's *Antony and
Cleopatra*:

> Come thou monarch of the Vine
> Plumpy Bacchus with pink eyne:

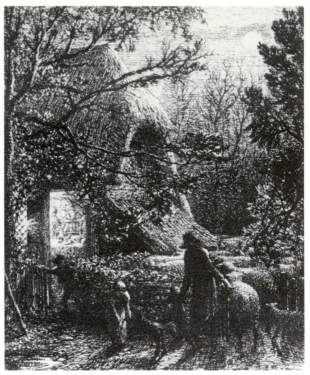

78 *Christmas* or *Folding the Last Sheep*, 1850. Etching; etched surface 98 × 81 mm (private collection, England)

> In thy vats our cares be drown'd;
> In thy grapes our hairs be crown'd;
> Cup us till the world go round;
> Cup us till the world go round!

(Act II, scene vii)

It contains an unusually hedonic element, more apparent here than in any other work by Palmer. The subject and treatment may have been suggested by the wood-engraving *The Cyder Feast* by Edward Calvert (1828),[21] which has a similar theme of tipsy abandon.

The Sleeping Shepherd approaches the Shoreham spirit very closely, in both subject and conception. When he was working on it, Palmer probably remembered much of the pastoral literature he had read, especially the passage from Milton's *L'Allegro*:

> ... the Plowman neer at hand,
> Whistles o'er the Furrow'd Land,
> And the Milkmaid singeth blithe,
> And the Mower whets his sithe,
> And every Shepherd tells his tale
> Under the hawthorn in the dale.

(Lines 63–8)

COME, THOU MONARCH OF THE VINE,
PLUMPY BACCHUS, WITH PINK EYNE,
IN THY VATS OUR CARES BE DROWN'D,
WITH THY GRAPES OUR HAIRS BE CROWN'D,
CUP US TILL THE WORLD GO ROUND;
CUP US, TILL THE WORLD GO ROUND'

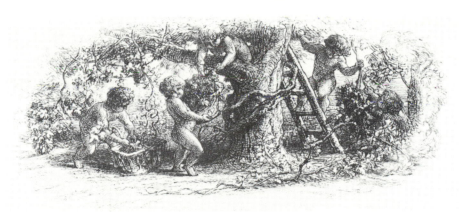

79 *The Vine* or *Plumpy Bacchus*, 1852. Etching; upper subject
89 × 127 mm, lower subject 57 × 110 mm (private collection,
England)

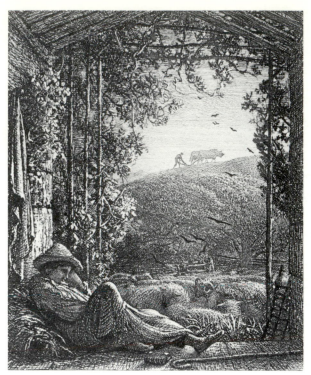

80 *The Sleeping Shepherd*, 1857. Etching; etched surface 95 × 78 mm
(private collection, England)

The little book lying on the ground beside the shepherd's foot may well be an
affectionate reference to the volume of Milton's poems, published by Jacob
Tonson, which Mary Ward gave to Palmer on her deathbed. A. H. Palmer
described this book in his *Memoir* of his father; it was an 'inseparable
companion', 'a duodecimo edition of Milton's minor poems, strongly bound
with brazen clasp and corners, with the intent of being constantly carried in the
pocket. As this little volume lies now before us, the smooth and rounded brass
and darkly polished leather binding, speak of the twenty years during which it
accompanied its owner everywhere.'[22]

The last of Palmer's early etchings, *The Rising Moon* (1857; illustration 81) and
The Weary Ploughman (1858; illustration 82), are both larger compositions than
those which preceded them; they mark the beginning of Palmer's greatest etched
work (discussed below, pp. 222–4). Each shows Palmer re-experiencing some
of the emotions of his early visionary work. The moon-drenched landscape and
the shepherd in *The Rising Moon* recall those in the intense Shoreham work
Cornfield by Moonlight, with the Evening Star (illustration 22), while the group of
cypresses at the right is probably a memory of those Palmer drew at the Villa
d'Este. The sub-title of *The Weary Ploughman, Tardus Bubulcus*, is a reminder of
the opening of Thomas Gray's *Elegy in a Country Churchyard*:

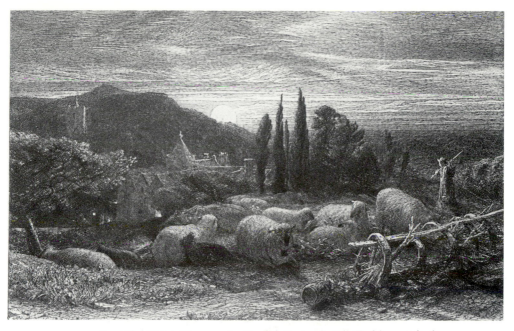

81 *The Rising Moon* or *An English Pastoral*, 1857. Etching; etched surface 117 × 190 mm (private collection, England)

82 *The Weary Ploughman* or *The Herdsman* or *Tardus Bubulcus*, 1858. Etching; etched surface 132 × 200 mm (private collection, England)

> The Curfew tolls the knell of parting day,
> The lowing herd wind slowly o'er the lea,
> The plowman homeward plods his weary way,
> And leaves the world to darkness and to me.

In both these works the snug clusters of buildings are recollections of Shoreham. The distant landscape in *The Rising Moon* is perhaps a memory of Wales, and that in *The Weary Ploughman* of Devon. Each, too, contains passages with the 'thousand little eyes', built up of dotting, dappling and hatching. In both the sky is brilliantly handled; in *The Weary Ploughman* it is full of drama – even Turner could hardly have achieved more in black and white.

In his middle and old age, etching helped Palmer to artistic salvation, but before that he had to face many personal misfortunes. Among them was near estrangement from Hannah who, since their return from Italy, had fallen progressively more deeply under her father's influence. It has been claimed that Linnell's prime concerns were to wean Hannah from the influence of the Church, to bring her back to Nonconformity, and to undermine Samuel's authority.[23] This cannot be wholly true, because in that case Linnell would hardly have given his daughter gifts of money to ease the couple's finances. Such gifts were certainly made, and without them a break in the marriage could more easily have been accomplished. As for winning her back into Nonconformity, there is no doubt her father would have liked that; in fact, although she sometimes seemed to be ready to break with the Church, she never did so.

Where father and daughter did wholeheartedly agree was in their dislike – it would not be an exaggeration to say hatred – of the Roman Catholic Church. After a visit to Douro Place of Cardinal Manning's brother Charles, himself a Catholic convert,[24] during which he lent her some religious books and invited her to call on him at his Redhill house, Hannah wrote to Linnell:

I see it will be very necessary for me to be firm with him and tell him at once I *cannot* read the Catholic books ... on this subject even if I give offence I must speak out ... He and Mr P: get on well together. Ah! would it were not so it is a trial to me to hear evil called good and to see what is vile approved of – but I hope if I do see the truth and wish only to do what is right that I may be kept from self-confidence or vain glory and try to match your meekness and gentleness of spirit which I can see and admire and yet possess not.[25]

As this passage demonstrates, Hannah's mind had become shuttered; it also shows that she was lacking in judgment, for meekness was emphatically not one of Linnell's attributes.

Palmer was upset by Hannah's new religious tendencies, and wrote down some of his thoughts.

That we may never have in future to misspend time in the deplorable mischief of religious controversy, pray understand, as I thought I often mentioned, that I am no Puseyite, but a most unworthy member of the Church of Christ. . . . that if I have any 'religious views' – if I

may use that disagreeable expression – they are about equally unfavourable to the Manning School and to Puritanism.

I have no doubt that the worship of the primitive Christians was a musical service, and therefore always should prefer a chanted ritual to a read one; but I should not frequent any church, nor have ever done so, where I thought that such ritual was accompanied by false doctrine, unless it were the only church within reach.

I believe that our cathedral service is more like that of the Christian Church at Jerusalem under the episcopate of St. James, than any other I have ever heard of. As to worship in any societies not under the authority of our own bishops, or attendance at them, I can truly say that I have hitherto set an example of self-denial; and [I] think in serious things of this kind it is always best to be on the safe side. Merely as an intellectual treat it would be a strong attraction to know that Dr. Newman* is coming to London and will preach on the Sunday evenings, but I have hitherto forborne.[26]

Hannah was often at Redstone Wood during this period, but apart from infrequent visits Samuel usually stayed in London to attend to his pupils. She was therefore exposed to the full impact of her father's puritanical beliefs. There was no religious observance of any kind at Redstone, Sunday and religious festivals were ignored and, what was quite unusual in the nineteenth century, Linnell not only painted on those days, but was quite happy to sell his work as well. Yet to his daughter he seems to have appeared as a saintly character or a prophet. Writing from Douro Place in 1858, she declared, in a style which (ironically) she had apparently derived from her husband's exalted manner:

You live on a *hill* in more senses than one 'standing on the vantage ground of truth' higher up it seems to me than anybody else in the world you can see things and understand what is hidden from eyes which are so far below ... You have with great kindness shewn me much as it were lifted me up to see and I long to toil up after you though to reach your height would be impossible even with your helping hand.[27]

Thomas More seems to have taken his father's side in this controversy, for in another letter to Linnell, Hannah complains of being 'shut up with those who have no sympathy with my feelings and with whom I cannot sympathize'.[28] A year or two later, when Linnell refused to allow Thomas More to stay at Redstone Wood after a serious illness, Hannah naturally reacted with some bitterness. In the meantime discord reigned at Douro Place. She told Linnell how busy she had been, and added pointedly, 'although I am not allowed to speak now on many subjects which interest me (seeing that I have "poisoned my mind"). Yet I shall be wanted to help frame drawings.'[29]

The rift was unavoidable. Samuel was completely rigid in his religious and moral beliefs, and was not slow to criticize his wife for what he saw as shortcomings in these and other matters. As Hannah told her father in answer to an invitation to visit him: 'Thank you very much for wishing to see me again so soon. Shines the sun ever so brightly I cannot come again yet. I shall be called a gadder abroad and I know not what, if I do. I am looked upon with eyes not so

* The great Anglican priest and Catholic apologist John Henry Newman (1801–90), converted in 1845 and created cardinal in 1879.

kind as I would wish and I must walk circumspectly.'[30] She was also provoked, not unnaturally, when one of Samuel's spinster admirers tried to advise her on the management of her husband and children.[31] But she made no attempt to help her husband to get away into the country to seek new inspiration for his art, and to refresh himself spiritually and physically. Nor did she suggest family excursions, preferring, when not at Redstone Wood, to remain in her own house and entertain her acquaintances.

No doubt on Linnell's prompting, Hannah became suspicious of the Giles family, several of whom were Catholics, and did her best to drive a wedge between Palmer and his cousin and fellow Ancient, John Giles (who in fact was not a Catholic), even though they were particularly close friends. For years, even after Palmer had married, they had a standing arrangement to dine together on Christmas Day. One Christmas when Hannah was dangerously ill, and a dinner was impossible, Giles paid Palmer a call, bringing with him what he called 'mincèd pies', which they consumed standing behind the front door to avoid disturbing the invalid. But Hannah so played upon Palmer's own slight mistrust of Catholicism, and the effect that an encounter with it might have on his children, that he broke with Giles, at least for a time. 'I am thankful', she told Linnell, 'to have been able to persuade Mr Palmer to this (to him) unpleasant duty'.[32] Giles is mentioned as an inveterate opposer of Nonconformity in an anecdote she related to her father about a surreptitious visit she made to a Baptist chapel, an outing which much displeased Samuel:

I went last night with Emma [one of the servants] to find her a Baptist Chapel and at last found one and finding that they were first going to have a meeting in the Vestry thought I should like to join them. We went in and enjoyed ourselves very much – the minister was a plain man but spoke very beautifully indeed and no one, not even Mr Giles could justly have accused him of one word of heresy. The whole thing was simple, good and just what one would wish. I came home much pleased and as I do not like concealment told Mr P what I had done, but he looked so grieved and displeased and said that he did not see his way at present to talk to me about it, but evidently thinks I have done very wrong. Now my conscience tells me (though rather vaguely) this perhaps is doing evil that good may come. So I suppose I should be doing wrong to go again.[33]

Not that Hannah always pleased her father, either: both men found her to have a will of her own. In 1852 she presented her sister Sarah with a cross for her necklace, and when he heard about it Linnell remonstrated with her, accusing her of trying to influence Sarah undesirably by giving her a crucifix. Hannah defended herself by saying that it was not a crucifix but a cross, and such things were worn by many women far removed from Catholicism.

In other matters besides religion there was friction in the Palmer household. Some of it was caused by Hannah's tattle. In 1855 she told Linnell that there had 'been some squabbling about the new Water-Colour President', and a few days afterwards wrote to tell him she had 'got severe blame for having mentioned the concerns and feuds of the W[ater] C[olour Society] to you as they were strictly private though I did not know it ... was a secret, and

mentioned it with no evil intent but I am not believed; nevertheless I speak the truth in this matter.'[34] A worse cause of irritation was that, largely because of Hannah's houseproud ways, there were few domestic comforts in the Douro Place house. Even Palmer's small hoard of treasures – plaster casts and interesting and beautiful relics of eighteenth-century England – was not sacrosanct; Hannah's suburban polish and respectability spared no room to accommodate old and shabby, if invaluable, relics from the past. One day, when she was staying with Linnell, Samuel wrote an exasperated letter to her about the muddle caused by her methods of housekeeping and the folly of living beyond their means.

Nothing but house-cleaning has been going on since you were away, and I have let them clean out my study closets; preferring the risk to an accumulation of dirt. Indeed there has been for a long time such a gradual diminution of books etc., that I am getting used to it, and have ceased to feel much annoyed at the reckless destruction of casts etc. in the attics, till at Mr. Cooke's the other day I saw in a prominent place over one of his parlour doors, a bas-relief [the same as that] which with several others of mine has long ago been destroyed ... What egregious blockheads we must be if we ever more attempt to vie with people who have fifty times our income![35]

The relations between Palmer and Linnell deteriorated with increasing rapidity. There was a vast difference between the fortunes of the two men: Linnell becoming ever wealthier as his art gained in popularity, and Palmer, by far the greater artist, struggling to make ends meet, and only very slowly gaining in social and artistic esteem. A. H. Palmer rightly considered that Palmer's financial depression was 'because he clave to his own ideals and not to the dealers'. Also he became more and more bewildered by the battle of life, though his courage never failed him altogether.'[36] Even at this stage in their relationship, Palmer did not profit from his experience, and continued to submit to Linnell as before, seeking his guidance in almost everything. He even gave in to Linnell's keeping the title deeds of his property and the agreements relating to it, and had to apply to Redstone Wood if he wanted any information. When his Shoreham tenant, Foreman, wished to buy one of his cottages, he wrote to Linnell to ascertain the cost of the conveyance, instead of applying to a solicitor.[37]

Decreasing sympathy in Palmer's attitude to Linnell is noticeable in his correspondence. Until the late summer of 1851 he had always subscribed letters 'Yours affectionately'. Abruptly this became 'Yours truly' or 'Yours very truly', the earlier subscript being used only for a short time at wide intervals before being dropped completely. As with Hannah, the rift was inevitable, brought about in this relationship by Linnell's high-handedness, Palmer's subservience and lack of tact, and intolerance on both sides. But the final rupture was yet to come.

By 1854 Palmer had been an associate member of the Water-Colour Society for eleven years, and during that period he had exhibited seventy works, including some of his best Italian studies. Now, much to his relief, he was

elected to full membership, for he felt that 'the appearance of my name year after year in the lower list had become a sort of public annual stigma'.[38] But if he expected his elevation to make much difference to sales he was disappointed, and both he and Hannah continued to rely on Linnell's munificence for many necessities and comforts. In July 1854 Linnell sent him £5 towards the cost of taking Thomas More for a holiday – probably to Margate – while Hannah spent the time at Redstone Wood. Palmer wrote appreciatively about this, saying,

I have not till now been able to reply to your kind offer of the 5.0.0 connected with More's holiday, not knowing whether I should be able to leave town at the same time with him.

As however the lessons which detained me are now over – we should like to go for a few days and by starting immediately we shall not hinder Annie a single day after you are ready for her at Redstone.[39]

Soon after this Palmer was writing to thank Linnell for some 'kindly arranged' help with the purchase of a mahogany table and some chairs.[40] And so things continued, with Palmer accepting more and more help from Linnell and increasingly submitting his affairs to him, until Linnell knew almost every penny of expenditure from Palmer's pocket. A statement to his father-in-law written in the summer of 1857 demonstrates both Palmer's parlous financial state and his reliance on Linnell.

When income tax is paid I shall have 4.0.0 to go on with and perhaps something may fall in which will prevent any necessity for applying to Mr Giles [probably for a loan] – but if you will allow it to remain open I will do as you wish me in case other things fail. It was the non sale of my large drawings last year which set matters wrong. Of the seven I sent this year three were sold before they went and the four remaining sold three minutes after the Private View opened one of them to Mr Pocock of the Art Union another to Mr Topham. Part of the money for the three is paid: when all remaining is paid for the whole, it will amount to 73.0.0. but I shall not get any of it till the end of July.

When I last wrote to you I owed 61.0.0 now it is reduced to 25 with money owing to *me* which will cover it –

The sum you have kindly placed at our disposal – should nothing come in in the mean time, will just prevent what I have hitherto succeeded in staving off from week to week – the sale of my American stock – which at one time I had begun to take steps to sell – but as it was increased to its present amount 26.0.0 per annum by little savings I was very unwilling to do it – for we have found the 13.0.0 every 6 months most useful. However things are now I think taking a turn for the better and we have had no doctors' bills lately which were a cruel drag upon us – and I still feel the non-sale of the last years drawings though they did me good in several other ways.

With every attempt at economy, the kind of house we live in and the kind of people we are obliged to associate with – and from whom I get pupils – and at the private view for instance the sale of one of my drawings – render it necessary to make a tolerable appearance as to dress when we go out – and the constant keeping of two servants – costs a great deal more than I like though I do not see in what we can retrench. It is in household expenses that the money principally goes and it really is disheartening for sovereigns melt away by magic – and I believe my Grandfather who left fifteen thousand pounds did not spend nearly so much. We *never* give dinners – *scarcely* ever have friends to tea and then *only in the way of*

business – when it is absolutely necessary not to disoblige important connexions – have *no* droppers in.[41]

In short, Palmer had little idea of business, and though this was not discreditable in itself it did mean that there was constant restraint in the Palmer household, adding to an already tense atmosphere. Lack of financial independence, combined with a deep penetration of every aspect of his life by his father-in-law, would be hopelessly humiliating to almost any man, yet Palmer seems to have been less affected by it than might be expected. His sense of self-esteem was highly individual, which is perhaps why his relationship with Linnell developed as it did.

Palmer himself oscillated between euphoria and extreme despondency. A. H. Palmer considered that it would have been better for his father if he had never married, and had instead devoted himself to his art and to travel in 'the wild country and little remote cities of Italy, in the search for Virgilian pastorals'.[42] Samuel seems to have held similar opinions. After his two sons had been seriously ill, he told George Richmond that 'we should by no means persuade those to marry who are content to be single – and ... we married folks should condole one another, as you have kindly condoled with me and as I, "by these presents," condole with you'.[43]

In addition to his other problems, and doubtless in part at least because of them, Palmer's health deteriorated while he was living in town, and during the 1850s asthma made him continually ill and weak. Once when he had planned to pay a visit to George Richmond he was prevented as 'Saturday's East Wind blew me an *asthma* and those female Fates who, in every house, rule over the destinies of men applied a mustard plaster to my right pectoral on Saturday night – prescribing a Sunday's nursing.' On another occasion he postponed a visit to Richmond as he felt 'so very weak and poorly'. During March 1856 he wrote, 'My breathing is rather equivocal just now – so that I cannot safely come ... till milder weather sets in.' In the summer of 1859 he wrote to Hannah, who was probably paying one of her visits to Redstone Wood, 'I DREAD the DUST of town, which withers me whenever I get out; and if I would have my choice would prefer a month's incessant rain.'[44]

A cure seemed out of the question and desperately he turned to homœopathy, which apparently worked, and from that time he enthusiastically recommended it to his friends, including the Richmonds, to whom he sent some medicine, with this advice:

Globules should be taken not less than an hour before or after a meal: – going to bed and waking in the morning are good times – Let them dissolve of themselves on the tongue. What should *I* have done the other day without them when I was out without an overcoat in a driving rain and was going to Highgate to dry gradually? But I had my box in my waistcoat pocket and 2 globules of Dulcamara* made me as safe as if I had been sitting by the fire! What should I have done when I lost my voice in the very beginning of a lesson if the

* I.e. bittersweet (*Solanum dulcamara*), the dry stems of which were formerly used as a diuretic and sedative.

homoeopathic mother had not brought it out as clear as a bell with a single dose – why gone home – lost my fee and had a lay up of Asthma.[45]

Again adopting regimens of health in advance of his time, Palmer allowed homœopathy to supplant orthodox medicine in the household. He was out of step with the next generation too: despite its apparent beneficial effect on his father's asthma, A. H. Palmer remained sceptical and considered the advocacy of homœopathy an example of 'the ineptitude and puzzlement in practical affairs [which] was as strongly marked a feature in my father's career as a clarity of expression and thought in art and literature'.[46]

Socially Palmer remained as odd as ever, but he saw the amusing side of this himself, and never resented a laugh at his own expense. In April 1856 one of his lapses produced an apology to Mrs Richmond, written under the address of 'The howling wilderness'. He had, he said,

done a deed at which could all England hear of it the ears of all England would tingle – a deed calculated to lower me in my profession below the level of a sign-painter to make my friends cut me as we are coming out of church to banish me in short from society.

Had I maintained three wives at once had I sent my children to boarding school at Sierra Leone I verily believe I should have committed no crime so capital in the eyes of my beloved countrymen as that which I perpetrated last night at your house.

It of course was palpable to all, but little can those who beheld it picture to themselves my horrors of remorse when after leaving your house and elevating my right leg upon the first scraper with a view to the tucking up of my trowsers I found that operation already completed and that I had forgotten before entering your saloon to adjust that portion of my toilet – which had been arranged at Kensington with a view to the sloughs of mud through which I had to wade. The art of tucking up ones trowsers at night when about to pass through mud is every way commendable – but it is very disrespectful to enter a friend's drawing room in that phase of the lower extremities – I therefore have to ask pardon for a very blameable forgetfulness –

... Let so inexpressible a guilt draw inexpressibler pity towards your inexpressibly distressed – I dare not sign my name.[47]

But there were other habits that failed to amuse – especially in the eyes of the Linnells. Among these was his snuff-taking (in any case hardly a reasonable indulgence for an asthma subject) which, with smoking, the Linnells held in abomination. One unpleasant result of excessive snuff-taking is coffee-coloured drops falling from the nose – which should be caught in a handkerchief, but, Linnell claimed, one of Palmer's letters to him was snuff-stained, and (unusually for one who normally preserved all correspondence) he promptly burnt it, complaining bitterly to Palmer about his dirty habits. Palmer sent a disclaimer, to which Linnell rejoined by sending him some doggerel verse in which he referred to the 'vicious habit' of stuffing noses with 'the nasty weed', and ended by casting doubts on Palmer's moral fibre:

> ... he who has preserved his moral senses
> He is the man and he alone
> To judge of good and bad who has not done
> Nor wishes once to do the moral thing
> Which on the guilty punishment must bring.[48]

The peculiar mix of jocular antagonism, encountered before in Linnell's letters to his son-in-law, must have perplexed the candid Palmer and upset his composure still further.

తా్

One of his best opportunities for years to escape from the discomforts of his life came to Palmer in 1855, when William Etty's biographer, Alexander Gilchrist, approached him for information about William Blake, an account of whose life he was also writing. Palmer responded enthusiastically, and both he and Hannah spent much time with Mr and Mrs Gilchrist reminiscing about Blake and discussing his work. One evening everyone became so absorbed that they did not break up until dawn. Palmer's interest in Blake was so strongly rekindled that in a number of communications to Gilchrist he set down the most vivid recollections of Blake's charismatic personality that have ever been written (see, for example, above, p. 23–5). The exercise must also have brought home to him the dreams and hopes of his own youth, with feelings of nostalgia and disillusion that can perhaps be imagined.

Palmer's understanding of Blake was limited and he never claimed to comprehend the obscure prophetic works. But he did grasp the strength and directness of Blake's psyche, and saw him for what he was, 'a man without a mask'.[49] It was a perceptive comment by a man who hid his own sometimes inadequate character under many masks, not least his reticent and respectable exterior, which completely contrasted with Blake's often coarse outspokenness. Palmer mentioned this aspect of Blake to Richmond, thinking of Blake's couplet 'Then old Nobodaddy aloft/Farted & belched & cough'd':[50] 'Poor Mr Blake was "peculiar" on these subjects, and made a remark which is more decorously preserved in memory than committed to writing.'[51] Similarly he exhorted Mrs Anne Gilchrist, who completed the *Life of Blake* after her husband died:

Pray don't send to the printers any *extracts* made from the book itself [*The Marriage of Heaven and Hell*] which has not been looked over and prepared for the press as I saw this evg. an indecent word in the text – at least a coarse one . . . I would recommend the same caution as to all Blake manuscripts not already prepared – on account of other matters which 'crop up' now and then and which would be considered BLASPHEMOUS and might ruin the sale of the work if shown up in any illnatured review.[52]

A few weeks later he wrote to her on the same lines: 'I should let no passage appear in which the word Bible, or those of the persons of the Blessed Trinity, or the Messiah were irreverently connected . . . I should simply put ***s; and in case of omitting a page or chapter, simply say "the —th Chapter is omitted"'. Nevertheless, with characteristic scrupulousness, he advised her to state 'where complete copies could be consulted, I suppose the British Museum. Thus I should be guilty of no injustice to Blake, nor would I ever omit without asterisks; for it is not just to any author, living or dead, to join clauses when *he* has words intervening.'[53]

Mrs Gilchrist heeded his advice; she quoted extensively from *The Marriage of Heaven and Hell*, but omitted whole portions. Palmer excused Blake's outspokenness on the ground that he 'sometimes wrote under irritation',[54] but here he was wrong; Blake may have spoken under irritation, but what he committed to print were his considered thoughts and opinions. That Palmer could have said this shows how little he understood his mentor's intellectual honesty. If Blake could have read Palmer's comment he might have exclaimed, as he once wrote of his well-intentioned but unperceptive patron, William Hayley: 'Do be my Enemy for Friendship's sake.'[55]

Gilchrist refused an offer by Linnell to have a hand in the book, which may have added fuel to Linnell's resentment of Palmer. Mrs Gilchrist mentioned Linnell's proposed help to Dante Gabriel Rossetti; she is an independent witness of his autocratic manner:

Mr Linnell did offer, I well remember, to read the proofs of the MS. for my Husband, the bare notion of which filled him with horror: I do not think he ever showed proof or manuscript to the most congenial friend even. He had made most minute notes of all that Linnell told him; and there is a good deal in the shape of letters in Linnell's own handwriting, all of which have been most carefully used. In the mode of viewing the facts, I fancy there would often be considerable divergency between Linnell and my Husband. Besides a biographer's duty often is to balance the evidence of conflicting witnesses. When Linnell made the same offer to me, I hesitated, for the case was different. No – I do not think I did hesitate – for he frankly said 'that he might put in or take out what he did not agree with,' or words to that effect – and I felt sure it would be a most imprudent, and indeed treacherous thing on my part to accede to.[56]

ऊ

In 1856 Palmer exhibited two large works (about 540 × 749 mm) in the annual exhibition of the Water-Colour Society, both subjects taken from Milton's *Comus*: *The Brothers, guided by the Attendant Spirit, Discover the Palace and Bowers of Comus* (private collection, U.S.A.) and *The Brothers in Comus lingering under the Vine* (private collection, England). For almost the first time, these brought some stirring of public interest in Palmer's work; it was not much, but enormously encouraging to the hitherto neglected artist. Notices referring to them were carried in *The Guardian* of 30 April and *The Critic* of 1 May. *The Guardian* described them as 'Works of high imagination and extraordinary power. In *The Brothers lingering under the Vine* ... a sunlight effect is produced which is absolutely dazzling. The orb of the sun was perhaps never more boldly nor more successfully painted. In the other ... massive forms of trees, illuminated by a magical light, are introduced with the finest effect.'[57] But although they were among the best works he had painted since *Tintagel Castle, approaching Rain* (illustration 63), both remained unsold, and months of careful and loving thought and work brought him not a penny.

There is another picture belonging to the same series and painted at about

the same time: *The Dell of Comus* (The Royal Pavilion, Art Gallery and Museums, Brighton; illustration 83). It is the most attractive composition of the three and illustrates lines spoken by the Attendant Spirit:

> This evening late by then the chewing flocks
> Had ta'n their supper on the savoury Herb
> Of Knot-grass dew-besprent, and were in fold,
> I sate me down to watch upon a bank
> With Ivy canopied, and interwove
> With flaunting Hony-suckle, and began
> Wrapt in a pleasing fit of melancholy
> To meditate my rural minstrelsie,
> Till fancy had her fill, but ere a close
> The wonted roar was up amidst the Woods,
> And fill'd the Air with barbarous dissonance.

(Lines 540–50)

In his rendering of the scene Palmer followed Milton closely. In the left foreground, the Attendant Spirit is seated 'habited like a Shepherd' as in the stage directions; shading his eyes with his left hand he looks towards the dell at the right, in which, in an unholy glow, Comus's rout dance and sing, accompany-

83 *The Dell of Comus*, 1855. Watercolour and body colour on London board; 540 × 749 mm (The Royal Pavilion, Art Gallery and Museums, Brighton)

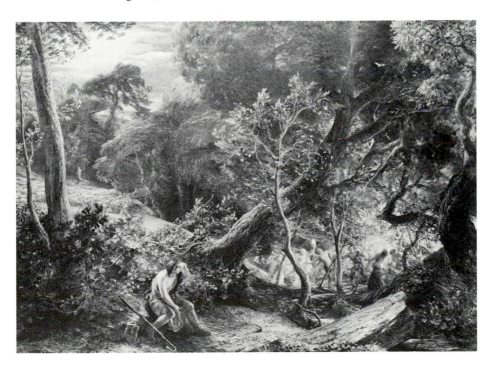

ing themselves with tambourine, drum and cymbals. In the centre distance at the left is a shepherd and his flock 'in fold'.

The most interesting point about these watercolours, however, is that they are precursors, both in size and in treatment, of Palmer's late works illustrating Milton's *L'Allegro* and *Il Penseroso* (discussed below, Chapter 6). Like those works, the *Comus* watercolours again show the strong influence of Claude – especially the dancing figures in *The Dell*, which recall comparable figures in Claude's *Landscape with the Adoration of the Golden Calf*.[58] The landscape, too, looks forward to the later Milton series, with such details as the outcrops of rocks remembered from the Welsh studies, leavened with some influence from the works of Salvator Rosa; and the shepherd and flock, which glance back to the Shoreham years.

In 1858 Palmer made his fourth visit to Devon and Cornwall since 1848, this time taking Thomas More for company. Encouraged by the reception of his *Comus* watercolours, he was feeling more optimistic than he had been for some time. He had told Hannah that she must be available to help, so if she wanted to go to Redstone she must do so before he went to Devon:

It will require such undivided attention to maintain and, D.V., improve the step which I have for the last two or three years, by the kind providence of God, made in public estima- tion, that for the future, when I settle down to my exhibition work it will not do for you to be absent. Therefore if you wish to *stay* at Redstone this year, it must be *before* I get my peep at Devonshire. I must therefore forgo the harvest, and take my chance for a shot with the partridges over the stubble; and in the meantime with my increased power of making use of nature, I believe I am losing hundreds – eventually, perhaps, thousands of pounds.[59]

From Devon he wrote to Hannah with something like enthusiasm: 'My little drawings seem to have done me real good with the artistic public. The secretary of one of the great provincial exhibitions called the other day to *beg* me to send something, and really I felt a little confused, as Lord Palmerston could not have been approached with more respect.'[60]

Notwithstanding such promise, success was still evasive, and within a few months he was lamenting that he was 'a living flour-mill which has to grind corn for others . . . I seem doomed never to see again that first flush of summer splendour which entranced me at Shoreham.'[61] He was becoming disillusioned with memories of those visionary years, and added a regretful note to his early annotations in his copy of Payne Knight's *Analytical Inquiry into the Principles of Taste*:

I knew the positive and eccentric young man who wrote the notes in these pages. He believed in art (however foolishly); he believed in men (as he read of them in books). He spent years in hard study and reading and wished to do good with his knowledge. He thought also it might with unwavering industry help towards an honest maintenance. He has now lived to find out his mistake. He is living somewhere in the environs of London, old, and neglected, isolated – laughing at the delusion under which he trimmed the mid- night lamp and cherished the romance of the good and beautiful; except so far as that, for their *own sake*, he values them above choice gold. He has learned however not to 'throw

pearls to hogs'; and appears, I believe, in company, only a poor good-natured fellow fond of a harmless jest.[62]

Disenchantment did not prevent Palmer from making some effective land-scape studies during this tour of Devon and Cornwall, which he later used as references for more formal compositions. There are some especially notable Cornish studies in black chalk on sketchbook leaves (Victoria and Albert Museum; Yale Center for British Art) and some more finished watercolour studies, such as *Grower Point and Short Island from Petty Point* (probably Growar Island and Penally Point, near Boscastle; Fogg Art Museum, Harvard; illustration 84), *Study of Waves breaking upon the Seashore* (National Gallery of Canada, Ottawa; illustration 85) and, most striking of all, *Storm and Wreck on the North Coast of Cornwall* (City of Manchester Art Galleries; illustration 86), which was later used as a study for the narrative watercolour *Wrecked at Home* (1862, and untraced since).

In some of these sketches, especially *Grower Rock and Short Island* and *Storm and Wreck*, there is a strong accentuation of highlights achieved by white body colour, giving a probably intentional exaggeration, perhaps to remind the artist of special effects. The black chalk sketches demonstrate Palmer's skill in making

84 *Grower Rock and Short Island from Petty Point*, 1858. Black crayon and body colour on paper; 189 × 274 mm (Fogg Art Museum, Harvard University, Cambridge, Massachusetts)

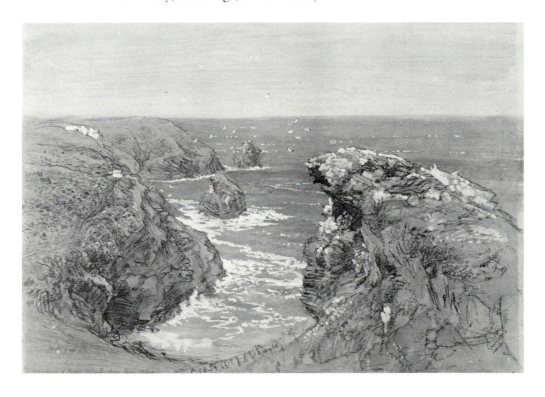

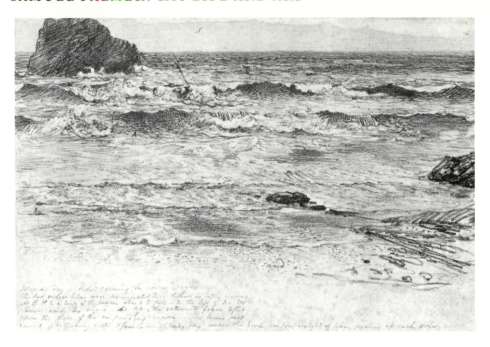

85 *Study of Waves breaking upon the Seashore, Cornwall*, 1858. Pencil on paper; 168 × 252 mm (National Gallery of Canada, Ottawa)

quick studies; and it is interesting to note that even in this simple medium he is still using dotting and scribbling to represent various textures. Again characteristically, most of the studies are annotated, some quite elaborately. On *Study of Waves* the several parts of the design are labelled A, B, C and D, to which the annotation refers:

Windy Day – tide coming in over sands/the two ridges below even terminated here & there by little waves/At B & C a leap of the foam about to fall – to the left of D d[itt]o:/blown aside by wind. At A A the returned foam lifted/upon the slope of the impended wave. The lower part/consists of returning water & foam. Cloudy day under the bird central weight of foam pushing up each side.

Lifelong habit had perfected Palmer's ability to make an analytic record of a visual effect in words as well as pictures; a drawing of breaking waves could be made from his description alone.

ഇ

As Thomas More grew into adolescence, Palmer concentrated on the development of his character and mind with ever-increasing vigour, allowing it to take

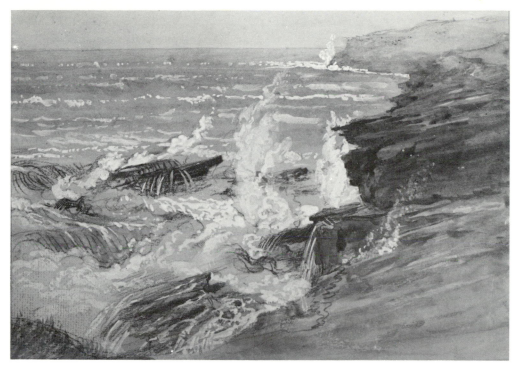

86 *Storm and Wreck on the North Coast of Cornwall*, 1858.
Watercolour, pencil and body colour on paper; sight size
187 × 265 mm (City of Manchester Art Galleries)

precedence over every other consideration, even the boy's physical health. More
first attended a preparatory school kept by a Mr Gaitskell, and later was sent to
Kensington proprietary school, then under the headmastership of William Haig
Brown (1823–1907), who from 1863 was a noted headmaster of Charterhouse.
More was apparently a bright pupil, but his father failed completely to under-
stand that the boy needed rest and recreation as well as intellectual stimulus.

More's main and almost sole relaxation was music, and he became an
excellent amateur pianist. His teacher, whom he shared with Richmond's son
Willy (later Sir William Blake Richmond R.A.), was Mr Woolman, organist of
St Nicholas Church, Great Yarmouth. The Palmer piano was 'an old tall up-
right grand, a beautiful old piece of cabinet work whose sweet voice was heard
through red pleated silk'.[63] But music added sedentary recreation to sedentary
work, a combination which helped to undermine Thomas More's health. And
just in case there should be an unfilled hour, Palmer instructed his son in
sketching from nature, which also hardly required much expense of physical
energy. Unfortunately one form of exercise Palmer did encourage was actually
dangerous – Thomas More had boxing lessons (boxing being then a recreation
for young gentlemen), which seem likely, from what happened later, to have
caused him internal head injuries.

Earlier More had been a spirited boy and a great practical joker, a side of his character which was not appreciated by the Linnell household. But now the endless hours of study and his stay-at-home hobby began not only to weary him but to sap his energy. Naturally this produced tensions that sometimes burst through the surface of his stagnant life. One such outburst occurred in 1856 when he ran away from home with Willy Richmond, with less than fourpence between them. Once the alarm had been raised they were found in less than forty-eight hours, at Staines, and had the degradation of being marched home by a policeman. 'The Escapade', as it was known to the Palmer and Richmond families, assumed disproportionate importance. Samuel especially was almost distraught at this instance of More's wilfulness, but resisted the realization that it was a symptom of discontent kindled by his own close surveillance. So hard was More driven that it seemed to him as if his father would punish him whatever his deserts, and indeed scarcely cared for him. That he had such thoughts is indicated by a remark he made when Willy Richmond broke down and wept at one point of their flight – that before many hours had passed their homes would be reconciled to their departure. Following 'The Escapade', Thomas More was forbidden to see Willy again. The break was absolute; Willy recalled how some time afterwards he 'met More in Knightsbridge, but he turned his head away so as not to seem to have seen me'.[64] Further, poor More had to listen to a two-hour lecture on his shortcomings by his father's friend C. W. Cope.[65] The unfortunate Willy Richmond was punished by being made to memorize the letters of abuse he had received. Meanwhile the other members of the two families remained as close and friendly as ever.

Palmer's ambition for Thomas More was that he should enter the Church; but Thomas More wanted to go to sea, no doubt feeling that this would give him more freedom than he was likely to know with his father nearby. Both Samuel and Hannah would hear nothing of this, but when Thomas More persisted, Hannah confided resentfully to her mother:

More is still bent on going to sea. I think we shall have to give him a year of it and see how he likes it. He expects to get over the sea-sickness in a fortnight and I think he had better try. If children are not contented when they have every comfort and kindness they can desire they had better try whether they can get more happiness among strangers.[66]

Writing to her father on the same subject, Hannah changed her ground some-what and said (which would have pleased Linnell), 'So would I rather have a sailor than a bishop such as they are nowadays . . . I would rather have More an omnibus conductor or a shoemaker or any honest trade than he should be either a lawyer or a clergyman – but the latter there is no chance of, he does not even think of it.'[67]

Although Hannah seems from this to have been weakening, Samuel frus-trated More's sea-fever. The boy then tried to find other ways of breaking out of the parental yoke, one of which was to set off on a walking tour with a schoolfel-low, Arthur Symonds. Even this mild outing proved hazardous for him. Run-

ning to find shelter during a torrential downpour, they were delayed by a gate, and a bolt of lightning struck the road just ahead of them where they would certainly have been but for the delay. Predictably, Samuel fussed over his son's escape, and used it to illustrate a moral lesson. Mentioning that lightning had recently struck the tower of the Royal Exchange and the spire of Bow Church, he admonished More:

To you and Symonds lightning stories ought always to bring a moment's serious reflection – some thankfulness some good resolve. I trust your legs 'sowed their wild oats' in Kent and Surrey – and that you will see the folly of over fatiguing yourself in any way when about D.V. to begin a course of study upon which under the Divine Blessing all your future depends ... Let me beg you to do your Greek in the mornings – not at night. In the clear country air you might do *some* before breakfast. After a solid quiet piece of morning work you will doubly enjoy your day. May God bless you and give you with His grace, a *sound* mind in a sound body – a *sound* mind – which first secures essentials and sees in everything its relative value.[68]

When everything is taken into account, it is not surprising that Thomas More turned into a pompous prig. His father probably encouraged the tone and content of the naïve verse he wrote from time to time:

> Birthdays are milestones on the road of life
> Where each may pause, and think awhile and rest
> Amid his journeyings, secure from strife
> And all that may disturb a wayworn breast.[69]

His grandson's pomposity was no more welcome to Linnell than his predilection for practical joking; it is unlikely that he appreciated the rather condescending letter More wrote him in January 1861, to acknowledge the loan of a book:

I am very much obliged for the book you have lent me and for the kind trouble you have taken in writing – The former seems as far as I have read very clever but neither conclusive nor charitable. I am willing to abide by the test proposed page 4 – 'by their *fruits* ye shall know them' and prefer to estimate the theory from the *practice* of its upholders rather than to condemn many thousands of conscientious and learned men from my own opinion (supposing it were adverse) of their doctrine.[70]

And Linnell, who prided himself on his self-taught Latin and Greek, was not pleased when, having laid a Greek trap for his grandson, More extricated himself without consulting a book.[71] Obviously neither of his parents was likely to teach him much about the benefits of tact, and in general More's behaviour was cheeky and high-handed. He showed insufficient respect to his elders (a cardinal sin in Victorian social life) and addressed his uncles and aunts by their Christian names, without a prefix. A friend of the Linnells, with whom he once stayed, complained that he sat up writing until midnight and was wilful and difficult to please.[72]

Consequently he was not a welcome visitor at his grandparents', and at the beginning of 1859, when Samuel and Hannah suggested that he should spend a holiday at Redstone Wood convalescing from an attack of rheumatic fever,

Linnell refused, pointing out that Mrs Linnell had herself been ill. This the Palmers resented and thought insulting, reacting with unwonted energy. To their protests, Linnell replied with justifiable anger:

I shall only beg to observe that if a favour is asked and when not complied with the request is followed by reproachful taunts it appears to me to be making a positive demand in the most offensive way. I offered to help you in any other way than that one and for refusing that I have strong reasons besides those of inconvenience and anxiety to Mrs L. and when I said the thing was not to be my decision sh^d have been quietly submitted to and credit given to me for a desire to help you, of which there has I think been some proof at sundry times but which seems to be all forgotten thro' the one refusal. This I am sorry to say is the usual course of things and needs no illustration.[73]

A little later, in an attempt at reconciliation, Linnell invited the whole Palmer family to spend a day at Redstone Wood. But Palmer refused, replying coolly that 'More is not free until the midsummer holidays at which time I am unable to leave; so it is not easy for us to visit the country together.'[74] Linnell's attitude was more practical than that of More's fidgety father, who seemed even at this stage unable to leave his son in peace for a few weeks or months so as to recover his health, but instead piled one task on another.

Thomas More became interested in bibliophily, which, like music, appealed to Samuel. If he had a shilling or two to spend he liked nothing better than to look for bargains on the Faringdon Road bookstalls. This interest led him to make friends with an elderly lady, Mrs George, who lived in Mill Street, off Conduit Street, in London. Her especial hobby was Grangerizing,* and the nimble-fingered Thomas More helped her in this with enthusiasm. Samuel saw such activities not as recreational, but as new sources of incentive, and made no effort to tone down his son's zeal, but urged him to redouble his efforts. Throughout Samuel's letters to Thomas More there is hardly one without an overriding note of moral, religious or educational advice. The effect is depressing in the extreme. A letter written in Hastings in May 1859 is typical:

I have been to Church these 2 Sundays and to day Whit Sunday commended you heartily to God at the Blessed Sacrament. O! that you may feel what a blessed thing it is to love Him – as the centre of all loveliness and truth – without *this love* all our earthly ties pleasures and attachments are treacherous and fragile. – but with God and in God our pleasures studies and amusements will be innocent and leave behind no remorse.[75]

ಌಌ

Thomas More's health, always precarious, was adversely affected by an attack of scarlet fever in November 1859. His younger brother was also infected, as was Hannah, but more mildly. The boys recovered quickly, as Palmer told Richmond:

* Extra-illustrating books by inserting prints etc. From the English biographer, J. Granger (died 1776), who left blank pages for the purpose in his *History of England*, 1769.

You will be glad I know to hear that by the Divine Mercy both our children have been spared and are doing well. So are the servants – uninfected – though every way most kind and assiduous. So am I, on the principle that the worst can't be worsened. My poor wife has, not a scarlet, but a sort of gentler pink madder fever with watching and nursing. More won't peel, his skin is so tough. In a day or two Herbert is expected to be walking about with his skin in his hand like a plaything – after the manner of a legend.[76]

But Thomas More was affected more deeply than Palmer realized. Scarlet fever probably increased a profounder weakness that became more apparent during the months ahead. For the present all seemed well, and he was sent on a re-cuperative holiday with a Miss Ronalds, a friend of both the Palmers and the Linnells. Linnell lent him servants to help with his luggage and sent him some beer to consume during the holiday which would help to strengthen him.[77]

Even during this period of convalescence, Palmer continued to ply Thomas More with advice on goodness, his health and his work. He exhorted him to be sure that he did two new confirmation papers, and told him that he was expected to work for an Oxford scholarship on his return.[78] If he were to go up to Oxford, Palmer was half prepared to accompany him and make a new start in his own life.[79] In the meantime he was terrified that his son might be too ill to pass the examination, and harassed him unceasingly:

If you go in to the garden without your cap your complement of life will be ended – as the Rheumatic Fever will fly straight to your brain. – Probably in a couple of days you will feel so much better as to be running in and out without your cap – to prevent this any wise boy would carry his cap in his pocket – Above all mind about wet clothes.[80]

Thomas More had shown signs of weakness during his last term at school and often felt drowsy, especially during the afternoons; once he had fallen asleep during a lecture. The master was offended, thinking that the boy had found his lecture dull. More was full of remorse, and seeing his master in the distance on the school cricket-field one day, composed an impromptu apology in verse – a more lively piece than the efforts one suspects were composed for his father's sake:

> St Paul was preaching, Entychus
> Unhappy fell asleep,
> Unable though attentive all
> His wakeful sense to keep.
> He fell from window – and if I
> From prizèd favour fall,
> Would choose to sleep as he had slept
> Unless awaked by Paul.[81]

His apology was at once accepted and happy relations were restored. A pupil of his ability and assiduity would hardly be out of favour for long. In his last term at school (spring 1861) he competed for the Latin prize, and though he wrote only fifty lines out of the one hundred stipulated, the judges liked his work so much that they unhesitatingly awarded him the prize.[82] His progress was such

that by now he was second in place only to the head boy, and was on excellent terms with the headmaster, Haig Brown. But he was reaching the end of his tether, his health was deteriorating rapidly, and it was obvious that a change of air and complete rest were necessary.

Samuel decided to look for a country retreat for the whole family – a place where he himself could also work on new drawings. A friend found what appeared to be a perfect location: High Ashes Farm, worked by a Mr Sparks, situated on high ground between Holmbury Hill and Leith Hill. Nearby was a cottage owned by the artist Richard Redgrave, slightly known to the Palmers and in time a close friend. Hannah and the boys went to High Ashes Farm on 22 April, Samuel planning to join them in May. In the meantime he showered Hannah with advice and misgivings lest the effect of their respectable upbringing of Alfred Herbert should be destroyed by association with local children – a far cry from his unconcerned attitude to social conventions in the early days of their marriage. And he was still agitated about the boys' health.

I hope Hub [Herbert] will not get sitting in the sun without a parasol when out on the heath ... I doubt whether cream will do More good except in the mid intervals of his meals – you will see whether his hands fatten on the new milk – Following the plough too soon would knock him up but I hope he gets out to the afternoon milking with Hub – As there is no single reason for keeping late hours on the top of Leith Hill I think you should all march out to the milking at 7 – taking a little pint mug to know what you have drunken – I dare say by this time More *feels* well and full of vigour but that is not what we want – I would rather see less vigour and more flesh.[83]

Incredibly, though this visit to the country was primarily to restore Thomas More's health, Palmer saw it also as an opportunity to push his son on to further scholarly effort. In one letter he begins with a long religious exhortation, advises More to take his 'morning's milk hot from the cow', and hints that he might write an article about Leith Hill; in another, the last letter he ever wrote to More, he loads him with instructions about drawing and composition.[84] At first the young man was energetic enough to play on his father's violin, to collect and preserve wild flowers, and to go shooting rabbits with a gun lent him by Mr Sparks. But he quickly deteriorated, and on the day that Palmer joined the party felt so ill that he told Hannah, 'I fear I shall be unable to stand up to receive my father when he comes.'[85]

Even so, perhaps because there were intermittent improvements, the pernicious state of More's health did not yet dawn on Palmer. He took happy strolls round the farm with him, full of hope that he would recover and return to school so that he could take his Oxford scholarship. Hannah seems to have taken a more realistic view, and just before Samuel's arrival, wrote to her father expressing the hope 'that More will get better though at present do not see any improvement; on the contrary he has had a relapse the last few days and is very poorly indeed. It keeps one very anxious and with the depressing weather seems almost too much for one's spirits.'[86] Linnell paid a visit to the

Palmers at High Ashes and did not like the cold, exposed situation, judging it, probably correctly, as unsuited to More's condition.

At the Etching Club, Palmer told one of his fellow members, the famous surgeon Sir Francis Seymour Haden, about More's illness, and he offered to help as far as he could; to assist him, Samuel made some rough pencil notes, which were found among his memoranda after his death. They show that by now he had accepted the truth:

Two months ago [that is some time in May] utterly out of sorts yet able to walk to Leith Hill Tower and back. Now ... frequent and distressing pain. Unable to walk but by an effort. Dreadfully depressed, irritable and nervous ... he is dreadfully frightened about himself – talks of his grave and his shroud – asks us to let him alone that he may die and only give us one short trouble. Complains of tender breezes on a hot day as chilly. When in the chaise wishes to come back again when he has been out only three quarters of an hour – Extreme sensitiveness to noise. This has been so more or less than a twelve month. The tremor in his hands has been also noticed for a long time back. Sometimes he says he fears he shall lose his reason through the pain. Saturday ... depression of spirits very great. For the morning ride of an hour and a half and the afternoon ride of an hour. Both times he begged to come home again. He seems to feel no pleasure in the air or drive ... When well he is courageous to daring, now a little toss of the donkey's head frightens him.

From his complaining of a dull pain in the head and from its hanging so about him I thought perhaps the steel [taken as a tonic] was affecting it or the heat or some distant cause over and above the neuralgia. He used to say that boxing made his head feel fuzzy. He had a hard blow when taking a lesson. Spine back becoming deformed. His mother says he [has the] distressed look about the eyes of an epileptic person she knows.[87]

Thomas More Palmer died on 11 July 1861 at the age of nineteen. Miss Evelyn Redgrave was staying at her father's nearby cottage and many years later recalled the dreadful evening:

I well remember (she wrote) a farm boy from High Ashes coming to say More had had a bad seizure late in the evening. I think my father must have been in Town for Mama and Louie Barwell set out, with our garden boy to carry a lantern (the Pine woods were intensely dark at night), to give any help they could. Louie Barwell tried to soothe Mr Palmer's grief and despair. My mother stayed all night.[88]

As soon as he received word of his grandson's death, Linnell went to High Ashes Farm and tried to persuade Hannah to come home with him, saying 'Let the dead bury their dead.' Mrs Redgrave was shocked and would have none of this: 'I will not allow you to carry off your daughter till her son is buried.'[89] Linnell's attitude seems callous in the extreme; A. H. Palmer thought that it was because he was simply immune from emotions.[90]

Palmer was in no condition even to understand what was being said. He was hysterical with grief and 'in some ways ceased to exist after the last breath on the cold lips and the last glimpse of the face (peaceful in death) as they dragged him away'.[91] He was taken to the house of Hannah's brother James at Redhill, from which he wrote to his two old friends Edward Calvert and George Richmond. To Calvert he said:

As you are the *first* of my friends whom I sit down to make partaker of my sorrow, I will not wait for black-edged paper, which is sent for. You I take first, for you were first in kindness when dear little Mary was called away, and your *kind, kind* heart will be wrung to hear that at our lodging at High Ashes, near Dorking, on Leith Hill, my darling Thomas More left us at a quarter to six. It was effusion of blood on the brain.

To Richmond, he filled in a few further details. It was, he said, and it filled him with remorse to write it, 'Over-work! breaking of a vessel in the head – It was a long long *fit* and he died without pain but insensible at High Ashes where his poor mother is now. The doctors forced me away and brought me here. What *shall* we do? The cup of bitterness overflows.'[92]

Haden was consulted at least a year too late, but it is in any case improbable that anything could have been done for the boy. The diagnosis, which was delivered on the day of More's death, has now been lost, but it possibly showed that, following his attacks of rheumatic fever and scarlet fever, he was suffering from severe heart disease and possibly also from a severe cerebral abscess or tumour.[93] To Palmer extra poignancy was added to the tragedy by the knowledge that More's condition had been aggravated, and maybe caused, by his own misguided attempts to force his son, and that when he finally consulted Haden death was already inevitable.

Samuel was too torn by grief to attend his son's funeral, but George Richmond was there, and so was his son Willy who, at last forgiven for his part in 'The Escapade', made a drawing of his friend on his deathbed. Hannah followed the contemporary custom that women did not attend funerals; but she 'stole down, with one friend in the twilight of that evening to look upon the newly filled grave!'[94]

Driven nearly insane by Thomas More's death, Palmer must have realized that his early admonitions had come to rest on his own shoulders. He had foretold that when his father died and was buried, More would be glad to have been a good boy. Now that their imagined positions were reversed, his grief was boundless. To the Richmonds he confided the agony of his circumstances:

Think my dear friends of the horrors of the last ten days – James Linnell most kindly took me in – but to be unoccupied a moment was *madness*. I woke till very lately every morning before dawn and was obliged to employ myself in writing incessantly till the usual breakfast hour. Then *out out out* to find a lodging for poor Annie! To have remained at High Ashes would have *killed* me (O how blessed *that* would have been!) To be still far away was worse than any death.[95]

Headmaster Haig Brown spoke of Thomas More at a school prize-giving on 23 July 1861, which Mrs C. W. Cope described to Hannah:

The names of those who had obtained scholarships etc were mentioned. Mr Haig Brown then paused and with some hesitation of manner said, he had been reminded that one more name remained, which he felt a particular difficulty in mentioning for he who had borne it had been taken away from amongst us. But those who knew Palmer would bear him out in saying that he was a boy of unusual promise; for young as he was he was already distinguished. In music, in art, in literature his talents were of no ordinary character. To him had been awarded the Latin Prize Poem even on his deathbed. All who knew him loved him,

and his character in the school was of the highest order. Mr Brown apologised for the emotion he manifested for his voice trembled and it was with difficulty that he could command himself sufficiently to speak and when at last he proceeded to say how he loved him he fairly broke down and was obliged to give way to his tears.[96]

There were torrents of tears, and endless lamentations. To Gilchrist, who had taken an interest in More, had entertained him at his Cheyne Row house, and now set about obtaining a stone for his grave, Palmer wrote 'We are smitten down by a blow from which we can only partially recover during any lapse of time and but for dear little Herbert I think Annie and I would earnestly pray that *that* time may be short.' And, the following month, 'The blast which has torn me up by the roots – blows on – sporting with leaves and twigs and scattering everything.'[97] Again to Gilchrist he wrote in September:

I must lay by my pen for a little while for this morning my grief broke forth all afresh and my eyelids are stiff with weeping. In the night I dreamed that the dear boy was alive and about, temperately, to resume his studies – that he was in Douro Place and that I was talking with him. This has occurred twice – in the former dream I heard him sweetly singing. – Who can describe the horror of awaking from such dreams to the dread reality?[98]

Unabated, his conscience dogged him. Of his son's school, he exclaimed, 'Would to God I had never sent him there!'[99]

Samuel summed up his brief relationship with Thomas More in a pathetic document headed *The 1861 Lifes Balance Sheet*:

What I have lost or wherein consists my anguish My elder son. I am left with the 'fearful' joy of an *only* son. I have lost a wise son who could counsel me. A son whose culture was an honour to me. A son whose progress to intellectual maturity and probable eminence would compensate for my own decline and weakness. Our conversation ranging through the years makes every subject recall him. Some of the South of England which I know best recalls him when I see or hear of it. The Cornish Coast recalls it and Kynance Cove he so strongly loved. His books and papers remind me.
His prize essays and bookcase.
His own hard lot to have.*
What I have gained or what set off of comfort there may be
The loathed and horrid saving of about one hundred a year.
I cannot have the torture of losing him again.
Being lost I can live in no anxiety as to losing him.
A *great consolation*. That I have been liberal and handsome in my dealings with him, that he was always well fed – and to the very utmost of my means made happy.
That he loved theology and chose the Church.
That he was Truthful Industrious Courageous
That he believed in the Gospel.[100]

He never recovered from his son's death, and never visited his grave. Both he and Hannah were obsessed by Thomas More's memory and attributed to him qualities quite beyond a young boy's capabilities – brilliant wisdom, genius, superhuman industry, all were his. Every scrap of his handwriting was preserved like the relic of a saint, and brought out to be shown to every visitor.

* In his transcript A. H. Palmer marked this line with a query, as if it were not clear in the original.

6 Grief and the inspiration of experience

The Palmers felt unable to return to Douro Place with its sad memories of Thomas More. Neither could they continue as they were, Samuel with James Linnell, Hannah at Redstone Wood. It was therefore imperative to find a new home as quickly as possible; pending that they took lodgings with a Mrs Dobson in Elm Cottage, Redhill, which were uncongenial. In September they rented a cottage in Park Lane, Reigate, Palmer going to earth in it 'like a sorely wounded animal no longer able to meet his kind [and unable] to hide his grief'.[1] The cottage was near Redstone Wood; Palmer knew the district well, and he had many friends there, so it had much to commend it.

When at last he felt able to receive friends they visited him regularly and attempted to raise his spirits. The young Richmonds came often, and Alexander Gilchrist from time to time. Many of these visitors gave their whole attention to Palmer, almost completely ignoring Hannah, much to her chagrin. She was especially offended in this way by another of Samuel's friends, Reginald Palgrave, later clerk to the House of Commons, and never referred to him except as 'that individual'. But however much his friends tried to rally Samuel, however much attention they gave him, however often they came, he was, even apart from his bereavement, totally miserable. Every aspect of domestic life seemed pointless. 'All that is left untouched by the finger of woe', he told Mrs Richmond, 'is the black cat who was found this morning purring in the copper with two black kittens – or I should rather say in *a* copper, as there are two coppers two kitchens – two pumps – two wash houses – two rainwater butts.'[2] Palmer always got considerable pleasure from his friendship with cats. Writing again from Park Lane in March 1862, he described how he 'set a chair for "Trot": up jumps poor puss, and between us we make a segment of a circle, at all events ... "Trot", like her betters, has a pair of eyes – an eye of love and an eye to the milk-jug. Like her betters she purrs *for* her milk – *unlike* many of them, she purrs *afterwards*.'[3]

Of the cottage, he unburdened himself to George Richmond's daughter Julia, one of his favourites:

You are mistaken Dear Julia as to my liking Reigate. I am here merely because I could not stay in Kensington which had helped to kill my boy – and because having no temporary home or shelter in the country while I could turn myself about, I thought it better to begin here where we knew a few human faces than in other parts where we were quite strangers –

But to give poor Herbert a few more years of life if God will, I want a tolerably bracing spot – hard to find here.[4]

Soon after they had moved into the Park Lane cottage, Hannah suffered a crippling attack of rheumatism, brought on by the damp atmosphere of 'Casa Rheumatica', as Palmer dubbed it;[5] so she moved into more comfortable quarters at Redstone Wood, taking Herbert with her, and leaving Samuel to his grief and his books, with nobody but Herbert's nurse and the cat for company.[6] Here, despite all adversity, what was best in Samuel's character took over, and he turned to his obligations and his work, which though they did little to assuage his grief, made life easier to face. He wrote in his commonplace book:

If it be the Divine will that I live on after this calamity I must try to do my DUTY – my duty towards God and my duty towards my neighbour. My wife and child are my nearest neighbours. I must use my calling for their support. How can I make works which will cheer others when quite cheerless myself? Perhaps thus. 1st, choosing themes I *loved*, for I love no art themes now; 2nd, very simple and massive in effect; 3rd, getting in whole effect (after the figures are well designed) at a heat; 4th, sufficient model realization; 5th, delicate pencilling. Can etching be made productive? Vanity of vanities. August 28, 1861.[7]

§

It comes as no surprise that this was one of Palmer's least productive periods as an artist; still, as in his other periods of adversity, those paintings and etchings he did create indicate little if anything of the tragedy he was experiencing. His great achievements in post-Shoreham painting and etching were still in the future. For the present he painted watercolours such as *The Abbey Stream* (1861; Yale Center for British Art) and *The Streamlet, Harvesters on Hillside* (1861; private collection, England), pleasantly gentle conceptions, mildly nostalgic in feeling. The texture of some works painted at this period, such as *The Abbey Stream*, is softer than in much of his past work, and this is probably an indication of the 'new style' for which he was searching (see above, pp. 164–5). As in almost every one of his works, however, there is much dappling, especially evident here in the middle distance and on the surface of the stream.

The tranquillity of these works during a period of high tragedy is added evidence that after Shoreham he kept his art and his life in separate compartments. The special quality he achieved during his earlier years because his life and art were, on the contrary, so entwined was seldom realized again until he approached old age. His paintings of the late 1850s and early 1860s do include a number of narrative pieces that centre on shipwrecks, such as *After the Storm* (1861; private collection, England) and *Wrecked at Home – a Husband and a Brother Saved* (1862, and untraced since), and their subject-matter may have been a reflection – subconscious or deliberate – of the state of his life. But they were probably initiated earlier; the idea of *After the Storm*, for example, may have come from the drawing done in Cornwall in 1858, *Storm and Wreck on the*

North Coast of Cornwall (illustration 86). There were also quite different narrative themes, for instance *The Two Pet Lambs* (*circa* 1863; National Gallery of Scotland; illustration 87). The lambs here are a real lamb, held in the arms of a woman, and a baby held aloft by another woman. In this work Palmer reverts to his long-tried practice – generally less evident at this period – of leaving some areas unfinished around a focal area. He still had a hankering to express himself in oil, though he rarely put it into practice. However, one successful work of this kind is the narrative painting *Children returning from Gleaning* (1864; Smith College Museum of Art; illustration 88). It indicates the continuing strong influence of Linnell, and in its treatment resembles Linnell's *The River Kennet, near Newbury* (1815; Fitzwilliam Museum).

Palmer made two etchings at about this time: *The Early Ploughman* or *The Morning Spread upon the Mountains* (begun before 1861) and *The Morning of Life* (begun 1860–1). The former is an especially fine plate, and the rich conception is handled with great sensitivity (illustration 89). It is sunrise, and a ploughman is bent over his plough, hauled by a team of oxen, in a small field beside a bridged stream. Another ploughman and his team are at work in the distance. Under cypresses at the right a woman carrying a pitcher on her head, with another in her hand, looks towards the nearer ploughman. At the left, beyond the stream, is a hill, with ruins on its slope. In the distance are mountains, probably suggested by an alpine memory. A flock of peewits flies above the slope, helping to hold the composition together; the slanting tree in the left foreground works to similar effect. One or two of its details recall the late Shoreham work *The Shearers* (illustration 32): the figure of the ploughman in the etching is a reverse of the central figure in the painting; the ploughman's hat resembles the straw hat hanging by the door in the earlier work – Palmer himself sometimes wore such a hat.

87 *The Two Pet Lambs*, *circa* 1863. Watercolour and body colour on card; 203 × 434 mm (National Gallery of Scotland, Edinburgh, Department of Prints and Drawings)

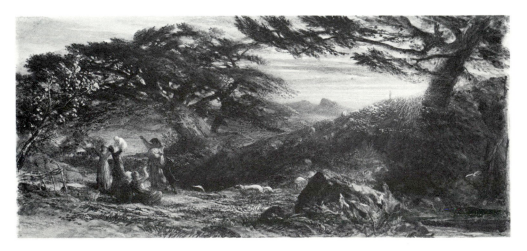

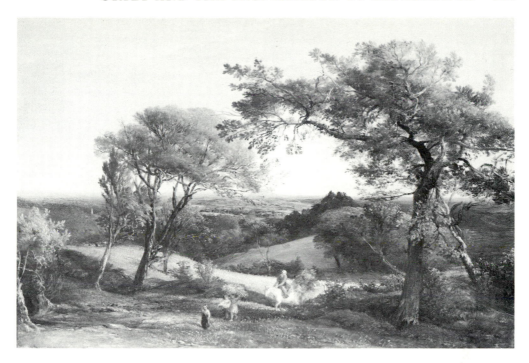

88 *Children returning from Gleaning*, 1864. Oil on canvas;
29.7 × 45 cm (Smith College Museum of Art, Northampton,
Massachusetts)

The figure of the woman closely resembles that of one of the women in
Edward Calvert's wood-engraving *The Brook*.[8] This in turn was derived from a
figure in Blake's watercolour *Jacob's Ladder* or *Jacob's Dream* (British
Museum), and all three figures – Blake's, Calvert's, Palmer's – were probably
derived originally from a figure on a Greek coin or gem. Calvert made con-
stant use of these sources,[9] and Blake's interest in them was cited by Palmer in
a letter to Gilchrist: 'When he approached ... some of the inventions pre-
served in the Antique Gems, all his powers were concentrated in admir-
ation.'[10] Palmer himself had a collection of casts of antique gems which, with
some miniature antique busts, he kept in a box and in calico bags. He
mentioned these in a letter of 29 May 1862:

Mr Newman [an artist's colourman at Soho Square] made me eight or ten of his cedar
colour-boxes without partitions, and a little deeper than usual, in which I possess a fine
sculpture-gallery, having filled them with casts from the finest antique gems. These are
most useful for reference, when working out lines caught from nature. I assure you there is
nothing far-fetched in this. All the best landscape-painters have studied figures a great
deal.[11]

The Morning of Life (illustration 76), published in its final state in *Etchings*

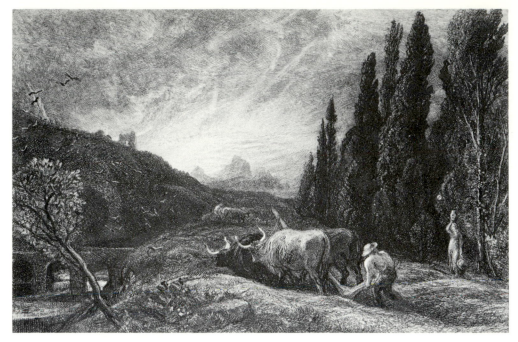

89 *The Early Ploughman* or *The Morning Spread upon the Mountains*,
begun before 1861. Etching; etched surface 130/131 × 197 mm
(private collection, England)

for the Art-Union of London by the Etching Club (1872),* started out as a classical
subject, *Hercules and Cacus*. Palmer later told the art historian P. G. Hamerton,
'it was begun years ago to illustrate a classical subject; but finding I could
no-how clip my poodle into lion-shape, I even let the hair grow, and christened
him for the Art Union, *The Morning of Life*'.[12] In the final composition of the
plate, the figure of Hercules has been transformed into a woman gathering
fallen apples into a basket. The setting of a woodland clearing, with sunrays
shining through the trees, men washing sheep in a stream and two boys hauling
a sheep to the stream to be washed in its turn, are all far removed from the
original subject of Hercules' pursuit of a cattle-thief. Again the composition
shows Linnell's influence; the subject of sheep-washing appears in a similar
woodland clearing in an oil painting by Linnell, probably of about the same
date, *Woodlands near Redhill* (private collection, England), which depicts the
grounds of Redstone Wood.[13]

The quality of the printing of the 540 impressions for the Art Union
displeased Palmer. He was sent fifteen impressions which A. H. Palmer said
were 'fifteen slaps in the face'.[14] They were printed by the copperplate printer

* The Art Union of London, founded in 1836, organized lotteries for money prizes intended for
purchasing approved works of art. It also published prints, some in book form. See Raymond Lister,
Prints and Printmaking, London, 1984, pp. 72–3, 118.

Frederick Goulding, who later was one of the only printers to win Palmer's praise, but for the present he lacked experience and, as A. H. Palmer said, he was 'not yet the glorious creature of Shepherd's Bush Road'.[15] The production of portfolios and books of etchings by the Etching Club was equally disappointing. With his growing interest in etching, Palmer gave much of his attention to the affairs of the Club, though they rarely gave him any satisfaction:

Nothing could have seemed more certain than that our Club would have got up in the best manner a portfolio of etchings* for which they charged twenty guineas [£21] – I have not yet seen it, but am told by persons who have seen one copy that the mounts are of inferior machine made paper, – some, wrong side outwards: – that the mount, which is thick enough to cast a shadow, comes close up to the subjects, in one case somewhat over it, and that the hollows are not cut accurately at right angles.[16]

Shortly afterwards he reported that although 'I do not like to complain of the getting up, upon hearsay, never having seen the new Club work ... One subscriber sent his copy back and has had the sunk mounts enlarged so as to show a little of the plate paper round the etching.'[17]

Palmer was also irritated by the Club's restriction on the size of the plates, but apparently this was overcome, for later it did publish some of his larger plates. In this connexion A. H. Palmer spoke of his father as 'A man who habitually used not only swan pinions [large quill pens] but broad reed pens, and who advised his pupils to do the same – who detested "niggle", and who sometimes painted in water colour with a palette knife.'[18] A man with such preferences was unlikely to want to work exclusively on such small compositions and close detail as his early etchings encompassed. But the almost miniature style of such works as his original designs for *Pictures from Italy* should not be overlooked, for they and the early etchings are evidence of Palmer's interest in close as well as broad work.

What he did strive for in his etching was not size or breadth of handling, but the effect of 'those thousands of little sparkles of white paper between the lines even of the darkest parts'.[19] He was not interested in 'states' as such, except insofar as they indicated steps towards his ideal, an ideal that was rarely attained even in his most brilliant proofs. Nevertheless, Palmer's enthusiasm for etching remained undiminished, even during his old age. Yet at the beginning of the last great period of his life's work, he wrote of the difficulties of obtaining an adequate reward for the time he lavished on his plates:

If this kind of needlework could be made fairly remunerative, I should be content to do nothing else, so curiously attractive is the teazing, temper-trying, yet fascinating copper. But my etchings consume much time, and I am not alone in discovering that, like the cash absorbed by bricks and mortar, the final amount often doubles the estimate: and this time has to be withdrawn from commissions which are really lucrative. I can get 100 guineas [£105] for quite a small drawing which does not occupy nearly the time of some of my etchings.[20]

* A portfolio of twenty-one etchings by members of the Etching Club, containing Palmer's *The Lonely Tower* (see below, illustration 96).

ᘒᘓ

Soon after Thomas More's death, Palmer's new friend Alexander Gilchrist died of scarlet fever, leaving his wife Anne to fend for herself and their children. To economize she left London for the less expensive countryside, and acquired a cottage at Haslemere in Surrey. Here, with brave resolution and in the face of many odds, she completed her husband's biography of William Blake. Notwithstanding his own troubles, Palmer did what he could to succour her, and this to some extent distracted his mind from his own tragedy. Two years later, in November 1863, Anne Gilchrist sent Palmer a copy of the newly published *Life of Blake*, which he excitedly acknowledged:

How shall I thank you enough for such a treasure as this dear delightful book – how keep it so long out of my hands as will suffice to let me fill this paper? I could not wait for the paper knife but fell upon it, reading all in between: – now, I have cut the first volume, – and read wildly everywhere: – and now again I begin at the beginning, and meanwhile write to tell you how it has delighted me: – raising, however, a strange ferment of distressing and delicious thought.[21]

It was the last time he and Mrs Gilchrist corresponded. He had begged her not to write when she 'could be otherwise better employed',[22] and she evidently took this literally. And she may have been prompted to discontinue the correspondence because she disliked Palmer's prim, though undoubtedly well-meant, advice to her son Percy. There certainly seems to be presumption in some of it: 'I hope Percy will buckle to his Latin grammar *because* he feels it disagreeable and dry, for he must remember that everything he has learned was so at first, and that the value of everything on earth is pretty much in proportion to the difficulty of acquiring it.' In another letter, he hopes 'that Percy has acquired the art and habit of *fixing his attention* ... for it is only by fixed attention that boys can dispose of their lessons'.[23] Even with his own terrible experience only a few months behind, he was still oblivious to the dangers of forcing excessive work on the young.

On 27 August 1862 Palmer's 'earliest friend'[24] and fellow Ancient, Francis Oliver Finch, had died of a stroke. This was not completely unexpected as he had suffered strokes in 1857 and again in 1861, at which time Palmer wrote: 'Dearest dearest Finch has been stricken again – would that I could suffer and die for him. I think I have observed that all the best people come to calamity. I mean no compliment to myself – a sorry scrub like me is too much honoured by being in such company.'[25] When Finch died Palmer referred to him as a '*very* old friend of Blake; for indeed among Blake's friends, he was one of the MOST REMARKABLE – remarkable for such moral symmetry and beauty, such active kindliness and benevolence as do honour to any profession'.[26] A memorial essay by Palmer was printed in Mrs Finch's *Memorials of Francis Oliver Finch*.

Palmer's own sorrow remained immense, insupportable. It was ever-present, even in his dreams. As he told Richmond, he dreamed that More's death and funeral had been figments of his imagination, that the boy was yet alive. 'For a

second after waking', he wrote, 'the joy remained – then come the knell which wakes me every morning. More *is* dead More *is* dead Yes this is most romantic –. On a sudden living in the country – new scenes – new faces – pure air improved health – bright sunlight – and every morning the knell More *is* dead – More *is* dead.'[27]

In the midst of this consuming anguish the relationship between Samuel and Hannah changed subtly, with Samuel, perhaps seriously and perhaps face-tiously, representing himself as the henpecked husband. It is possible that with the deterioration of his affection for Linnell the father-figure, Samuel saw in Hannah, though she was younger than himself, a masterful materfamilias. At any rate he denigrated himself more conspicuously than before; time after time he refers to himself disparagingly by such sobriquets as 'Sand of the desert', 'The man who turns the mangle', 'a crushed worm', 'a squashed worm', 'The eel in the pan', 'A vapour', 'The most unhappy of men', 'Nobody', 'Mr Fearing', 'Vanity of Vanities', and 'Blind Infancy'.[28] On the other hand Hannah is 'Head of the Family' or 'Head of the House'. He told Cope that he was managed by a committee of women.[29] And he grumbled about the in-trusions of domestic work. 'What a hideous vortex is all this domestic pertur-bation ...' he wrote, 'Orpheus looked back on purpose; he dreaded a second bout of housekeeping.'[30]

The affairs of his brother William continued to plague Samuel even at this most distressing period. In 1848 William had been promoted to attendant in the antique gallery at the British Museum, but in the autumn of 1861, after a long illness (diagnosed as disease of the cranial bones and rheumatism) and extensive sick-leave, he lost his job, apparently without recompense. Samuel referred to this as 'the deplorable Museum affair',[31] and wrote to a few friends, including George Richmond and Sir Charles Eastlake, to ascertain if something could be done to get William a pension. A month or so later, in January 1862, he was awarded a superannuation of £46 a year.[32] Palmer seems at last to have forgiven William for his treachery over his pictures (see above, pp. 125-6); he even tried, though unsuccessfully, to obtain a position at the Museum for William's son.

ಬಾ

The damp atmosphere of the Park Lane cottage was affecting Hannah more and more seriously, and Samuel realized that a move to a healthier place was impera-tive. Hannah, who now paid little attention to Samuel's ideals and wishes, insisted that they must continue to live near Redstone Wood. He would have preferred the ambience of the countryside and life in a primitive cottage; she must have a suburban villa where she could live a bourgeois existence with a maid or two and where there were conventional friends to entertain and be entertained by. In due course she discovered a Gothic villa named Furze Hill House, which stood in Mead Vale, Redhill (such was the postal address; the

house was really in the parish of Reigate). It was close to Redstone Wood, and it put Samuel in a location where his teaching practice must diminish, and with it his income; in these circumstances Linnell's bounty was more important than ever.

Furze Hill House still exists, but has been renamed The Chantry, as it was built on land reputed to be the site of a chantry connected with Reigate Priory. It was erected by a local builder, James Fisher, in 1860, and the Palmers moved in in May 1862. Fisher became bankrupt in April 1864, and the house was bought by Hannah's brother, John Linnell Junior, who allowed the Palmers to continue living there at an annual rent of £75. On his death in 1906 he bequeathed it to A. H. Palmer.[33] It is a picturesque house of Merstham sandstone (or Reigate stone) with a high-pointed gable on the central portion, giving it the appearance of a chapel. There is a gabled wing at each side, and gargoyles accentuate the Gothic note. There is also a bell-tower with an alarm bell, the rope for which was in Palmer's painting room; he did not hesitate to toll it vigorously when necessary, as once when some roughs let their donkeys loose to graze on his cabbages.

Furze Hill House had originally been built for an infirm old lady and its layout was somewhat idiosyncratic. The site slopes sharply so that the lower floor is obscured from one viewpoint; this contained the kitchen, scullery, cellar and servants' quarters. The main rooms are on the floor above; three of them, a bedroom, the drawing-room and Palmer's 'retreat', as he liked to call it, led into a large and lofty hall, open to the rafters, with stencilled walls and an open fireplace with andirons. Outside was a garden, 400 feet above sea-level, divided from a nearby furze field by a hedge of laurel and holly. On a clear day it was possible to see the South Downs as far as Chanctonbury Ring, and the hills of Kent, which would often have called to mind the happy days at Shoreham, though by this time he had had to become hardened to the many desecrations of the countryside – railways, telegraph wires, housing developments – brought to pass in his lifetime.[34]

At Furze Hill House Samuel and Hannah tried to re-make their shattered life, but they were sadly at variance over the way to achieve this. Samuel had an enquiring mind and his interests ranged from the visual arts to literature, from music to theology, from mathematics to social problems. Hannah's mind was restricted by her domestic horizon, by the reading of religious tracts and sentimental fiction, and by her circle of acquaintance. On the whole Samuel was contented to let Hannah go on in her own way, just so long as she did not interfere with what went on in his room, his 'inviolate retreat'. In this small workroom – it was only 15 feet square – he did exactly as he liked, painting, etching, reading or just sleeping. And here he kept his treasures – books, plaster casts, manuscripts, pictures and prints by Blake, and his own Shoreham relics – which for all Hannah cared would have been left at Park Lane by the removal men. Needless to say, the room was crowded to capacity, so that it was difficult to turn round without knocking something over. The bookshelves and the

position of the bed and fireplace ensured that his easel could only be put up in one position, and so far as lighting was concerned, that position was wrong. Here too, among many portfolios and folders, was what Palmer called his 'curiosity portfolio', containing 'mind toners', such as the card engraved for George Cumberland by William Blake, Thomas Bewick's wood-engraving *The Wild Bull*, and Edward Calvert's exquisite little wood-engraving *The Chamber Idyll* (illustration 18).[35]

But Palmer's room was not big enough to contain everything, and much overflowed into the dining-room, including some books annotated by Blake. Distributed through the house were Hannah's copy of Cammucini's Titian, Blake's Dante and Job engravings, which were piled on the grand piano, and proofs of his *Pastorals of Virgil* wood-engravings, which hung on the wall beside a door leading on to a rustic verandah. And there were many of Palmer's own drawings: three walls in the drawing-room contained nothing else. In a closet which Palmer called 'the butler's pantry' there were more books, three tempera paintings by Blake (later restored by George Richmond), and a dirty brown paper parcel which was not opened until after Palmer had died, and was then found to contain the manuscript of an unpublished poem by Blake and some unbound sheets of his early *Poetical Sketches*. These must have had many narrow escapes from destruction during bouts of cleaning directed by Hannah. It will probably never be known exactly what or how much was destroyed in this way; many of Palmer's books were damaged, some beyond repair, by being roughly clapped together to fetch out dust.

Other oddments in the house included a statuette of Hercules under a glass globe, the skull of a man said to have been killed at the Battle of Hastings, and a pair of crimping irons and a green smock acquired at Shoreham. Palmer's occupation of his room caused some rearrangement elsewhere. The dining-room became Hannah's drawing-room, and a small upstairs room was made into a dining-room. This left only two other bedrooms, one for Hannah, the other for Herbert, both draughty; Palmer dubbed one of them 'Bronchitis Bower'. To prevent boots from spoiling her floors, Hannah laid down druggets that marked out the routes between doors.

Among Hannah's visitors were a number of amateur sketchers whose knowledge of art was nil. Some were convinced that etchings were pen-and-ink work, and one of them was found scratching with a penknife at one of Samuel's best proofs in an attempt to decide the matter. Such company drove Palmer to distraction, but in his little retreat he was secure, for nobody was allowed to enter it without his special permission. He described in graphic terms to George Richmond's son John his detestation of Hannah's bourgeois world:

I'm sick of it all ... the drawing-room-genteel-life-servant-keeping-system altogether; and if I were alone again would build a vast airy hut on a dry soil in some old fashioned town where there was a wholesome cook-shop and be my own housemaid and char-woman. Servants have been made what they are by the foolish example of their 'betters' but they

are killing off their mistresses by wholesale with the incessant worry – To think that loving peace and a simple life one should be entangled in these things like a fly in a tar-barrel.[36]

Generally, though, Palmer's lot seems to have been improved at Furze Hill House, since he was able to detach himself – some of the time – from domestic pressures. To George Richmond he commented caustically:

Lodging here, and being permitted to take my meals with the family, I attribute any *strangely* improved health to two secondary causes, good cookery and the being raised above *those evening mists*. 'The family' say that the air is quite different directly they descend the hill towards Reigate – stifling in hot weather and much colder in the damps of winter.[37]

During the spring-cleaning season, he usually decamped to his friend the narrative painter James Clark Hook, whose beautiful house, Silverbeck, in Surrey, Palmer called 'Elysium'.[38] When he returned to his little suburban villa after these 'usual summer moves', as he called them, he was depressed.[39] After a short visit to London, he unburdened himself to Richmond about a typical cleaning session:

My room in the mean time having been *thoroughly set to rights* my leather-cased Meersham [*sic*] and another pipe were not to be found, not to this hour (mid-day next) have I got a single puff – Such is ORDER! I had provided against such chances by keeping a few clays in the BUTLER'S PANTRY but doubtless they were self-annihilated with awe, at finding themselves in so august a 'locality'. I am so *dis*orderly you see!![40]

ॐ

Palmer's ideal country garden would have been luxuriant and rich, and would have contained water in some form – a fountain, a spring, a stream or a lake. But the garden at Furze Hill House, perched on a ridge of sand, was almost arid, and every can of water had to be pumped by hand from a small concrete tank at the cost of a halfpenny a bucket. To save this as far as possible, Palmer irrigated his plants with his washing water. He could not conceive a landscape without water, and there is hardly a landscape study in his *oeuvre* without it. During one of his visits to Devon he wrote: 'NEVER FORGET THE CHARM of running water. In Berrynarbor valleys it gushes everywhere.'[41]

His idea of stocking his garden was unusual: wild flowers were his favourites, and Furze Hill garden included bindweed, wood anemones, foxgloves, hairbells, heath, ling and primroses. This was one of the few things on which he and Linnell still agreed. But his own patch of garden was small; elsewhere everything was dominated by Hannah's ideas, with lawns and flower beds clipped, trimmed and weeded like any other suburban garden. So long as she did not interfere with his own 'wild' patch he was content, though sometimes he allowed himself an outburst, such as when a new servant weeded it. He wrote about this in the summer of 1866 to Miss Frances Redgrave: 'I *will* have my weeds though! The white convolvuli are commencing their tortuosities (to speak in Reigate dialect), and Herbert has made a bench for the arbour. Miss Mary [the

new housemaid] commenced weeding the other day, and pulled up both my hairbell roots, that I have been coaxing for three years into the garden.' Ten years earlier, he had written under a sketch of grass tufts and dandelions in his Grove Street garden: 'Farewell, soft clusters – the only pretty things about this premises – ye are to be mowed this evening, and to leave a scraped scalp of "RESPECTABILITY".'[42] Herbert Palmer commented sympathetically in one of his notebooks on his father's enforced withdrawal into a mere corner of the garden:

But these few anemones, wild-flowers and a small bush of honeysuckle were the only outdoor interests for the whole year left to the poor wretch who had gloried in the perfumed and enchanted Shoreham twilights and in gardens such as those he had sketched with such remarkable enthusiasm of technique at Shoreham and in those still more glorious of the Villa d'Este.[43]

Palmer's poignant and solitary figure was to be seen from time to time quietly strolling in his garden, supporting himself, especially in his later years, with a big ivory-tipped staff made from a massive old whalebone-ribbed umbrella. This was liable to be brought into play in moments of anger: one evening he was on the lawn with Herbert and a friend, and Hannah sent out a housemaid to remind Samuel that Herbert was wearing his best trousers. Silently but with concentrated resolution, he took his staff and violently trounced an ornamental yew tree, making it a scapegoat for all that the respectable surroundings of Reigate and its inhabitants represented.

He still visited London occasionally in connexion with his work, as well as to get away from domestic cleaning; once he went specifically to study an area 1 inch square on a single picture. Sometimes he visited Colnaghi's gallery to examine their stock, or to buy a print, perhaps an etching after Claude. Often he stayed overnight with John Giles. On these visits he dressed in his best, but far from fashionable, clothes. He wore a Croatian cravat (a type worn in the seventeenth century by Croatian mercenaries and used in England before the introduction of shirt-collars), tucked into a double-breasted waistcoat. Over this he wore a long and enormous broadcloth coat with vast pockets, and his big head was encased in a silk hat. His eccentric appearance inevitably drew the attention of passers-by but he was quite unaware of the impression he made. This was added to by his habit of standing before anything that attracted his attention and making loud comments about it in his rich tenor voice. Once he stopped at the window of a milliner's shop, resoundingly disparaging the 'Jezebel Tops' displayed there. A crowd soon collected to enjoy the spectacle, but Palmer was oblivious of his audience; his companion fled.[44]

Palmer disapproved of many of the female fashions of his day, and mentioned to Frances Redgrave a lecture by Charles Kingsley on

the TIGHT LACING CURSE. Yes, I say CURSE, and I mean it, and wonder how Kingsley could have done his duty so thoroughly and at the same time have kept his temper so well: he is leniently inclined to excuse it on the plea of our very incomplete civilization, yet he says

forty years of warning have proved useless, which argues much moral perverseness. He is amused at the peals of laughter with which a tight-waisted female would have been greeted by the ladies of Attica. I have the honour to have long shared this ludicrous vision with Mr Kingsley, and to have imagined the very fish-women of the Piraeus pelting her with seaweed.[45]

He was not alone in his views on corsets. Despite the prevailing fashion there was an Anti-Tight-Lacing League, including among its members the artist G. F. Watts and the architect Edward William Godwin.[46]

ဆ

During the first years at Furze Hill House Herbert was a lonely, almost forgotten child. Samuel had forced his elder son's studies but now, for a long time, he completely neglected the education of the younger boy, who said later that he was taught nothing until he was twelve.[47] His upbringing was odd in other ways too: Hannah took him, a most unwilling victim, for a walk each morning to Reigate, dressed ridiculously in home-made petticoats and an outlandish coat with a frilled collar, a butt for the laughs and jeers of other small boys whom he passed in the street. Not surprisingly, he recalled this period as one of the unhappiest of his life. He was, he said, 'shut up in the house of mourning, unable to read or write; without toys; without any resources'. Even at Christmas the house remained dismal, and because of this childhood experience, the festival was a depressing occasion for him for the rest of his life.[48]

From his window the solitary Herbert observed the variety and interest of wild-life in the garden – mammals, birds, reptiles and insects. This grew into an abiding enthusiasm and he determined to become a naturalist; he never became a professional, but equally his interest never evaporated. His father greatly disapproved of it, reminding him of Pope's aphorism that 'The proper study of Mankind is Man',[49] but this only resulted in Herbert continuing his interest in secret, so that he felt himself even more isolated than before.

Though he lacked friends of his own age, some grown-ups were kind to him. One was his uncle John Linnell Junior, who was curator of Reigate Museum and a painter; he was also an entomologist, and kindled Herbert's imagination by showing him his insect collection. Herbert later attributed his skill in the delicate operations of etching to the dexterity he acquired in handling insects. Other friends included the Redgrave sisters, Evelyn and Frances, who befriended him at the time of Thomas More's death and had taken an interest in him ever since. 'They were', he said, 'a lovely pair when they fished the Palmer tadpole out of the mud.'[50] They were among the most frequent visitors to Furze Hill House, and Frances especially perceived in Samuel an intellectual and artistic integrity which many other contemporaries failed to discern. When she visited the House, Herbert later recalled, it 'seemed changed, glorified and serene, and full of new interest'.[51] Sometimes during these visits she was taken by Hannah to Redstone Wood, as she recalled in a letter to Herbert written in 1917:

90 Alfred Herbert Palmer, *circa* 1865. From a photograph by F. Otto's School of Photography, Redhill (collection of Mr A. H. Palmer II, Vancouver, Canada)

Your grandfather was a great autocrat. I ought not to say a *word* against him because he was always very kind to me when I went over to Redstone with Mrs. Palmer and I enjoyed my visits there exceedingly and your grandmother seated by the fire in her bedroom and talking so kindly. *But* I was always a little afraid of him as he thought poorly of an R.As. daughter [Linnell was never elected to the Academy] and he considered that we lived in heathen darkness at Furze Hill Cottage, a place which always shone to me in a most illuminating atmosphere some of my happiest moments being spent in the little studio there. There was no comparison between that and the fine studio at Redstone as to which I preferred to be in. Your father's conversation was so delightful and so amusing and so enlightening. Mr Linnell's remarks on the whole were admonishing. My religious opinions were attacked. Still the whole family party sitting round the table at tea and the kindness of the sons and daughters made Redstone very pleasant to me and Mrs. Palmers lovely [Italian] drawings round the room added to the charm.[52]

At last Palmer began to realize that some of his ideas on the upbringing of children were deficient. To John Reed, one of Herbert's godparents (the other was Charles West Cope), he wrote:

Your little godson is growing up ... near ten years old, but in spite of this air, which they say is so fine, looking old and unchildlike, better now having had six weeks incessant play of one kind or another with Harry Cope [son of his second godfather; he was staying at Furze Hill during an epidemic near his home]. There is no school here we quite like, yet he wants the company of playmates and altogether I don't quite see how he could be in a worse place; so my last plank is gone. Better for a child to be playing about in London gutters than to be alone in a house of mourning.[53]

The melancholy atmosphere of bereavement at Furze Hill House was not always immediately apparent to strangers, for as time went on Palmer was usually able to hide his grief under an apparently cheerful, even jovial and jocular exterior. But when the family were alone the atmosphere was usually grim, with the two parents disunited in everything except a determination to mourn their dead son for the remainder of their lives. They made no attempt to provide for Herbert any of the young society they saw he lacked, and it is not surprising that he later admitted to being shy 'to the boundaries of terror'.[54]

Eventually Palmer did take on Herbert's education, but, as he told John Reed, he was fearful because 'dear Herbert is so delicate, though without any specific disease, that we hardly think he will live to grow up ... He is going on for 12 yet only learns a little at home in the morning. I give him half an hour and find him delightful to teach quite as quick as – "There comes my fit again".'[55] Herbert ought to have been thankful for the delicacy of his health, for given normal vigour he might have presented a tempting subject for another bout of 'forcing' by his father, who once confessed that education was his hobby.[56] 'I always took unqualified delight', he wrote, 'in the development of young minds ... When I called at Kensington School and saw the boys popping in and out of the doors and passages – *that* was *my* fairy land. I felt like a creature in its natural element.'[57] As it was, his attitude to Herbert was considerably more relaxed than it had been to Thomas More, though he did send his younger son plenty of 'improving' passages in his letters.

Herbert's poor physique was strengthened as a result of a suggestion by Mrs Richard Redgrave, who realized that if nothing was done about it, he would go into a decline and probably die. She told Palmer that the boy should be given a course of military drill. He agreed, and a Mr Johns, a former sergeant major of the Grenadier Guards, was engaged to train him. Johns was 6 feet 2 inches tall, broadly built, and much admired by Herbert, who, apart from drill, received instruction in broad-sword and single-stick exercises. 'I have', he was soon able to tell George Richmond, 'become twice as broad and strong as I was before.'[58] To these experiences he attributed the onset of one of his major enthusiasms – a love of firearms.[59]

Thus Herbert spent his days partly in lessons from his father, partly in drill and partly in surreptitious entomological studies. During the evening Samuel,

Hannah and Herbert forgathered and Samuel would read aloud, often from Dickens. Once Herbert had gone to bed Samuel returned to his drawings, perhaps here and there adding little touches and sometimes making erasures, always after long periods of silent cogitation. Meanwhile Hannah took up her beloved letter-writing, sending her acquaintances reports of the nothings of her daily existence. Markedly inferior to the letters which years ago she had sent back from Italy, there were addressed at this period mainly to old friends in Kensington, but later their chief recipient was Mrs Redgrave.

Herbert shared his father's disgust with Hannah's houseproud regime, and became his fellow conspirator. In a regretful mood at a later date, he wrote that his father chose him for a companion not because he was particularly interested in him, but because no other was available.[60] But he certainly had much of Samuel's society, especially in his 'retreat', where he helped him prepare art materials, or to accomplish economic makeshifts – which included the repair of slippers with boiled cobbler's wax and firing a gun up the hall chimney to bring down the soot.

∽∾∽

The prevailing middle-class ambience of Reigate notwithstanding, Palmer did find one or two kindred spirits; among them, living in the fashionable Wray Park area, was one of his oldest friends, the former Miss Williams, a daughter of Dr William Williams, at whose house in Hackney his birth had been registered. Miss Williams had now become the wife of the Reverend Thomas Preston Wright, a rich parson; they lived in a splendid house, which had been designed for them by Decimus Burton's erstwhile pupil William Hakewill, and stood in extensive grounds. Mrs Wright's brother, Dr Walter Williams, was a close neighbour. Mr and Mrs Wright's sons, John Preston and Thomas Howard, became great friends of Palmer. When he first moved to Furze Hill House they were still boys. In time John Preston Wright went up to Cambridge and took holy orders, while Thomas Howard Wright matriculated at Oxford, read law, and was called to the bar.

To poor Herbert, whose experience had never before broken out of the restricted family circle, the Wrights' home came as a marvellous revelation, a striking disclosure of what delights and pleasures life could hold. He later wrote of the multitude of toys and games he saw there, and he remembered the scene at Christmas 1862, with a great glittering table piled with good things and a vast quantity of gifts arranged around the Christmas tree, something for everybody in the establishment, down to the cowman and the page. 'It was then', he wrote, 'that I received my first gift a little pencil case.'[61]

During the university vacations the Wright brothers visited Palmer frequently; he set aside certain evenings each week to receive them, and on these occasions conversation ranged over many topics – rarely, however, including art, a subject he tried to avoid in general conversation. John Preston was

especially welcome; Palmer counted his visits among his greatest consolations. But he was also very fond of Thomas Howard, and when he heard of his first success at Oxford, wept for joy, no doubt recalling his own frustrated plans for Thomas More. Many years on, the two brothers recalled their impressions of Samuel in letters to Herbert:

Though he doubted human nature and belittled and abused mankind, at times with freedom and acerbity, he never distrusted a human being. I never heard him utter a hard word of any one person in the world and I do not believe that he cherished a hard thought of anyone he had ever spoken with. His attacks were not against men and women but against qualities, vices, wickednesses, idealized dramatized and personified ... If he had striven with every fibre to make himself an ordinary being he would have failed ... A dignity attended all his ways for his was a life that knew nothing of the common and sordid incentive to action.[62]

John Preston Wright recalled an incident which illustrated Palmer's artistic spontaneity rather than his more usual painstaking practice:

One evening between the years 1863 and 1866 (I cannot fix the date more exactly) I was sitting in the painting room with my back to the fireplace and my right arm resting on the table. [Palmer] was sitting on the opposite side of the table. We were talking of I know not what when [he] suddenly asked me to keep my arm in exactly the position in which it was as he wanted to sketch the folds of the sleeve of my coat for a drawing on which he was engaged from Il Penseroso Or if the air will not permit etc.*[63]

Samuel's old uneasiness surfaced again when Herbert went to Oxford to visit Howard Wright for a few days. His arrival was preceded by a fussy letter indicating that he was used to blankets, imploring that his bed linen be well aired, and advising Howard that they should both 'see what of art there is in Oxford'.[64]

Palmer's ill-health – especially asthma – still persisted. There is little doubt that it was exaggerated by hypochondria: his son said that he would make a fuss over a scratch.[65] But in September 1864[66] and later he seems for a time to have been really ill, complaining of extreme weakness; this continued for some years, certainly until the late 1860s, after which he began to recuperate. He was told that he would not be properly well unless he took more exercise. His only physical exertion was to pad about his garden, for he hated to see the havoc brought upon the countryside by developers. Nevertheless, on the advice of his doctor he began to take long walks, for which he donned an old gardening hat and an old Inverness cape, with Virgil's *Eclogues* in his pocket to read on the way. He would march to a five-barred gate some distance off, touch it with his stick, turn round, and return 'scowling with anger and disgust much as a member of a chain gang goes back after exercise to prison'.[67]

Yet his health was after all unbroken, for he ate sensibly and drank little alcohol. He wrote to George Richmond's daughter Julia, giving some indication of his own diet when he recommended her 'to breakfast upon Betts's cocoa with oleaginous globosities bobbing about as you stir it like porpoises of

* The drawing (Victoria and Albert Museum) was for *The Bellman* (illustrations 97, 98).

the deep. And if this is "too rich", for gross it is *not*, then a slice of beef and a pint of home-brewed.'[68] He chewed his food well and never lost his teeth. He continued to take snuff and allowed himself a post-prandial smoke, usually in a churchwarden's pipe, but these were his only indulgences. His brother, William Palmer, died at Margate on 31 July 1866. Replying to a letter of condolence from Richmond, Palmer referred to his own illness: 'My Brother's last years were spent in great bodily pain, but otherwise so used as to give a good hope that he had entered into rest. About the same time I was confronted with death in its sudden and startling aspect.'[69]

There were occasional reminders of pleasanter carefree days, such as when he heard from Albin Martin, their travelling companion on the last stages of the Italian tour – now married with grown-up daughters and living in New Zealand. Palmer replied to him in a generally grumbling vein, reflecting with disfavour on contemporary morals and customs.[70] He continued to correspond with and to see the surviving fellow Ancients – George Richmond, John Giles (with whom he was reconciled) and Edward Calvert, who was more than ever withdrawn from the world, painting hazy visions of an Hellenic Golden Age and working on heady speculations on the interrelationship of art, music and religion. Of him Palmer wrote to an unidentified art purchaser:

Another name you will meet with some twenty years back is Edward Calvert who now does not exhibit, an artist and philosopher to whose converse I am deeply indebted. Not knowing whether a drawing or sketch of his would be attainable, I enclose my card in case you would like to try; but, as he is much engaged in recluse study, recommend writing to him to ask when he will be disengaged . . . I have enjoyed a poem, in a few touches of Mr Calvert's chalk or charcoal. His is the Doric or Attic delicacy – but tastes differ. *Perhaps* he might show you his beautiful wood cut *cut by himself* 'The Christian ploughing the last furrow of life' and a few others; but I don't know.[71]

The days in which that wonderful engraving was made must have seemed remote to the ageing artist of Furze Hill. But though he was never again to experience the innocent happiness he had known among the little Kentish hills, he did, in the last years of his life, regain much of his artistic vision and create some of the finest things he had conceived since his youth.

നു

The later years of Palmer's life were dominated by two important artistic projects, both inspired by verse: one by Virgil's *Eclogues*, the other, the more spectacular, by Milton's two companion poems, *L'Allegro*, an invocation to the goddess Mirth, and *Il Penseroso*, an invocation to the goddess Melancholy, the former revolving around the pleasures of day, the latter around the moods of night.

The Milton project was the upshot of the sale of a little watercolour Palmer exhibited at the Water-Colour Society's Winter Exhibition in 1863: *Twilight – The Chapel by the Bridge* (now untraced). It caught the attention of John

Ruskin's solicitor, Leonard Rowe Valpy, who bought it. Valpy fancied himself as an art expert and had strong ideas about painting, and although he had bought *Twilight* he disliked the bright rayed light which Palmer had depicted coming from within the chapel. He wrote a courteous letter to the artist, enquiring if he would be willing to tone it down somewhat, and, anxious to please, Palmer agreed without hesitation: 'You have exactly described my own impression as to the lights in the windows, and reflections. I think they glare a little, and should rather glimmer. I am always glad to adopt a suggestion like yours, especially when it would enhance poetic mystery.'[72] A little later he was able to report that he had 'spent a morning on the "Chapel by the Bridge", and not an unpleasant one, as I think it has made the difference of the few last sun-glows, "which give the fruit their sweetness"'.[73]

Valpy was pleased with Palmer's modification and soon afterwards asked if he could show him anything that he 'had in hand which specially affected his "inner sympathies"'.[74] With some enthusiasm Palmer replied:

You read my thoughts! – It is really very curious. Here is the evidence. 1st. The last touch was put to *The Chapel by the Bridge* the moment before I opened your letter: 2ndly. All the time I was writing my last, Mr Chance's name* was on the tip of my pen, as the very man for the work [of framing the watercolour]; but I thought it hardly fair to introduce a rival to whomsoever you might usually employ ... 3rdly, and most curious of all, you ask me to show you anything I may be upon 'which specially affects my inner sympathies'. Now only three days have passed since I did begin the meditation of a subject which, for twenty years, has affected my sympathies with sevenfold inwardness; though now, for the first time, I seem to feel in some sort of the power of realizing it.[75]

He went on to quote lines from *Il Penseroso*, which, he said, 'Edmund Burke thought the finest poem in the English language.' He was trying to illustrate the passage (which he slightly misquoted):

> Or if the Ayr will not permit,
> Som still removed place will fit,
> Where glowing Embers through the room
> Teach light to counterfeit a gloom,
> Far from all resort of mirth,
> Save the Cricket on the hearth.

> (Lines 77–82)

The size of the drawing was to be 'the size of your *Chapel*'. It would depict

The student in his country, old-fashioned room, meditating between the lights: the room dimly bronzed by the dying embers (*warranted without* 'RAYS'!) and a very cool, deep glimpse of landscape, and fragment of clouded moon seen through the lattice, just silvering the head and shoulders: the young wife in shade, spinning perhaps, on one side of the fireplace.[76]

In fact, although this was the first subject in the series that Palmer attempted, he never got beyond the rough charcoal sketch (Victoria and Albert Museum), on the verso of which A. H. Palmer wrote, 'The First sketch for an Il Penseroso

* See above, p. 134.

subject/which, in spite of his attempts, defeated S.P. totally/much to his sorrow.' But it did help him to visualize the subjects, the remainder of which were carried through successfully:

I carried the Minor Poems in my pocket for twenty years, and once went into the country expressly for retirement while attempting a set of designs for *L'Allegro* and *Il Penseroso*, not one of which I have painted (!!!), though I have often made and sold other subjects from Milton. But I have often dreamed the daydream of a small-sized set of subjects (not however monotonous in their shape yet still a set; perhaps a dozen or so), half from the one and half from the other poem. For I never artistically knew 'such a sacred and homefelt delight' as when endeavouring in all humililty, to realize after a sort of imagery of Milton.[77]

Valpy commissioned the watercolours in 1864, and they occupied the artist on and off until his death in 1881, when one or two were still not quite finished – or at any rate not considered so by Palmer himself. Their progress led to a long correspondence between him and his client, in which all kinds of subjects – artistic, religious and literary – were discussed and argued over. It was a strange relationship, the sensitive and gentle artist allied with the saturnine and adamantine client who so loaded him with suggestions and criticisms that it was obvious that 'the painter ... was to be placed in an artistic harness and Valpy was to hold the reins'.[78]

Insensitive to Palmer's feelings, Valpy adopted a condescending attitude and was full of self-centred affectation. On one of his visits Palmer's young friend Thomas Howard Wright was present, and was so irritated by Valpy's hauteur and dull droning voice that he withdrew to Herbert's bedroom to unburden his contempt. Herbert left a vivid description of his father's client:

[He] had strong dark features, a low retreating forehead, black hair in places turning grey and a smile so reluctant as to be almost sardonic. In it the sombre eyes never joined. There was slow deliberate enunciation of commonplaces in a deep voice and greater unresponsiveness to the lighter vein of his host's table talk than I ever witnessed even in the case of the Linnells. The experiment of showing him any of Blake's work was never tried. Valpy seemed to be the reincarnation of some hip and thigh puritan who might have run his great sword through pictures in a gallery or smashed up with the hilt the windows of any Chapel by a bridge or elsewhere ... Worst of all he had a fine repertory of what he imagined to be studio gestures, exclamations and attitudes all of which fitted him ill and from all of which my father was utterly free.[79]

Valpy helped Palmer to choose the subjects. This is confirmed by a letter from the artist, written in July 1864, in which he says he is longing to see what Valpy had marked 'as Miltonic gems in rich settings', and adds, absolutely characteristically:

Even though one knows every line by heart, select and precious passages gain somewhat by social sympathetic love. The choice of subject is at once a compliment and a stimulus to the artist. It will, no doubt, be a work of time to make the selection, and there is much to be thought and said ... For Milton, space is essential, as also to secure more final dreaming and refinement; not large enough for diffuseness, but large enough to make [the] amber sky a *spread* of light. Long sweeping lines and largeness of parts are essential for Milton.[80]

Eight subjects were finally chosen: *The Eastern Gate*, *The Prospect* (both private collections, England) and *A Towered City* or *The Haunted Stream* (Rijksmuseum) from *L'Allegro*, and *The Curfew* or *The Wide Water'd Shore* (Rijksmuseum), *The Bellman* and *Morning* or *The Dripping Eaves* (both Devonshire Collection, Chatsworth), *The Lonely Tower* (Yale Center for British Art) and *The Waters Murmuring* (private collection, England) from *Il Penseroso* (see illustrations 91–5, 97). In addition Palmer made several smaller versions of the same designs and some preliminary designs in brown wash. Examples of the latter are in the Victoria and Albert Museum and Cincinnati Art Museum; there is a small version of *The Bellman* in the Cecil Higgins Art Gallery, Bedford, and of *The Lonely Tower* in the Huntington Library and Art Gallery, San Marino, California.

The eight main designs are all of about the same size: approximately 504 × 718 mm. They are among Palmer's biggest watercolours, and in them he took the medium to its limits, using every device at his disposal. In places he used pure watercolour, from brushwork applied *au premier coup* to minute and painstaking dotting and dappling; elsewhere he used body colour enriched with gum, albumen and, in places, shell gold. The resulting textures are of a luxuriance usually present only in oil or tempera. Nevertheless the preliminary

91 *The Curfew* or *The Wide Water'd Shore*, 1870. Watercolour and body colour on London board; 500 × 711 mm (Rijksmuseum, Amsterdam)

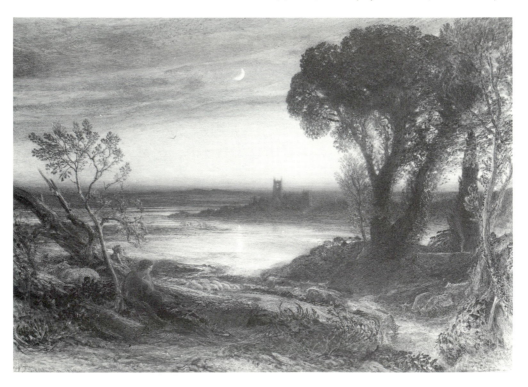

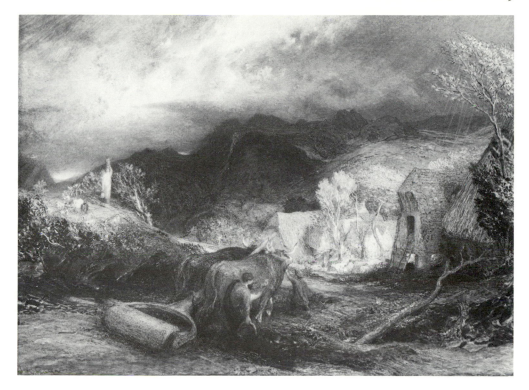

92 *Morning* or *The Dripping Eaves*, 1869. Watercolour and body
colour on London board; 502 × 708 mm (Devonshire Collection,
Chatsworth, reproduced by permission of the Chatsworth Settlement
Trustees)

designs in brown wash tend to be preferred, because of their immediacy, re-
straint and (somewhat misleading) resemblance to Palmer's early visionary
work.

The big watercolours are considered by some to be too highly wrought, too
studied, their colour too hot. They do vary somewhat in quality, but the best of
them, such as *The Bellman* and *A Towered City*, are brilliant conceptions which
do full justice to the poems they illustrate. Each contains indications of a
lifetime of experience. In *The Bellman*, for instance (illustration 97), the village
scene recalls Shoreham (and in some ways resembles its present appearance);
the distant mountains are a curious mixture of Italian Apennines and
Devonshire tors; while the resting oxen may be a memory of 'the oxen of
Theocritus and Virgil', which Palmer mentioned many years before in a letter
from Italy.[81]

A Towered City is based on lines 117–30 of *L'Allegro*:

> Towred Cities please us then,
> And the busie humm of men,
> Where throngs of Knights and Barons bold,

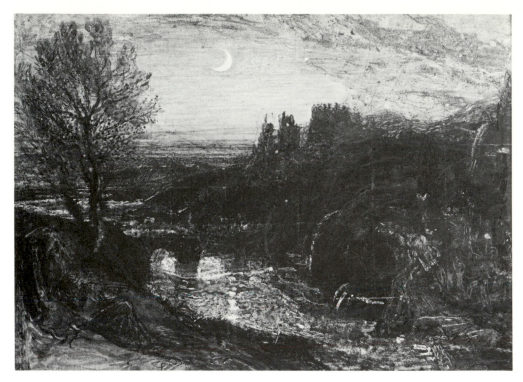

93 *A Towered City* or *The Haunted Stream* (preliminary study), *circa* 1868. Brown wash with white body colour on card; design area 202 × 284 mm (by courtesy of the Board of Trustees of the Victoria and Albert Museum)

In weeds of Peace high triumphs hold,
With store of Ladies, whose bright eies
Rain influence, and judge the prise
Of wit, or Arms, while both contend
To win her Grace, whom all commend.
There let *Hymen* oft appear
In Saffron robe, with Taper clear,
And pomp, and feast, and revelry,
With mask, and antique Pageantry,
Such sights as youthfull Poets dream
On summer eeves by haunted stream.

Palmer's depiction exactly fits the festive mood of the passage, with 'throngs of Knights and Barons' crossing the bridge, and a rout of revellers on the causeway at the right. The towered city, in silhouette against the early evening sky, is based on a general view of Tivoli, which Palmer visited in 1838 and 1839, but which here he probably derived from Claude's versions of the view in *Liber Veritatis*,[82] where the placing of the tree, the bridge and the city itself are the same. On the bank at the left is a sleeping 'youthfull poet', whose figure recalls

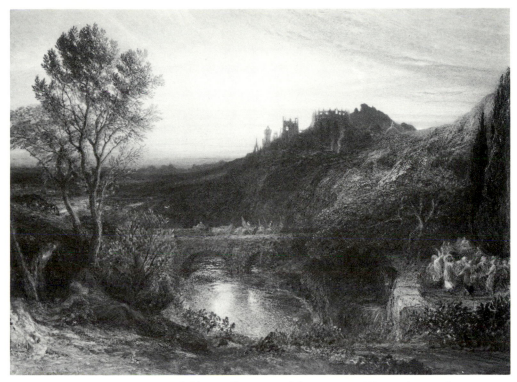

94 *A Towered City* or *The Haunted Stream*, 1868. Watercolour and body colour with thick gum in places, on London board; 511 × 708 mm (Rijksmuseum, Amsterdam)

the sleeping shepherds that appeared in many of Palmer's earlier works, and the whole scene is the poet's 'dream On summer eeves by haunted stream'. The actual landscape contains no towered city, or throngs of knights or revellers, but is a quiet countryside in which the poet is resting and dreaming his dream.

Similar care went into all the Milton designs. His son wrote of Palmer's 'soliloquies ... motionless before his easel holding a candle-stick and touching at long intervals with his twig of ripe charcoal such designs as the Milton series'. Sometimes instead of a candle he would use a small adjustable colza oil lamp, in order to show every detail clearly. Hence the drawings need to be viewed in a very low light, for then they have the character Palmer intended and take on the appearance of the actual scene in twilight.[83]

The Miltons became almost an integral part of Palmer's being while he was working on them: an extension of his mind as well as an arena for the full resources of his art. It is therefore hardly surprising that discord arose between him and Valpy, who vigorously pushed his own ideas of the designs and their meaning. It did not surface, however, until the parsimonious Valpy asked Palmer to abate his fee, even haggling over the cost of a frame, about fifteen years after giving him the commission. Although it is not now known what his

fee amounted to, A. H. Palmer claimed that it was in any case pitifully low for the amount of work involved.[84] Even Palmer, gentle and passive by nature, was stung into what was for him a sharp retort:

I loved the subjects, and was willing to be a loser in all but the higher matters of Art and Friendship. I do not in the least complain that I have lost a thousand pounds by them. It was my own act and deed. In the same time, I could have made thrice the number of telling and effective drawings of the same size, but I considered your taste and feeling so much above the ordinary standard that, in order fuller to satisfy them, I have *lavished time without limit or measure*, even after I myself considered the works complete.[85]

Valpy seems indeed to have been an unsatisfactory character, but before condemning him it is as well to recall that without him the Milton series, a major achievement of Palmer's mature output, would probably never have been painted. To this should be added that it was the generosity of a settlement that Linnell made on Hannah (as on his other daughters), as well as other financial help he sent to her from time to time, that ensured Palmer's freedom to undertake the commission.

Among the happiest incidental results of the Milton commission were two etchings, Palmer's greatest essays in the medium: *The Lonely Tower* and *The Bellman* (illustrations 96 and 98), which reproduce the compositions of the watercolours of the same subjects. He explained their inception in a letter to Valpy:

The Etching dream came over me in this way. I am making my working sketches a quarter of the size of the drawings, and was surprised and not displeased to notice the variety – the difference of each from all the rest. I saw within, a set of highly-finished etchings the size of Turner's *Liber Studiorum*; and as finished as my moonlight with the cypresses[86] a set making a book – a compact block of work which I would fain hope might live when I am with the fallen leaves.[87]

That was written in October 1864; the fact that only two etchings were completed, and those only by 1879, is an indication of Palmer's slow and toilsome method of work. Though – or perhaps because – they are monochrome they appear more perfectly conceived works than the two watercolours; in them Palmer was freed from 'the dreadful death-grapple with colour which makes every earnest artist's liver a pathological curiosity',[88] and was able to concentrate on the linear and chiaroscuro effects of etching. Yet his approach was still that of a painter. The following passage from one of his notebooks is about painting, but could equally be applied to his etchings:

The ANIMATOR is CHIAROSCURO. HOLES of DARK, BOLD CAST SHADOWS – the same PLAYFUL and INTRICATE sometimes, when cast from trees like (blueish) soft, gray, blotting or dappling over the finished matter (figures most beautiful under this effect). Where figures or sheep come in nearly front light against holes of shade under trees they are like plates or bassi-relievi of wrought gold.[89]

All of this is evident in the two etchings. *The Lonely Tower* is especially powerful; its monochrome is much more numinous in effect than the polychrome of the painting. The deeply etched lines recall the rich lines of Palmer's

pen, ink and wash studies of 1825. Its symbols are wide ranging, from the nostalgic waning moon and the bright constellations of the Great Bear and the Heavenly Twins, to the dark crevice with an owl flying along it, the ominous 'Druidic' trilithons on the horizon, and the shepherds, resting among their sheep while gazing longingly at the distant tower with a light in its window.

But Palmer's own preference seems to have been for *The Bellman*, about which he wrote:

It is a breaking out of village-fever long after contact – a dream of that genuine village [Shoreham] where I mused away some of my best years, designing what nobody would care for, and contracting, among good books, a fastidious and unpopular taste. I had no room in my *Bellman* for that translucent current, rich with trout, a river not unknown to song [the Darent]; nor for the so-called 'idiot' on the bridge with whom I always chatted – like to like perhaps. But there were all the village appurtenances – the wise-woman behind the age, still resorted to; the shoemaker always before it, such virtue is in the smell of leather; the rumbling mill, and haunted mansion in a shadowy paddock, where sceptics had seen more than they could account for; the vicarage with its learned traditions; the Wordsworth brought to memory every three hours, by

95 *The Lonely Tower*, 1868. Watercolour and body colour, with thick gum in places, on London board mounted on wood panel; 510 × 705 mm (Yale Center for British Art, New Haven, Connecticut, Paul Mellon Collection)

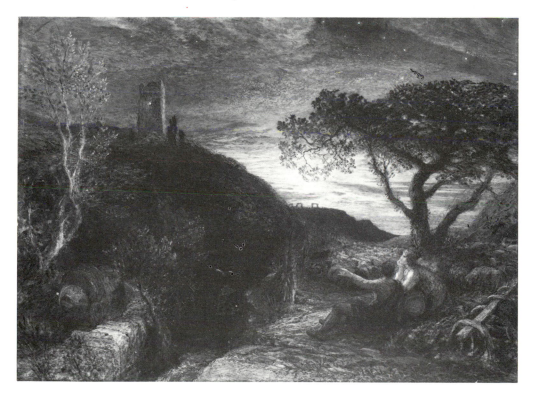

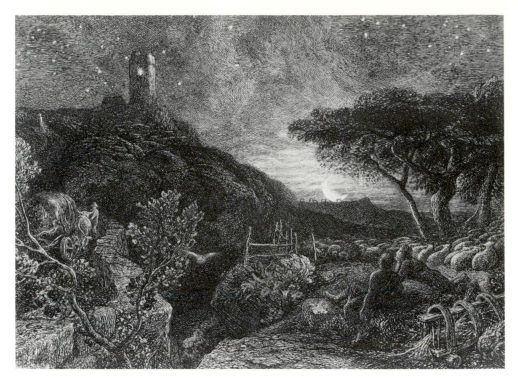

96 *The Lonely Tower*, 1879. Etching; etched surface
165/167 × 233 mm (private collection, England)

'– the crazy old church clock
 And the bewilder'd chimes.'

Byron would have stuffed his ears with cotton had he been forced to live there.[90]

Palmer's enthusiastic restlessness increased as the Miltons and their related etchings neared completion. This was a pattern that was always evident as fulfilment of a project approached, contrasting with the lack of enthusiasm with which, frequently, it had been begun. Of this sequence Thomas Howard Wright said, 'I remember that he told me he always began upon a picture with an almost invincible repugnance; but when once the "constitutional in-dolence" as he called it was conquered ... he became so absolutely absorbed that time and place vanished and he was in the land where he was painting, that land never to be reached but always to be striven for.'[91]

தை

From the early days when his imagination was quickened by Blake's wood-engravings for Thornton's *Pastorals of Virgil*, Palmer had loved the *Eclogues*, and his feeling for them was reinforced first by Thomas More's interest and

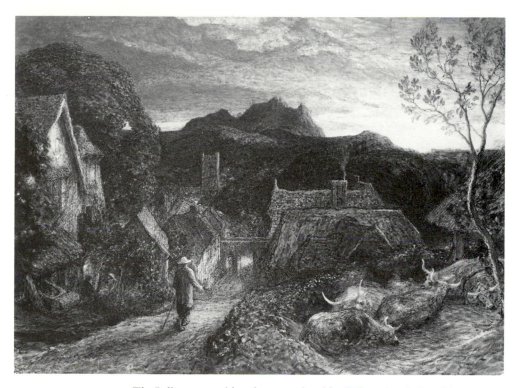

97 *The Bellman*, considered uncompleted by Palmer just before his death in 1881. Watercolour and body colour on London board laid down on wood panel; 506 × 705 mm (Devonshire Collection, Chatsworth, reproduced by permission of the Chatsworth Settlement Trustees)

success in classics, and later by a determination to make his own English translation of the work, in verse. This he accomplished, turning it into a series of delightful pastorals, even if in the process he occasionally showed scant regard for Virgil's original. In the Second Eclogue, for instance, he transforms the theme of pederastic love into what was for his time a more acceptable story, in which the beloved is not a boy, but a pretty girl. Instead of Corydon the shepherd 'aflame for the fair Alexis, his master's pet', Palmer writes of Corydon's love for 'comely Galatea', which, while forestalling any contemporary accusations of indecency or concupiscence, hardly does justice to Virgil's original.

Nevertheless, the translation conveys the true atmosphere of the *Eclogues*. Considering Palmer's lack of formal education, his achievement is little short of amazing. He chose to cast his translation in rhyming couplets, a form which often becomes leaden in unskilful hands, but which Palmer masters with variety of stress and enjambement, for example in the Third Eclogue:

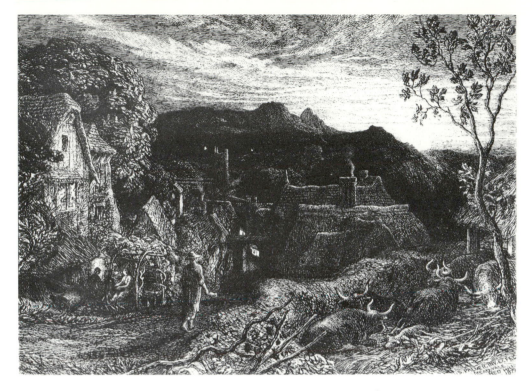

98 *The Bellman*, 1879. Etching; etched surface 167 × 233 mm
(private collection, England)

> Always a luckless fold were Ægon's sheep;
> As now, while he, far off, so jealously
> Watches Neæra's steps, afraid lest she
> May love me better, and his suit refuse
> At last; this hireling keeper drains the ewes
> Twice in an hour, makes market of the dams,
> And chaffers with the milk filch'd from the lambs.

The translation is at its best where the imagery is concrete and recalls his
Shoreham years (and the world of his etchings), as in the Fourth Eclogue:

> Now, fairest boy, will the new-teeming earth
> No culture wait, but poor to make thee mirth,
> As toys of off'ring she can soonest bear,
> Wild nard and errant ivy everywhere,
> And with th'Egyptian lily twined in play,
> Laughing acanthus: now the ewes will stray
> Untended, and at eve the goats come home
> Heavy with fragrant milk: the herds may roam
> Loosely at will . . .
> No later than the day when thou canst read

Of heroes, busy with each generous deed
Thy father wrought, thus early bent to learn
What strenuous virtue dares, the field will turn
To gold, with the soft beards of ripening corn,
Grape clusters mellow on th'uncultured thorn,
Hard oaks with dew-like honey fill the bough ...
 No harrows then the generous glebe will brook,
Nor purple vintages the pruning-hook;
The sturdy ploughman from his oxen now
Loosens the yoke; no fallows need the plough;
Nor shall the snowy fleeces learn to lie
With many a hue of counterfeiting dye;
But o'er the mead the ram himself bear wool
Or of a softly blushing purple full,
Or saffron; either shall spontaneous grow,
And feeding lambs in Syrian tinctures glow.

When the translation was at last published posthumously in 1883, as *An English Version of the Eclogues of Virgil*, it was prefaced with an introductory essay by Palmer, 'Some Observations on the Country and on Rural Poetry'. This is a beautiful piece of work, the art of poetic writing being subordinate only to painting and etching in Palmer's mind. It is the fruition not only of his wide knowledge of literature, but of his absorption and retention of what he had read over the years. His main argument is that poetry is a source of moral education, and that the pastoral, by eschewing such degrading locations as the city, the court and the battlefield, presents a virtuous context, rational occupations, and honest feelings. This is an entirely traditional theme – he would have found it in Sir Philip Sidney's *Defence of Poesie*, which he cites – but, typically, it was not currently fashionable.

So great is his delight in literature, moreover, that he digresses to share his enthusiasm for points of style without particular reference to the pastoral. For example, after quoting *Macbeth* he comments: 'Thus do remote allusions and changing mastery set off the narrative with the foil of a broad contrast: similes connect the excursive opposite with the coherent story.' This taste for surprising and apparently incongruous metaphors is, again, unusual in someone of his generation, and would have been fostered (or instilled) by his reading of seventeenth-century authors. In this essay alone, he mentions or quotes Cowley, Waller, Denham, Fletcher, Locke, Clarendon, Temple and – naturally – Milton, none of them especially popular in his day. But he does not mention only seventeenth-century writers, or only English ones; among others are Gray, Bernard le Bovier de Fontenelle, Johnson, Samuel Maitland, Lavater, Goldwin Smith, Pope, and of course Virgil.

If the 'Observations' are compared with the *Address* (Appendix 1), it will be seen that Palmer's views of the pastoral life changed little over the years. Nostalgia for the bygone countryside of England and anxiety to prevent

change are present in both, as is the ideal of security and welfare in village life of the kind he had experienced fifty years before:

In the fertile vale of Avon in Wiltshire where anciently, within a distance of thirty miles, stood fifty mansions or manor houses, it was said as many years ago, that there were then only eight remaining. Each of these with its village or hamlet, was a little polity, in which rule and subordination might be only harsher names for guidance and loyalty: there were no extremes of wealth and destitution, of insolence and servility.

He contrasts this with the changes which have overtaken such a life, and which incidentally had overtaken himself as well; yet poetry still offered refuge:

Whither were these old families dispersed, after they had ceased to live 'among their own people'? It may be that some of the descendants were doing nobler work in crowded cities; arresting the advance of disease or crime; and that in scant leisure, turning over their old school books, georgical verse revived agrarian instincts, and seemed to refresh the fœtid neighbourhood, like a Tramontana from the Apennine: for rural poetry is the pleasure ground of those who live in cities. It repairs in a measure the natural link which has been broken when man has been removed from the cultivation of his native earth, and sees little from the windows that can make vision desirable: it is then that verse presents to fancy what is lost to sight; and when all the foulnesses without are frozen down into a black fog, he may call for lights, refresh the fire, and have tolerable weather with the poets.

The 'Observations' contain many examples of Palmer's well-judged turns of phrase, which convey his imaginative way of looking at his subjects. Discussing debased forms of the pastoral, he writes of 'its wax-jointed pipes and poetic sheep which never come to mutton'. In 'over-peopled' London, 'human beings are breathing an atmosphere which decomposes stone'. Like Keats (whose work he knew and appreciated), he often focusses not, as might be expected in a painter, on visual effects, but on the more intimate senses, such as smell – as when he contrasts the scents of 'bean-fields, violets and new-mown hay' with the city's 'reeking drains'.

On the evidence of the 'Observations' alone, it is clear that Palmer could as easily – perhaps more easily – have been a writer as a painter. This is even clearer when his notebook and sketchbook entries and his voluminous letters are taken into account.

Palmer sought the advice of his friend Philip Gilbert Hamerton, the art critic and historian, about publishing the translation:

Most likely you are full of engagements when in town, yet I sometimes hope that you will spend a day here in spring-time. If you would like to do so as an act of penance, I would annoy you with inquiries as to the best way of disposing of a completed verse translation of Virgil's *Eclogues* which, right or wrong, I am resolved (all being well) to print. Whether they would be eligible one by one for any periodical I don't know, or whether there would be an opening for the disposal of the copyright.

It seems desirable that those who do not read them in the original should have some version from which the pastoral essence has not quite evaporated.

Whatever my version may be, it is a work done *con amore* in the superlative degree; but so is murder by a zealous 'Thug'. It has been 'bread eaten in secret', as no one but my son knows of it.[92]

Hamerton advised him not to publish it unless he were prepared to illustrate it himself. Palmer was disappointed; he had hoped that the translation would stand on its own merits, although he had also told Hamerton, 'If Blake were alive and I could afford it, I would ask him to make a head-piece to each bucolic.' But to illustrate it himself was a different matter; nonetheless, after thinking it over he came round to Hamerton's view, and cogitated as to the best way to proceed. After consulting Hamerton once again, and after considering various techniques for reproducing his drawings, he decided that original etchings would provide the best solution.

As always when he began a new work, Palmer started the designs in a depressed frame of mind; indeed he was almost subdued by a feeling of loathing for the idea. However, as he developed the designs, this gradually gave way to pleasure, and finally to a dominant enthusiasm. He ordered twelve copper-plates, though ten etchings were actually planned.[93] As usual, progress was slow and he had completed only one plate, *Opening the Fold* or *Early Morning* (for the Eighth Eclogue, illustration 100), when he died in 1881. It illustrates these lines from his own translation:

> Scarce with her rosy fingers had the dawn
> From glimmering heaven the veil of night withdrawn,

99 *Thy Very Cradle Quickens*, illustration to the Fourth Eclogue in Palmer's *An English Version of the Pastorals of Virgil, circa* 1876. Pencil, pen and ink and watercolour on card; design area 102 × 152 mm (private collection, England)

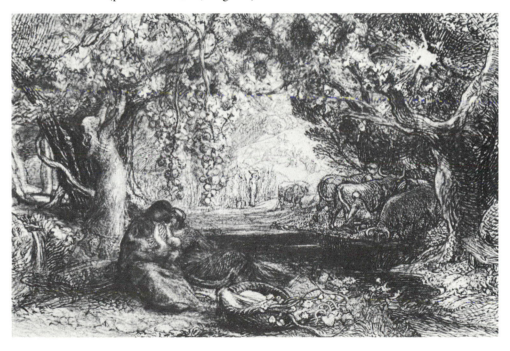

Or folded flocks were loose to browse anew
O'er mountain thyme or trefoil wet with dew,
When leaning sad on olive tree beside,
These, his last numbers, hapless Damon plied.

The composition of this *aubade* is filled with pastoral sweetness: a few stars remain in the sky, and a shepherd unfolds his sheep while another, 'hapless Damon', leans against a tree playing a melody on his pipe. A cottage, recalling Shoreham studies, with smoke rising from its chimney, lies beyond the sheepfold. The landscape is divided by a lush valley with a river flowing through it; in the distance are craggy hills (an amalgam of Alps, Welsh mountains and Devonshire tors). Rooks glide in the sky, and the wisps of cloud are pierced with rays from the rising sun. To Hamerton, *Opening the Fold* was

the most completely beautiful of all Samuel Palmer's etchings ... It is full of air and space, the eye wanders over it for miles, and yet at the same time there is a sweet solemnity in it ... My own first impression was wonder that a man of Palmer's age should have been able to execute such a piece of work. To say that there is no trace of decadence in that plate would be true but not true enough. The plate is the perfect consummation of Palmer's experience, knowledge, and manual power.[94]

Palmer's energy was confirmed by his son, who said that while he was developing this etching he was 'intellectually vigorous, and entirely free from all but the

100 *Opening the Fold* or *Early Morning*, 1880. Etching; etched surface
117 × 175 mm (private collection, England)

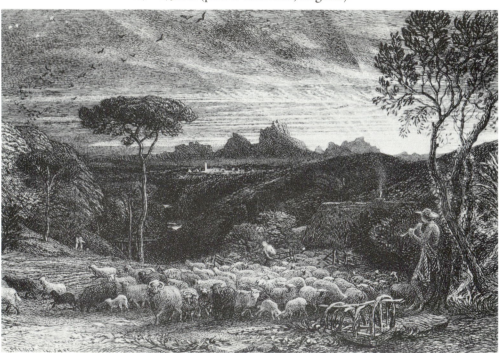

normal infirmity of a sedentary man of his age ... He seemed to have escaped unusually well the effects of old age on the judgment and manipulative dexterity'.[95]

As usual Palmer had the greatest difficulty in achieving the perfect impressions for which he longed, but the prospect of doing so improved considerably when Herbert decided to learn the trade of printing from copperplates. Hitherto Palmer's prints had been taken by a specialist firm, Gad and Martin, but they produced results which fell far short of his ideal. Subsequently he was almost persuaded by Hamerton to buy a light, attractive but apparently useless press of his own invention. Herbert recalled this and the outcome, in letters to Martin Hardie:

One day I called on [Frederick] Goulding at Gate St. en route for Roberson's [the art dealers], whence I proposed later on, to carry home to Reigate one of [Hamerton's] little presses under my arm. 'Printing press with blanket and cloth £2.2.0' as the catalogue had it. Goulding could sugar-coat acid contempt in courtesy. He applied it to Hamerton, his presses, and all his works. I went sadly home as to the press ... My first little press was made [at the Cavendish Engineering Works] to Goulding's order before he knew just what was involved; and what an effect his wonderful teaching would have on SP's future work. Perhaps you do not know the infinite difference between that first press and the second, made [by Hughes and Kimber] in accordance with Goulding's minute specification. It was designed in order to secure the immense but elastic pressure which he said my father's work needed. It was full of good points which were the result of Goulding's vast experience ... From the first day Goulding also insisted on a very rich, stiff, *finely ground* ink as essential for S.P.'s technique – ink made with very old and well-matured oil ... S.P. ... was *intensely* fond of his first press; I suppose because it brought him the solution of all his difficulties, and gave so much realism to all his new schemes.[96]

Even with this background of more expert printing, Palmer was rarely completely satisfied with the results. Herbert Palmer wrote of the 'Scarcity of those proofs *which realised* [Palmer's] *ideal*. The story of his agonies at Gad and Martin's – the appeals upon the margins, his utter ignorance of the technique of printing; all prove that the impressions which did come up to his ideal were few.'[97] The particular difficulties with the printing of *Opening the Fold*, and the conditions in which the impressions should be taken, were subjects of a long and detailed letter to Herbert written on 22 October 1880; Herbert had recently been experimenting with impressions pulled in brown ink.

However much tempests may rage before and after, the Hours of ART-WORK MUST BE QUIET HOURS, and printing like yours *is* art work. When we want a lambent flame we clear the grate, getting the noise and dust over *for the time*.

If anything bustles me, I am forced to sit still and make an artificial quiet, before I can put a right touch.

Success in the printing of this etching – which printing is your interest as well as mine, depends on delight in solitude and locked doors, a contemplative mood, and intense concentration. Indeed these are the conditions of all high excellence. Men who have these enjoy society all the more by contrast. However much torn by business outside, the great men have been quiet in their studios ...

I have just opened the 2 proofs – Pray throw your brown ink into the dust-hole.

I have sometimes thought that, in punishment perhaps for some long forgotten sins – a malignant demon has been suffered to dash the cup from my lip – just when I thought some peculiar benefit had mercifully been sent. Such a demon could have done no worse than to suggest 'brown ink' to you ...

The Black impression is so very good (the sky absolutely *perfect*) that ten minutes work upon this plate would be enough ...

The edge of the tree A is, at the [*sketch*] top a trifle too light and may be amended by two lines like mine in the Red Chalk. 2$^{\text{ndly}}$ The sucking lamb's bended knee is slightly too light at the joint, and a very little too long perhaps, which rather injures the perspicuity of the action.

3 Perhaps the *lower* part of the clump of trees BB – is wiped rather too hard.

4

As to general effect I have to suggest only that the darkest parts of the bushes behind figure [*sketch*] should be the deepest dark in the subject and a little darker than the cool dip into the river-reeks – between the figure opening the fold and the great pine stem – which is quite light enough pray do not use the match either there or on the river lights – I have done this in the retouching.

The essence of the etching is *crispness* – and anything like the tint left by too thin an ink between the lines, fatal –

5 Perhaps the dark side of the provender trough is too hard wiped.

I hope you will go over the above carefully as it has cost me my best daylight.[98]

When he died Palmer left four further uncompleted etched plates and these, in accordance with a promise made at his deathbed, were finished by his son. They are *The Homeward Star* (for the First Eclogue; illustration 101), *The Cypress Grove* (for the Fifth Eclogue), *The Sepulchre* (for the Eighth Eclogue) and *Moeris and Galatea* (for the Ninth Eclogue). The extent of Herbert's work is debatable, but it probably did not amount to much; he himself said, 'Of these plates I laid the grounds and reworking grounds; I proved the plates *before* S.P.s death and bit them in, but did *NOT* stop out.'[99]. There exists a proof of *The Sepulchre* signed by Palmer, which suggests that he considered it either complete or near to completion at that point.

The Virgil etchings were among Palmer's favourite works, but they lack the grandeur of the two great Milton plates *The Bellman* and *The Lonely Tower*. As Herbert pointed out, they 'were intended to be mere adjuncts of the *English Version* [Palmer's translation]; and were entirely subservient to that work; which, when all else was shattered to fragments by his bereaval [Thomas More's death], was my father's chief consolation'.[100] Like the Milton series, the Virgil designs were an epitome of his life's experience of landscape, for, as in *Opening the Fold*, elements may be recognized from Shoreham, and from Wales, Italy and Devonshire. Many of the original drawings, originally planned as designs for further etchings, were reproduced in *An English Version*. Palmer was frequently

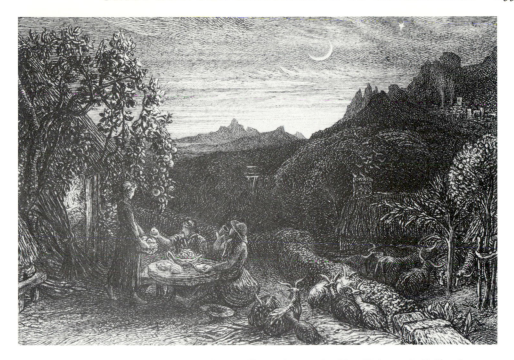

101 *The Homeward Star*, illustration to the First Eclogue in Palmer's
An English Version of the Pastorals of Virgil, begun *circa* 1880, completed
by A. H. Palmer before 1883. Etching; etched surface 100 × 151 mm
(private collection, England)

at his best in monochrome (see for example the 1825 drawings, many of the
Shoreham works, and the designs for *Pictures from Italy*); the Virgil drawings
are no exception, despite the fact that he did not intend them to be so repro-
duced. These compositions contain many reminders of Claude, especially in the
form and placing of the trees, in the gestures and placing of the figures, and not
least in their genial atmosphere.

Ⴙ

Palmer broadened his friendships as he grew older, and he kept his old
friendships constantly refreshed. His intimacy with the two Wright brothers
continued; he corresponded regularly with both, covering a wide range of
subjects and interests. Another sympathetic acquaintance was the critic, artist
and collector Frederic George Stephens (1828 – 1907), who gave Palmer great
pleasure when he wrote understandingly about the etching *The Herdsman's
Cottage* or *Sunset*, published in *The Portfolio* for November 1872. His article,
printed in the same number (p. 162), describes Palmer 'among the most
poetical of our artists', and continues:

The Dorian mood, which seems to characterise his mind, is surely not one of mere luxurious

musings, or the enjoyment of sweet intellectual idleness, but instead of these – as the artist's ideas of his art involve in execution prodigiously patient labour and devotion, not the less stern because manifested in gracious, rich, and contemplative forms – behind, and making more precious the beauty of those sunsets which have furnished him with so many subjects, the wealth of those sunrises, the pathos of those 'earnest stars' that shine in so many of his twilight nights, and the glories of those slowly-gathering dawns in which he delights, there is more than ever the idyllic poetry which is the natural and obvious outcome of these subjects and their treatment. It is as if the profound and awful sweetness of George Herbert's pious, chastened, and severely simple muse had found words as gorgeous, as vivid and as diversified as those which Crashaw employed, or as if the feverish, fretful, vague and wavering genius of the latter had imparted its splendours of expression to the contemplative, suave, and serious mind of the former.

Hamerton added an appreciative note to this, so at last Palmer was able to feel that some public recognition was coming to him; he sent grateful letters to each writer.[101]

His reputation seemed to be taking a happier turn, but Palmer's family anxieties did not diminish. One important consideration was Herbert's future. Instead of considering his son's natural inclination towards entomology, Palmer decided to make an artist of him and sent him as a student at the Royal Academy, where he remained until 1875.

Herbert became an able draughtsman, but no more. He made some good chalk portraits, but his heart was never in painting, and whenever possible he turned to studying natural history and firearms to assuage his discontent. In the practical affairs of business he was better equipped than his father – perhaps he had inherited this talent from Linnell. Having witnessed his father making a wreck of all his business affairs made him more alert and determined in struggling for his rights, simply in the interest of self-preservation. He helped Samuel in several areas, not only on business matters, but also with artistic concerns, such as an agreement with the Fine Art Society, and pirated impressions of his etching *The Early Ploughman*. And apart from proofing and printing many of his father's etchings, Herbert arranged the framing of his works and packing them for dispatch.[102]

Although his finances eased somewhat as old age approached, Palmer was still far from affluent and relied on friends for newspapers and journals. He looked for small economies wherever he could, and even went so far as to reply to letters on half-sheets torn off the ones he received. At Furze Hill his space was even more circumscribed than before and caused him actual physical discomfort. Even his cat, Tab, had to spend much of his time on his lap as there was so little room for him on the floor, and playfully patted the leaves of Palmer's books as he turned the pages. His books were a continuing solace; they became increasingly shabby, but he would not let a bookbinder near them. 'How dirt cheap are really good books,' he once remarked to Calvert, 'when we compare them with the price and intrinsic value of everything else we lay out money upon.'[103] In the last weeks of his life, too ill to work, he 'sprang upon his books' for relief. 'The true book-lover is all tiger', he said.

'He tears open his prey, and slakes his drought with huge draughts from the jugular.'[104]

Despite his vitality – he claimed to be working harder than when he was thirty – Palmer was still dogged by ill-health. He complained that 'even going up the steps to a railway platform quite takes away my breath'. He excused himself to Holman Hunt for missing a meeting of the Etching Club, because 'A narrow escape of congestion of the lungs ... confines me during the winter to two rooms kept at equal temperatures, my "den" and my drawing-room.'[105] In 1878, at the age of seventy-three, he was still working for four hours at a stretch *with my whole mind bent upon it*, but grumbled that this was his limit, though 'Sometimes the train of thought is renewed when designing, or what not, in the evening.'[106] Even when confined to bed by illness or bad weather he continued to work, as he told George Richmond during one bout of indisposition:

I am hoping for permission to get out of my room shortly, – being fairly well, minus a little asthma and perpetual nose blowing! I get to work (on small things of course) in bed – on a little bed-table Herbert has made me, till dinner, then dismiss my table and take a nap – rise and dress for tea and then get to work again by one of those invaluable Silber lamps (how they *save the eyes*) until 10 o'clock but either thus, or when I am allowed to cross the hall, how delighted I should be to have a day's talk with you.[107]

ဢဢ

In August 1875 William Blake was again in Palmer's mind. An unsigned article (the writer was a Dr Richardson) appeared in *Chambers's Journal* which claimed that Blake had spent thirty years in a lunatic asylum. Palmer's attention was drawn to this by John Preston Wright,[108] and, prompted by Linnell, he wrote to F. G. Stephens, who edited the art section of the *Athenaeum*, asking if he would publish letters from himself, Linnell and others, contradicting Richardson's assertions. Palmer had no doubt of Blake's sanity:

Without alluding to his writings, which are here not in question, I remember William Blake, in the quiet consistency of his daily life, as one of the sanest, if not the most thoroughly sane man I have ever known. The flights of his genius were scarcely more marvellous than the ceaseless industry and skilful management of affairs which enabled him on a very small income to find time for very great works.[109]

Only a few months before he died, Palmer still thought of this old friend of his youth, perhaps appreciating him more than ever before: 'I certainly knew *one* man who was an Unity', he wrote, '– but he was one of a thousand, of *Ten* thousand; – the greatest Art genius this country ever saw. Of course I allude to William Blake, – of whose drawings Flaxman said that the day would come when they would be as eagerly sought for as those of Michael Angelo.'[110] And in February 1881 he wrote with gratitude of Blake's principal patron, Thomas Butts (1757–1845), clerk in the Muster Master General's Office, who, he said, 'for years stood between the greatest designer in England and the

102 Samuel Palmer in later life. From a photograph
(private collection, England)

workhouse, – that designer being, *of all men whom I ever knew*, the most *practically sane, steady, frugal* and *industrious*'.[111]

By contrast Palmer's affection for his even older friend, John Linnell, diminished to vanishing point. Since 1859 the men had exchanged few letters. Palmer's latest surviving communication to his father-in-law, written in 1878, is a formal note on the subject of oil lamps. It is sad that a friendship originally based on deep mutual regard should have fizzled out in this way. Both men were

at fault: Linnell was overbearing, intolerant and interfering; Palmer was obstinate, weak and tactless; and given this collision of temperaments, the deterioration in their relationship was probably inevitable.

Declining years brought the deaths of more friends. In 1875 another of the Ancients departed – Frederick Tatham; whatever the truth of his alleged destruction of some of Blake's works on religious grounds,[112] Palmer did not doubt his essential goodness, which he instanced in a letter to George Richmond's wife:

I seldom think of Shoreham without recalling his persistent and self-denying kindness to a poor cottager whose sores he daily dressed with his own hands, and that for months together; nor did I ever witness such ardour of continuous study as that which at one time he devoted to a branch of art-study; and happily, with commensurate results in the opinion of some of the best artists. During this time there were three consecutive weeks in which all regularities of food and repose were slighted.[113]

Frederick's brother Arthur had died during the previous year. In 1880 yet another Ancient died, one who had been especially close to Palmer, his cousin John Giles. And January 1881 saw the death of Julia Richmond, which snapped a link in the chain of memories of Italian days. At about the time of John Giles's death, Palmer, despite his bad health, was trying to seek financial support for the 72-year-old widow of Francis Oliver Finch. He enlisted the aid of C. W. Cope and Richard Redgrave, and with their help managed to secure her a gratuity of £20 from the Cooke Fund, administered by the Royal Academy for the benefit of needy painters who were not academicians or associates.

To Edward Calvert, who was to outlive him, he wrote a few months before he died, 'Your kindnesses to me are among my few pleasures of memory. They were of a rare quality; for, as my wife and I love to say, they never varied with my circumstances which, though never prosperous, were sometimes much the reverse. You hated me for three days for singing you "The British Grenadiers" and that was all!'[114] Calvert died in 1883; Richmond, the youngest of the Ancients, lingered until 1896, loaded with honours. He died a rich man and the founder of a dynasty. Linnell outlived his son-in-law, dying in 1882, after 'clinging tenaciously to all his old prejudices and habits without the slightest sign of modifying any of them'.[115]

To the last, Samuel continued to dispense gratuitous advice to his friends, although over the years it became less abrasive. Pages were written to C. W. Cope about choosing a house in Surrey. To Dr William Williams's son he wrote on Boxing Day 1879 exhorting him to 'DO THE MOST DISAGREEABLE THING FIRST – pantomimic words, transformable into competency, freedom, and fine weather in the conscience.'[116] He proffered the same advice to F. G. Stephens for his son Holman, whom he called 'The Golden Holly': 'Of Christmas decorations may your "Golden Holly" ever be the best and brightest! ... I hope he has learned to work before he plays, that he may make a pastime of his work.'[117] But 'The Golden Holly' had been finding amusement

in some of the more outspoken passages in Shakespeare, and his father appealed to Palmer for advice. He had no hesitation in recommending a bowdlerized edition:

If he is set upon it, I should, as soon as possible, give him the 'Family Shakespeare' – if there be such a book – I have certainly heard of it – and suppose that nothing is pared away but what is rotten. If so it is a most desirable book for the G.H. ... it may be said how stupid I must be to suppose that a boy will grow up without often meeting with impure books. I do not suppose it; but think that is the very reason why a parent should not add another – should not deliberately leave in a child's possession, what few adults can read without being the worse for it. The pagan Juvenal says that PURITY should be inscribed over the door of every house where there is a boy.[118]

Yet despite such earnest outpourings, Palmer's sense of comedy did not desert him in old age. One of his favourite diversions was to entertain his friends with parodies of contemporary music on the piano, or with vocal imitations of cats on the roof. He claimed that he missed the voices of cats when he was staying in the country:

What varieties of tone, what richness in the 'instrumentation' of that furry orchestra. I regretted being kept awake here for *one* night by the nightingales in our garden, but should not in London have regretted *three* such nights, while the feline charmers – 'All night long' their 'am'rous descant sung'.[119] It is the school and origin of *modern* music, it is nature's comic Opera, and what comedy was ever half so comic?[120]

But such moments were much outweighed by sadness and disillusion in Palmer's last years. He doubted if he would live to see the completion of the Virgil book. In November 1880, he wrote: '[I] am now ready to depart, for I don't see that I am of any farther use, or how my *one* pet project of *the book* is to be realized together with other things which must be done. But all being otherwise well, I will *try* to fight it out.'[121] It was not until 1883, two years after his death, that *An English Version of the Eclogues of Virgil* was published. Herbert lavished every loving care upon it, but it made little impact, so perhaps it was best that its author should have died while still anticipating its possible success.

His mind continually harked back to his beloved Thomas More, whose tragic story he always alluded to as 'the catastrophe of my life'. His own death was not an altogether unwelcome prospect. 'If I were *quite* certain of rejoining my beloved ones', he wrote, 'I should chide the slow hours which separated me.'[122] He expressed some envy of 'those who can look back with some satisfaction on the past', while asking '*Who* could bear to live his life again?' – implying that he at least could not.[123] This, however, did not prevent him from wishing to see his old friend George Richmond, with whom he doubtless reminisced about their earlier days. 'We hope', he wrote, 'you will soon make your last visit your last but one: – and then many more, nothing can make it more welcome, but a line the day before will provide better entertainment.'[124]

Between Samuel and Hannah there was, during their last years together, a new tenderness and greater understanding than they had known since they were first married, and this imparted a special poignancy to the middle years of poverty, misunderstanding and mistrust. Hannah came at last to appreciate Samuel's real qualities, and he was ready and happy to reciprocate. They became reunited as they had been during the Italian years, when Hannah was little more than a girl and her husband still a promising young man. They went out together on long drives in a fly pulled by a sleepy horse, guided by a sleepy driver. It was on one of these drives, through the Surrey hamlet of Gatton, that Palmer made his last sketches from nature. During his last summer he still ventured into his garden to gaze at his beloved wild flowers. He did not have the energy to continue his daily walk, but his appetite remained good and his handwriting, though less tidy than before, remained firm.

He was steadfast in his adherence to the Church of England. He loved the services in St Paul's Cathedral – they were his ideal of worship; those in Reigate Church lagged far behind them, and made him angry. Notwithstanding, he and Hannah attended, and always made a point of sitting among the poorer parishioners. In his later life high-church services were introduced, and after that Hannah preferred to attend a nearby evangelical church; Samuel continued as before.

In January 1881 the winter weather was appalling: roads were blocked by ice and snow, the streets of London were deserted, and in the countryside enormous numbers of sheep were slaughtered because there was no food for them. Palmer did not venture out of his room, where he sat up in bed wrapped in a thick white jacket, elaborating his Virgil designs. The last one on which he worked – it never reached the etching stage – was for the Tenth Eclogue; *Pan came, Arcadian Tetrarch ever Good* (The Art Museum, Princeton University). On the table beside his bed was an old cigar box containing the precious copperplates of the Virgil etchings, and occasionally his emaciated hand would stretch out to touch it, as if he derived some comfort from the contact. Herbert Palmer, who had recently married, saw him six days before his death, when he promised to complete the plates already begun.

Palmer died on 24 May 1881, serene and at peace, as his old friend George Richmond knelt beside his bed in prayer. He was buried on a showery morning, to the accompaniment of the song of a skylark, in a quiet corner of Reigate churchyard. Hannah, whose mind gave way during her last years, was laid with him in 1893.

Samuel Palmer's reputation as an artist seemed, apart from a close circle of admirers, to have perished with him, and it was not until well into the following century, starting with the showing at the Victoria and Albert Museum in 1926 of 'An Exhibition of Drawings, Etchings and Woodcuts by Samuel Palmer and other Disciples of William Blake', that his work began to be assessed at its true worth; and for some years it was only his Shoreham works and their immediate predecessors that were properly appreciated. Now

we have begun to realize the value of the work of his subsequent career: the Welsh landscapes, some of the Italian studies, later watercolours of the English countryside, the Miltons and the Virgils, and especially his great etchings, ripened with such abiding and loving care, in which he condensed a lifetime of vision into a few square inches.

APPENDIX 1

An Address to the Electors of West Kent

Samuel Palmer's unsigned *An Address to the Electors of West Kent* was until recently known only through a reference in a letter by John Linnell and a few extracts in the *Maidstone Gazette* of 11 December 1832. But a copy has now been discovered by Michael Collinge of the Institute of Historical Research of London University, in the Maidstone Public Record Office. It was reprinted, accompanied by an article by David Bindman, in *Blake: An Illustrated Quarterly*, Vol. 19, No. 2 (1985), pp. 56–68. It is reprinted here from the latter, preceded by details of the title-page. A further copy, discovered subsequently, is now in the present author's possession.

AN ADDRESS/TO THE/ELECTORS/OF/WEST KENT;/WHICH IS ALSO/SUBMITTED TO THE ATTENTION/OF/ELECTORS IN GENERAL./[*decorative rule*]/BY AN ELECTOR./1832./[*rule*] 'WHATEVER CHARITY WE OWE TO MEN'S PERSONS, WE OWE/NONE TO THEIR ERRORS.'/[*rule*]/LONDON: JOSEPH SHACKELL, PRINTER, WINE OFFICE COURT,/FLEET STREET.

AN ADDRESS
to the
ELECTORS OF WEST KENT.
MY LORDS AND GENTLEMEN;

An individual, who has the honour to be of your number, ventures to address you on the subject of the approaching election; and entreats you to afford him a few moments' serious attention; which he claims, not for himself, but for the importance of his subject.

SIR WILLIAM R. P. GEARY comes forward, and offers himself as your Representative; promising an assiduous attention to Parliamentary duties. He will strenuously support the agricultural interest; and such a modification of the tithe laws as may comport with the security of all other kinds of property. He will also promote, to the utmost of his power, every rational, effective and substantial reform. He comes from the heart of the county; and from his family and connections, we cannot but believe him to be a lover of agriculture; an interest now upon the very verge of destruction. SIR WILLIAM is an INDEPENDENT CANDIDATE, and the son of a late INDEPENDENT MEMBER.

Surely no person connected with the agricultural interest, and solicitous for the welfare of this great county, can for a moment lend his influence to the

opposing faction, who denounce the protecting duties as a 'Bread Tax,' and taunt SIR WILLIAM with a desire of continuing it. Now as every Kentish farmer, who is in his right wits, conceives some sort of 'Bread Tax' to be the very condition of his existence, how could our adversaries be so very simple as to tell him plainly, that his only chance of preserving it was by voting for SIR WILLIAM GEARY? However, as they have been so kindly explicit, I hope, like men of common sense, we shall take them at their word, and vote for SIR WILLIAM, as they advise. Their hostility to Agriculture, which could not long be concealed, notwithstanding any professions they might have made to the contrary, sufficiently bespeaks them to belong to the caste of the Radical Reformers, MOST FALSELY SO CALLED; who are the natural enemies of the farmer, and, by consequence, of the manufacturer; for commerce and agriculture must stand or fall together; – and, therefore, of all national prosperity.

One is almost tempted to believe that some cunning Agriculturist, in disguise, drew up their manifesto, and laughed at them in his sleeve; for certainly it is its own best refutation. SIR WILLIAM GEARY has promised to support the Agriculturist; and this is the very reason for which agricultural Kent is called upon to repudiate him! *Risum teneatis*. Rome was saved by the cackling of geese: and truly, if the jacobinic citadel might be preserved by similar multitudes, it must be acknowledged to be impregnable!

Thus have they forfeited the support of all sensible farmers; and at the same time disgusted every honest man, whether Whig or Tory, by retailing, in the true spirit of jacobinism, a falsehood respecting the income of the Church, so outrageous; that it looks like a droll burlesque and caricature, even of the flagitious system of misrepresentation and imposture, by which that profligate faction is supported.

With respect to the Candidates themselves, who have been unitedly soliciting your suffrages; nothing can be farther from the writer's intention than to offer them personal disrespect: he would be the first to yield them that deference which all gentlemen have a right to claim from each other in private society: but he feels it his duty to speak very plainly of the faction whose support those gentlemen have deigned to conciliate.

Another objection to SIR WILLIAM is his youth. It is said, 'We want men of experience in Parliament:' But, beside that often one man of thirty will be found wiser than another of seventy; that multitude of years does not always teach wisdom: that every profession affords numerous instances of the young attaining honours and distinction; and of aged men who could never rise from mediocrity; and that some of our most splendid public characters have signalized themselves when but scarcely out of their minority: how, we should be glad to know, are we to obtain Representatives of great Parliamentary experience, unless by sending them in betimes, we give them an opportunity to acquire it? If we return none but old men, we defeat that object entirely; and our *Council of Ancients* must ever be a bench of venerable novices. But, above all, I would ask, is it not most expedient, that in the great

sensate of a nation there should be found the energy and fire of youth, as well as the deliberative sagacity of age? The parents of all sublime works are Intellect and Will.

Some have strangely refused to support SIR WILLIAM GEARY, on account of their being, from early associations, attached to the Whigs. Alas! it is but an ill compliment to the Whigs of sixteen hundred and eighty-eight, to mistake for their successors a rabble of incendiaries and jacobins. The politics promulgated by our adversaries are not those of MARLBOROUGH or CHATHAM, but of THISTLEWOOD and BRANDRETH!

No! Brother Electors! – The Radical upas tree never sprouted from the stock of ancient British Whiggishm; but it is the importation of yesterday, from poor, degraded, dishonoured, Atheistical France.

That once gay nation long led the mode in our more innocent fripperies of dress and fashion: we amused ourselves with her toys and trinkets; and with perfect good humour saw her play the Harlequin to Europe. But she rose in our estimation, when she began to struggle against aristocratic tyranny. She obtained her freedom: and, alas! immediately lost it again, irretrievably; by confiding it, as the people of England are at this moment confiding their own – to revolutionary empyrics. Then, when suddenly distracted with an infernal phrenzy, her songs and dances became the yells and contortions of possession; and, in a frantic spasm, she hurled over the Continent fire-brands, arrows, and death: who, with more alacrity than the Kentish patriot, sprang forward, and bound the demoniac?

And shall *we*, even now, bitten with that self same madness; while, though somewhat exhausted with her paroxysm, France yet heaves in incurable distraction; shall *we* mistake her ravings for the voice of Delphic Sibyl; and proceed to model, or rather unmodel, every institution of our country, and tumble them all together, into the semblance of that kingless, lawless, churchless, Godless, comfortless, and most chaotic Utopia of French philosophy?

Shall we assay to repair here and there a crumbing pinnacle of our Constitution, by cannonading the buttresses and sapping the foundations?

Shall we invite over the Gaul to help us raze those bulwarks, which he too well knows to be thunder-proof; and put up a pagoda of trash and tinsel on the site?

But now, behold, you are called out, Men of Kent – yes, YOU, whose frown has made the Frenchman shiver – to mince and caper in the ballet of liberalism; and to bring up the death-dance of Parisian assassins and sans-culottes!

They were the Men of Kent who dictated terms to the Norman Conqueror: and they are Men of Kent, who are now asked to become morally the vassals of France.

Who does not remember that crisis – God forbid any Englishman should forget it! – when Wordsworth sang,

'Ye men of Kent, 'tis Victory or Death!'

Then, even as one man, rose up this noble county; and with a front of spotless loyalty, scared Napoleon from our shore. O let not their degenerate children crouch to an invasion of much more fatal principles and doctrines.

The mane of the British Lion can receive no decoration from shreds of tri-coloured ribbon; nor will he cut any very majestic figure in the eyes of Europe, if we suffer our new-fangled politicians to retrench his tusks and talons; and to lead him about as a show, with the Monkey of French innovation mounted upon his back.

O my countrymen, for shame! for shame! – Methinks I see the mouldered heroes of Crecy and Agincourt, of Trafalgar and Waterloo rise up to hoot us from among the nations!

But let it be so no longer! Put on, once more, the invincible armour of old English, of old Kentish loyalty. Strangle the snake corruption wherever you shall find it; and every where promote, in God's name, effectual reform: but leave not your hearths and altars a prey to the most heartless, the most bloody, most obscene, profane, and atrocious faction, which ever defied God and insulted humanity.

You will NOT suffer those temples where you received the Christian name to fall an easy prey to sacrilegious plunderers! You will NOT let that dust which covers the ashes of your parents, be made the filthy track of Jacobinical hyenas!

Farmers of Kent – we are tempted with a share of the promised spoliation of the CHURCH! – There *was* a time when every Kentish yeoman would have spurned at the wretch who should have dared to tickle him with such a bait – to offer him such an insult! But piety and honour are in the sepulchre.

I would fain hope, however, that there are still very few of us who would not experience some shudder of conscience, at the thought of thieving from the Church of England her freehold lands and tenements: few among the uncultivated; few among the vicious: few in our jails and halls: few anywhere, but within the precincts of our political unions. There are gradations even in atrocious felony. It is not every burglar who would violate an altar. But what are we to think of those vassals of perdition who would put forth their hands to the freeholds of the Church: who are not afraid to appear in the presence of their Creator branded with sacrilege! It is scarcely, perhaps, to be regretted, that these lepers are now catalogued, and marked, and numbered, and huddled together in the pest-house of the unionists.

So much for the Church lands. As to the tithe laws, they are about to undergo revision: perhaps very considerable alteration. SIR WILLIAM GEARY has offered to promote any amelioration; any equitable adjustment: nor can any one be more likely to watch the interests of the Kentish farmer closely, during the discussion in Parliament.

But there are some very honest and well meaning persons to be found, who imagine that an abolition of the tithe altogether would relieve the farmer from his present difficulties: who suppose that if the tenth sheaf were not put into the tithe waggon, the farmer would put the value of that sheaf into his own pocket;

whereas nothing can be more false; because the tithe is always allowed for in the rent, which would be so much greater if there were no tithe. Land will always be let to the best bidders; and whatever men will give for a piece of land to-day, knowing it to be subject to tithe; they would give proportionably more for it to-morrow, tithe free; whether the tithe be a real tenth, or seventh, as some say; or whatsoever proportion it bears to the farmer's returns.

Farmers! Messrs HODGES and RIDER are to attempt two things in behalf of their constituents. In the first place, they will sweep away the 'Bread Tax,' that is, the protecting duties on foreign corn; which you know will utterly ruin you. But then, they tell you that they will try to abolish the payment of tithe: and who would not gladly be ruined, for the pleasure of seeing the tithe laws abolished! Now it is not unlikely that they may bring about a free trade in corn; because free trade is the fashion; but it is by no means so probable they will succeed in immediately abolishing the tithe, because that can scarcely be done without a revolution. Well; you know that a free trade in corn will throw the farms out of cultivation; starve the whole of the peasantry; and force many of you to emigrate from your native country for ever: but I will show you that the abolition of tithe, at the same moment, would not put a farthing into your hands, to defray the expences of the melancholy passage!

In all matters of sale and traffic

> '——— The worth of anything
> Is as much money as 'twill bring.'

A tithe-free farm fetches a proportionably high rent: therefore were all the farms tithe free, from the abolition of the tithe laws; all the farms would fetch a rental proportionably increased. What then would the farmer gain by it? Supposing the tithe were doubled: you would go [to] the landlord for an equivalent deduction in your rent – supposing the tithe abolished; he would come to *you* for an equivalent increase. Our mistake lies in not clearly understanding *what it is* that we rent of our landlord. We may, perhaps, imagine that we pay him for the whole of the crops which we produce; and that the tithe card takes away a tenth of that produce, for the whole of which we have made our landlord a consideration: but it is no such thing: we never paid for that tenth: it was not charged in our rent. In short, we pay our landlord for the right of disposing of nine tenths of the produce of his land; and if the other tenth were not removed by the tithe man the landowner would take care to demand it in rent. It is irksome to be put to the proof of anything so self-evident, where every argument is like a truism.

The best informed authors will inform us that the ancient landowners, who built most of our parish churches, left to their children only nine tenths of the profits of the estates which descended to them: the remaining tenth they bequeathed in the shape of the present tithe, to their respective churches for ever: and that bequest was and is ratified by the laws of our country. Therefore the landowner who is possessed of a thousand acres, receives only the profits of

nine hundred: to-morrow, were the tithe law repealed, he would have ten hundred, bona fide disposable to his own use and benefit. Now when we can suppose our landlord not to be aware that a thousand acres are worth a higher rental than nine hundred, then indeed we may expect to be benefited by an abolition of the tithes!

The small tradesman and the poor would be losers indeed, by the proposed innovation: for the money which is in most cases spent and distributed among them by the clergyman's family, would be often drawn away by absentee landlords, and spent at a distance from the parish, if not in a foreign land.

As to the very ancient triple distribution of the tithe, which has been spoken of in certain quarters; one part to the poor; another to the parochial clergy; and a third towards the repairs of the Cathedral; a moment's reflection will convince us of its impractibility at present; when by the blessing of God our parish churches are so vastly multiplied; and I am happy to add, multiplying. The solicitude of the enemy for the beauty of our cathedrals is a little out of character: we may believe it to equal their sympathy for the poor: with respect to whom, be it remembered, that the clergyman *pays his full share of poor-rate upon his income*; to say nothing of the innumerable private charities, and neighbourly benefits conferred on their parishioners, by the great majority of that amiable and venerable, though most shamefully calumniated order.

But the landholder would, in effect, gain little more than the farmer, by the abolition of tithe: for, as the whole income of the Church, divided equally among her clergy, has been calculated scarcely to afford a decent maintenance to each; at least as much as was before levied in tithe, must then be imposed as a tax by government. So long then as the clergy should be decently supported, there would be no transfer of their incomes to the landed proprietor or to any one else. And if a revolutionary government were to ensue, and abolish our religious establishment altogether; which would be one of its first achiev[e]ments; the landholder will not be so simple as to believe that the Radicals would suffer him to sit down quietly with his increased rent: that is, supposing there were any rent to be had, after free trade had emptied his farms and exiled his tenants. No; they will tax him, and fleece him to the skin; and then confiscate his estates. The demagogue is the natural enemy of the landholders: for he finds in them at once the toughest obstacles to his ambition, and the most delicious temptations to his voracity. He will, therefore, spare no pains to decoy and devour them.

I will not attempt to adumbrate the gradations of slow torment, through which the crew of a triumphant political union would pare down the wretch who should fall into their clutches; condemned of that crime, in their estimation the most inexpiable; the possession of wealth. The spectacle of a whale under the hatchets of his harpooners; or rather of the South American Indian, made through a summer day the amusement of his captors, would present a lively type of the proceedings of these national anatomists with the catalogue of his possessions; and, perhaps, with the members of his person! I most humbly confess myself inadequate to do justice to that consummation of fraud, rapine,

outrage, and barbarity, which may be expected from the Radicals of England, improving upon the example of the French Jacobins.

The British landholders are, however, too well aware of the motives of the Liberals, very readily to accept any boon from their hands. But, lest the people at large should be wired in a like gin; I shall take the liberty to exhibit before them, for a few moments, their French neighbours, gulled by the bait, and struggling in the toils; and it is then to be hoped that they will take care not to render themselves most forlorn exceptions to the general verity of the sacred proverb, that 'the snare is surely spread in vain, in the sight of any bird.'

'Having' – 'prepared the public mind, the assembly made a bold attack on the Church. They discovered, by the light of philosophy, that France contained too many churches, and, of course, too many pastors. Great part of them were therefore to be suppressed; and to make the innovation go down with the people, all tithes were to be abolished. The measure succeeded; but what did the people gain by the abolition of the tithes? – not a farthing; for a tax of twenty *per cent*. was immediately laid on the lands in consequence of it. The cheat was not perceived till it was too late.'

'But, the abolition of the tithes, the only motive of which was to debase the Clergy in the opinions of the people, was but a trifle to what was to follow.'

Then, with respect to the seizure of the landed property of the French Church; which was, beyond comparison, more extensive than that of our own: – 'To obtain the sanction of the people to this act, they were told, that the wealth of the Church would not only pay off the national debt, but render taxes in future unnecessary. No deception was ever so barefaced as this; but even this was not wanted; for the people themselves had already begun to taste the sweets of plunder. Avarice tempted the trading part of the nation to approve of the measure. At the time of passing the decree they were seen among the first to applaud it. They saw an easy means of obtaining those fine rich estates, the possession of which they had, perhaps, long coveted. In vain were they told, that the purchaser would partake in the infamy of the robbery; that, if the title of the communities could not render property secure, that same property could never be secure under any title the plunderers could give. In vain were they told, that in sanctioning the seizure of the wealth of others, they were sanctioning the seizure of their own, whenever that all-devouring monster, the sovereign people, should call on them for it. In vain were they told all this: they purchased: they saw with pleasure the plundered Clergy driven from their dwellings; but scarcely had they taken possession of their ill-gotten wealth, when not only that, but the remains of their other property were wrenched from them. Since that we have seen decree upon decree launched forth against the rich: their account books have been submitted to public examination: they have been obliged to give drafts for the funds which they possessed even in foreign countries: all their letters have been intercepted and read. How many hundreds of them have we seen led to the scaffold, merely because they were proprietors of what their sovereign stood in need of! These were acts of unexampled

tyranny; but, as they respected the persons who applauded the seizure of the estates of the Church, they were perfectly just. Several of these avaricious purchasers have been murdered within the walls of those buldings, whence they had assisted to drive the lawful proprietors: this was just: it was the measure they had meted to others. They shared the fate of the injured Clergy, without sharing the pity which that fate excited. When dragged forth to slaughter in their turn, they were left without even the right of complaining: the last stab of the assassin was accompanied with the reflection, that it was just.'

'I have dwelt the longer on this subject, as it is, perhaps, the most striking and most awful example of the consequences of a violation of property, that the world ever saw. Let it serve to warn all those who wish to raise their fortunes on the ruin of others, that sooner or later, their own turn must come. From this act of the Constituent Assembly we may date the violation, in France, of every right that men ought to hold dear. Hence the seizure of all gold and silver as the property of the nation: hence the law preventing the son to claim the property of his father: hence the abominable tyranny of requisitions; and hence thousands and thousands of the murders, that have disgraced unhappy France.'

These extracts are from pages 169 and 180, of a little book printed at Philadelphia, and reprinted in London about the year 1797: it is entitled, 'The Bloody Buoy, thrown out as a Warning to the Political Pilots of America; or, a Faithful Relation of a Multitude of Acts of Horrid Barbarity, such as the Eye never witnessed, the Tongue never expressed, or the Imagination conceived, until the commencement of the French Revolution. To which is added an Instructive Essay, tracing these dreadful Effects to their real Causes.'

My Countrymen! the primary sources of all, were INFIDELITY; and those *principles* of rebellion and plunder, its legitimate offspring, which are now so industriously disseminated among ourselves: and if it be reasonable to anticipate like effects from like causes, we should be holding ourselves in solemn preparation for the worst: yet with no dreary misgiving, that the Providence which has so long signally blessed and protected this island, will forsake us in extremity: but with an ardent faith and confidence that He who has now withdrawn Himself for a while, and from His high and invisible watch tower in the heavens, is beholding the fury of His enemies, and the lukewarmness of his servants; will suddenly descend among us, and deliver us gloriously, at that moment when we shall lay the ark of our liberties on the altar of the sanctuary; and, banded together in one impregnable phalanx of holy patriotism – SWEAR TO DEFEND THEM IN HIS NAME!

Is this the rant of a fanatic? – NO. It is the zealous but sober voice of one who dares to speak what millions think: millions, who seem stunned and panic-stricken, by the yelling of a crew of savages, and a thoughtless rabble who follow them. It is the voice of one who would deem it happiness and glory indeed, to die for his country, in some great struggle against some great enemy: but who shudders to take his death at the talons of a club of runnagates whom his fathers would have hissed into the sea! It is the voice of one, who, among

other histories, has perused the awful annals of the great French revolution, and has not nodded over the book: wherein rivers of blood, and plains of desolation; conflag[r]ation, assassination, violation, treachery, sacrilege, blasphemy, and every variety of wretchedness, and every enormity of abomination, are as familiar as household words.

And it is to this, Kentish Yeomen, that our heartless adversaries are reducing *us*: it is thus they began in France: and the most ready dupes of the Parisian radicals became the earliest victims of their fury, the moment they hesitated to plunge with them into gulfs of blood.

We charge the Radicals of England; and they will, perhaps, glory in the charge; with having eulogized that revolution through all its stages: with having palliated its atrocities, that they might promulgate its principles. Nor have they, from that day to this, left a stone unturned to accomplish an imitation of it among ourselves. Indeed we cannot refuse to admire the industry and ingenuity of these spiders; though we desire to tear their web: nay we could find in our heart, to pity the unfortunate fowler, who, after completing all his trains and contrivances; and standing ready in mute expectation with his hand half extended toward the prey; should suddenly behold all his nets, and gins, and springes broken in pieces. There will, indeed, be much sympathy, and much surprise, should we venture to transfer these doctors of absurdity, and 'architects of ruin' from the University of Europe to the Academy of Laputa: should our frigid obtuseness be unable to conceive the sublimity of their vast plans for the emancipation of the species; after all the breath which the illuminati of more genial climates have spent upon us: – after all their *performances* on the Continent of Europe, to demonstrate it: – should we still be found unable precisely to apprehend, how the subversion of all government will tend to the security of peace, liberty, and property; and how exceedingly both learning and virtue, and above all religion and piety would be promoted, by the plunder and extirpation of Christian establishments!

The sentimental Ceruti* said, with his last breath, 'The only regret I have in leaving the world, is, that I leave a religion on earth.' His words were applauded by the Assembly, the Radical Assembly of France. And it is, no doubt, with many of our own tender hearted liberals, a melancholy reflection; that their most venerable and hoary sages of revolution may, even now, perhaps, not survive *every* civil and religious institution: – that they may 'go to their own place,' before they have amassed a full legacy of curses for their posterity. However, no exertions have been wanting on their part: their efforts have been alike patient, orderly, united, and energetic. Their army is at last drawn out; and is about to make the grand charge. It has many raw recruits: but many disciplined veterans, and able marshals. Their watchwords are Liberty, and Reform: noble words indeed, but most foully abused. Let us execrate their principles; but imitate, for once, their union and energy. If we are divided, and disor-

* [Giacomo Ceruti (fl. *circa* 1750), Milanese painter.]

ganized; and above all, if we are panic-stricken, every thing is lost. No superiority of numbers will avail us, if we are separated, or wavering, or unprepared. In 1780 eight hundred thousand Londoners looked on in consternation, while a handful of pickpockets ravaged their property for three days! An eye witness of the Bristol outrages declared, that at the beginning, forty persons might have dispersed the rioters easily. On the 9th of November 1830, the leaders of the Radicals not being prepared to show themselves; and being disconcerted by a premature discovery of their plot; their mobs being consequently not so well organized as the police; the latter saved the metropolis from destruction. It was, I think, Marat, one of the Radical Reformers of France, who boasted that with three hundred ruffians hired at a Louis d'or per day, he could govern all France: and why? because all France was dismembered and panic-stricken.

Let us remember the fable of the lion and the bulls.

It is true we vastly, and beyond comparison outnumber the enemy: but then we are men of peace; and they are beasts of prey. We are strongest by day: they ravine in the night; for their optics are adapted to darkness. And it is now a very dark night for Europe. The radicals are elated; for it is a dark and foggy night; when thieves are always on the alert. They are housebreakers: we are quiet householders, who have drawn the curtains, and retired to rest!

Permit me to suggest to you, Electors of West Kent, that this is no time to multiply party distinctions, or to remember old grudges. We should travel in Caravan; prepared against a horde of thieves far more cruel than wandering Arabs. These highwaymen will rifle us if they catch us singly; but take to their heels over hedge and ditch, should they once meet us walking together on the King's Highway.

Let the *good old* Whigs, the Tories high and low, and the men of no party, for once come together, and twist a threefold cord which may not easily be broken.

It was thus Britain was saved in 1792, from a revolution which our illuminati were then on the very point of effecting. She was saved by nothing less than an inspiration from Heaven: by nothing else than a most sudden, universal revulsion of patriotism; and a simultaneous consociation, from one end of the kingdom to the other. And this revolution our abandoned Liberals had striven to bring about, while the blood of France was yet hot and reeking; and with the stench of that great butchery under their nostrils! In the extension of their philanthropy, which, indeed, they truly allege to be trammelled with no vulgar demarkations of patriotic geography, they were instituting a flesh market for the cannibals of Europe; and preparing to slay their brethren for the shambles. France was too narrow for them; and they were about to enlarge that slaughterhouse of Europe by throwing into it the habitations of their fathers.

The French had been smitten with giddiness from God; and distracted with delirious theories, more multitudinous than the tongues of Babel: but it was not while they were aspiring to raise a pinnacle to the skies; but were laying, in the very depths of Hell, the foundations of a charnel-house for Christendom.

But they meted out upon *themselves* the 'line of confusion and the stones of emptiness.' After laying waste one of the richest countries in the world, to obtain liberty and equality; they fell at once into the most abject military bondage, under a remorseless tyrant; who, wonderful to say, has ever been the pagod of our own most furious republicans and levellers: at whose spoliation of the liberties of Europe they exulted: at whose signal defeat and overthrow, by the blessing of God on the valour of their countrymen, they have scarcely ceased their wailings to this day.

In words, they are peace-makers and philanthropists: in deeds, they are incendiaries and assassins. They extenuated Buonaparte's most unprovoked a[g]gressions and invasions; and had he invaded *their own country*, would have hailed him with acclamations! But, when the standard of Spanish independence was lifted up; no sooner did Wellington and British valour drive him from the Peninsula, and unbind the nations; than truly, on a sudden, no cloistered maiden was to be found so sensitive, nay, so pious as the Radical! Yes, he who had beheld with sullen indifference the excesses of Robespierre, and with savage transport the exploits of Napoleon: would now, forsooth, doubt the very lawfulness of defensive warfare! He would question whether any true disciple of the Prince of Peace could take up arms! He would faint at the clash of a sword or the beating of a drum!

Gratitude the Radicals do not know. Their insolence ever increases with indulgence. Till they get the power into their hands, they whimper like school-boys; nay they can sob, and lisp, and languish like an infant: – the moment they are elvated, they dash in pieces the dupe who lifted them up. They are a generation of crocodiles, who mimic the wailings of distress, and devour those who come to relieve it.

They can put on the most saintly garb of Apostolic simplicity; and associate with the disciples that they may betray the Master. They are, at present, filled with apprehension, lest Christianity should suffer through an over-fed priesthood; and are most politely assiduous to relieve them of their superfluities: nay, so earnest are they found in this pious work; that even freehold estates, secured by the most indubitable titles to the Church, and legacies entailed upon it with the most awful sanctions, would be alienated at their touch: and signatures, and seals, and stamps, and rolls of parchment, would become dissolved in a moment, in the furnace of their Evangelical charity! Did our fathers pour forth their treasures at the feet of the Redeemer; and, in the most solemn manner, endow the Church with them for ever? – Hark! – these children of Judas Iscariot are inquiring, 'Why is not all this sold, and the money given to the poor?['] – But this they say, not because they care for the poor; but because they are thieves, and desire to clutch the bag, and to make off with its contents!

The Radicals have long clamoured for Parliamentary Reform, and a full representation, as the national panacea. This has been granted them, even to the extent of their own desires: and are they satisfied? Are they about to treat this reformed Parliament, this darling of their hopes, as nursing mothers? – or have

they, while it is yet in the womb, prepared their political unions to hector over, and bully it?

They now declare that this is but a *first step*: it is tolerated, however, because they imagine that they behold in it the dawn and twilight of a republic.

By this faction the Queen has already been most publicly menaced with the scaffold, in terms aggravated by personal insult: and our Sovereign, whose venerable parent's memory is, at present, a favourite butt of their savage vituperation: our beloved Sovereign, whose reign has been hitherto one series of concession; will fall the earliest victim to their baseness and perfidy; unless it should please the Almighty to dash their projects, and to 'turn the counsel of Ahitophel into foolishness.'*

The English Radical, and the Gallic Jacobin 'are brethren; instruments of cruelty are in their habitations. O my soul, come not thou into their secret; unto their assembly, mine honour, be not thou united: for in their anger they slew a man, and in their self-will they digged down a wall. Cursed be their anger, for it was fierce; and their wrath, for it was cruel' [Genesis xlix, 5–7]. They are the abortions and monsters of the moral universe; uncouth, perverse, and opposite to nature. They will grovel in the dust before a tyrant: but with a gentle and parental Sovereign 'their neck is as an iron sinew; and their brow brass' [Isaiah xlviii, 4]. They will cringe under the rod; and bite the hand that caresses them.

And will you, my countrymen, suffer this deplorable faction to pour out, not their representatives, but their delegates over the counties: to send forth their foxes, two by two, into your harvests, tied together by revolutionary pledges; and dragging between them the firebrands of destruction? Samson sent fire-b[r]ands to the *Philistine* fields. But *we*, if we make Constituents of these foxes of free trade and liberalism; shall be directing the matches of a starving peasantry to our own garners; and politically, shall light up such a fire in our country, as nothing will extinguish but the waters of desolation.

Samson, in death as in life heroic, brought down upon his head the vault of Dagon; and perished with his foes. But *we* are shattering the citadel of *our own* strength; the tabernacle of our constitution, the temple of our liberties, and the sanctuary of our God. We are tugging at those two main pillars; our loyalty and our piety; and shall be ground to power, in the crash and perdition of our country.

> So fond are mortal men,
> Fallen into wrath divine,
> As their own ruin on themselves t'invite;
> Insensate left or to sense reprobate;
> And with blindness internal struck.
>
> MILTON [*Samson Agonistes*, lines 1682–6]

Brother Electors; we have been requested to return to Parliament two Gentlemen, who have, unhappily, ranked themselves under the standard of the, so called, Radical Reformers. Personal remark is remote from my intention: but I would remind you that the Radicals have ever been found adverse to the

* [See John Milton, *Animadversions upon the Remonstrants Defence*, xv, 79.]

agricultural interest: that whatever they may pretend; they will, if possible, sweep away your protecting duties.

Farmers! They were the wretched leaders of this wretched faction, who, during the late dreadful fires, strenuously encouraged the incendiaries! Some of the most abandoned of them published cheap tracts for distribution among the poor, stimulating them to fire their master's property. But now, if there be a Radical Parliament; the starvation produced by free trade, and the consequent reckless desperation of the peasantry; will supersede the necessity of all other stimulants. If, then, you patronise Radicalism, in any shape, you will have yourselves to thank for the consequences.

Already, the fires have begun. Do you wish them to blaze once more over the kingdom? If you do; send Radicals into Parliament; make Radicals of the poor; and as those principles effectually relieve all classes from every religious and moral restraint; neither property nor life will be for a moment secure. Conflagration has already ravaged your harvests; and assassination and massacre are in its train.

Landholders, who have estates to be confiscated, or laid in ashes: Farmers, who have free trade, and annihilation impending over you: Manufacturers, who must be beggared in the bankruptcy of your country: Fund-holders, who desire not the *wet sponge*: Britons, who have liberty to lose: Christians, who have a religion to be blasphemed: now is the time for your last struggle! The ensuing Election is not a question of party politics; much less, a paltry squabble of family interests: but Existence, or Annihilation, to good old England!

Let us then rally once more: Whigs, Tories, Moderates; and especially every Christian man in West Kent; – it may be for the last time; – round the noble standard of Old Kentish Loyalty; and defend it to the last. If we triumph; our children will say of us; – 'These were the sacred heroes, who, amid the convulsion of the world, serenely held fast, and transmitted to us the birthright of our liberties: nay, all our glory, in the inheritance of the British Name.' If we perish in the contest; let it not be, O Spirit of Albion, as recreants and dastards: but with Thy standard clenched in our grasp; or folded about our hearts!

God prosper the good old cause: it is His Own. Is it the cause of old England: of our beloved Monarch: of our nobles: most truly of all our middle classes; and pre-eminently of the poor; who, in the destruction of commerce and agriculture; of order and property, get nothing of the spoil; but suffer every extremity of wretchedness and famine.

The other cause is that of the Devil and his Angels; masked under a pretended indignation at State tyranny, and Church corruption: witness, again, the great French Revolution: wherein the King, after making every just concession, and much more was savagely murdered: the nobles were massacred and banished: the Clergy butchered by companies, or assassinated at their church doors. A strumpet was dressed up, and publicly adored in the Cathedral of Paris, as the Goddess of Reason: our Saviour was denounced as an arch imposter, and the profession of his religion was prohibited!

The whole Radical and Atheistical party of England is now marshalled against the constitutional and religious; and Europe is looking on in solemn expectation[.]

The result of the ensuing Election will turn the balance. *One additional Conservative Member may save this great nation: – the vote of any one individual may secure that Member's election*. Every friend to our cause, however humble, should energize as if all depended on himself.

Unanimous co-operation and individual energy may do all things.

Electors; he who has thus taken the liberty to address you, however inadequate to the task; claims, at last, the merit of disinterestedness. SIR WILLIAM GEARY is personally unknown to him: nor will he obtain any sort of benefit by that Gentleman's return to Parliament. He has addressed you, without the instigation of a second person: without the knowledge of SIR WILLIAM, or any of his Committees. The writer receives not one farthing of the great or small tithe: *he has no connection with, or dependence on the Clergy*: he is neither a prophet, nor the son of a prophet. Alas! it is no longer a little cloud of the bigness of a man's hand, which hovers in our political horizon, but a blackness of darkness which it requires no prophetic direction to perceive. He is not accustomed to push himself forward: he loves not to hear himself talk; but would rather have listened while another spoke. He has not obtruded into the front ranks of the loyal army: but would be overwhelmed by the sense of such presumption. He had waited long in the rear and outposts, hoping that some stronger arm might be lifted up against the big and boastful Philistine of Jacobinism, who has hurled defiance alike at the institutions of men and the armies of God. And he has no heartier desire than that while he is picking up these few pebbles from the brook, and cutting out this rustic sling, he may be superseded and borne away by one sudden acclamation of re-kindled patriotism from Guernsey to the Hebrides: that Britain may never become intellectually a province of France: that her wolves of revolution may hear once more the British lion roaring from the cliffs of Kent, and be discomfitted: that we may never like the Trojans; whom old historians repute our ancestors; be undone by the presents of an enemy: but that the liberty and equality which our treacherous neighbours have offered us, as winged steeds to be yoked into the car of human improvement; may be timely suspected to be full of armed men: and, finally: that all our countrymen who have been deceived and over-persuaded by the internal troublers of our peace, may have the true nobility of mind readily and frankly to confess their mistake: and, instead of setting by the ears every class and order of society; may strive as heartily to promote that universal good will, and blessed brotherly union, which are the only root and basis of our prosperity and strength: which are able to lift us up, once more, in the scale of nations; and to constitute Britannia, as she was ever wont to be, the arbitress of the destinies, and the guardian of the liberties of Europe.

FINIS

APPENDIX 2

Samuel Palmer Senior's congregation at Aylesbury

In a postscript to a letter written to Martin Hardie on 1 February 1928, A. H. Palmer mentions Samuel Palmer Senior's Aylesbury 'flock': 'S.P. the elder was absolutely unstable in his actions. There was no knowing what he would do next, and I think that he may have been unstable in his religious beliefs also. Finally he issued a leaflet, price 1^d [about $\frac{1}{2}$p.], advertising for a congregation of which he would be the pastor. In this he was successful for a brief time.' (V.&A.) Presumably the leaflet was printed before Samuel Palmer Senior left Bloomsbury, and used on later occasions, including the establishment of the congregation at Aylesbury.

Mr A. H. Palmer II of Vancouver, B.C., owns a copy of the leaflet. It is probably unique. The title-page reads: ON THE FORMATION OF A NEW CHURCH By Samuel Palmer. *No.* 10, *Broad Street, Bloomsbury.* LONDON: PRINTED BY T. HARJETTE, 29, BEDFORD STREET, COVENT GARDEN. [Price 1^d].

ADDRESS

READER,

I wish to unite with some believers in the apostolic gospel for the public worship of God. In order that you may know my sentiments, the following assertions will declare them:

There is one God, even the Father; there is one Mediator between God and men, the man Christ Jesus. Those passages of Scripture which lead the reader to suppose that Christ is God, are explained by other texts which represent God the Father as dwelling in his Son.

It is scriptural to speak of Christ as the Son of God, but not as God the Son. The influence of the Spirit of God is to be implored, but not the influence of God the Spirit. Election; eternal, personal, and unconditional; particular redemption; and the final perseverance of the saints, are evident truths of the Holy Scriptures. Faith is belief, and belief is faith. Faith is 'of the operation of God,' and is 'the faith of God's elect.' That faith which is fruitless is worthless. The perpetuity of baptism is doubtful, and therefore not to be practised. The Lord's Supper should be observed every Lord's day. There should be a visible separation in the public worship of God, between the members of the Church and the other hearers. More than one brother should be employed in public

worship. Those who read or preach should not be distinguished from the rest by any peculiarity of dress, either in form or colour. No expenses should be incurred but for rent and the weekly contribution for the poor. Church meetings should be public, and a vestry is unnecessary. A most free intercourse among all the members is desirable, which must be regulated by circumstances. The ground of union must be faith in Christ. Unity of sentiment is very desirable; but hardly to be claimed except in matters of importance.

Family prayer is desirable, if all in the family be believers, but otherwise it should be omitted; as also the giving of thanks audibly before we eat. 'Enter into thy closet and pray to thy Father who is in secret.'

There is a difficulty on the subject of prayer. Peter said to Simon Magus; 'Pray God if perhaps the thought of thy heart may be forgiven thee, for I perceive thou art in the gall of bitterness and bond of iniquity.' But James says, 'Let not that man think he shall obtain any thing of the Lord' who does not pray in faith.

From these considerations it seems unadvisable to pray with sick persons who know not God; the gospel should be declared to them without social prayer.

With respect to alms-giving; it is unscriptural to publish the names of the donors, because it opposes the precept of Christ, 'Let not your left hand know what your right hand doth.'

These particulars might be much enlarged, but I wish to detain the reader but a short time. These few hints are sufficient for my present purpose, 'Where *two or three* are met together in my name, there am I in the midst of them.'

The foregoing are some of my sentiments, to which I wish to draw the attention of believers, that a union may be speedily formed; and that we may 'earnestly contend for the faith once delivered to the saints.'

Notes

For key to abbreviations see below, Abbreviations and select bibliography.

1 THE GATEWAY TO THE VALLEY

1 *L.* 1880 (26).
2 Ibid.
3 A.H.P.
4 Certificate of Freedom, 8 May 1805
 (Ivimy).
5 *L.* 1880 (26).
6 Ibid.
7 *L.&L.*, p. 59n.
8 A.H.P.
9 Ibid.
10 *L.* 1871 (7), 1872 (1).
11 A.H.P.
12 *L.* 1860 (18), 1871 (7).
13 *L.* 1814 (1).
14 Ibid.
15 *L.* 1814 (1).
16 A.H.P.
17 Ibid.
18 *L.* 1871 (7).
19 A.H.P.
20 *L.&L.*, p. 5.
21 L. from A. H. Palmer to Sir Frank
 Short, 13 May 1928 (Ashmolean
 Museum).
22 *L.* 1865 (8) (transcript, Ivimy).
23 *L.* 1871 (7).
24 Ibid.
25 *L.&L.*, p. 32.
26 *L.* 1815 (1).
27 *L.* 1863 (2).
28 A.H.P.
29 *L.&L.*, p. 6.
30 *L.* 1875 (15).
31 A.H.P.
32 Described and illustrated in Raymond
 Lister, *Samuel Palmer and the
 Ancients*, Cambridge, 1984, Cat.
 No. 56.
33 *L.* 1871 (7).
34 Algernon Graves, *British Institution,
 1806–1867, A Complete Dictionary
 of Contributors*, London, 1908,
 p. 413, and *Royal Academy of Arts, A
 Complete Dictionary of Contributors*,
 London, 1906, Vol. VI, p. 44.
35 *L.* 1872 (23) (Pierpont Morgan
 Library MS MA 3454–III).
36 Illustrated in M. Butlin, *Watercolours
 from the Turner Bequest
 1819–1845*, London, 1968.
37 *L.* 1872 (6).
38 A.H.P.
39 Eliza Finch, *Memorials of Francis Oliver
 Finch*, London, 1865, p. 353.
40 Ibid. pp. 354–8.
41 *L.&L.*, pp. 12–13.
42 Ibid. p. 16.
43 II Samuel vi, 22.
44 A.H.P.
45 Ibid.
46 *L.* 1827 (4) (Pierpont Morgan Library
 MS MA 3455–3).
47 *L.&L.*, p. 14.
48 A.H.P.
49 *L.&L.*, p. 14; A.H.P.
50 *L.&L.*, pp. 14, 16.
51 Ibid. p. 15.
52 Sketchbook, p. 2.
53 Ibid. p. III.
54 A.H.P.
55 Ibid.
56 Ibid.
57 Linnell Trust.
58 Ibid.
59 26 August 1828 (Linnell Trust). See
 L., pp. 29–30, n. 1.
60 A.H.P.
61 Ibid.

62 Ibid
63 Sketchbook, p. 2.
64 *Blake Records*, p. 282.
65 Linnell Trust.
66 Ibid.
67 *L.* 1860 (10).
68 *L.&L.*, pp. 9–10.
69 *L.* 1855 (4).
70 Gilchrist, p. 283; cf. *L.* 1861 (10).
71 *L.&L.*, p. 16.
72 Ibid. pp. 15–16.
73 Sketchbook, pp. 28, 114.
74 Keynes, p. 585.
75 A.H.P.
76 Keynes, p. 817.
77 Ibid. p. 793.
78 Robert T. Peterson, *The Art of Ecstasy*, London, 1970, p. 31.
79 *L.&L.*, p. 18.
80 Gilchrist, p. 300.
81 A.H.P.
82 Gilchrist, pp. 299–300; *L.&L.*, p.24, n.2.
83 L. from Frederick Tatham to Francis Harvey, *Blake Records*, p.41, n.4.
84 *L.* 1880 (17) (Pierpont Morgan Library MS MA 3454–135).
85 *Athenaeum*, 25 August 1883.
86 *Calvert*, p. 19.
87 A. T. Story, *James Holmes and John Varley*, London, 1894, p. 105.
88 A.H.P.
89 Keynes, p. 502.
90 Ibid. p. 649.

2 THE VALLEY OF VISION

1 *L.* 1828 (4) (Pierpont Morgan Library MS MA 3455–6).
2 *L.* 1871 (7).
3 A.H.P.
4 Ibid.
5 *L.* 1823 (1).
6 A.H.P.
7 Ibid.
8 *Calvert*, p. 37.
9 A.H.P.
10 *Calvert*, p. 35.
11 Ibid. p. 36.
12 A.H.P.
13 Hartley MSS.
14 *L.* 1827 (2).
15 'Some Observations on the Country and on Rural Poetry', *English Version*, p. 1.
16 L. from A. H. Palmer to Martin Hardie, 20 July 1920 (V.&A.).
17 Lister, *Calvert*, pls. xxiii, xxviii, xxxvi.
18 Raymond Lister, *George Richmond: A Critical Biography*, London, 1981, pls. 3, 20, 21, 22.
19 *L.* 1862 (3).
20 *Georgics* Book I, lines 1–5.
21 Sketchbook, pp. 74–5.
22 Ibid. p. 127.
23 *Calvert*, p. 33.
24 *L.* 1828 (9).
25 Ivimy.
26 *L.&L.*, pp. 33–4.
27 *L.* 1827 (4) (Pierpont Morgan Library MS MA 3455–3).
28 Third edition, London, 1674, preliminary page A2 recto.
29 Ibid. p. 130.
30 *L.&L.*, p. 44.
31 Trans. Joseph Davidson, London, 1790, pp. 53–4.
32 *L.* 1828 (11).
33 Keynes, pp. 611, 792.
34 *L.* 1828 (11).
35 *L.* 1875 (7).
36 A.H.P., cf. *L.&L.*, p. 79.
37 *L.* 1880 (19).
38 *L.* 1827 (3).
39 *L.* 1870 (5).
40 Unpubd l. to George Richmond, 13 December 1870 (Pierpont Morgan Library MS MA 3454–102).
41 *L.* 1879 (5).
42 *L.* 1878 (7).
43 *L.* 1828 (5).
44 *L.* 1831 (1).
45 *L.* 1826 (1).
46 *L.* 1834 (4) (Pierpont Morgan Library MS MA 3455–9).
47 Gilchrist, p. 353.
48 A.H.P.
49 Ibid.
50 Ibid.
51 Linnell Trust.
52 *L.&L.*, p. 39.
53 *L.* 1828 (4) (Pierpont Morgan Library MS MA 3455–6).
54 A.H.P.
55 *L.* 1828 (6).
56 *L.* 1828 (9). For Calvert's *The Cyder Feast*, see Lister, *Calvert*, pl. xxiii.

57 *L.* 1834 (1) (Pierpont Morgan Library MS MA 3455–8).

58 A.H.P.

59 *L.* 1828 (2).

60 See Raymond Lister, 'Welby Sherman and Samuel Palmer's *The Shepherd*', *Connoisseur*, July 1977, pp. 212–13.

61 *L.* 1828 (4) (Pierpont Morgan Library MS MA 3455–6).

62 Ivimy.

63 Genesis iii, 19.

64 *L.&L.*, pp. 54–5.

65 A.H.P.

66 *L.* 1828 (10); 1829 (3).

67 *L.* 1834 (1) (Pierpont Morgan Library MS MA 3454–9).

68 A.H.P.

69 Linnell Trust.

70 Ibid.

71 A.H.P.

72 Ibid.

73 Ibid.

74 L. from A. H. Palmer to F. L. Griggs, 27 June 1926 (Mrs Nina Griggs).

75 A.H.P.

76 *L.* 1835 (1).

77 Unpubd l., 1 February 1876 (Pierpont Morgan Library MS MA 3454–121).

78 *L.* 1835 (2).

79 *L.* 1836 (1) (Pierpont Morgan Library MS MA 3454–1).

80 Ibid.

81 *L.* 1836 (1) (Pierpont Morgan Library MS MA 3454–1); see also *L.* Appendix II.

82 *Calvert*, p. 97.

83 A.H.P.

84 *Calvert*, p. 49.

85 *L.* 1837 (1).

86 A.H.P.

87 *L.* 1837 (2).

88 A.H.P.

89 Ibid. Transcribed from the second volume of Palmer's commonplace book (now presumed destroyed).

3 ITALIAN INTERLUDE

1 A.H.P.

2 Ivimy.

3 A.H.P.

4 Ivimy.

5 A.H.P. (transcript of l. to Palmer, 28 September 1838).

6 A.H.P.

7 *L.* 1838 (4).

8 *L.* 1837 (6).

9 *L.* 1837 (7).

10 Ibid.

11 *L.* 1837 (8).

12 Ibid.

13 Ibid.

14 *L.* 1837 (9), 1838 (1, 2, 9).

15 5 December 1837 (Linnell Trust).

16 *L.* 1837 (9).

17 *L.* 1838 (1).

18 *L.* 1838 (7).

19 *L.* 1828 (9).

20 *L.* 1838 (4).

21 15 April 1838 (Linnell Trust).

22 Ibid.

23 *L.* 1838 (6).

24 9 February 1838 (Linnell Trust).

25 29 April 1838 (Linnell Trust).

26 *L.* 1838 (9).

27 Ibid.

28 A.H.P.

29 *L.* 1837 (6).

30 F. M. Redgrave, *Richard Redgrave*, London, 1891, p. 51.

31 *L.* 1838 (15).

32 15 April 1838 (Linnell Trust).

33 *L.* 1838 (3).

34 15 April 1838 (Linnell Trust).

35 Ibid.

36 *L.* 1839 (4).

37 19 May 1839 (Linnell Trust).

38 Ibid.

39 *L.* 1838 (9).

40 26 May 1839 (Linnell Trust).

41 *L.* 1838 (3).

42 26 June 1838 (Linnell Trust).

43 *L.* 1838 (9).

44 *L.* 1839 (3).

45 *L.* 1839 (5).

46 23 December 1838 (Linnell Trust).

47 A.H.P.

48 *L.* 1838 (4, 8).

49 *L.* 1838 (10).

50 *L.* 1837 (9).

51 4 January 1838 (Linnell Trust).

52 *L.* 1838 (2).

53 *L.* 1838 (10).

54 A.H.P.

55 22 June 1838 (Linnell Trust).

56 *L.* 1838 (3).

57 *L.* 1838 (4).

58 *L.* 1838 (9).

59 23 November 1838 (Linnell Trust).

60 *L.* 1839 (2).

61 *L.* 1838 (10).
62 *Night Thoughts* Night I, line 417.
63 *L.* 1838 (8).
64 26 June 1838 (Linnell Trust).
65 *L.* 1838 (8).
66 *L.* 1839 (18).
67 *L.* 1834 (1) (Pierpont Morgan Library MS MA 3455–9).
68 *L.* 1838 (13) (Pierpont Morgan Library MS MA 3454–3).
69 *L.* 1839 (23) (Pierpont Morgan Library MS MA 3454–5).
70 *L.* 1838 (13) (Pierpont Morgan Library MS MA 3454–3).
71 *L.* 1839 (6).
72 26 April 1839 (Linnell Trust).
73 *L.* 1839 (13).
74 30 September 1839 (Linnell Trust).
75 *L.* 1838 (2).
76 *L.* 1838 (7).
77 *L.* 1838 (6) (Pierpont Morgan Library MS MA 3454–2).
78 *L.* 1839 (4).
79 Ibid.
80 *L.* 1838 (6) (Pierpont Morgan Library MS MA 3454–2), 1839 (17).
81 *L.* 1838 (8).
82 *L.* 1838 (7).
83 *L.* 1838 (10).
84 *L.* 1838 (22) (Pierpont Morgan Library MS MA 3454–4).
85 *L.* 1858 (3).
86 *L.* 1838 (23).
87 *L.* 1838 (8).
88 *L.* 1838 (23).
89 6 January 1839 (Linnell Trust).
90 *L.* 1839 (3).
91 16 February 1839 (Linnell Trust).
92 24 January 1839 (Linnell Trust).
93 *L.* 1839 (5).
94 Ibid.
95 *L.* 1839 (6).
96 *L.* 1839 (9, 10); 5–9 April 1839 (Linnell Trust).
97 8 March 1839 (Linnell Trust).
98 *L.* 1839 (6).
99 Ibid.
100 24 March 1839 (Linnell Trust).
101 *L.* 1839 (10).
102 *L.* 1839 (12).
103 *L.* 1839 (10).
104 *L.* 1839 (9).
105 *L.* 1839 (10).
106 Ibid.
107 26 April 1839 (Linnell Trust).

108 *L.* 1839 (10).
109 10 May 1839 (Linnell Trust).
110 *L.* 1839 (13).
111 Ibid.
112 26 May 1839 (Linnell Trust).
113 *L.* 1839 (15).
114 Ibid.
115 *L.* 1839 (16).
116 *L.* 1839 (23) (Pierpont Morgan Library, MS MA 3454 – 5).
117 *L.* 1839 (18).
118 Ibid.
119 9 July 1839 (Linnell Trust).
120 *L.* 1839 (20).
121 Ibid.
122 *L.* 1839 (21).
123 11 June 1839 (Linnell Trust).
124 *L.* 1839 (20).
125 *L.* 1839 (22).
126 5 September 1839 (Linnell Trust).
127 20 September 1839 (Linnell Trust).
128 *L.* 1839 (24).
129 16 October 1839 (Linnell Trust).
130 *L.* 1839 (22).
131 Ibid.
132 *L.* 1839 (25); cf. *Paradise Lost* Book I, lines 249–51.
133 23 November 1839 (Linnell Trust).
134 *L.* 1839 (4).
135 Ivimy. Cf. *L.* 1839 (26).
136 L. from A. H. Palmer to F. L. Griggs, 6 June 1926 (Mrs Nina Griggs); cf. *Anne Gilchrist*, p. x.
137 A.H.P.
138 Ibid.

4 THE BATTLE OF LIFE

1 *L.* 1840 (2).
2 Louisa Twining, *Recollections of Life and Work*, London, 1893, pp. 19–20.
3 *L.* 1864 (24).
4 A.H.P.; cf. *L.* 1844 (1).
5 *L.* 1851 (1, 2) (Pierpont Morgan Library MS MA 3454–17, 18).
6 *L.* 1871 (8), 1881 (8).
7 *L.* 1857 (2) (Pierpont Morgan Library MS MA 3454–35).
8 *L.&L.*, p. 15.
9 Ivimy.
10 A.H.P.
11 Ibid.
12 *L.* 1844 (2).
13 *L.* 1845 (7).
14 A.H.P.

15 L. 1843 (1).
16 Ivimy.
17 L.&L., p. 73.
18 Ibid. p. 69.
19 Ibid. p. 73.
20 L. 1843 (7).
21 Unpubd l. to George Richmond, 2 January 1873 (Pierpont Morgan Library MS MA 3454–112).
22 L. 1843 (4); L.&L., p. 75.
23 A.H.P.
24 L. 1844 (4).
25 L. 1845 (6).
26 Ibid.
27 L. 1847 (6).
28 L. 1846 (5).
29 L.&L., pp. 78–9.
30 This recently discovered MS (V.&A.) was selectively printed L.&L., p. 79, and first printed in full in Mark Abley (ed.), *Samuel Palmer: The Parting Light*, Manchester, 1985, pp. 116–20, on which this transcription is based.
31 Vancouver Notebook.
32 L.&L., pp. 80–1.
33 L. 1847 (5).
34 A.H.P.
35 L. 1846 (8).
36 L. 1846 (7).
37 A.H.P. (transcript).
38 L. 1845 (8).
39 L.&L., pp. 84–5, 88; R. Lister, *George Richmond: A Critical Biography*, London, 1981, pp. 150–75.
40 L. 1846 (2), reprinted by permission of the Huntington Library, San Marino, California.
41 *The Letters of Charles Dickens*, ed. Kathleen Tillotson, Oxford, 1977, Vol. IV, pp. 503, 516, 517–18, 520–1.
42 Ibid. pp. 546–7.
43 L. 1846 (3).
44 L. to Martin Hardie, 11 July 1920 (V.&A.).
45 L. 1846 (4).
46 A.H.P.
47 L. 1853 (2).
48 A.H.P.
49 L. 1847 (9).
50 A.H.P.
51 L. 1847 (11).
52 L.&L., pp. 85–6.
53 L. 1862 (5).
54 A.H.P.
55 L. 1848 (2).

56 L. 1848 (4).
57 L. 1848 (3).
58 L. 1848 (5).
59 A.H.P.
60 L.&L., pp. 87–8.
61 L. 1849 (1) (Pierpont Morgan Library MS MA 3454–12).
62 L. 1849 (8).
63 L. 1849 (6) (Pierpont Morgan Library MS MA 3454–13), 1849 (7, 9).
64 London, 1826, Vol. II, p. 72.
65 L. 1864 (18).
66 Reproduced L.&L., facing p. 106.
67 Michael Kitson, *Claude Lorrain: Liber Veritatis*, London, 1978, pls. 111, 122, 165.
68 L.&L., p. 103.

5 A HARVEST OF TRAGEDY

1 L. from Mrs Margaret Auchmuty to A. H. Palmer, 1 July 1928 (Ivimy).
2 L. 1861 (6).
3 L.&L., p. 101.
4 L. to F. L. Griggs from A. H. Palmer, 18 July 1930 (Mrs Nina Griggs).
5 L. 1854 (3).
6 L. 1855 (3) (Pierpont Morgan Library MS MA 3454–27).
7 27 December 1920 (V.&A.)
8 L.&L., pp. 88–9.
9 Ibid. p. 156n.
10 Unpubd L. (Pierpont Morgan Library MS MA 3454–67).
11 L.&L., p. 89.
12 Ibid. pp. 102–4.
13 Ibid. p. 114.
14 Ibid. p. 106.
15 Martin Hardie, *Samuel Palmer*, London, 1928, p. 19.
16 L.&L., p. 99.
17 Ibid.
18 Ibid.
19 L. 1876 (5).
20 L.&L., p. 100.
21 Lister, *Calvert*, pl. xxii.
22 A. H. Palmer, *Samuel Palmer: A Memoir*, London, 1882, p. 7.
23 A.H.P.
24 E. S. Purcell, *Life of Cardinal Manning*, London, 1896, Vol. II, p. 13.
25 A.H.P.
26 L. 1849 (11).

27 A.H.P.
28 Ibid.
29 Ibid.
30 Ibid.
31 Ibid.
32 Ibid.
33 A.H.P. (transcript).
34 A.H.P.
35 *L.* 1856 (8).
36 A.H.P.
37 *L.* 1850 (2), 1851 (8).
38 *L.* 1854 (4) (Pierpont Morgan Library MS MA 3454–24).
39 *L.* 1854 (5).
40 *L.* 1854 (6).
41 *L.* 1857 (7).
42 A.H.P.
43 *L.* 1859 (11) (Pierpont Morgan Library MS MA 3454–39).
44 *L.* 1851 (2), 1854 (1) (Pierpont Morgan Library MS MA 3454–18, 25); 1855 (1), 1859 (5).
45 *L.* 1855 (2) (Pierpont Morgan Library MS MA 3454–26).
46 A.H.P.
47 *L.* 1856 (3) (Pierpont Morgan Library MS MA 3454–30).
48 Linnell Trust.
49 *L.* 1855 (4).
50 Keynes, p. 185.
51 *L.* 1860 (20) (Pierpont Morgan Library MS MA 3454–43).
52 *L.* 1862 (11).
53 *L.* 1862 (12).
54 Ibid.
55 Keynes, p. 545.
56 *Anne Gilchrist*, pp. 132–3.
57 *The Guardian*, 30 April 1856, p. 343.
58 Michael Kitson, *Claude Lorrain: Liber Veritatis*, London, 1978, pl. 129.
59 *L.* 1858 (6).
60 *L.* 1858 (7).
61 *L.* 1859 (6).
62 *L.&L.*, p. 37.
63 A.H.P.
64 A. M. W. Stirling, *The Richmond Papers*, London, 1926, p. 148.
65 A.H.P. l. from Hannah Palmer to Linnell (transcript).
66 Linnell Trust.
67 Ibid.
68 *L.* 1860 (15).
69 Linnell Trust.
70 Ibid.
71 A.H.P.

72 Ibid.
73 Linnell Trust.
74 *L.* 1859 (3).
75 *L.* 1859 (4).
76 *L.* 1859 (11) (Pierpont Morgan Library MS MA 3454–39).
77 A.H.P.
78 Ibid.
79 Ibid; *L.&L.*, p. 119.
80 *L.* 1860 (4).
81 Hannah Palmer: MS volume of transcripts and notes (Mr A. H. Palmer II, Vancouver, B.C.).
82 Ibid.
83 *L.* 1861 (6).
84 *L.* 1861 (15, 17).
85 Hannah Palmer (see above, n. 81); A.H.P.
86 A.H.P. (transcript).
87 Ibid.
88 A.H.P.
89 Ibid.
90 Ibid.
91 Ibid.
92 *L.* 1861 (20); (21) (Pierpont Morgan Library MS MA 3454–44).
93 I am grateful to Dr E. V. Bevan for this suggestion.
94 *L.* 1861 (26) (Pierpont Morgan Library MS MA 3454–46).
95 Ibid.
96 A.H.P. (transcript).
97 *L.* 1861 (24, 31).
98 *L.* 1861 (32).
99 Ibid.
100 A.H.P. (transcript).

6 GRIEF AND THE INSPIRATION OF EXPERIENCE

1 A.H.P.
2 *L.* 1861 (34) (Pierpont Morgan Library MS MA 3454–49).
3 *L.* 1862 (4).
4 *L.* 1861 (39) (Pierpont Morgan Library MS MA 3454–53).
5 Unpubd l. to George Richmond, 29 April 1862 (Pierpont Morgan Library MS MA 3454–56).
6 A.H.P.
7 *L.&L.*, p. 125.
8 Lister, *Calvert*, pl. xxx, pp. 82–5, 104.
9 Ibid. pp. 88–9.
10 *L.* 1855 (4).

11 *L.* 1862 (8).

12 *L.* 1872 (1).

13 I am grateful to Miss Joan Linnell Ivimy for identifying the view.

14 *V.&A. 1926 Cat.*, p.81.

15 Ibid. p. 80; Martin Hardie, *Frederick Goulding Master Printer of Copper Plates*, Stirling, 1910.

16 *L.* 1880 (5).

17 *L.* 1880 (7).

18 L. from A. H. Palmer to Martin Hardie, 19 January 1913 (V.&A.).

19 Ibid.

20 *L.* 1871 (4).

21 *L.* 1863 (8).

22 Ibid.

23 Ibid.; *L.* 1862 (12).

24 *L.* 1863 (1).

25 *L.* 1861 (34) (Pierpont Morgan Library MS MA 3454–49).

26 *L.* 1863 (1).

27 *L.* 1861 (38) (Pierpont Morgan Library MS MA 3454–52).

28 *L.* 1861 (34, 37, 38, 39) (Pierpont Morgan Library MS MA 3454–49, 51, 52, 53); 1862 (9); 1871 (2); 1880 (21, 30).

29 C. H. Cope, *Reminiscences of Charles West Cope RA*, London, 1891, p. 193.

30 *L.* 1873 (2).

31 *L.* 1861 (34) (Pierpont Morgan Library MS MA 3454–49).

32 L. from A. H. Palmer to Martin Hardie, 30 September 1926 (V. & A.).

33 A.H.P.; some details communicated by Mr John E. A. Samuels.

34 L. from A. H. Palmer to F. L. Griggs, 2 May 1927 (Ashmolean Museum).

35 Robert N. Essick, *The Separate Plates of William Blake*, Princeton, N. J., 1983, fig. 57; Raymond Lister, *Great Images of British Printmaking*, London, 1978, pl. 1; Lister *Calvert*, pls. xxxvi, xxxvii.

36 *L.* 1868 (10) (Pierpont Morgan Library MS MA 3454–72).

37 Unpubd l., June 1871 (Pierpont Morgan Library MS MA 3454–105).

38 *L.&L.*, p. 137.

39 *L.* 1875 (10); cf. l. from A. H. Palmer to F. L. Griggs, 20 December 1927 (Mrs Nina Griggs); A. H. Palmer, 'James Clark Hook R.A.', *The Portfolio*, 1888, pp. 1–9, 35–43, 74–82, 105–11, 165–70.

40 Unpubd l., 24 December 1868 (Pierpont Morgan Library MS MA 3454–79).

41 *L.&L.*, p. 107.

42 *L.* 1866 (5); *L.&L.*, p. 106.

43 A.H.P.

44 *L.&L.*, p. 136.

45 *L.* 1869 (9).

46 Ronald Pearsall, *The Worm in the Bud*, Harmondsworth, 1971, p. 161.

47 L. from A. H. Palmer to Sir Frank Short, 28 July 1928 (Ashmolean Museum).

48 Ibid. 31 December, 1926 (Ashmolean Museum).

49 *Essay on May*, Epistle ii, line 2.

50 L. from A. H. Palmer to F. L. Griggs, 6 August 1926 (Mrs Nina Griggs).

51 A.H.P.

52 A.H.P. (transcript).

53 *L.* 1863 (2).

54 A.H.P.

55 *L.* 1865 (8); the quotation is from *Macbeth*, III.iv.21.

56 *L.* 1870 (5).

57 Unpubd l. to George Richmond, 29 April 1862 (Pierpont Morgan Library MS MA 3454–58).

58 Unpubd l., December 1868 (Pierpont Morgan Library MS MA 3454–76).

59 A.H.P.

60 Ibid.

61 Ibid.

62 A.H.P. (transcript).

63 A.H.P.

64 *L.* 1870 (2).

65 A.H.P.

66 *L.* 1864 (14).

67 A.H.P.

68 *L.* 1866 (7) (Pierpont Morgan Library MS MA 3454–68).

69 Unpubd l., August 1866 (Pierpont Morgan Library MS MA 3454–67).

70 *L.* 1686 (1).

71 *L.* 1868 (8); for the wood-engraving *The Ploughman*, see Lister, *Calvert*, pl. xvii.

72 *L.* 1863 (9).

73 *L.* 1864 (5).

74 *L.&L.*, pp. 149–50.

75 *L.* 1864 (6).

76 *L.* 1864 (6).

77 Ibid.

78 A.H.P.

79 Ibid.

80 *L.* 1864 (9).

81 *L.* 1839 (9).

82 Michael Kitson, *Claude Lorrain: Liber Veritatis*, London, 1978, pls. 24, 67, 79.

83 A.H.P.

84 L. from A. H. Palmer to Sir Frank Short, 10 May 1923 (Ashmolean Museum).

85 *L.* 1879 (6).

86 *The Rising Moon* or *An English Pastoral*, Raymond Lister, *Samuel Palmer and his Etchings*, London, 1969, No. 7.

87 *L.* 1864 (20).

88 *L.* 1872 (21).

89 *L.&L.*, p. 82.

90 *L.* 1879 (12).

91 A.H.P. (transcript).

92 *L.* 1872 (1).

93 *L.&L.*, p. 157; A.H.P.

94 *V.&A. 1926 Cat.*, p. 85.

95 Ibid.

96 L.s from A. H. Palmer to Martin Hardie, 27 December 1920, 30 March 1924 (V.&A.).

97 L. from A. H. Palmer to Martin Hardie, 1 October 1922 (V.&A.).

98 *L.* 1880 (34).

99 L. from A. H. Palmer to Martin Hardie, 9 April 1922 (V.&A.).

100 Ibid. 9 April 1924 (V.&A.).

101 *L.* 1872 (19, 20).

102 *L.* 1879 (28); 1880 (14, 31, 33); 1881 (18).

103 *L.* 1864 (2).

104 *L.&L.*, p. 163.

105 *L.* 1873 (7); 1880 (2).

106 *L.&L.*, p. 161.

107 Unpubd l., 1 February 1876 (Pierpont Morgan Library MS MA 3454–121).

108 Unpubd l. to George Richmond, 17 August 1875 (Pierpont Morgan Library MS MA 3454–118).

109 *L.* 1875 (14).

110 *L.* 1880 (32).

111 *L.* 1881 (5).

112 See *Blake Records*, pp. 413–18; *Blake Studies*, p. 157; *Anne Gilchrist*, pp. 129–31.

113 *L.* 1878 (5).

114 *L.* 1880 (43).

115 A.H.P.

116 *L.* 1879 (26).

117 *L.* 1879 (27).

118 *L.* 1880 (1).

119 *Paradise Lost* Book IV, line 603.

120 *L.* 1880 (35).

121 *L.* 1880 (37).

122 *L.* 1881 (14, 19).

123 Unpubd l. to George Richmond, 25 April 1881 (Pierpont Morgan Library MS MA 3454–140).

124 Ibid.

Abbreviations and select bibliography

Unless otherwise stated, the place of publication is London.

A.H.P.	A. H. Palmer's unpublished notes, in the possession of Miss Joan Linnell Ivimy
Anne Gilchrist	Herbert Harlakenden Gilchrist: *Anne Gilchrist: Her Life and Writings*, 1887
Blake Records	G. E. Bentley Jr: *Blake Records*, Oxford, 1969
Blake Studies	Sir Geoffrey Keynes: *Blake Studies*, 2nd edn, Oxford, 1971
Calvert	[Samuel Calvert:] *A Memoir of Edward Calvert Artist by his Third Son*, 1893
English Version	Samuel Palmer: *An English Version of the Eclogues of Virgil*, 1883
Gilchrist	Alexander Gilchrist: *Life of William Blake*, 1863, ed. Ruthven Todd, 1942
Hartley MSS	MSS and other materials in the possession of Mrs Miriam Hartley
Ivimy	Ivimy MSS in the possession of Miss Joan Linnell Ivimy
Keynes	Sir Geoffrey Keynes (ed.): *The Complete Writings of William Blake*, Oxford, 1966
L., l.	Letter
L.	Raymond Lister (ed.): *The Letters of Samuel Palmer*, Oxford, 1974
L. & L.	A. H. Palmer: *The Life and Letters of Samuel Palmer Painter and Etcher*, 1892 (facsimile reprint, 1972)
Linnell Trust	MSS and other material in the possession of the Linnell Trust
Lister, *Calvert*	Raymond Lister: *Edward Calvert*, 1962
Sketchbook	Palmer's 1824 Sketchbook, British Museum. Facsimile, with an introduction and commentary by Martin Butlin, 1962
Unpubd	Unpublished
V. & A.	Victoria and Albert Museum
V. & A. 1926 Cat.	Victoria and Albert Museum: *Catalogue of an Exhibition of Drawings, Etchings and Woodcuts by Samuel Palmer and other Disciples of William Blake*, 1926
Vancouver Notebook	Notebook made by Samuel Palmer and A. H. Palmer containing technical notes, transcripts etc., in the possession of Mr A. H. Palmer II, Vancouver, Canada

In addition to the works listed above, the following are recommended for further reading:

Mark Abley: *Samuel Palmer: The Parting Light*, Manchester, 1985 [a selection of Palmer's writings]

R. G. Alexander: *A Catalogue of the Etchings of Samuel Palmer*, 1937 (Print Collectors' Club, No. 6)

Arts Council of Great Britain: *Samuel Palmer and His Circle. The Shoreham Period*, 1956

G. E. Bentley, Jr, Robert N. Essick, Morton D. Paley and Robert R. Wark: *Essays on the Blake Followers*, San Marino, California, 1983

Laurence Binyon: *The Followers of William Blake*, 1925

David Blayney Brown: *Samuel Palmer ... Loan Exhibition from the Ashmolean Museum*, Oxford, 1982

David Cecil: *Visionary and Dreamer: Two Poetic Painters: Samuel Palmer and Edward Burne-Jones*, Princeton, N.J., 1969

Katharine Crouan: *John Linnell: A Centennial Exhibition*, Cambridge, 1982

Arnold Fawcus, Sir Geoffrey Keynes, Raymond Lister and Graham Reynolds: *Samuel Palmer: A Vision Recaptured: The Complete Etchings and the Paintings for Milton and for Virgil*, 1978

Larry Gleeson: *Followers of Blake*, Santa Barbara Museum of Art, 1976

Geoffrey Grigson: *Samuel Palmer, the Visionary Years*, 1947
 Samuel Palmer's Valley of Vision, 1960

Martin Hardie: *Water-colour Painting in Britain*, II: *The Romantic Period*, ed. Dudley Snelgrove with Jonathan Mayne and Basil Taylor, 1967
 Samuel Palmer, 1928 (Print Collectors' Club, No. 7)

Helen Irwin: 'Samuel Palmer, Poet of Light and Shade', *Apollo*, August 1981

Raymond Lister: 'The Book Illustrations of Samuel Palmer', *The Book Collector* 28 (1979), pp. 67–103
 British Romantic Art, 1973
 George Richmond: a Critical Biography, 1981
 Catalogue Raisonné of the Works of Samuel Palmer, Cambridge, 1988
 The Paintings of Samuel Palmer, Cambridge, 1985
 Samuel Palmer and his Etchings, 1969
 Samuel Palmer and the Ancients, Cambridge, 1984
 Samuel Palmer in Palmer Country, East Bergholt, 1980 [with topographical notes by A. K. Astbury]

Edward Malins: *Samuel Palmer's Italian Honeymoon*, 1968

A. H. Palmer: *Samuel Palmer: A Memoir*, 1882

Hannah Palmer: MS volume of transcripts and notes, in the possession of Mr A. H. Palmer II. Vancouver, Canada

William L. Pressly Jr: 'Samuel Palmer: The Etching Dream', *Record of the Art Museum, Princeton University* XXIX.2, 1970
 'Samuel Palmer and the Pastoral Convention', Ibid. XXVIII.2, 1969, pp. 22–37

Joseph Viscomi: *Prints by William Blake and His Followers*, Ithaca, N.Y., 1983

Index